0/97

Baroque Art

BAROQUE ART
A Topical Dictionary

IRENE EARLS

Greenwood Press

WESTPORT, CONNECTICUT • LONDON

Library of Congress Cataloging-in-Publication Data

Earls, Irene.
 Baroque art : a topical dictionary / Irene Earls.
 p. cm.
 Includes bibliographical references and index.
 ISBN 0–313–29406–2 (alk. paper)
 1. Art, Baroque—Dictionaries. I. Title.
 N6415.B3E18 1996
 709'.03'203—dc20 95–51397

British Library Cataloguing in Publication Data is available.

Library of Congress Catalog Card Number: 95–51397
ISBN: 0–313–29406–2

First published in 1996

Greenwood Press, 88 Post Road West, Westport, CT 06881
An imprint of Greenwood Publishing Group, Inc.

Printed in the United States of America

The paper used in this book complies with the
Permanent Paper Standard issued by the National
Information Standards Organization (Z39.48–1984).

10 9 8 7 6 5 4 3 2 1

Contents

Preface

This dictionary is planned to assist those individuals interested in the topics used by artists during the 17th century or that period known in history as the Baroque. The book is a reference source for identifying and understanding the art of Italy and northern Europe during the 1600s. It contains basic information about topics that were popular subjects of painting and sculpture and the decorative arts during this time. Also included are a limited number of entries on characteristic schools, media, techniques and other terminology one might find in the art history volumes covering this period. These entries serve as background information and provide a basic art history vocabulary for understanding or clarifying certain topics or for identifying iconographic inclusions or mythological gods or goddesses. Readers may also supplement information found in each article through a system of internal cross-references.

When a topic, person or other Baroque term for which there is a separate entry appears in another entry, this is indicated on the first mention by the use of capital letters. ''See'' references and a subject index provide readers with an even more complete location of topics and other entries. The general subject index includes the names of other persons mentioned in the text plus other key words and phrases that will enable the reader to identify and understand a topic or a special term. A list of Popes, important patrons of Baroque art, can be found in Appendix A. As an aid to further study, a list of northern European and Italian Baroque artists, with their life dates and nationalities, has been included (Appendix B). This appendix has been compiled from the example lines found at the end of topical entries and from artists specifically named in certain entries. It is not a complete list of all Baroque artists, but, rather, an index of those mentioned in this dictionary. A bibliography is also provided for further reference.

Arranged in one alphabetical sequence, the entries concentrate on topics related to those works of art created between the late 16th century and a few years

after the start of the 18th century. During this time artists sometimes illustrated stories from the Bible, the lives and deaths and legends of the Christian saints as told in the *Golden Legend* and other sources, mythological subjects, certain historical events, and important or influential individuals. Artists chose their subjects for a variety of reasons, and an understanding of the resulting works of art presupposes some knowledge of the sources from which they and their patrons drew. It may be true that many biblical, mythological, historical, and other references or allusions in Baroque art are incomprehensible to the present generation. In the belief that gaps of knowledge exist, this book has been designed to help fill them: passages from the Bible and other references, such as Ovid's *Metamorphoses,* have been included.

The purpose is to foster an art history literacy and help those who are interested to understand and to enjoy works of art more fully. Certainly a knowledge of the meaning of a work of art opens new realms of enjoyment and appreciation. Also, it is important to note that this knowledge is not confined to the Baroque. Because some of the topics appear in various periods from antiquity to the 19th century, one could, by extension, say that this book is not limited entirely to Baroque art. Long after the Baroque period, many of the same topics, such as Tobias and Parnassus and Saint Martin, appear again in works of art.

Certainly a book about topics can only be selective, especially within the confines of one volume. With increasing specialization in the history of art, Baroque art is being analyzed in ever finer focus. Such scholarly application is good, but in order for the gallery visitor, student, researcher or any interested person exploring new territory to find an unbiased view of Baroque topics, the entries here have been written according to generally accepted views and traditional emphasis, not individual interpretations. For this same reason, the guiding principle of selection has been to center on the mainstream. A topic painted only one time on the wall of a remote Baroque church in Rome, for example, will probably not be found here. On the other hand, a few topics that were painted or sculpted by only two or three artists have been included. These deal with the topical content of certain works that are commonly found, although not always explained, in general art history survey and picture books.

All entries, those explaining topical content and those providing an art history context, are brief and essentially definitional. A topical article is entered in the form of the title of a painting or a piece of sculpture. Alternate titles may be entered as cross-references. For example, there is an entry for EXPULSION OF HAGAR. This same topic is sometimes titled *Banishment of Hagar and Ishmael,* which appears as a cross-reference. Each topic is discussed, usually in the form of an explanation of the legend or story; if pertinent, identifying attributes and symbols are listed. *"See"* references may be included. For example, at the end of the entry PUNISHMENT OF MIDAS, the reader will find *See* MIDAS AND BACCHUS. Cross-references are capitalized upon first mention within an entry, after which they appear as normal text. For example, within the entry AGONY IN THE GARDEN, one finds *Instruments of the Passion* capitalized to indicate

that this topic has been included. In this manner the reader will be directed to further information. Concluding each topical entry is a reference to an example of a work on the subject. A typical example illustrating an entry takes the following form: The artist's name is provided, then the title of the work (if different from the subject), the location of the work (be reminded that works, especially paintings, do move about), the author's name from a book in which the picture appears and the figure number of the illustration (or page number if figures are not indicated). (Full references to the illustration sources are given in the bibliography.) Finally, some examples and artists' names have been incorporated into certain articles to provide a more complete definition. No special mode was used in selecting the examples. An effort was made, however, to include many different artists, both from Italy and from northern Europe.

Marilyn Brownstein, my editor at Greenwood Publishing Group who guided the progress of my previous volume, *Renaissance Art,* created the concept of the topical dictionary; and for this successful idea she deserves not only the credit she is due, but praise for taking the time and interest and energy needed to develop a new concept. Alicia Merritt, currently acquisitions editor for art and architecture at Greenwood, deserves special mention for being available, for answering absolutely without delay all questions, for nudging when a nudge was needed, for understanding. Cathryn Lee, also in the Editorial Department at Greenwood, must be thanked for going miles beyond the call of duty. Sandra Steele, tireless librarian at West Orange High School, Winter Garden, Florida, receives my thanks. And finally, my husband, Ed Earls, should receive a medal of some sort for patience.

Introduction

When attempting to define the Baroque, one finds that the word, the period, the artists—all elude the limits of not only one pinpoint definition but also one that is wider, more expansive; one finds that the origins of the word are obscured, infinitely tangled in the perplexities of history. Although the etymology of the word "Baroque" is somewhat enigmatic, there is no doubt that the Baroque had papal Rome as its birthplace. Yet the varying art forms and the vast differences found in the style called "Baroque" indicate a period and an area beyond 17th-century Italy.

The word itself may have been extracted from *baroco,* a name coined by medieval logicians to identify a syllogism that antischolastic writers of the 16th century found absurd and pointless; or from *barocchio,* an Italian word used since the late Middle Ages to indicate shifty or tricky monetary procedures; or from the Portuguese *barocco,* a word applied since the 16th century to label knotty, deformed pearls. Wherever, whatever its beginnings, the term "Baroque" has been used since the 18th century to indicate paintings, poems, architecture, literature and all else that is dynamic, dramatic and, to some eyes, astonishing and incredible—even ugly. During the 1600s the Baroque bloomed more articulately, dramatically and eloquently in the absolutist Catholic countries than in the Protestant Republic of the United Netherlands. In the north the conservative straight-lined modes of quiet classicism seemed to thwart the international scope of the grand awesome display and the incredible stagy theatricalism, the blinding storms of angels and clouds typical of the extremes in the expressionism that is Italian Baroque. For example, the art of 17th-century France is more classicistic than Baroque. Calm and classical rationality can be seen in landscapes such as those of Nicolas Poussin. But in Italy, where one finds astonishing artistic restlessness and provocative, even sensual religious tensions, there is a frequent shift from Classicism to Baroque, even in the careers of individual artists. There is also an opposition of Classicism in the dramatic

dynamism of northern painters such as Peter Paul Rubens. This dualism holds well into the 19th and even the 20th century. Because of this the Baroque has been divided by some historians into three successive phases: Early (1600–1750), High (1625–1675) and Late (1675–1750).

When late 18th-century German and French writers spoke of "baroque" taste, they purposely pointed to anything lacking culture or refinement or elegance. They used the word to indicate the thoroughly ungraceful, the offensive product of the troglodytes of an uncultivated world, the downright gauche. In the unrestrained assaults made by Neoclassic critics on Italian art of the 17th and 18th centuries, "baroque" sometimes indicated the furthest limits, the hinterlands of aesthetic freakishness—a kind of artistic miscreation. Used all-inclusively to point out a style, the word is stumbled upon only during the 19th century, and then unmistakably when the rampant condemnation of a monumental artist like Bernini was about to shift to a somewhat softened view.

Besides all this, the Baroque era was varied. In Italy it was large and energetic, dazzling and bright, spectacular and tempestuous, voluptuous and rapturous, spacious and excessive. Yet when one travels north to stand in awe before a canvas painted in the 1660s by the northern Baroque artist Rembrandt, one encounters the glooms of muted firelight, the shadowy pales of an inner world; one encounters the silence of ruby sparkles and russet dark places and moods of thick amber scarlets and the stunning golds of gilded skin.

Above all this pulchritude, this beauty far beyond what any eye had ever seen before and may never see again, the 17th century was an age of religion, Catholic and Protestant, and ugly tortures in the name of religion. The stubborn, the insincere were forced into submission, and witch hunts brought agony and death to thousands of the forty million peasants upon which the ponderous structure of civilization rested. Here were people who wanted only to dig their fields, bind their sheaves, raise their children and be left alone. They cared nothing for the distant and removed activities of their rulers. Their world was one of work and mind-boggling horrors, a Europe lacerated and bleeding under the sharp and merciless swords of vicious warfare. Beneath a veneer of dignity and manners, exaggerated courtesies, silks and satins and cheaper cloths as well were drunkenness and ferocious cruelty. Yet some did not blink an eye. One must be reminded that rape, robbery, torture, bloodshed and famine were less disgusting to a people whose everyday life was encompassed by them in milder forms. Savage tortures were inflicted at most criminal trials; horrible and prolonged executions were performed before great, excited and demanding audiences. And yet beyond a brutally theatrical and lengthy execution, peasants lived mostly in ignorance of the events happening about them, suffered their effects mutely and revolted only when intolerable conditions threatened their lives. Most remained crude and indifferent. Some simply starved and suffered silently and prayed to God. It has been said that next to the 20th century, the 16th and 17th centuries were the cruelest that humans have endured.

Never had the Churches seemed stronger than at the beginning of the 17th

century, and it is incredible that a single generation was to witness their depo-sition from political dominance. The sense of imminent fall, the eerie feel of it, the dreadful danger of it, however, was not threatening enough to bring the conflicting Churches together. The quibbling issues between Catholic and Prot-estant doctrines obscured the realities like smoke hides the wind-fanned fire that encroaches—hides it well until it is too late. But beyond this, there is no doubt that the Churches had already set the stage for their own destruction.

Behind the religious issues, the glorious façades of baptisms and mass and monks were the realities of the everyday. One can be rendered speechless when standing before the incomparable beauty of canvas and marble produced at this time—a time unbelievably of stink and decaying offal in the streets, of no drainage about wretched hovels, of the hideousness of carrion birds fussing over public dumps or picking rotting bodies on the gibbets, the carcasses of murderers broken bone after bone on the wheels and left, still alive, for all to see and listen to. The chance for change was microscopic when one considers the dip-lomatic pulse of Europe, which was slow beyond human comprehension today—like that of the horse traffic on which all communications depended. Also impeding change were superstitious beliefs nurtured by a pamphlet literature in which every strange happening was recorded on the spot, magnified, exaggerated and unchallenged. Gruesome and abominable fears flourished even among the educated.

Superstitious and slow, cruel and hideous, decadent and suspicious, magnif-icent and dazzling, the Baroque was a time of vast expansion, a degree of spreading out previously unheard of. This great boom was followed by an age of earth-changing discovery. The progressive, aggressive national powers col-onized and took what they wanted. Conflicts and jealousies between small Re-naissance cities were superseded by grisly, bloody wars between towering militant empires. The physics and astronomy proposed by Newton, Kepler and Galileo gave new meaning to Baroque expansiveness as humanity's optical range was changed forever to include the microscopic spaces of the cellular and the macroscopic spaces of the heavens of a fading medieval God.

The Baroque is gripped by the monster of interest in the unfurl of the great immensities and awesomeness of new-found space. At this time Pascal, nearly on his knees, writes in amazed awe and reverence: ''the silence of these infinite spaces frightens me.'' At the same time Milton booms of the ''vast and bound-less deep.'' The sonnets of Shakespeare ponder the inconstancy, the unstable-ness, the pitiful brevity of life, the disfiguring ravages of time on all that is lovely. The Dutch painter Jacob van Ruisdael paints the ephemeral passage of time in moody, sullen clouds blackly weighted with storm; he paints fitful, unsettled seas and fluttering, fluctuating lights that drift and touch things. Paint-ers and sculptors depict action at the exact moment it occurs, as in Caravaggio's *Conversion of Saint Paul.* Here no seconds have lapsed as Saul, blind and struck dumb, thuds to bare ground after having been hurled from his horse by the dazzling bolt that is God Himself. Allegorical illustrations reveal the relentless

enemy time as a ferocious old man mangling all with his scythe or eating his children. Time acquired heady scientific implications of not only the instantaneous but also the never-before-seen breathtaking realms of infinity.

Intoxicating the Baroque mind is light. The wonders of sunlight, the dims and flames of fires' light, the soft enchantment of God's light, that same mystical light bowed down to for thousands of years—glorified and venerated, manipulated and given magical powers, praised and exalted. Yet the hypnotic substance of light does not dim in its age-old marriage with spirituality in the religion, the painting and sculpture. It symbolizes even more than ever inspiration, truth of dogma, the glorious visions and illusions of otherworldly mysteries and saints, virgin mother of God, the beloved face of the Divine.

Some historians see the age of the Baroque as synonymous with the Catholic abhorrence of Protestantism. Between the pontificates of Paul III (Farnese) 1534–1549 and Sixtus V (Peretti) in the 1580s, the popes fanned the fires to an aggressive military, diplomatic and theological campaign to obliterate that loathful devil, that evil monster that was Protestantism. Catholics feared that Protestants would engulf the continent. Successful in part, they managed, by different devices, to wipe out many Protestant gains in central and southern Europe. Energetic reformers, sunk in fight-or-die battles of the Catholic Counter Reformation, found art a useful tool, tried and true propaganda. Paintings of ghastly martyrdoms were welcomed in the day-by-day heats of hatred and violence. And it can be said with some authority that the older and more united Catholicism should have won the conflict. A century had passed since the 1517 Reformation, and the Catholic Church had hoped, had tried to re-unite Christendom. Yet it failed.

In an attempt at success, Catholic countries used every device of art to stimulate pious emotions, sometimes to the passionate pitch of ecstasy, to lure the strays back to the fold. Also one must note that outside Italy, clever politicians like Colbert, minister to Louis XIV, observed that the Baroque religious style, with its ability to arouse tempestuous fevers and new peaks of love for God, could be used to subserve autocratic regimes through the glorification of the monarch. Thus, luscious display and unlimited magnificence and splendor and jewels and costumes frame the extravagant life of the courts of the 17th century. The modes of furniture and dress are the most ornate ever designed.

In the north, on the other hand, Holland takes a place in the splendors of 17th century art with certain limitations. Dutch painting can be sanctioned in the distinctions of Baroque art, since the latter embraces Realism as well as Classicism. In the case of Holland, Realism is more important than Classicism. In the field of painting this widened aspect of the Baroque can best be maintained when we realize that the European leadership lies with Italy only during the early decades (with Caravaggio), shifting in the second generation to Flanders (with Rubens) and about the middle of the century to France (with Poussin and then the style of Louis XIV). Holland's High Baroque phase (c. 1625–1645) is closer to Ruben's mature years than to Bernini's, and about the middle of the

century, the classical influence was seen in certain tendencies in the painting at that time.

Holland's deviation from the international movement—owing to national and cultural differences—is at least as significant as its participation in it. In Holland alone was to be found the phenomenon of all-embracing Realism, which was unparalleled in both comprehensiveness and quiet and spiritual intimacy. The Dutch described their life and their environment, their country and their city sights so thoroughly that their paintings provide a nearly complete pictorial record of their culture, and their art was more than mere reportage.

The Baroque lasted longer in Austria and Catholic Germany and, overall, had the least influence in Protestant countries. The Late Baroque slipped nearly imperceptibly into the Rococo of the 18th century, and, as could be expected, the Age of Reason finally rejected both and produced Neoclassicism.

Baroque Art

A

ABANDONMENT OF ARMIDA. *See* RINALDO AND ARMIDA.

ACHILLES AND THE DAUGHTERS OF LYCOMEDES. Achilles and the daughters of Lycomedes is the story of a hero who hid by dressing in woman's clothes. It is the most popular Achillean theme, although this story is told, with others, by later authors (Hyginus, *Fabulae* 96; Ovid, *Metamorphoses* 13:162–70; Philostratus the Younger, *Imagines* 1) and is not a part of the original Homeric theme. As the story goes, the contingents were gathering for the Trojan War when Peleus, his father, or Thetis, his mother, knowing that Achilles (their only child) would die at Troy, hid him in Scyros, dressed as a girl. Here he met Deïdameia, daughter of Lycomedes, king of the island. Calchas having told the Greeks that Troy could not be taken without Achilles, sent Odysseus with other Greek chieftains to find him. They knew he was somewhere on the island of Scyros, entrusted to King Lycomedes. Thus, to trap him into revealing his identity, they cleverly placed a heap of gifts before the girls who lived there—all manner of clothes, jewelry and other female enticements. Cunningly though, among these treasures they placed a shield, a spear and a sword. Achilles admired the clothes and jewels with his female companions, but upon hearing a trumpet, he instinctively picked up the weapons and thus revealed himself. After this he went willingly with Odysseus and other envoys. All the evidence reveals that Achilles was a man, real or imaginary, and not a "faded" god. His portrait was drawn by Homer and later writers only added details. This story was depicted in Roman paintings and on Roman sarcophagi (caskets). During the 17th century, Achilles is depicted with a group of female figures crowded enthusiastically around a chest bulging with jewels and female fineries. One of them (Achilles) lifts a sword. Odysseus and other warriors may stand or kneel at one side watching.

Example: Nicolas Poussin, Museum of Fine Arts, Boston. (Friedlaender, fig. 66)

ACHILLES ON SKYROS. *See* ACHILLES AND THE DAUGHTERS OF LYCOMEDES.

ACIS AND GALATEA. The story of Galatea and Acis is found in Ovid's *Metamorphoses* 13:738. Scylla, the sea deity, one of Nereus's daughters and a companion of the Tritons, received a visit from the sea goddess Galatea, and while the lovely goddess combed her hair, she told Scylla her sad story of POLYPHEMUS, the one-eyed giant, the Cyclops who fell in love with her and played his flute (a symbol of lust), singing praises to her beauty. "You are whiter, Galatea [as her name implies], than the snowy petals of the 'liguster' [according to Cartari, Galatea even has white hair and described it as the color "of a morass"], more flowery than the fields, slenderer than the alder-tree." "All the mountains" says Galatea, "felt the sound of his rustic piping; the waves felt it too. I, hiding beneath a rock and resting in the lap of my Acis, heard the words he sang at a great distance and well remembered them." Galatea was a Nereid, or sea nymph of Sicilian origin, who loved the handsome young Acis. But she was loved by Polyphemus. The one-eyed giant spent his days sitting on a cliff overlooking the sea of Sicily where Galatea frolicked. He played love songs to her on his flute or syrinx, his pipes of Pan of a hundred reeds, also a symbol of lust. Eliciting no response, he decided one day to leave the cliff and search for her by the seashore. He found her in the arms of her lover, Acis. Seeing him they fled, but the giant flung a boulder at Acis and killed him. Hearing Acis's pitiable cries, Galatea changed him into a little river (this is told at the end of Ovid's story), and his blood turned into the River Acis. After this, she dived into the sea off the coast of Sicily.

A sea creature, Galatea is not shown with a wreath, for such decorations were reserved for deities of rivers, where reeds grow. Acis is beautiful and only sixteen years old. According to Ovid, his beard had just begun to grow. "Pulcher et octonus iterum natalibus actis," therefore, he is shown sometimes with a girlish figure. *See also* POLYPHEMUS and LANDSCAPE WITH POLYPHEMUS.

Example: Claude Lorrain, Gallery, Dresden. (Friedlaender, fig. 120)

ADAM AND EVE. *See* TEMPTATION OF ADAM AND EVE.

ADONIS. *See* DEATH OF ADONIS.

ADORATION OF THE GOLDEN CALF (*Dance before the Golden Calf*). The story of Moses and the Israelites who worship a golden calf is found in Exodus 32:1–24. "When the people saw that Moses delayed to come down from the mountain, the people gathered themselves together to Aaron, Moses' brother, and said to him 'Up, make us gods, who shall go before us; as for Moses, the man who brought us up out of the land of Egypt, we do not know what has become of him.' And Aaron told them to take off their rings of gold

and give them to him. And they did and he made a molten calf and built an altar. When Moses returned from the mountain with the two tables of the testimony in his hands he said to Aaron, 'What did this people do to you that you have brought a great sin upon them?' And Aaron said what they had told him, that they did not know what had happened to the man who had brought them up out of the land of Egypt. And I said to them, 'Let any who have gold take it off; so they gave it to me, and I threw it into the fire, and there came out this calf.' "

Enraged, Moses threw down the tablets and destroyed the golden calf. He later returned to Sinai and received more tablets from God. After this he built the Ark of the Covenant, guarded by two cherubim (angels) of gold, in which the tablets were deposited. Moses is usually shown standing above a scene of men and women who dance in happy abandon around a statue of a golden calf placed high on a decorated pedestal. Moses is throwing down the stone Tablets of Law in anger as he watches the scene of sin below. Aaron, usually pointing to the calf above, may be surrounded by a group of nearly hysterical worshippers, who fling their hands, dance and bow down in abandon.

Example: Nicolas Poussin, National Gallery, London. (Friedlaender, colorplate 22)

ADORATION OF THE KINGS (*Adoration of the Magi*). The story of the birth of Jesus in Bethlehem, Judea, is told in Matthew 2:1–12 and represents the first act of homage paid to Jesus by the pagan world. According to Matthew, "In the days of Herod the king, behold, wise men from the East came to Jerusalem, saying, 'Where is he who has been born king of the Jews? For we have seen his star in the East, and have come to worship him.' " The magi were directed by Herod's men to go to Bethlehem. But fearing trouble, "Herod summoned the wise men secretly and ascertained from them what time the star appeared; and he sent them to Bethlehem, saying, 'Go and search diligently for the child, and when you have found him bring me word that I too may come and worship him.' " They followed the star that came to rest over the place where Jesus was and upon finding him fell down and worshipped him. They gave him treasures of gold, frankincense and myrrh. "And being warned in a dream not to return to Herod, they departed to their own country by another way."

Historically, the three men were astrologers of the Persian court and actually priests of the cult of Mithras (ancient Persian god of light and truth), which had become popular in the Roman empire during the early days of Christianity. Tertullian, a Christian writer c. 160–230, was the first to name them as kings, and although the Gospels do not mention the number of men present, three are most often shown because of the number of gifts presented. (Two men are depicted on a third-century fresco in the Petrus and Marcellinus catacomb, and four appear in the Cemetery of Domitilla of the fourth century.) Their names, Caspar or Jasper (the oldest), Balthazar, a Negro, and Melchior, the youngest, may have originated as late as the 9th century in a pontifical at Ravenna. Ob-

vious signs of their eastern origin are present: turbans, camels, leopards or perhaps the star and crescent of the Saracens. Joseph, the Virgin's husband, is usually present. The English historian Bede, c. 673–735, explained the symbolism of their gifts: Frankincense was in homage to Christ's divinity; gold represented his kingship; myrrh, used in embalming, was a foreshadowing of his death and crucifixion. Later, the Magi came to personify the three parts of the known world, Europe, Africa and Asia, paying homage to Christ, which explains the traditional appearance of Balthazar from Africa. The theme was also meant to symbolize the submission of the temporal powers to the authority of the church. The January 6th feast of the Epiphany observes certain manifestations of Christ to mankind, particularly that of the Adoration of the Magi.

Example: Giacinto Gimignani, Burghley House, Marquess of Exeter. (Waterhouse, fig. 54)

ADORATION OF THE MAGI. *See* ADORATION OF THE KINGS.

ADORATION OF THE NAME OF JESUS (*Triumph of the Name of Jesus*). IHS is the "sacred monogram" which was taken originally from an abbreviation of the Greek form of the word Jesus, IHCUC or IHSUS. During the 9th century, IHS, the first three letters of Jesus' name in Greek, appeared on certain coins of the Byzantine Empire. After the Western Church adopted the monogram, sometimes the meaning "Iesus Hominum Salvator" or "Jesus Savior of Men" came to be used, and also the term "I Have Suffered," although both are historically incorrect. Sometimes a bar placed above the central H, signifying the omission of the last two letters, is turned into a cross by extending the vertical stroke of the H. The letters have also had the meaning "Jesum Habemus Socium," or "We have Jesus for our companion."

The monogram IHS is used in the decoration of many religious objects and also in art. One particularly outstanding example is the illusionistic ceiling fresco over the nave in the 17th-century Jesuit church known as Il Gesù. Here, the name of Jesus (as IHS) seems to have appeared miraculously in the sky (on the nave of the church under which the congregation would listen to the celebration of the Mass), complete with blazing blues and fluffy whites. The name, the IHS which forms the central focus of this fresco, however, is so great and powerful, throbbing within its blinding whites and glittering golds, that the blessed and even the angels are thrown aside and must struggle to place themselves back in that area of glory closest to the name reserved for only the holiest and most devout among them. At the same time the damned and Satan and all his vices are viciously flung down and hurled without mercy toward a black and raging fire that is hell.

Example: Giovanni Battista Gaulli (called Baciccio), Ceiling fresco on the nave of Il Gesù, Rome. (Held and Posner, fig. 122)

ADORATION OF THE SHEPHERDS. The announcement of the birth of Jesus by an angel (traditionally Gabriel) to the shepherds in the fields is found

in Luke 2:8–12. "And in that region there were shepherds out in the field, keeping watch over their flock by night. And an angel of the Lord appeared to them, and the glory of the Lord shone around them, and they were filled with fear. And the angel said to them 'Be not afraid; for behold, I bring you good news of a great joy which will come to all the people for to you is born this day in the city of David a Savior, who is Christ the Lord. And this will be a sign for you: you will find a babe wrapped in swaddling cloths and lying in a manger.' "

The scene of the adoration is not shown in art until the end of the 15th century and changes thereafter considerably until the 17th. During the Baroque, artists show the shepherds bringing ordinary gifts, such as a jug of milk, a basket of eggs and squawking hens. They may carry a bagpipe and a syrinx. The inclusion of musical instruments in an Adoration scene may derive not only from the pastoral tradition, but possibly from a custom in some sections of Italy where pipes are played at Christmas before images of the Virgin Mary and the Christ Child. The shepherds are shown grouped in reverence around the baby. They may have removed their hats and some may kneel. There are usually three men and their gifts are simple. Gifts are not mentioned by Luke and were probably created as an analogy with those of the Magi, as it would seem appropriate that they should offer the child something no matter how rustic or ordinary it might be.

Example: Caravaggio, Museo Nazionale, Messina. (Bottari, fig. 73)

AENEAS. *See* STORY OF AENEAS.

AFTERIMAGE. *See* COMPLEMENTARY AFTERIMAGE.

AGNES IN PRISON. *See* SAINT AGNES IN PRISON.

AGONY IN THE GARDEN. Christ's struggle with himself in the garden after the Last Supper (EUCHARIST) and before his CRUCIFIXION is found in Matthew 26:36–46, Mark 14:32–42 and Luke 22:39–46. Matthew wrote "and he [Jesus] said to his disciples, 'Sit here, while I go yonder and pray.' And taking with him Peter and the two sons of Zeb'edee, he began to be sorrowful and troubled." Thus begins the struggle of Jesus between the two sides of his nature, the human side that feared the torture and suffering imminent in crucifixion and the divine side that gave him the strength he needed to endure the physical pain. Luke says, "And there appeared to him an angel from heaven, strengthening him. And being in an agony he prayed more earnestly; and his sweat became like great drops of blood falling down upon the ground." And the words of Mark, when Jesus speaks at the end of his time in the garden, " 'The hour has come; the Son of man is betrayed into the hands of sinners. Rise, let us be going; see, my betrayer is at hand.' "

The nature of Christ's struggle came to take two distinct forms. Angels some-

times appear before him holding the INSTRUMENTS OF THE PASSION, or an angel bears the chalice and the wafer. The idea of showing Christ as if he were about to receive communion possibly came from the gospels' reference to a cup and actually has no basis in fact. In the gospel of Mark, Jesus says, " 'remove this cup from me.' " Christ's agony in the garden was not a popular topic during the Baroque period and is rarely found.

Example: Jacques Callot, Wash drawing, Chatsworth, Derbyshire. (Blunt, fig. 150)

ALEXANDER'S DEFEAT OF DARIUS. *See* BATTLE OF ISSUS.

ALLA PRIMA. Sometimes called direct painting, *alla prima* is a method of painting directly on to a surface (such as a canvas or a wall). This is done instead of designing a planned composition in which layers of translucent paint all play a part in the final appearance of the painting. When using the *alla prima* technique, either the underpainting is not done or the artist makes only simple outlines of the main design of the composition. Each area of color is applied to the surface as it will appear in the final work. There is no translucent overlayer changing colors from cool to warm. This method of direct painting was first practiced in the 17th century by artists such as Caravaggio, although Michelangelo in the 16th century painted at least one figure on the Sistine Chapel ceiling *alla prima.*

ALLEGORY OF FAME. Since classical antiquity, Fame has been shown as a female figure. During the Baroque period, she is nearly always holding a trumpet, which is long and thin and straight (an instrument she did not have in antiquity). Sometimes she carries two trumpets, one extremely long, one extremely short—for good will and bad repute, respectively. She may also hold a palm frond as a symbol of victory and may wear a decorated crown for the same reason. Some artists show her sitting on a globe, the sign of her universality. She may be shown with another of her symbols, the winged horse Pegasus (who later became a symbol for immortality). Fame may be depicted leading the Seven Liberal Arts (grammar, logic, rhetoric, geometry, arithmetic, astronomy and music) up to Olympus, or she may be shown in conjunction with the Virtues.

Example: Valerio Castello, Palazzo Reale, Genoa. (Waterhouse, fig. 186)

ALLEGORY OF PEACE. In secular allegories, Peace celebrates the results of good and successful government, the end of a war, or the exemplary qualities of a statesman. Female, she is usually winged. She may wear an olive crown or be offered one or hold an olive branch. She may have a dove, an attribute taken from Genesis 8:10–11: "He [Noah] sent forth a dove from him, to see if the waters had subsided from the face of the ground; but the dove found no place to set her root, and she returned to him to the ark . . . again he sent forth the dove . . . and the dove came back to him . . . and lo, in her mouth, a freshly

plucked olive leaf.'' If a cornucopia is shown, the reference is to the plenty brought by Peace. A caduceus (a rod entwined by two snakes with a pair of small wings at the top) may be depicted because it was the emblem of the messenger in ancient Greece and the person carrying it was granted safe and unmolested passage. In Baroque art, Peace is sometimes shown with a flaming torch setting fire to the weapons and accouterments of war.

Example: Simon Vouet, Chatsworth, Derbyshire. (Blunt, fig. 201)

ALLEGORY OF THE ART OF PAINTING. *See* ARTIST IN HIS STUDIO.

ALLEGORY OF THE MISSIONARY WORK OF THE JESUITS (*Triumph of St. Ignatius*). St. Ignatius of Loyola was the founder of the SO-CIETY OF JESUS in 1556. One of his most famous and fruitful works was the book of his *Spiritual Exercises,* first published in Rome with papal approval in 1548. In the fifteen years that he directed his order, St. Ignatius watched it grow from ten members to over one thousand in nine countries and provinces of Europe and also in Brazil and India. On the morning of July 31, 1556, he died so suddenly and so unexpectedly that he did not receive the last sacraments. He was canonized in 1622 and Pope Pius XI declared him the heavenly patron of retreats and spiritual exercises.

In Rome, the church Sant' Ignazio was dedicated to his memory. On the ceiling of this church, in the most impressive and astonishing tour de force of QUADRATURA painting (illusionistic painting of architectural perspectives) in the 17th century, St. Ignatius and his disciples are carried to Christ, who waits far above in an infinite heaven that has miraculously opened. Figures personi-fying the four parts of the world surround him. There are figures from Europe, Asia, Africa and America. The actual architecture of the walls of the church seem to extend into infinity, into heaven, where an allegorical scene representing the benevolent activities of the Jesuit Order are depicted. A spectator standing at an especially marked spot on the floor of the church feels mysteriously lifted toward heaven and made dizzy by the multitudinous figures that move in the sky. From other viewpoints, and especially from the sides of the church, the ceiling is astonishing, as columns seem to fall sideways or inwards and the worshipper begins to feel that the architecture is about to crash to the floor. *See also* ENTRANCE OF ST. IGNATIUS INTO PARADISE and GLORY OF ST. IGNATIUS.

Example: Fra Andrea Pozzo, Ceiling of the nave, Sant' Ignazio, Rome. (Waterhouse, fig. 65)

ALLEGORY ON THE DEATH OF LORENZO IL MAGNIFICO. The un-deniable equality before death whether one be rich or poor, the example that death was no respecter of persons, young or old, popes or emperors or peasants, was shown in painting in the form of allegories and triumphs and all manner of death scenes during the Baroque. After the killer plagues that decimated

Europe in the 14th century, all living persons were acutely aware of the presence of death in ways horrible and brutal completely unknown to us today. Death takes many forms in painting and is seen in numerous allegories similar to that of Lorenzo il Magnifico. Usually the themes illustrate the idea that all humans are equal before Death. Early works illustrate this well with a row of figures of descending social order showing a pope and an emperor, cardinals and lesser members of the church, those of educated occupations and finally the poor, untutored peasants. The Three Fates may be included. In Greek and Roman religions, the Three Fates were spirits believed to determine every person's destiny, which they established at birth. It was believed that after this they controlled not only the events of life but its duration. Usually they are depicted as three old and ugly women who spin the thread of life, then measure and cut off the allotted length, some extremely long and, of course, some inordinately short. Clotho has the distaff (a staff on which thread is wound for use in spinning), or sometimes a spinning wheel; Lachesis holds the spindle; and Atropos holds her scissors ready to snip the thread. The Fates usually form part of large allegorical works, as is the case of that of the death of Lorenzo il Magnifico, one of the towering figures of the Italian Renaissance. Here they appear in the lower right corner. A swan is sometimes depicted to illustrate the idea maintained by classical writers that the swan uttered a beautiful song at its death and that the soul of a poet entered into its body. Lorenzo il Magnifico, a reputable scholar and poet, wrote love lyrics, carnival songs, rustic poems, odes and sonnets. A warrior representing death may be included, dark and fearsome, holding a sword and shield.

Example: Francesco Furini, Museo degli Argenti, Florence. (Waterhouse, fig. 136)

ALMSGIVING OF ST. ELIZABETH. The daughter of the king of Hungary, Elizabeth (d. November 17, 1231), married at age fourteen and had three children. Her husband, Louis of Thurginia, with whom she had been raised, put no obstacles in the way of his wife's good deeds, her simple and mortified life, her long and sincere hours of prayer. Unfortunately, Louis died of the plague at Otranto after taking up the cross during the Crusades. Elizabeth built a hospital where she fed the infirm and weak and provided for helpless children at her own expense. She fed nine hundred daily at her gate, besides taking care of a multitude in different parts of the dominions. Children and the elderly are shown being fed and cared for on the steps of her palace.

Example: Bartolomeo Schedoni, Palazzo Reale, Naples. (Waterhouse, fig. 92)

ALTARPIECE (reredos and, in Italian, *pala d'altare*). The altarpieces of Roman Baroque churches were decorated as panels of illusionistic ornament to enhance and heighten the dramatic effect of the church interior as a whole. During the 17th century, altarpieces were no longer designed to instruct the worshipper with scenes from the life of Christ or to illustrate the martyrdom of a saint. They were built to arouse religious passion with a resplendent portrait

or a single dazzling episode, as, for example, in Gian Lorenzo Bernini's marble of St. Teresa's mystic vision in the Cornaro Chapel of Sta Maria della Victoria, 1644–7. Here the pictorial program was obvious, its meaning understandable, while the sumptuousness of the imposing theatrical "stage" and sunlight let in through a specially hidden window added to the effect of awe and magnificence. Roman Baroque churches were copied all over Europe, and their lavishly adorned altars holding a single expressive section in sculpture, painting or bas relief gave artists a comprehensive model for Catholic altars in the 17th and 18th centuries. In details of style, however, these altars followed the vacillating trends of the Baroque and the Rococo style that followed. *See also* RETABLE.

AMBROSE BAPTIZING SAINT AUGUSTINE (*Baptism of Saint Augustine*). Saint Ambrose, one of the four Latin (Western) doctors or fathers of the Church and Bishop of Milan, died April 4, 397, at about age fifty-seven. He spent a great part of his life crushing Arianism, a doctrine concerning the relationship of God the Father to Christ, which was thought of as heresy and in direct opposition to the Father, Son and Holy Ghost of the Trinity. Sometimes he is shown with a three-knotted whip (the number three is associated with the Trinity) in allusion to his struggle against Arius and his followers. He may also be depicted in the act of castigating them with his knotted whip. A beehive denotes the swarm of bees said to have alighted about his mouth as he slept in his cradle (a tale also told of Plato and others who were known for their superior erudition). Ambrose is shown in bishop's robes with crozier (staff carried by or before a bishop or abbot) and mitre (hat worn by a pope). He sometimes holds a book with the inscription "In carne vivere preter carnem angelicam et non humanam," "to be nourished by food, but rather the food of angels, not of mortals," a reference to his name Ambrosia, a food. Ambrose sometimes appears with the other three Latin doctors, Jerome, Gregory and Augustine. He is depicted baptizing Augustine, who, during his youth, was influenced by Ambrose's teaching. *See also* AUGUSTINE AND THE CHILD.

Example: Giovanni Battista Crespi (known as Il Cerano), S. Marco, Milan. (Waterhouse, fig. 115)

AMORETTO. In Italian *amorino* (plural *amorini*), "little love," or cupid; sometimes called a PUTTO (*putti*).

AMORE VINCITORE. *See* EROS TRIUMPHANT.

ANAMORPHOSIS. The word appears first during the Baroque and refers to a painting or drawing that is so designed as to give a distorted image of the object represented but that, if seen from a specified point or reflected in a curved reflective surface, shows the object in true perspective and proportion. The earliest examples can be found in Leonardo's notes. Anamorphoses can be found in some 16th-century manuals on perspective, such as works by Daniel Barber

and Vignola-Dante, and were common by the 17th century. *The Jesuit's Perspective (La Perspective Practiqué par un Religieux de la Compagnie de Jésus),* Paris, 1649, gives the reader information on the subject. The Greeks were probably the first to distort normal proportions so that their works, intended for higher placement (such as a pediment on a temple), would appear normal from a lower viewpoint.

ANATOMY LECTURE OF DR. NICHOLAS TULP. This canvas was Rembrandt's first major group commission and represents Dr. Tulp (1593–1674), one of the most esteemed doctors and surgeons of the 17th century, who is shown demonstrating the ligaments of the forearm with the help of his major source book, *Vesalius,* propped and open at the end of the table, the book also serving as a REPOUSSOIR figure. Dr. Tulp was nominated praelector in anatomy at Amsterdam in 1628, became a burgomaster and was elected representative of the States of East Friesia and Holland. The figure closest to the doctor, Mathjis Kalkoen, is holding a piece of paper on which the names of the other spectators are written. The corpse is that of a criminal, Adriaen Adriaensz, known as Het King, who was dissected on January 31, 1632. The men were painted for the Corporation of Surgeons, and the painting later hung in their Anatomy Theatre, where it stayed until they were forced to sell it due to economic pressures. The canvas was purchased by William I of Holland and is still in the collection of the Mauritshuis in the Netherlands. Most historians agree that Dr. Tulp is the finest of Rembrandt's earlier works even though it demonstrates that he had not mastered entirely the unity of expression and conception that can be found in the *SYNDICS OF THE CLOTHWORKERS' GUILD,* for example. The portrait of Dr. Tulp in a frontal pose is formal and stiff and differs from the group of onlookers, which is somewhat ununified. The small center group shows interest in the operation, while the rest are placed in various individual poses. Rembrandt's use of the exposed muscles in the arm adds a note of unexpected, sudden color, which gives the pallor of the corpse a strong emphasis and at the same time increases the warmth and life in the onlookers.

Example: Rembrandt van Rijn, Mauritshuis, The Hague. (Held and Posner, color-plate 37)

ANDREW ADORING HIS CROSS. The calling of Andrew, one of Christ's apostles, can be found in John 1:40–41. The main source for his story and eventual crucifixion is the apocryphal book of the "Acts of Andrew," 3d century and also Voragine's GOLDEN LEGEND. The word Andrew comes from anthropos or man, meaning manly. His martyrdom by crucifixion has been told by the priests and deacons of Achaea or Asia, who witnessed it. After the Crucifixion of Jesus, Andrew settled in Achaea and "filled the whole region with churches." Andrew, arguing with Aegeus, the proconsul of the region, told him that the mystery of the cross was a great one. Aegeus said the cross was a punishment and not a mystery. At this time Andrew explained the mystery of

Redemption, and it was after this that Aegeus, furious, ordered twenty-one men to seize him, flog him and tie him, rather than nail him to the cross by his hands and feet so that his agony might last longer. As they led Andrew to the cross a crowd gathered and shouted his innocence. But the apostle asked them to do nothing to prevent his death. According to the *Golden Legend,* upon seeing the cross in the distance, Andrew greeted it by saying, "Hail, O Cross that hast been sanctified by the Body of Christ, and adorned with His limbs as with precious stones. Before the Lord was nailed to thee, thou didst inspire fear on earth; but now thou drawest heavenly love, and art desired as a boon. Thus I come to thee assured and joyful, so that thou mayest graciously receive me, the disciple of Him who hung upon thee: for I have always loved thee, and yearned for thy embrace. O good Cross, enobled and beautified by the limbs of the Lord, long desired, constantly loved, ceaselessly sought, take me away from men and return me to my Master, in order that He, having redeemed me by thee, may receive me from thee."

After adoring his cross, Andrew handed his garments to his executioners and they tied him to the cross as they had been commanded. His cross is thought to have been in the shape of an X, or saltire (also saltier) shape, which is sometimes known as the Saint Andrew cross. Andrew, depicted as the extremely old man that he was, is shown on his knees praying before his X-shaped cross. An executioner removes his clothes while others fix the cross in place. A crowd gathers in the background.

Example: Carlo Dolci, Palazzo Pitti, Florence. (Waterhouse, fig. 141)

ANDREW BOUND TO THE CROSS. According to Voragine's GOLDEN LEGEND, Andrew, the apostle was crucified on an X-cross. For two days he hung there alive and, according to those who saw him, preached to twenty thousand people. On the third day many individuals in the crowd began to threaten the proconsul Aegeus with death because Aegeus was responsible for Andrew's punishment. They told Aegeus that it was an abominable thing to inflict unbearable torment on an old man of gentleness and piety. Aegeus, afraid of the crowd, told his men to have Andrew taken from the cross. But Andrew said he would not come down from the cross alive: "And already I see my King awaiting me in heaven." When the soldiers sought to unbind him, they were unable to touch him because their arms fell away powerless. Andrew is shown upon his cross while a great crowd is held back by Roman soldiers. *Putti* (angels) hover above holding the palm of martyrdom and a crown. *See also* ANDREW ADORING HIS CROSS.

Example: Mattia Preti, S. Andrea della Valle. (Waterhouse, fig. 164)

ANDROMEDA. The mythological story of Andromeda is told by Ovid in *Metamorphoses* 4:668–739. Andromeda was the daughter of Cepheus, king of the Ethiopians, and his wife, Cassiepeia, or Cassiope. Cassiepeia bragged to everyone that she was more beautiful than the Nereids (sea nymphs). Upon hearing

this the nymphs told the sea god Poseidon who, in a fury, flooded the land and sent a sea monster to ravage it. After consulting Ammon, King Cepheus learned that the only way to stop the destruction was to expose his daughter Andromeda to the monster. "Jupiter Ammon had unjustly ordered that the innocent Andromeda should pay the penalty for the boastful utterances of her mother the queen." Accordingly, Andromeda was chained to a rock by the sea shore. "When Perseus saw the princess, her arms chained to the hard rock, he would have taken her for a marble statue, had not the light breeze stirred her hair, and warm tears streamed from her eyes. Without realizing it, he fell in love." He swooped down, "attacked the monster's back and, to the sound of its bellowing, buried his sword up to its crooked hilt in the beast's right shoulder. Tormented by this deep wound, the creature now reared itself upright, high in the air, now plunged beneath the waters, now turned itself about like some fierce wild boar, encircled and terrified by a pack of baying hounds." Perseus killed the monster, freed Andromeda and got her father's consent to marry her.

Andromeda is depicted as a beautiful nude woman chained to a rock beside the sea. In the far distant sky, Perseus is shown riding the winged horse Pegasus and dangling the Gorgon's head.

Example: Peter Paul Rubens, Dahlem Museum, Berlin. (Held and Posner, color-plate 26)

ANGEL. The word "angel" is from the Greek *angelos,* which means messenger. In Baroque art angels are usually winged, chubby nude infants who fly and hover and play important roles in 17th-century religious scenes. They may also be older children with attenuated bodies, soft faces and flowing robes. They are always busy performing duties. Angels are mentioned frequently, especially in the Old Testament, where their primary function is to disclose God's will to the multitude. In the New Testament, the gospel of Luke refers frequently to angels. An angel is always present, for example, at the Expulsion of Adam and Eve from the garden. An angel, Gabriel, told Mary she would have a child (ANNUNCIATION) and also foretold the birth of John the Baptist. An angel appeared in Joseph's dream, the AGONY IN THE GARDEN and the SACRIFICE OF ISAAC, to name a few.

ANGEL APPEARING TO THE SHEPHERDS. The story of an angel appearing to shepherds is found in Luke 2:8–14. According to this account, many shepherds tended their flocks in the region where Jesus was born. "And an angel of the Lord appeared to them, and the glory of the Lord shone around them, and they were filled with fear. And the angel said to them, 'Be not afraid; for behold, I bring you good news of a great joy which will come to all the people; for to you is born this day in the city of David a Savior, who is Christ the Lord. And this will be a sign for you; you will find a babe wrapped in swaddling cloths and lying in a manger.' " At the time of the 16th-century Catholic COUNTER REFORMATION, the scene changes and becomes more

realistic. Artists crowd the previously nearly empty landscape with sheep, dogs, loaded pack animals and shepherds walking and on horseback. This trend continues into the Baroque. Shepherds appear more prosperous than in earlier versions. In the far background a small angel hovers over a multitude of people who crowd the entrance of a cave.

Example: Giovanni Benedetto Castiglione, City Art Gallery, Birmingham, England. (Waterhouse, fig. 189).

ANNE. Mother of the Virgin Mary, wife of Joachim. *See* MADONNA WITH ST. ANNE.

ANNUNCIATION. The announcement by the angel Gabriel to Mary that she would be the mother of God is told in Luke 1:26–38. According to the gospel, "he [the angel Gabriel] came to her and said, 'Hail, full of grace, the Lord is with you!' But she was greatly troubled at the saying, and considered in her mind what sort of greeting this might be. And the angel said to her, 'Do not be afraid, Mary, for you have found favour with God. And behold, you will conceive in your womb and bear a son, and you shall call his name Jesus.' " This moment is considered to be the Incarnation (when Christ took on human form) and occurred on March 25, the day of the vernal equinox (nine months before the NATIVITY, December 25, the day of the winter solstice, after which each succeeding day has more daylight). The feast of the Annunciation is celebrated March 25.

The prevalence, respect and perseverance of the theme throughout the ages reflects its doctrinal importance. Churches, chapels and altars are dedicated to the Annunciation. In painting, three elements are present: Mary, the Virgin mother of Jesus, the dove of the Holy Spirit, and Gabriel, the angel of the Annunciation. Additional symbols are sometimes included such as the lily, a symbol of Mary's purity, a distaff (a staff on which wool is wrapped) and a basket of wool. This alludes to Mary's upbringing in the Temple at Jerusalem where it was her duty to spin and weave priests' vestments. Seldom is she shown without her bible, always open, from which, according to Saint Bernard, she is studying the prophecy of Isaiah (7:14): "Behold, a young woman shall conceive and bear a son, and shall call his name Immanuel. He shall eat curds and honey when he knows how to refuse the evil and choose the good." A closed book is said to allude to Isaiah 29:11–12: "And the vision of all this has become to you like the words of a book that is sealed. When men give it to one who can read, saying, 'Read this,' he says, 'I cannot, for it is sealed.' And when they give the book to one who cannot read, saying, 'Read this,' he says, 'I cannot read.' " Mary either sits or stands or kneels at a *prie-dieu* (a reading desk with a ledge for kneeling at prayer). Gabriel is dressed in white and has descended towards Mary, although more often the angel is shown kneeling or standing before her. Gabriel is sometimes adrift on a fluff of clouds, meant to indicate

heaven. In Catholic COUNTER REFORMATION art, Gabriel may be accompanied by other angels (usually in the form of *putti*).

The iconography of Poussin's London *Annunciation* is unusual and worthy of mention. Mary sits on a cushion placed on a platform only several inches high. Her legs are crossed in the manner of an Oriental woman's to indicate the eastern setting. Her position may also symbolize her as the *sedes sapientiae,* the seat of wisdom. Her hands are not folded on her breast or held in the attitude of prayer; rather she holds them away from her and out (nearly as in an early Christian orant, or attitude of prayer, in which the arms were held high, the palms open). Her gesture is one of utmost submission. The book is open at her side and the Holy Spirit, a dove with outspread wings, hovers in a halo that nearly touches her head. Gabriel kneels before her and points with his right hand to her and with his left hand to heaven.

Example: Nicolas Poussin, National Gallery, London, and Condé, Chantilly. (Friedlaender, colorplate 44)

ANTHONY. *See* TEMPTATION OF ST. ANTONY.

APOCALYPSE. The apocalypse, a Greek word meaning the uncovering, is a kind of ancient Christian and Hebrew literature dealing with the end of the world. Mostly in the form of visions, the writing is replete with fantastic imagery and enigmatic symbols. The book of Revelation in the New Testament is sometimes called the Apocalypse. In the Old Testament apocalyptic elements appear in Zechariah, Daniel, Joel, Ezekiel and Isaiah. One of the chief Jewish apocalypses is the book called 4 Esdras. During the 16th-century COUNTER REFORMATION in Catholic countries, Mary was frequently depicted in Baroque paintings as the woman of the Apocalypse. Depicting the Mother of God in this manner was particularly popular in Spain. The Apocalypse is the last book of the New Testament, known as "The Revelation of St. John the Divine," in the Authorized Version. No early Christian manuscripts of the Revelation have survived. The earliest examples date from the 9th century and occur only in the West, as the Eastern Church doubted its authenticity.

APOLLO AND DAPHNE. The story of Apollo and his love for Daphne is found in Ovid's *Metamorphoses* 1:452 and the myths of Hyginus's *Fabulae* 203. Daphne was the daughter of the river god Peneus and was the second nymph to elude him (Marpessa being the first). According to Ovid, the mischievous Cupid (who may or may not be depicted) struck Apollo with the golden arrow that begins love and Daphne with the leaden arrow that causes love to flee. She ran and Apollo chased her. "So ran the god and girl, one swift in hope, the other in terror, but he ran more swiftly, borne on the wings of love, gave her no rest, shadowed her shoulder, breathed on her streaming hair. Her strength was gone, worn out by the long effort of the long flight . . . seeing the river of her father, cried 'O help me . . . change and destroy the body which has

given too much delight.' And hardly had she finished when her limbs grew numb and heavy, her soft breasts were closed with delicate bark, her hair was leaves, her arms were branches, and her speedy feet rooted and held, and her head became a tree top.''

Daphne is usually shown terrified and running, her fingers, toes and legs sprouting leaves. Apollo, with bow and quiver and determination, runs right behind her. Red cattle may be seen in the background. They are from Ovid's legend of Apollo and Mercury. Apollo is shown not as the radiant sun god, the creator of life, but as a lover who cannot have the woman of his desires. He may be simply seated, suffering from the arrow shot by Cupid. Daphne may also be shown unaware that Cupid has an arrow aimed toward her. Scenes from other writings may be included; for example, Mercury, Apollo's younger brother, may be shown stealing a golden arrow from Apollo's quiver. This scene is described in Philostratus's *Imagines*. The story symbolizes the victory of Chastity over Profane Love.

Example: Nicolas Poussin, The Louvre, Paris. (Friedlaender, colorplate 48 and fig. 130)

APOLLO AND VIRGIL. *See* INSPIRATION OF THE POET.

APOLLO GUARDING THE HERDS OF ADMETUS. One of the twelve Olympian Greek gods, Apollo was a deity of light who helped ripen crops, destroy pests and heal illnesses. Not only a god of youthful manly beauty and of reason, he was also associated with archery, medicine and music. Further, as a shepherd god, he protected and cared for flocks and herds. Also a god of prophecy, he had many oracular shrines, the main one being at Delphi. The island of Delos was sacred to him because it was there that the Titaness Leto (Roman Latona) gave birth to him and his sister Artemis (Roman Diana). Apollo angered his father, Zeus, when Zeus killed Apollo's son, Asclepius, the Greek god of healing, for resurrecting a dead man. In retaliation, Apollo killed the Cyclopes who made Zeus's thunderbolts because he did not dare avenge the death of Asclepius on Zeus himself. In consequence, Apollo was banished from heaven for a time and forced to serve a mortal. Zeus would have sent Apollo to Tartarus (that realm of darkness beneath the earth one passed through before reaching Hades) except that Leto pleaded for her son. Apollo was instead given a year's servitude under King Admetus, for whom he performed great services. Admetus was the king of Pherae in Thessaly. His wife was Alcestis, the daughter of Pelias, who had been brought back from the Underworld by Heracles. Admetus was renowned for his kindness and treated his divine serf, Apollo, with every consideration. Being a god of flocks and herds, he tended Admetus's horses and cattle.

Artists show Apollo seated in a peaceful, idyllic landscape, surrounded by grazing cattle and sheep, playing his lyre and singing. (He was especially vain about his musical prowess and kept the Muses as part of his retinue.)

Example: Claude Lorraine, *The Earl of Leicester,* Holkham, Norfolk. (Blunt, fig. 249)

APOLLONIA. A Christian saint and virgin martyr of Alexandria, Apollonia was put to death in 249 for refusing to sacrifice to pagan gods. She died the first year of the Emperor Decius's reign (249–251). Decius was a staunch upholder of all old Roman traditions. His persecution of the Christians resulted from his belief that the strict maintenance of state cults was essential to the continuance of the empire. As a result, his reign produced many martyrs, men and women who died in the name of their Christian God, including Apollonia. Her story, as told in Voragine's GOLDEN LEGEND, is brief and involves the Emperor Decius at the time a persecution against Christians raged in Alexandria. Decius's edicts encouraged a man named Divinus to arouse a superstitious mob against all Christians. His followers captured both men and women, tore some of them limb from limb and disfigured the faces and poked the eyes of others. After this, the Christians were chased from the city. Other Christians, who refused to worship Roman idols and cursed the mob when brought forth, were dragged through the town streets with their feet tied up with chains. The mob did not stop until their bodies fell apart.

When Apollonia was taken before the tribunal, without hesitation, savagely, the mob pulled out all her teeth; still not satisfied, they lit a giant fire and threatened to burn her alive if she did not join in their worship of idols. Seeing the raging fire, Apollonia stopped a moment, prayed within herself; and then, pulling free, she threw herself into the fire. Apollonia is usually shown as a beautiful young woman. She carries in her hand pincers, which hold a single tooth. She may also carry a martyr's palm. One executioner may have her hair tangled about his hand, while another pulls her teeth out with pincers. Apollonia is the patron saint of dentists and may be invoked against toothache.

Example: Francisco de Zurbarán, The Louvre, Paris. (Ruskin, colorplate 2–7)

APOLLO SAUROCTONOS. Also *Apollo Sauroktonos,* or Apollo as the "lizard slayer." Apollo's earliest adventure was the killing of Python, a formidable dragon that guarded Delphi. Artists depict Apollo as the ideal type of youth and manly beauty, although never in an immature or childish way. A prophetic god, his functions included medicine, music, archery, the care of flocks and herds and, less often, agriculture. He is sometimes associated with the loftier elements of civilization, instilling the highest religious and moral principles, approving codes of law and furthering philosophy.

The tendency to introduce Apollo as an inspirer and adviser into any and every myth that contains a prediction or a prophet may be traced to Delphic propaganda. Delphi claimed to be the center of the world, the famous stone called the *omphalos* (navel) marking the exact spot. Therefore, artists sometimes show Apollo sitting on this stone. Apollo is extremely popular in art from the 17th century on; he is shown dressed or undressed, young, carrying bow or lyre or both, alone or with Leto or Artemis, the Muses or other deities. As Sauroctonos, he is shown sitting on the *omphalos,* aiming an arrow at a lizard. Artemis,

Leto and the Muses are close by watching. Apollo's lyre and his flocks and herds are behind him.

Example: Nicolas Poussin, Drawing, The Louvre, Paris. (Friedlaender, fig. 80)

APOTHEOSIS OF ST. DOMINIC. The name Dominic, or Dominicus, is the same as *Domini custos,* the guardian of the Lord or *Domino custoditus,* guarded by the Lord. Saint Dominic was born in 1170 and died in 1221. In 1216, with the permission of Pope Innocent, he became the founder and father of the Order of Preachers called Dominican, or Black, Friars. According to the GOLDEN LEGEND, Dominic performed numerous miracles: One was on a young man, the nephew of Stephen, the cardinal of Fossa Nova, who was killed after falling with his horse into a ditch. After being brought up from the ditch, Stephen was put at Saint Dominic's feet. Dominic prayed for him and brought him to life. Another concerned an architect in the church of Saint Sixtus, who was led into the crypt where he was killed when a broken wall fell on him. Dominic asked that the body be taken from the cellar and brought to him. With prayer he restored the architect to life and health. Another miraculous event occurred when Saint Dominic was traveling in the rain and made the sign of the cross, which became a canopy: although the storm raged, no water fell on him and his companion. After traveling and preaching throughout Europe, Dominic fell ill on his return from Venice and requested to be taken to Bologna where he is buried.

Dominic appears frequently in church art of the Baroque period. During his apotheosis, or glorification, he wears the habit of his Order, a white tunic with a scapular (sleeveless garment held on the shoulders by strings) underneath a black cloak with a hood. He holds a book, the gospels, and a lily for chastity; he may also have a star on or above his forehead, alluding to the star his godmother saw upon his forehead when she lifted him from the sacred font as a baby. He is sometimes seen with a little dog, an allusion to the dream his mother had that she bore in her womb a little dog that held a lighted torch in its mouth and when the dog was born, it set the world on fire with the torch. Dominic is given credit for creating the rosary, an arrangement of beads in special sequence used for prayers to the Virgin Mary. He may hold a rosary, or receive one from the Virgin or from Jesus in her lap. One of his several inscriptions is *"Pater Sancte serva eos quos dedisti mihi in nomine tuo,"* "Holy Father, keep them in thy name, which thou hast given me," which is taken from John 17:11.

Example: Domenico Maria Canuti and Enrico Haffner, SS. Domenico e Sisto, Rome. (Wittkower, fig. 216)

APOTHEOSIS OF THE MEDICI DYNASTY. The Medici Dynasty was an Italian family that controlled Florence from the 15th century until 1737. During the early 15th century, after acquiring immense wealth as bankers and merchants, the Medici family became connected with the major houses of Europe through marriage. Besides acquiring the title Grand Duke of Tuscany in 1569,

they produced three popes, Leo X, Clement VII and Leo XI, two queens of France, Catherine de' Medici and Marie de' Medici, and several cardinals of the Catholic Church. During the years 1516–1521 the Medici also ruled the duchy of Urbino. The acquisition of the wealth of the Medici coincided with the triumph of the capitalist class over the artisans and guild merchants. The Medici were able to exert a tight control over the government without holding any official positions. On three occasions they were driven from Florence: 1433–1434, 1492–1512 and 1527–1530. Yet because of their connections and immense wealth and power, the attempts of the Florentine republicans to regain their former liberties failed.

The Medici were extravagant patrons of the arts, and even though their political influence began after most of the Italian Renaissance in Florence was waning, the wealth of this family allowed Florence to become the richest repository of painting, sculpture, architecture and literature since the Golden Age of Greece, the time of Pericles and the Parthenon c. 432 B.C. Florence as it stands today is mostly the result of the Medici fortune. In the beginning the rule of the Medici family was benevolent and balanced, but it became repressive and illiberal during the 17th century. The first family member of note was Giovanni di Bicci de' Medici (1360–1429). His oldest son, Cosimo de' Medici founded the senior line, which included Lorenzo de' Medici (il Magnifico); Lorenzo de' Medici, Duke of Urbino; Catherine de' Medici and others. The apotheosis, or glorification, of the Medici depicts a plethora of figures, the family, in heaven and on earth.

Example: Luca Giordano, Ceiling fresco, Palazzo Medici-Riccardi, Florence. (Held and Posner, fig. 124)

APPEARANCE OF THE VIRGIN TO ST. BRUNO. BRUNO, founder of the Carthusian Order, was born in Cologne about the year 1030 and died on October 6, 1101. He completed his education at the cathedral school of Rheims, in France, and later taught there for eighteen years. Bruno was known for his wisdom and virtue; yet at one time it is said he abandoned the active ecclesiastical life. In a time of prosperity, he enjoyed the world and its riches, honor and the favor of men. When the church of Rheims told him he would be their new archbishop, he resigned his worldly affairs and persuaded some of his friends to accompany him into solitude. In seclusion, Bruno had a true desire for perfection in virtue and all that was good. He was told there were woods and deserts suitable to his desire for finding perfect reclusion. Six of his friends accompanied him to his new retreat, and Bruno and these companions built an oratory in the desert of Chartreuse with small cells. This inconspicious beginning was the origin of the order of the Carthusians. St. Bruno has never been formally canonized, the Carthusians being against all occasions of publicity. In 1514, however, they ordained leave from Pope Leo X to keep his feast, and in 1674, Clement X extended it to include the whole Western Church. Bruno is shown kneeling before the Virgin Mary who hovers on a cloud before him. On her lap

is the infant Jesus who holds the book open before him. Angels watch from above. A mountainous desert landscape, that of Chartreuse, is in the background, the place where Bruno spent his years in solitude.

Example: Simon Vouet, S. Marino, Naples. (Blunt, fig. 199)

ARABESQUE. An interlacing and entwining kind of plant-form decoration, arabesque can be traced back to Roman art of the first century and found in various forms throughout the history of art and decoration. Although the arabesque is the most typical motif of Islamic decoration, the term itself is used by extension to include the extravagant combinations of flowing lines interwoven with frivolous, fanciful flowers and imaginative forms of fruit and leaves used by Baroque artists and decorators.

ARCADIAN SHEPHERDS. *See* ET IN ARCADIA EGO.

ARISTOTLE WITH THE BUST OF HOMER. Aristotle, a Greek philosopher, was born in Stagira in 384 B.C. and died at Chalcis in 322 B.C. Some historians call him the Stagirite. He studied under Plato and wrote dialogues that were praised for their eloquence. He is well known as the tutor to Alexander the Great. Basically he considered philosophy to be the discerning of the self-evident, changeless first principles that form the basis of all knowledge. He introduced the notion of category into logic and believed that reality could be classified according to categories. In art, Aristotle personified logic, one of the Seven Liberal Arts. During the 17th century, Aristotle's work was banished from physics by leaders of the scientific revolution. He is shown contemplating a bust of Homer, a principal figure of ancient Greek literature. Homer is considered to be the first European poet. Attributed to him are the *Iliad* and the *Odyssey,* which are ranked among the great works of Western literature. Legends about Homer abounded in ancient times. He was said to have been blind, his sightless eyes being a punishment for having slandered Helen of Troy. He was supposed to have been born on the Greek island of Chios, but scholars point instead to Smyrna. The study of Homer and his works was required of all Greek students in antiquity, and his literary heroes were worshipped in most parts of Greece.

Aristotle is shown in shadows, his right hand resting on the head of a bust of his blind teacher, his left touching a golden chain, the symbol of princely favor. It is draped from his shoulder to his hip and holds a medallion with the likeness of his most famous pupil, Alexander the Great, to whom he had taught the art of war using quotations from Homer. Homer, dictating his poetry, with noble features, stares from blind eyes into space. Usually he is depicted wearing a crown of laurel. He may hold two books, his *Iliad* and *Odyssey.* Often he plays or holds a stringed instrument, usually of the violin family, an allusion to the ancient practice of musical accompaniment to the recitation of poetry. Aristotle is contemplative, serious, pensive.

Example: Rembrandt van Rijn, the Metropolitan Museum of Art, New York. (Rosenberg, Slive, ter Kuile, fig. 83)

ARRIVAL OF MARIE DE' MEDICI AT MARSEILLES (*The Reception of Marie de' Medici at Marseilles*). Marie de' Medici was a queen of France, the second wife of King Henry IV and daughter of Francesco de' Medici, grand duke of Tuscany. She was born in 1573 and died in 1642. She married Henry, the first of the Bourbon kings, in 1600 at the age of 27, and when Henry was assassinated in 1610, Marie became regent for her son Louis XIII. The policies set by her husband were reversed. She replaced the Duc de Sully with Concini, one of her favorites, and squandered the treasury surplus in pensions to nobles and elaborate court extravagance. Moreover, she abandoned the anti-Hapsburg policy and formed a new Franco-Spanish alliance through the marriage of Louis to Anne of Austria, daughter of King Philip III of Spain. Marie was forced into exile after the murder of Concini in 1617.

Rubens's large canvas the *Arrival of Marie de' Medici at Marseilles* is one of a cycle memorializing and glorifying not only the queen's career but also that of Henry. Twenty-one huge historical-allegorical paintings were produced. In the "Arrival" scene, Marie has come to Marseilles, France, to marry Henry IV after a sea voyage from her home in Italy. Descending the ship on an elaborately draped crimson-covered walkway, she is surrounded by her ladies and welcomed by an allegory of France, a figure who kneels at her feet draped in the fleur-de-lis and holding a baton. The sky and sea rejoice at her safe arrival; the nereids or sea nymphs, and Poseidon, lord of the sea and a god of horses, salute her; and above flutters a winged Fame with her two trumpets, one long and one short for good and ill repute. Fame may hold a palm branch, the symbol of victory to which she is usually the sequel. For the same reason, she may also wear a crown. Outstanding in the opulently-carved stern-castle of the Baroque gallery, crowned by the famous Medici coat of arms, stands the lordly commander of the ship in a fabulous costume of silver and black. On his breast is the cross of a Knight of Malta, which may identify his ship as belonging to that order.

Example: Peter Paul Rubens, The Louvre, Paris. (Ruskin, colorplate 3–3)

ARTIST IN HIS STUDIO (*Allegory of the Art of Painting* and *The Studio*). The *Artist in His Studio* is an allegorical work and, according to some scholars, no less than a glorification of the art of painting itself. Its subject, the "Art of Painting," has been frequently discussed but remains an enigma to most scholars. The scene shows a painter (from the back) at his easel. He sits in a spacious, well-lit room. A modest model poses before the artist. Historians argue over whether the painter is a self-portrait of Jan Vermeer portraying himself from the back. Some believe, however, that a 17th-century Dutch artist would not represent himself in a "Gurgundian" costume such as the one shown in the picture. Others believe that the picture is more than likely a glorification of the art of

painting and not a self-portrait. Their argument is based on the fact that Vermeer's widow in 1676 gave the title *The Art of Painting (De Schilderconst)* to the work and made no reference to the canvas as a portrait of her deceased husband.

The model is Clio, the muse of fame and history, a goddess of creative inspiration, a companion of Apollo. She was the daughter of Jupiter and the Titaness Mnemosyne, or Memory. The objects on the table, a plaster cast, paper and a book, reinforce the basic theme. During the 17th century, Clio is usually depicted with an obvious crown of laurel leaves. Of the several varieties of laurel, the *Laurus nobilis,* a bay tree, was that from which the victor's crown was woven. In portraits, the laurel implies that the model is an artistic or literary figure. She usually holds a straight trumpet, the Roman tuba, and a book. The book may be *Herodotus* or *Thucydides.* The artist steadies his right hand on a MAHLSTICK, a rod with a cushioned tip used by painters; one can see that he has drawn the contours of Clio in white and has filled his canvas with her half-length figure. He appears to be painting the laurel leaves of her crown. She poses in the light of an implied window on the left, a large map behind her. The map represents both the northern and southern Netherlands. It is bordered by views of twenty cities and appears as if it could be read in extreme detail, although only the largest letters are legible.

Example: Jan Vermeer, Kunsthistorisches Museum, Vienna. (Held and Posner, color-plate 43)

ASCANIUS AND THE STAG. Ascanius (Latin authors also call him Iulus) was the son of Aeneas and the founder of Alba Longa, the second settlement of the Trojans in Italy and their home for three hundred years. His mother, according to Virgil, was the Trojan Creusa. After the fall of Troy, Ascanius accompanied his father to Italy. When Hera (Latin, Juno) caused Ascanius to kill a pet deer, war broke out between the Trojans and all the neighboring peoples, who assembled under Turnus, a powerful, fearless warrior. The Volscians joined the massing forces, led by Camilla, a beautiful virgin warrior. The story of Ascanius, or Iulus, and the stag is told in Virgil's *Aeneid* 7:664–690. "There was a stag, a beauty, with a giant spread of antlers, taken before weaning from a doe and brought up tame by boys, as by their father, Tyrrhus, the chief herdsman to the king and warden of his wide estates. Their sister, Silvia, had trained the beast with love to do her bidding. She would wreathe his horns with garlands, groom him, bathe him in a spring of limpid water. Placid under his hand, accustomed to the table of his mistress, the stag would roam the forest, then return, however late at night, to the gate he knew. Now as he wandered far from home the hounds of Iulus [Ascanius] on the hunt, furiously barking, started the stag. He had been floating down a river, keeping cool by a green bank. Ascanius himself, now on the chase and passionate for the honor of the kill, let fly a shaft from his bent bow: Allecto's guidance did not fail his hand or let him shoot amiss, and the arrow whizzing loud whipped on to pierce the

belly and the flank. Mortally hurt, the swift deer made for home in the farm buildings. Groaning, he found his stall, and coated with dark blood he filled the house with piteous cries, as though imploring mercy.''

Ascanius is shown aiming his bow at the stag, which stands innocently on the other side of a river looking at him. Ascanius's hounds and several of his huntsmen watch him from behind.

Example: Claude Lorrain, Ashmolean Museum, Oxford. (Blunt, fig. 254)

ASCENSION, THE (*Ascension of Christ*). The term ''Ascension'' is used to indicate the bodily ascent of Jesus into heaven on the fortieth day after his Resurrection. The story of the Ascension is told in Acts 1:9–12: ''As they were looking on [Jesus stood with his apostles on the Mount of Olives], he was lifted up and a cloud took him out of their sight. And while they were gazing into heaven as he went, behold, two men stood by them in white robes, and said, 'Men of Galilee, why do you stand looking into heaven? This Jesus, who was taken from you into heaven, will come in the same way as you saw him go into heaven.' ''

Artists generally depict the figure of Christ in the center of the work with his feet on a cloud. Angels (in the form of *putti; see* PUTTO) may be present. A complete ''Ascension'' has two sections, upper and lower, or heaven and earth. On earth, the apostles gaze toward heaven at the figure of Christ as it disappears into clouds. In heaven, Christ's feet rest on a cloud. He may hold the banner of Resurrection and make the sign of benediction with his right hand while angels play musical instruments. During the Baroque, the subject was used for illusionistic ceiling painting, and the formal composition of the Renaissance and earlier periods is lost.

Example: Giovanni Lanfranco, S. Giovanni dei Fiorentini Rome. (Waterhouse, fig. 35)

ASHES OF PHOCION COLLECTED BY HIS WIDOW. *See* FUNERAL OF PHOCION.

ASSUMPTION OF THE VIRGIN. The story of the Assumption of the ''Blessed Virgin Mary'' is told in Voragine's GOLDEN LEGEND. ''Assumption'' is the term used to indicate the taking up to heaven of the body and soul of the Virgin Mary. This was said to occur three days after her death. Assumption, taken from the Latin *adsumere,* to take up, implies that Mary was taken to heaven probably by angels. No scriptural foundation exists either for the belief of Mary's being borne to heaven or for her age at the time. According to the *Golden Legend* her age was uncertain, although it is believed that Mary conceived Jesus when she was fourteen years of age, and she was fifteen when he was born. She survived him by twenty-four years after they had lived together for thirty-three, and thus, Mary must have been seventy-two when she died. Other accounts say that she lived only twelve years after Jesus was crucified, and was sixty years old when she died. Nevertheless, the apostles of Jesus came

together at the death of Mary, and with them, about the third hour of the night, Jesus arrived with the ranks of the angels, the patriarchs, the martyrs, the confessors and the choir of virgins. After gathering, they took their places before the throne of the Virgin. They sang as a choir while three virgins washed Mary's body. Suddenly, Mary gave forth a light so blinding that they could touch it. The light shone for as long as the virgins washed Mary's body. Jesus' apostles placed Mary in the tomb and sat around her, as they had been commanded by the Lord. On the third day, Jesus, coming with a choir of angels, greeted them with the words *Pax vobis,* and immediately Mary's soul left her body and was assumed into heaven. The Assumption was popular during the 13th century, especially on the portals of churches dedicated to Notre Dame, or Our Lady. Thereafter, it remained an important topic.

Typically Mary is in mid-air, standing or enthroned. She is lifted by choirs of angels, who may play musical instruments. Mary's arms are outstretched and she looks toward heaven in rapture. The twelve apostles may be shown on the ground below gathered around the empty tomb. They watch in awe at the scene above, or they may be falling back, startled. God the Father, sometimes surrounded by seraphim and cherubim (angels), may be above, waiting to receive Mary. During the Baroque, painters of the Spanish Netherlands showed the tomb filled with roses (white roses symbolize purity) or lilies (other symbol for purity). Rubens introduced two women gathering roses. (The Virgin Mary is called the "rose without thorns"; that is, without sin.) Luke's account, 10:38–42, is read in churches on the feast of the Assumption after the suggestion by one scholar who said the two women represent Mary and Martha when Christ was in their house. The two women may stand for the body and soul of the Virgin, as suggested by a Christian writer of the COUNTER REFORMATION.

Example: Annibale Carracci, Cerasi Chapel, S. Marie del Popolo, Rome. (Wittkower, fig. 21)

ASTRONOMER. Astronomy is that branch of science that studies the natures and motions of celestial bodies, such as the galaxies, stars and planets in the universe. Of all the physical sciences, astronomy is possibly the oldest. No one knows when scientific observations of the heavens began, but the regularity of celestial motions was recognized by many primitive civilizations. Records of sorts were kept probably in order to predict future events. Astronomy was first used to provide a basis for a calendar; that is, units of months and years were determined by astronomical observations. Astronomers later served sailors and those wishing to keep time. As early as the 13th century, the Chinese had a working calendar. Shih Shen created the earliest known catalog c.350 B.C. of stars containing eight hundred entries. The Egyptians, Babylonians and Assyrians studied the heavens, their priests being the earliest astronomers. The Greeks, using methods different from earlier astronomers, developed a high level of astronomy from 600 B.C. to A.D. 400. Aristotle (384–322 B.C.) summarized most of the Greek astronomical work before him and remained the authority until

near the end of the Middle Ages. His belief that the earth does not move had a definite retarding effect on later astronomical progress. By the 17th century, Isaac Newton (1642–1727) succeeded in uniting the science of physics with astronomy. All progress in astronomy, until the middle of the 19th century was mostly an extension of Newton's work. The astronomer is shown at his desk, a window and books before him, studying the globe with an intensity found only in a scientist.

Example: Jan Vermeer, Private collection, Paris. (Rosenberg, Slive, ter Kuile, fig. 140)

ATALANTA AND HIPPOMENES. The story of Atalanta and Hippomenes is told by Ovid in *Metamorphoses* 10:560–707. Atalanta was an Arcadian heroine, who, disowned by her father, was suckled by a bear provided by Artemis. The first to wound the wild boar in the Calydonian boar hunt, she become a famous athletic huntress vowed to virginity. When a suitor approached her, she challenged him to a race in which the loser was put to death. She beat every suitor and remained a virgin until Hippomenes (sometimes called Melanion) challenged her. He dropped three golden apples (given to him by Venus) as they ran; and Atalanta, unable to resist them and believing she could take the time to pick them up, did so. She lost the race. According to Ovid: "As he [Hippomenes] praised Atalanta, he began to fall in love with her . . . [and] she darted off on winged feet. She seemed to the Boeotian youth to speed on her way like a Scythian arrow, but that only made him admire her beauty all the more. Indeed, she did make a lovely picture, as she raced: the wind blew back her long robes, as she held them up out of the way of her swift feet, her hair floated over her ivory shoulders, and the garters with embroidered edges which bound her legs streamed out in the breeze . . . the last lap was run, and Atalanta crowned with the wreath of victory. The men she had defeated groaned, and paid the penalty . . . Hippomenes was not deterred by their fate . . . and said, 'why seek a title you can easily win, defeating opponents who are slow and out of training? Race against me.' . . . As he spoke Schoeneus' daughter [Atalanta] looked at him tenderly, not sure whether she would rather win or lose. . . . Atalanta was beaten and the victor led away his prize." Atalanta and Hippomenes made love in the Temple of Cybele, and the goddess, furious and insulted, turned them both into lions.

Atalanta is usually shown in the act of stooping to pick up one of the apples thrown down by Hippomenes as he overtakes her. Some artists show Hippomenes receiving the apples from Venus.

Example: Guido Reni, Caposimonte Museum, Naples. (Ruskin, colorplate 1–25)

ATLANTES. Atlantes is a term used to denote the figures in Greek architecture used instead of columns to support a projecting roof or an entablature. The word is the plural of Atlas and came to be used as the masculine equivalent of caryatids for any sculptured figures bearing a lintel. Atlas was the Titan in Greek mythology, the son of Iapetus, who was condemned to support the sky on his

hands and head as a punishment for taking part in the revolt of the Titans against Zeus. Later, when it was discovered that the earth was round, Atlas was often shown as bearing the terrestrial globe on his shoulders. Atlantes were often included by Baroque painters in illusionistic ceiling paintings where they appeared to support the roof.

Example: Annibale Carracci, Ceiling fresco, Gallery Palazzo Farnese, Rome. (Held and Posner, colorplate 5)

ATLAS. *See* ATLANTES.

AUGUSTINE AND THE CHILD. Saint Augustine (354–430 A.D.) is one of the four Latin fathers, a doctor of the Church and bishop of Hippo in north Africa (close to present-day Annaba in Algeria). His Latin name is Aurelius Augustinus, and his Italian name is Agostino. He is possibly the most influential theologian of all time. Monica, his mother, was the greatest influence in his life, and she was later canonized. Yet, even though she brought him up as a devout Christian, he gave up his religion when he studied at Carthage. His interests then tended toward rhetoric. Later, in his *Confessions,* he repents of his unbridled youth in Carthage and the acts that led to an illegitimate son. He taught rhetoric in Rome in 376 and was teaching in Milan in 384 when his life changed. He was drawn to the religious fervor of the bishop of Milan, St. Ambrose.

In his *Confessions,* Augustine tells how, while meditating under a fig tree, he heard a child's voice tell him, *"Tolle, lege,"* "take and read." Opening the Bible at random, he found the words "Let us conduct ourselves becomingly as in the day, not in reveling and drunkenness, not in debauchery and licentiousness, not in quarreling and jealousy. Let Christ Jesus himself be the armor you wear" (Romans 13:13–14). This incident caused him to embrace Christianity once again. He was baptized by Ambrose on Easter Day, 387. He then returned to Tagaste, the place of his birth, where he lived a monastic life with friends. In 391 while in Hippo, he was selected against his will to be the priest there. For the rest of his life he lived in Hippo where he became auxiliary bishop and then bishop. He died during the siege of Hippo by the Vandals.

Events during his life include his often illustrated vision of a child beside the seashore. While walking along the seashore and meditating on the Trinity, Augustine came upon a child who had dug a hole in the sand. The child was trying to fill the deep hole with water by using a shell. Augustine told the child how useless his task was, and the small child answered, "No more so than for a human intelligence to fathom the mystery you are meditating [the Trinity—the Father, Son and Holy Spirit as one]." Augustine is usually dressed as a bishop, with mitre and crozier. Some artists show him wearing a monk's habit, sometimes under a cope (a cape-like vestment worn by priests). He is usually middle-aged and may have a short, dark beard. His attribute is a flaming heart, the symbol of religious fervor. In his *Confessions,* Augustus writes that as a student at Carthage he was led down the path of sin, and as a sign of remorse, he may

be shown with arrows piercing his breast. An infant in a cradle may be shown beside him, an allusion to his vision of the child at the seashore. Augustine is depicted in his Episcopal robes, or he may sit on a rock. His mother, Saint Monica, may sometimes kneel in prayer while angels hover overhead. If the subject is treated devotionally, the Virgin Mary appears in the heavens with angels. The child symbolizes Christ and may be shown as an angel holding a seashell.

Example: Carlo Maratta, S. Maria dei sette Dolori, Rome. (Waterhouse, fig. 67)

AUGUSTINE WASHING CHRIST'S FEET. Augustine may be shown with Ambrose, Gregory and Jerome, the other Latin fathers. He may also be shown with his mother, St. Monica, who had great influence on his life. He may be shown arriving at school, led by his mother and met by the schoolmaster. He may also be shown handing the rules of his order to monks or simply seated at his desk with pen in hand ready to write. The order was established in the 11th century; the rules drawn from Augustine's writings. He is shown washing Christ's feet, at which time he kneels before Jesus, who has one foot on Augustine's knee. A large basin of water is between them. Augustine looks at him with profound love and adoration. *See also* AUGUSTINE AND THE CHILD.

Example: Bernardo Strozzi, Accademia Ligustica, Genoa. (Waterhouse, fig. 182)

AURELIUS, MARCUS. *See* MARCUS AURELIUS.

AURORA. The Roman Eos, is the dawn goddess, a figure of mythology and not a cult. She was the sister of the sun god, Helios, and the daughter of Hyperion and Thea. She drove across the sky in a chariot with a pair of horses, Phaethon and Lampos, every morning. Her epithets, especially in Homer were "rosy-fingered," and "saffon-robed," in reference to the color of the sky at dawn. She had slept with Ares, the lover of Aphrodite, who revenged herself by giving Aurora an insatiable desire for young men. Thus, most of the stories about Aurora are of kidnappings of handsome men. The oldest of her lovers was the Trojan prince Tithonus whom Aurora asked Zeus to make immortal but forgot to ask for immortal youth. He became helpless and horrible with old age and talked endlessly. In a fit of loathing and revulsion, Aurora locked him in a closet. An older, perhaps original form of the story is that Tithonus became a cicada and chirped ceaselessly. In art he may be winged and appear in a two-horse chariot. Night may be shown to the left of the painting, dark in twilight's shadows, while day flies into the dazzling new dawn.

Example: Guercino, Rome, Fresco, Casino Ludovisi. (Wittkower, fig. 36)

AURORA AND CEPHALUS. In Greek mythology, Aurora (Greek, Eos) is the goddess of the dawn. As the sister of the sun-god, Helios, it was her duty every morning to lead Helios into the heavens. It so happened that most of the time she left her aged husband, Tithonus, sleeping. She had taken Tithonus as

her lover and asked Zeus to grant him immortality. Zeus did, but Aurora forgot to request eternal youth as well. Her real love was for the youth Cephalus, who, unfortunately, did not love her in return. Her passion for him caused her to neglect her duty of taking Helios through the heavens; consequently, the universe was threatened with chaos until Cupid shot Cephalus with the arrows of love, forcing him to return her love. Aurora is shown trying to embrace Cephalus while her chariot hitched to white winged horses stands ready. Also, a winged Aurora may swoop down from the sky to Cephalus while her chariot waits in the clouds. *Amoretti* (*see* AMORETTO), symbols of love, fly about. Old Tithonus may sleep nearby not aware of what is happening. During the 17th century a dog was added to the scene by the Italian dramatist Gabriello Chiabrera (1552–1636), who wrote the popular play *Il rapimento di Cefalo.*

Example: Nicolas Poussin, National Gallery, London. (Friedlaender, colorplate 15)

AUTUMN. The third work in a series (the others being *Winter,* SPRING, *Summer,* RUTH AND BOAZ) by Nicolas Poussin, *Autumn* signifies the fulfillment of the Law by Christ and shows huge clusters of grapes carried from the Promised Land. Grapes also suggest the consecrated wine, the other half of the EUCHARIST. The trees in a forest that mature and die in the middle ground symbolize the synagogue and the church, the death of the old and the bringing in of the new.

Example: Nicolas Poussin, the Louvre, Paris. (Friedlaender, fig. 129)

B

BACCHANAL. A scene of abandoned, festive merrymaking with music makers. MAENADS, the female followers of BACCHUS, and *putti* (*see* PUTTO) are shown playing instruments. A HERM of Pan, Greek god of the herds and flocks, the fields and woods, decorated with ivy and sacred to Bacchus, is high on a plinth, and at the base *putti* blow pipes in bacchic revelry.

Example: Giulio Carpioni, Museum of Art, Columbia, South Carolina. (Wittkower, fig. 228)

BACCHANAL BEFORE A TEMPLE. Here an unrestrained Saturnalian festival of merrymaking, feasting and revelry in celebration of the winter solstice (December 22) unfolds in wild and frenetic dancing, excessive drinking, the gestures of acrobats and the making of music with pipes (a symbol of lust), all of which are extremely pagan. The Roman festival of Saturn was held about December 17 and was a period of unbridled, often orgiastic, revelry.

Example: Nicolas Poussin, Drawing, Royal Library, Windsor Castle, England. (Friedlaender, fig. 38)

BACCHANALIAN REVEL BEFORE A TERM OF PAN. This bacchanalian festival that takes place before a screen of trees to the right and idealic mountains and peaceful meadows to the left, is joyous, but solemn. It features dancing nymphs and satyrs and Pan, the Greek god of flocks and herds, woods and fields. Pan personifies lust and is said to have charmed the nymphs with his pipes. He was also thought to have lain with all the MAENADS. His home was Arcadia, the romantic paradise of the pastoral poets and artists. Pan, along with the satyrs, centaurs, maenads, Silenus and Priapus, formed the retinue of BACCHUS.

Pan is shown with a goat-like face featuring horns, pointed ears and coarse features. Pan invented the syrinx, reed pipes aligned in a row of ascending

length. One graceful bacchante squeezes a bunch of grapes and the juice falls into a cup held high by a fat little boy, who has even another fat child grappling behind him trying to take the cup. A lusty satyr assaults a laughing bacchante who half-heartedly pushes him away, while her companion, a music maker, seems to pluck leaves from the satyr's head. Wreaths and flowers are underfoot along with an overfed, sated child. The HERM of Pan has been decorated with a wreath on his head and a ''criss-cross'' of ivy (leaves that were sacred to Bacchus) over his chest. Scenes such as this, allegories perhaps of Lust overcoming Chastity, were popular during the Baroque.

Example: Nicolas Poussin, National Gallery, London. (Friedlaender, colorplate 21)

BACCHUS. The Greek god Dionysus was known to the Romans as Bacchus (a Lydian word), who was popular as the god of wine. To the Greeks, though, he was a god of an emotional religion. Most scholars agree that Bacchus came from Thrace where his cult was famous and widely spread. In the beginning, Macedonian and Thracian women were devoted to his orgia. Later, after the legends swept over Greece, the ecstatic character of the cult caused women to abandon their work and homes, roam about in the mountains, whirl in dances, swing thyrsi (staffs tipped with pinecones) and torches and, at the peak of their ecstasy, seize upon an animal or even a child, according to the myths, tearing it apart and eating the bleeding pieces. Their belief was that in eating the parts of the animal the MAENADS incorporated the god and his power within themselves. It is believed that the god sometimes appeared in animal form and is therefore called ''bull'' or ''bull-horned.'' Bacchus and his maenads were dressed in deer skins. Sometimes, it is said, that the maenads wore masks. Bacchus's image many times consisted of a garment and a mask hung on a pole. These masks were human. Orgia were also celebrated in historical times on Mt. PARNASSUS by official cult associations of women. The frenzy of the orgia was tamed by Apollo, who brought the cult into the gentler forms of state religion. Dionysus existed in several forms. One was as a god of vegetation, not of the crops, but of the trees and fruit. He is also known as a god of fertility, in which case a phallus was carried in the Dionysiac processions. This Dionysus was the god of wine, for which today he is most popular and best-known.

In art he was first depicted in the sixth century and remained popular thereafter, especially in vase painting. He is shown alone, with nymphs and satyrs or maenads, escorting Hephaestus to Olympus, with Semele, Ariadne, drinking with Heracles or sailing his vine-ship. The birth from Zeus's thigh and the giving of the baby to the nymphs is also shown (*see* BIRTH OF BACCHUS). Bacchus is often shown as a naked youth, wearing grapes and large grapevine leaves about his head. He may hold a thyrsus (an ancient fertility symbol which is no more than a rod with a pine cone on the end and sometimes encircled with ivy.) He is frequently drunk, riding in his car drawn by goats or leopards or tigers (only occasionally horses or centaurs). He is accompanied by maenads and satyrs, who may retain animal characteristics such as a goatlike

face or goat legs or cloven hoofs. Usually they play pipes for the dancing and singing that accompany the Bacchic ritual. Satyrs may be shown with snakes as these formed part of the rites. In later art Bacchus became the example of all that was in direct contrast to virtue, intelligence and high-mindedness, and clarity of reason.

Example: Caravaggio, Uffizi Gallery, Florence. (Bottari, colorplate 5)

BACCHUS AND ARIADNE. *See* TRIUMPH OF BACCHUS AND ARIADNE.

BALAAM AND THE ASS. The story of Balaam and the ass is told in Numbers 22:1–35. The king of Moab was so alarmed by the arrival of the Israelites in the Jordan valley that he sent for Balaam to cause a curse to fall upon them. "Balaam . . . went with the princes of Moab. But God's anger was kindled . . . and the angel of the Lord took his stand in the way. . . . [Balaam] was riding on the ass, and two servants were with him. And the ass saw the angel . . . with a drawn sword . . . and the ass turned aside . . . and Balaam struck the ass, to turn her into the road. Then the angel . . . stood in a narrow path between the vineyards, with a wall on either side. And when the ass saw the angel . . . she pushed against the wall, and pressed Balaam's foot against the wall; so he struck her again. Then the angel . . . stood in the narrow place where there was no way to turn . . . When the ass saw the angel . . . she lay down under Balaam; . . . and he struck the ass with his staff. Then the Lord opened the mouth of the ass, and she said to Balaam, 'What have I done to you, that you have struck me these three times?' And Balaam said to the ass, 'Because you have made sport of me. I wish I had a sword in my hand, for then I would kill you.' And the ass said to Balaam, 'Am I not your ass, upon which you have ridden all your life . . . ? Was I ever accustomed to do so to you?' And he said, 'No.' Then the Lord opened the eyes of Balaam, and he saw the angel . . . standing in the way, with his drawn sword in his hand; and he bowed his head, and fell on his face."

The conversion of Balaam after seeing the angel was regarded as a prefiguration of the appearance of Christ to the apostle Thomas (known as DOUBTING THOMAS) after his death. The subject is rare during the Baroque. Balaam is shown astride the animal, beating it over the head with a stick while the angel is ready to stop him with a sword.

Example: Rembrandt van Rijn, Cognacq-Jay Museum, Paris. (Held and Posner, colorplate 40)

BALDACCHINO (ciborium). A cloth canopy held up at each corner by a rod and either placed over an altar or hung over a sacred object carried in a procession; also, a structure of some metal or durable material in the same shape as the cloth canopy. Baldacchinos with twisted columns and fringed canopies were common in Baroque churches during the 17th century, the most famous

being the bronze baldacchino designed by Gian Lorenzo Bernini that is placed over the altar in St. Peter's in Rome.

BALDACHIN. *See* BALDACCHINO.

BALDINUCCI, ABATE FILIPPO. Florentine art historian, philologist, antiquarian and artist, who was prominent in artistic circles at the court of the Medici dukes during the 17th century, Baldinucci lived from 1624 until 1696 and was adviser to Cardinal Leopoldo de' Medici. He helped form his collection of drawings and selected and bought paintings for Duke Cosimo III. His *Notizie de' Professori del disegno* (3 volumes published in 1681, 3 in 1781), includes lives of artists from Cimabue (a late 13th-century Proto-Renaissance painter) to his own time and is valuable for the information it gives about 16th-century Florentine artists as well as his own social circles. Baldinucci was one of the first to make use of every kind of document available in historical research and was in the closest circles of many leading artists. As an art historian, his intention was to continue Giorgio Vasari's *Lives of the Artists*. In 1686 he wrote the first history of engraving on copper and the first dictionary of artistic terms. Living in Rome, he was commissioned by Christina of Sweden (after her abdication) to write the life of Gian Lorenzo Bernini (1598–1680).

BAMBOCCIATE. Paintings of daily life in and around Rome during the 17th century. Bambocciate means "silly big baby," and as a term was created by Peter van Laer (Bamboccio). These paintings were regarded as a breach of decorum by the classicists, the SEICENTO Italian critics. The word was first used by Andrea Sacchi in a letter to his master, Francesco Albani, dated October 28, 1651, at which time he says, "I am persuaded that you will appreciate my informing you that among the things now in decline at Rome is painting. The painters of this city, seeing what a lofty thing true beauty in nature is, and how difficult it is to apprehend it and to represent decorously with a fitting nobleness of detail and proper expression, have taken upon themselves a certain freedom of conscience. They represent anything whatsoever, and badly; they copy reality and paint indecent and unseemly attitudes with no regard for grace and decorum. They will paint a rogue searching for lice, another drinking soup out of a bowl, a woman urinating and holding a braying donkey by the halter, a BACCHUS vomiting and a dog licking. Fie! This crowd of painters is patronized by certain dilettanti who buy their works to dispose of them at a small profit and then order new ones at six or eight scudi [former gold or silver coins valued at about one dollar] apiece. Such then is the unhappy state of painting. There are six real painters in Europe at most, but they have these *Bambioccianti* against them like pygmies picking at giants."

Attacks on the Bambioccianti in the 1640s coincided with the ascendancy of Classicism in Rome. The cut of criticism was, therefore, especially deep.

Example: Pieter van Laer (Il Bamboccio), *Farrier,* Collection Corrado Zingone, Rome. (Held and Posner, fig. 94)

BANISHMENT OF HAGAR AND ISHMAEL. *See* EXPULSION OF HAGAR.

BANQUET OF THE GODS. *See* MARRIAGE OF PELEUS AND THETIS.

BANQUET OF THE OFFICERS OF THE HAARLEM MILITIA COMPANY OF ST. GEORGE.

Militia companies, originally organized as guilds under the patronage of a certain saint, had a long history in the Netherlands. The militia organization was composed of citizens enrolled and trained for fighting in times of emergency. The ranks might be filled either by conscription or enlistment. In times of emergency, a militiaman immediately left his civilian duties and became a soldier until the crisis was over, at which time he resumed his civilian status. Dutch burghers out of necessity formed militia groups. Even from the time of the Middle Ages, the Dutch had maintained a degree of independence. In order to protect their towns against encroachments or attacks, they kept their militia groups at hand. At the beginning of the 16th century the Dutch militia companies started to decorate their buildings with their members seated as if in a group portrait. Haarlem is the capital city of North Holland province in the western Netherlands located on the Spaarne River close to the North Sea. (It was a boy of Haarlem who stopped a leak in the dike with his finger.)

The painting of the officers of the Haarlem Militia Company, with their patron saint, St. George, is a group portrait that exhibits the healthy strength and optimism of hard-working, hard-fighting men who helped build the new republic. The men are shown cleverly as individuals in a kind of portrait that presents the unique problem of how to portray a group in an interesting manner. Frans Hals was able to give equal prominence to every individual, but, rather than using a monotonous row of separate portraits, he combined the emphasis on individual likenesses with a compositional unity of the whole that is undeniably dynamic.

Example: Frans Hals, Frans Hals Museum Haarlem. (Rosenberg, Slive, ter Kuile, fig. 22)

BAPTISM.

In the Christian Church, baptism is the rite of initiation, the first cycle of the seven sacraments: baptism, communion, confirmation, confession, extreme unction, holy orders and matrimony. (All seven are not recognized by all churches.) Historically, baptism has been regarded as both a rebirth and an act of purification in which the baptismal font was symbolic of the immaculate womb of the Virgin Mary from which God was born as man.

Example: Nicolas Poussin, Collection Earl of Ellesmere, on loan to National Galleries of Scotland, Edinburgh. (Friedlaender, fig. 49)

BAPTISM OF CHRIST. The story of the baptism of Christ is told in Matthew 3:13–17, Mark 1:9–11, Luke 3:21–22 and John 1:29–34. Mark says, "In those days Jesus came from Nazareth of Galilee and was baptized by John in the Jordan. And when he came up out of the water, immediately he saw the heavens opened and the Spirit descending upon him like a dove; and a voice came from heaven, 'Thou art my beloved Son; with thee I am well pleased.' " Jesus was baptized along with a multitude of people. He is usually shown standing in the Jordan, ankle deep in the river. John the Baptist is on the bank and pours water over his head. (This is baptism by effusion, not immersion.)

Baroque painters sometimes depicted a multitude of people on both banks putting on or removing their clothes, watching the miracle of the Holy Spirit or resting. Some show the Holy Spirit as a dove hovering over the head of Christ. John uses a cup or a shell or sometimes a cupped hand. The landscape may be prominent, showing the Jordan meandering through a pleasant vista with meadows and trees. John may kneel while Christ stands or both may stand. Artists of the 17th century, emphasizing Christ's humility, depict Jesus kneeling before John. The baptism of Christ became a popular subject for the altarpieces of baptisteries and churches dedicated to St. John and also for donors who shared his Christian name. Donors sometimes had themselves included kneeling in the scene.

Example: Guido Reni, Kunsthistorisches Museum, Vienna. (Held and Posner, fig. 100)

BAPTISM OF SAINT AUGUSTINE. *See* AMBROSE BAPTIZING SAINT AUGUSTINE.

BARROCO. Portuguese word meaning an irregularly shaped pearl from which the word Baroque may have originated. The term was originally used in a disparaging sense. The use of "Baroque" in a denigrating manner has ended and the word has been included in art historical vocabulary for many years as a blanket term for the art of the period between the years 1600 and c.1750.

BARTHOLOMEW, ST. *See* MARTYRDOM OF ST. BARTHOLOMEW.

BAS RELIEF. *Basso rilievo,* or low relief, is a term used when the scale of projection in which the forms protrude from a plane or curved surface is only slight and there is no undercutting. In an earlier kind of low relief sometimes used by the Egyptians called *coelanaglyphic,* the surface of the stone remained as background and the figures were carved with positive projections as opposed to negative projections, as in the case of intaglio, a kind of relief in which the design is incised and sunk beneath the surface of the stone or material and molded in reverse. *Rilievo stiacciato,* or *schiacciato,* is the form of an extremely low relief practiced for the first time in the 15th century by Donato Donatello. Bas reliefs of every kind were executed during the Baroque in stone, metal, wood or just about any strong, solid material.

BATHSHEBA (*Bathsheba at Her Toilet Seen By King David* and *Bathsheba with King David's Letter*). The story of Bathsheba is found in 2 Samuel 11:2–17, 12:16–25. She was the wife of Uriah the Hittite and was also the mistress and later the wife of David, the shepherd boy who became the king of Israel. King David observed the beautiful Bathsheba in her bath one evening as he was walking on the roof of his palace. As he watched her servants bathe her, he decided he had to possess her. Upon discovering that her husband was away serving in David's own army, he had her brought to his palace and made love to her. When he discovered she was carrying his child, he sent a dispatch to her husband's army commander telling him to send Uriah to the forefront of the most dangerous battle, knowing that Uriah would not survive the front lines. Uriah was killed as a result, and David married Bathsheba. But all was not good because God punished David by causing the death of his child, which survived only a few days, even after David had repented.

Artists sometimes show a messenger arriving with a letter written by David, even though the Bible does not record this fact. Bathsheba may be shown contemplating the letter. Should she remain faithful to her husband, Uriah, or should she obey the king? The medieval church thought of David as a prefiguration of Christ and Bathsheba as the church. Bathsheba in her innocence was interpreted as an image of the church saved by baptism and saved from the Devil (David) by Christ.

Example: Rembrandt van Rijn, The Louvre, Paris. (Gerson, colorplate p. 107)

BATTLE OF GIBRALTAR, 25 APRIL 1607. Gibraltar is a town and also the name of the strait that joins the Atlantic Ocean with the Mediterranean Sea. The famous Rock of Gibraltar is one of the Pillars of Hercules, the ancient mythological name for cliffs flanking the eastern entrance to the strait, which are usually identified with Mt. Acha at Ceuta in Africa and Gibraltar in Europe. The word *Gibraltar* is from the Arabic *Jabal-al-Tarik,* which means Mount of Tarik. The name Gibraltar dates from the capture of the peninsula by Tarik, a Moorish ruler. In 1309 the Spanish captured the area and defended it until 1333, but it was not until 1462 that they recovered it from the Moors.

The artist depicts the battle showing a Dutch man-of-war ramming an exploding Spanish flagship. Their collision fills the foreground while men and gear, block and tackle fly far above the struggling ships through the air and scatter like rain pellets over the water. Sails are torn and masts are shattered. Lifeboats, one full and one empty, bob below. Men swim in the water and jump ship.

Example: Hendrick Vroom, Rijksmuseum, Amsterdam. (Rosenberg, Slive, ter Kuile, fig. 230)

BATTLE OF ISSUS (*Alexander's Defeat of Darius*). Issus is an ancient town of Southeast Asia Minor located in present-day Turkey. It is situated near the head of the modern Gulf of Iskenderun on a thin strip of land flanked by high mountains. Nearby is the pass called the Cilician Gates. Although Issus was the

scene of three historic monumental battles, the battle usually depicted by artists is that of Alexander the Great, king of Macedon and conqueror of much of Asia. At Issus in 333 B.C., Alexander overthrew the forces of the Persian king, Darius III, who fled before him. This BATTLEPIECE shows both sides of the contest on a flat plain. Alexander is shown, in a kind of Baroque violence and ordered chaos, astride his favorite horse, Bucephalus, who became as famous in legend as the man himself.

Example: Pietro da Cortona, Capitoline Gallery, Rome. (Waterhouse, fig. 43)

BATTLE OF LEPANTO. The naval battle of Lepanto, October 7, 1571, was an engagement between Turks and Christians. It was fought at the mouth of the Gulf of Patras, a large bay off Lepanto (Inebahi) on the Greek coast. John of Austria (d. 1578), the commander of the fleet of the Holy League, opposed the Turkish fleet under Uluç Ali Pasha. The allied fleet of about two hundred galleys, not counting smaller ships, was made up mainly of Venetian, Spanish and papal ships and of vessels sent by a few Italian states. The approximately thirty thousand fighting men involved in this fleet were evenly matched with the Turkish fleet. At the end of the battle, the Turkish navy had been destroyed with the exception of forty galleys, with which Uluç Ali fled. Approximately fifteen thousand Turks were killed or captured and ten thousand Christian galley slaves were given freedom. Enormous amounts of booty were involved. The Christians lost over seven thousand men. The famous Spanish writer Cervantes, a member of the allied fleet was wounded and lost the use of his left arm in this battle. With Lepanto, the first major Turkish defeat by the Christians, the myth of Turkish naval invincibility was ended. The battle was important in the sense that a Turkish victory possibly would have made the Ottoman Empire supreme in the Mediterranean.

In typically Baroque theatrics, the artists depict an almost unbelievable dramatic entanglement of men, parts of ships, masts and keels, against a swirl of tempestuous storm clouds, all shown in a vast theatrical TENEBRISM.

Example: Giovanni Coli and Filippo Gherardi, 1675–1678, Palazzo Colonna, Gallery, Rome. (Wittkower, fig. 218)

BATTLE OF SENNACHERIB. Sennacherib, or Senherib, was king of Assyria from 705 to 681 B.C., when he died. The son of Sargon, Sennacherib lived most of his twenty-four-year-long reign fighting battles to maintain the lands conquered by his father. History is not exact as to the sequence of his numerous battles and conquests, but his first campaign was probably waged against Babylon. It was after this that he marched against an uprising of Palestine, Philistia and Phoenicia, western nations supported by Egypt. In 701 B.C., he defeated the Egyptians at Eltekeh and, eager for more conquests, set his sites on Jerusalem. Sennacherib sacked Judaean cities and attacked Jerusalem, forcing the king to pay a heavy tribute. It was at this time that Hezekiah built the famous Siloam tunnel to protect the city water supply that was threatened by the Assyrian

forces. An account of Sennacherib's story tells his side of the expedition against Hezekiah. It is not clear historically whether the biblical account of the plague that swept through Sennacherib's forces occurred at this time or at a later date. Lord Byron's poem "The Destruction of Sennacherib" is based on the account in 2 Chronicles 32. Uprisings in Babylon called the king to that part of the world, and he began a naval campaign against the Chaldaeans. He destroyed Elam and finally fought both the Elamites and the Chaldaeans at the Battle of Halulina, or Khalui, c.691 B.C. The outcome of this ferocious battle is uncertain. Sennacherib's story is told in Isaiah 36 and 37 and in 2 Kings 18 and 19. "And that night the angel of the Lord went forth, and slew a hundred and eighty-five thousand in the camp of the Assyrians; and when men arose early in the morning, behold, these were all dead bodies." Sennacherib was murdered by two of his own sons.

A multitude of men and horses are shown in combat, falling, dying, struggling. The angel of the Lord, wielding a sword, swoops down from the dark of night heavens.

Example: Tanzio da Varallo, St. Gaudenzio, Novara. (Waterhouse, fig. 122)

BATTLE OF THE AMAZONS. The Amazons were a race of mythical female warriors who lived in southwest Asia Minor (after having come from the Caucasus). They were especially skilled at riding horses and experts with the bow and arrow. It is believed they were the first to use cavalry. In antiquity their name was interpreted as meaning that they amputated their right breasts (*mazos* in Greek) so as to be able to hold a bow and shoot an arrow more precisely and also to hold spears in battle. An Amazon woman had to kill a man before she could marry, and all male children were either disfigured or killed at birth. In the *Illiad* the Amazons were warred on by Bellerophon and Priam, and in post-Homeric legend they came to aid Troy after Hector was killed under Queen Penthesilea, who was killed by Achilles. Heracles also went into battle with the Amazons to capture the girdle of Hippolyte, who became the wife of Theseus. The Amazons invaded Attica and Athens, its capital, but were pushed back by Theseus.

The battleground shown by artists is a tangled confusion of horses and warriors. Amazon women draw their bows; Athenian warriors, led by Theseus, wield axes and swords. Some artists show a dramatic fight on a bridge from which conquered riders and their horses are hurled into the river.

Example: Peter Paul Rubens, Alte Pinakothek, Munich. (Bazin, fig. 47)

BATTLEPIECE. Scenes of battle painted by artists throughout the ages have changed with the styles and times. Artists have shown the reception of hostages, the parading of prisoners, the battles. The Greeks were the first to record the heroic tradition of the historical battle scene when they depicted battles of the Lapiths and Centaurs, the sack of Troy and Hercules warring with the Amazons. The long explanatory narrative shown in strips, such as one sees on Trajan's

Column, was used by the Romans, although the style sometimes referred to as the ''strip-cartoon'' technique was used by the Assyrians. The battle CARTOONS of Michelangelo and Leonardo initiated a style that developed into the Baroque. Le Brun's *Battles of Alexander,* painted in 1662, now in the Louvre, was derived from this line of work and helped form the models for the later great heroic battlepieces. An original style was begun by Titian in his *Battle of Cadore,* which was followed in the 17th century by the flamboyant, yet vigorous battle scenes of Peter Paul Rubens. Another kind of painting executed during the Baroque was referred to by the term ''battlepiece.'' This scene was a small battle illustrating no specific conflict. Often no more than a pleasant skirmish, the drama was chosen because of an opportunity to render clouds of gun smoke, billowing dust, a lot of movement and showy color and the swashbuckling drama of men killing one another. All of this was placed within a landscape.

A wide, sweeping landscape was used by Altdorfer as the background for his depiction of opposing and slanting spears in his BATTLE OF ISSUS in 1529. But in the 17th century, Jacques Callot used a similar device to construct his composition and render large numbers of fighters courageously engaged. Louis XIV used painters such as Charles Parrocel and van der Meulen to show his victories in panoramic scenes sweeping the countryside in order to show the precise directions of the armies. Callot was also noted for his GRANDES MISÈRES DE LA GUERRE, a series of etchings done in 1633, among which one finds the explicit and gruesome *The Hanging Tree.*

BEHEADING OF ST. JOHN THE BAPTIST. The story of the decollation, or the beheading, of Saint JOHN THE BAPTIST is told in the GOLDEN LEGEND. John the Baptist (Giovanni Battista) was the forerunner, or messenger, of Christ; as such, he forms a link between the Old and New Testaments. He is considered the last in the line of Old Testament prophets and the first of the saints in the New Testament, where his story is told. John was the son of Elizabeth, a kinswoman of the Virgin Mary and Zacharias, a priest of the Temple of Jerusalem. As a preacher, he lived an ascetic life in the desert and baptized all those who came to the banks of the Jordan River. When he baptized Jesus, the Holy Ghost in the form of a dove was seen by all present as it descended from heaven. John was sent to prison by Herod Antipas, the son of Herod the Great, and later was executed because of a promise made by Herod to his stepdaughter, Salome. This story is told in Mark 6:21–28: ''Herod on his birthday gave a banquet for his courtiers and officers and the leading men of Galilee. For when Herodias' daughter came in and danced, she pleased Herod and his guests; and the king said to the girl, 'Ask me for whatever you wish and I will grant it.' And he vowed to her, 'Whatever you ask me, I will give you, even half of my kingdom.' And she went out, and said to her mother, 'What shall I ask?' And she said, 'The head of John the baptizer.' And she came in immediately with haste to the king, and asked saying, 'I want you to give me at once the head of John the Baptist on a platter.' And the king was exceedingly sorry;

but because of his oaths and his guests he did not want to break his word to her. And immediately the king sent a soldier of the guard and gave orders to bring his head. He went and beheaded him in the prison, and brought his head on a platter, and gave it to the girl; and the girl gave it to her mother.'' Herod did not go unpunished for his crime, but was condemned to exile.

Artists depict John with his hands tied behind his back in a dark prison yard kneeling before an executioner with a sword. He may wear a blindfold. Herodias and Herod may be shown peering from gray shadows. Some artists show the executioner presenting the head to Salome, who holds a dish with which to receive it.

Example: Caravaggio. Cathedral of St. John, Valletta, Malta. (Bottari, pp. 62, 63, 64)

BELISARIUS. *See* BLIND BELISARIUS.

BELLORI, GIOVANNI PIETRO. An Italian biographer, collector and anti-quarian, Bellori was born in 1615 and died in 1696. He was one of a group of scholars who helped excavate and record Roman antiquities, for which he was later named ''Antiquarian of Rome'' by Clement X. Bellori was antiquarian and librarian to Christina of Sweden, who moved to Rome after her abdication. He wrote the text to some of Bartoli's illustrated works on ancient tombs and reliefs. In 1672 he wrote *Vite de' pittori, scultori et archietti moderni* and dedicated the work to Jean Baptiste Colbert (1619–1683) who had, in 1648, founded the French Academy. This work has become a basic source for the history of the Baroque period. A special characteristic of Bellori's work is that he concentrated on artists selected for their importance and gave each a comprehensive treatment. The preface to his work was given as a lecture to the Academy of Saint Luke at Rome in 1664. Here Bellori advanced the antique as the model of excellence.

BELSHAZZAR SEES THE WRITING ON THE WALL. Belshazzar, the son of Nebuchadnezzar, was king of Babylon in the 6th century B.C. The story of his magnificent banquet with his wives and concubines and all his courtiers, which has no historical basis, is told in Daniel 5: ''[T]hey brought in the golden and silver vessels which had been taken out of the temple, the house of God in Jerusalem; and the king and his lords, his wives, and his concubines drank from them. They drank wine, and praised the gods of gold and silver, bronze, iron, wood, and stone. Immediately the fingers of a man's hand appeared and wrote on the plaster of the wall of the king's palace, opposite the lampstand; and the king saw the hand as it wrote. Then the king's colour changed, and his thoughts alarmed him; his limbs gave way and his knees knocked together. . . . The king said to the wise men of Babylon, 'Whoever reads this writing, and shows me its interpretation, shall be clothed with purple, and have a chain of gold about his neck, and shall be the third ruler in the kingdom.' '' But the wise men could not read the writing and King Belshazzar was further terrified. He sent for Daniel, who said the words told of the fall of the Babylonian kingdom and the

death of the king. That night Belshazzar was killed and his kingdom was taken by Darius the Persian.

At the time Rembrandt painted Belshazzar, Manasseh ben Israel was writing a treatise on the subject (published in 1639). In it he says that Belshazzar's men were unable to read the writing on the wall because the words were written from above to below rather than from right to left. One sees this in the painting. Belshazzar is shown standing resplendent but horrified, leaning back and away from the pale mysterious hand and the ghostly white letters on the wall close by his side. His guests, terrified, spill their wine and knock over expensive gold cups. In Christian art Belshazzar stands for a type of Antichrist, the upholder of paganism.

Example: Rembrandt van Rijn, National Gallery, London. (Gerson, colorplate 77; colorplate detail p. 41)

BENEDICT BLESSING THE LOAVES. The story of Saint Benedict is told in the GOLDEN LEGEND; his life was written by Saint Gregory. Benedict was an Italian monk who lived from 480 to 547. He was the founder of the oldest western monastic order in existence, the Benedictines. Most of the facts of his life are legend. He was born in the province of Nursia (east of Spoleto), in Italy. When still a young boy, he turned his back on study and went to Rome. He then went to Subiaco to live as a hermit in the desert. His nurse, Cyrilla, followed him and, completely loyal, remained with him as his cook. However, Benedict eventually stole away from her, desiring total solitude, and went to live in a cave where he stayed for three years unknown to anyone except a monk, Romano, who gave him food. Even so, the monk had to lower the food to Benedict on a long cord to which he had attached a bell. When a neighboring religious community discovered his presence and asked him to direct them, he did. It wasn't long, however, before they found his codes of living too strict. Thus, he left them to return to his solitary life. He founded the monastery at Monte Cassino when he began the rule of his order, which in time became the chief rule in western monasticism. His code required chastity, poverty and obedience. In addition to a rigorous life, he demanded devoted manual labor and the irrevocability of monastic vows. He was remembered for acts of curing mental illness, healing and even exorcism. During the Middle Ages most individuals believed that insanity was caused by demons moving into a person's body and that the only cure was to drive them out with prayer, which is the reason artists depict demons emerging from the mouth. Benedict was buried in the oratory of Saint JOHN THE BAPTIST, which had been originally built upon the ruins of an ancient temple of Apollo.

Scenes of Benedict are common. He is shown as an extremely old man with a long white beard (only occasionally do artists show him clean-shaven). He has no identifiable dress and may wear either the black habit of the original Order of Benedictines or the white habit of the later reformed institutions. He may have a pastoral staff and a plain mitre, a rod, or aspergillum, used to

sprinkle holy water (necessary for the rite of exorcism). He may have a broken sieve or a tray. (On his trip to Rome with his nurse, she accidentally broke the sieve and Benedict mended it miraculously.) A raven with a loaf of bread in its beak refers to the envious priest who tried to poison him. (The priest was later killed when a house collapsed on him.) The bread may have a snake emerging from it as a reference to evil. A broken cup, wine glass or pitcher refers to another attempt to poison him. The cup broke and the wine spilled. A thorny bush refers to the sexual feelings Benedict overcame by throwing himself into its spikes. His sister, Scholastica, may be beside him, a nun in a black habit. Two of his pupils, Maurus and Placidus (both sons of patrician Roman families), may be in close proximity. Maurus holds a pair of scales or a pilgrim's staff. Placidus (murdered by Moorish pirates at Messina) holds the martyr's palm.

Example: Pietro Novelli, Convento, Monreale. (Waterhouse, fig. 175)

BÉRAIN, JEAN. A French Baroque designer and decorator, Bérain was among the most influential and imaginative of 17th-century designers. His designs, GROTESQUES and ARABESQUES, were imitated to the point that they moved the Baroque into the Rococo, the movement of the following century. Bérain created his earliest official work for CHARLES LE BRUN (1619–1690), the French painter and decorator responsible for the decorative schemes at Versailles. Bérain's decorations consisted of twelve plates of ornament for the Galerie d'Apollon at the Louvre, in Paris. Near the end of the 17th century he was employed as engraver by the *Bâtiments du roi*. Bérain is considered by some scholars to be the most influential artistic force in designing the costumes, displays for celebrations, stage settings, out-of-door fêtes and ballet-operas presented by LOUIS XIV at Versailles. At Menus-Plaisirs, he held the position of *Desinateur de la Chambre et du Cabinet du roi* from 1682 until his death in 1711. One of his most famous pieces is the *Bureau du roi*. His later works using oriental motifs are sometimes seen as the first phase of the Rococo and also as one of the forerunners of French 18th-century CHINOISERIE (Chinese wares). Bérain is also given credit for the 18th-century vogue for SINGERIES (figures of monkeys aping human activities).

BETRAYAL OF CHRIST (*The Kiss of Judas*). The story of the Betrayal of Christ is told in all four gospels, Matthew 26:45–56, Mark 14:43–52, Luke 22:47–53, John 18:1–12. The arrest of Jesus in the garden of Gethsemane follows sequentially the AGONY IN THE GARDEN. According to Matthew: "Behold, the hour is at hand, and the Son of man is betrayed into the hands of sinners. Rise, let us be going, see, my betrayer is at hand. While he was still speaking, Judas came, one of the twelve, and with him a great crowd with swords and clubs from the chief priests and the elders of the people. Now the betrayer had given them a sign, saying, 'The one I shall kiss is the man; seize him.' And he came up to Jesus at once and said, 'Hail, Master!' And he kissed him.'' Matthew, Mark and Luke tell how Judas approached Jesus and kissed him, to let

the Roman soldiers know who he was. John, however, does not mention the kiss. He describes how Jesus identified himself to the soldiers: "So Judas, procuring a band of soldiers and some officers from the chief priests and the Pharisees, went there with lanterns and torches and weapons. Then Jesus, knowing all that was to befall him, came forward and said to them, 'Whom do you seek?' They answered him, 'Jesus of Nazareth.' Jesus said to them, 'I am he.' Judas, who betrayed him, was standing with them. When he said to them, 'I am he,' they drew back and fell to the ground."

Most often artists depict Judas in the act of kissing Jesus. Usually the two are surrounded by soldiers and sometimes Jewish elders. The Romans are armed with spears and halberds, or halberts (combination spear and battle-ax). They hold torches and lanterns. One may throw a rope about Jesus. Judas is always shown shorter than Christ. This tradition is possibly derived from the account given by Bridget of Sweden, a 14th-century mystic, in her *Revelations.* The incident that follows, the cutting off of the slave's ear, is mentioned in all four gospels, though only John names the participants: "Simon Peter, having a sword, drew it and struck the high priest's slave and cut off his right ear. The slave's name was Malchus. Jesus said to Peter, 'Put your sword into its sheath; shall I not drink the cup which the Father has given me?' " Peter and Malchus are shown struggling on the ground while Judas kisses Jesus.

Example: Anthony Van Dyck, Minneapolis Institute of Arts. (Held and Posner, fig. 222)

BETROTHAL OF THE VIRGIN. *See* MARRIAGE OF THE VIRGIN.

BIBIANA REFUSING TO SACRIFICE TO IDOLS. Bibiana, known as Vivian, was persecuted under the Roman emperor Julian the Apostate. After her arrest for being a Christian and refusing to sacrifice to pagan idols, she was tied to a column and whipped with cords that had lead attached on the ends. After her death a church was raised on the site of her father's palace, and there she was buried with her mother and sister, who were also Christian martyrs. Bibiana is shown beside St. Rufina, her back turned to the saint, the pagan altar and a statue of the Roman god. A group of priestesses watches the drama with looks of disdain.

Example: Pietro da Cortona, Sta. Bibiana, Rome. (Wittkower, fig. 151)

BIRTH OF BACCHUS. The story of the birth of BACCHUS is told in Ovid's *Metamorphoses* 3:310–312. He was born from his father Jupiter's thigh, having been sewn into it by Mercury after his mother, Semele, had been consumed by one of Jupiter's thunderbolts during her pregnancy. On Juno's advice (prompted by jealousy upon learning that Semele was pregnant by Jupiter), Semele persuaded Jupiter to make love to her without benefit of a disguise. Unable to change her mind, he did so, reluctantly, and so awesome was his power that she caught fire and in seconds was reduced to a pitiful pile of ashes. Jupiter

saved her unborn child by taking him from her body while it was still in flames
and implanting the baby in his thigh where he remained until he was born. The
baby was taken by Mercury and handed over to nymphs who lived in a cave
on Mount Nysa.

Mercury is shown with his winged feet and helmet giving the child to the
nymph Dirce to protect him from Juno. He points to Jupiter, the source of the
miracle, who reclines, after his labor, on his bed in the sky. He is attended by
Hebe, the Greek goddess of youth. She holds a large cup of ambrosia to his
lips. Jupiter's eagle, with wings spread, hovers beside them on the left, watching.
A group of naiads (nymphs of the rivers, lakes, springs and fountains) emerges
from the water, eager to see the new child. Helios may be present, drawn in his
chariot. Pan, nearly hidden in the trees, makes music on his syrinx to welcome
the new child. Present also are NARCISSUS AND ECHO. Narcissus, pale and
ghostlike is half naked and is either dead or dying on the ground. Narcissi bloom
about his head. Echo is shown wasting away in the background.

Example: Nicolas Poussin, Fogg Art Museum, Harvard University, Cambridge, Mas-
sachusetts. (Friedlaender, colorplate 45)

BIRTH OF LOUIS XIII. Louis XIII was king of France from 1610, when he
was born, until 1643, when he died. He succeeded Henry IV, his father, under
the regency of Marie de' Medici, his mother. In 1615 he married Anne of
Austria after having been excluded from affairs of state by his mother (even
though he had been declared of age in 1614). In 1617 Louis had his mother's
minister Concino Concini assassinated with the help of his own favorite, Charles
d'Albert, duc de Luynes. After this Marie de' Medici was sent into retirement.
Reconciled to her in 1622, Louis entrusted the government to her protégé Car-
dinal Richelieu in 1624. By 1630 his mother was urging him to get rid of
Richelieu, but he reacted by sending her into exile again. After this episode,
Louis gave his full support to Richelieu and his successor, Cardinal Mazarin.
Richelieu centralized government control and strengthened royal authority.
Louis's reign was noted for the establishment of the French Academy and for
the work of St. Vincent de Paul and St. Francis of Sales in religion, Pierre
Corneille in literature and René Descartes in philosophy.

Louis is shown as a newborn baby, held by an assistant, watched by his
mother and her ladies. Apollo, barely visible, soars like lightning through the
sky in his chariot.

Example: Peter Paul Rubens, The Louvre, Paris. (Bazin, fig. 49)

BIRTH OF THE VIRGIN (*Nativity of the Virgin Mary*). The Virgin Mary
was the mother of Jesus Christ. Her mother was Anna, sometimes Anne, and
her father was Joachim. According to the GOLDEN LEGEND, the authors of
which took the story from the apocryphal New Testament literature, Saint Je-
rome (342–420) wrote in his *Prologue* that in his early youth he read the history
of the nativity of the Mother of God in a little book, then later wrote it down

as precisely as he could from memory. He tells that Joachim took a wife named Anna, who was from Bethlehem. They lived together for twenty years, and during all that time they had no children. One day Joachim was forcibly driven from the temple at Jerusalem during the Feast of the Dedication because he was a childless man. Joachim, humiliated and ashamed to return to his home, went away to live in the wilderness among his shepherds. When he was alone one day an angel appeared to him and told him that Anna would bear a daughter for him and her name would be Mary: "And as she will be born of a barren mother, so will she herself, in wondrous wise, beget the Son of the Most High whose name will be called Jesus." But at home Anna cried because she did not know where Joachim was. According to the apocryphal Protevangelium, an angel appeared to Anna while she sat in her garden under a laurel tree lamenting her barrenness. Seeing baby sparrows in a nest in the tree above her she was saddened to discover that even the birds were fruitful. Anna and Joachim were both visited by an angel who told them to meet at the Golden Gate of Jerusalem. "And Anna conceived and bore a girl child, and called her name Mary."

Anna is shown seated, holding her baby, surrounded by servants.

Example: Simon Vouet, S. Francesco a Ripa, Rome. (Blunt, fig. 198)

BISTRE. During the 17th century, bistre was often used by artists such as Rembrandt as a wash for pen-and-ink drawings. It is prepared by boiling soot. Transparent and without body, it can also be used with watercolors.

BITUMEN. Also known as asphaltum, bitumen (mineral pitch or coal tar) is a transparent brown pigment which, when first used, gives a lustrous, glowing quality but later turns nearly black and opaque. Eventually it develops a CRA-QUELURE, but it never completely hardens. The pigment was used for underpainting by several masters, and its poor drying power has caused damage to their paintings. During the 17th century Rembrandt used bitumen as a GLAZE.

BLIND BELISARIUS. A frequent theme in art and literature, blindness is sometimes a metaphor for solitary loneliness. Being blind, the individual is altogether separated from the world and is left isolated, forced to live a friendless and secluded life. Blindness can also be a symbol for the seclusion and alienation of genius. In this sense it is the greatest of all prices one must pay as the cost of possessing brilliant intellect and creativity. (For Homer though, blindness is a source of strength.) Belisarius is a blind man, who additionally is forced to endure life as a wretched outcast, unable to work for a living, existing in a never-ending state of despair and hopelessness as one who must humbly beg for food and anything else needed for survival.

Belisarius is shown slumped and seated in a doorway, his withered, quaking hands holding a basket into which alms (never enough) are being dropped by some generous person. His sightless eyes are without focus; his posture resolute,

defeated, subdued and pitiful. He is the pathetic person none of us ever wants
to be.

Example: Rembrandt van Rijn, Pen and ink, Dahlem Museum, Berlin. (Held and Posner, fig. 272)

BLINDING OF SAMSON BY THE PHILISTINES. SAMSON, an Old Testament judge, a man whose life captured the creative imaginations of a multitude
of artists and poets, was cleverly deceived by Delilah, a Philistine woman. She
had been bribed to persuade Samson to reveal the source of his prodigious power
and strength. When he finally told her his secret, after fooling her several times,
she lulled him to sleep and signaled a Philistine who lay in wait outside. The
man sneaked in and cut Samson's hair. Samson awoke to find himself a helpless
man surrounded by enemies. Delilah told him, ''The Philistines are upon you,
Samson.'' And he awoke from his sleep and said, ''I will go out as at other
times, and shake myself free.'' But he did not know that the Lord had left him.
He was captured, blinded and thrown into a prison at Gaza. The story of his
blinding and subsequent death is described in the Book of Judges 16:20–22:
''And the Philistines seized him and gouged out his eyes, and brought him down
to Gaza, and bound him with bronze fetters; and he ground at the mill in the
prison.''

Samson is shown on the ground inside a tent struggling mightily as he is held
down by Philistines while one stabs his eye with a long, sharpened spear.

Example: Rembrandt van Rijn, Städelsches Kunstinstitut, Frankfurt (Gerson, colorplate
p. 229; colorplate detail p. 49)

BLIND LEADING THE BLIND. This story is described in Matthew 15:10–
14 and Luke 6:39. According to Matthew, ''He [Jesus] called the people to him
and said to them, 'Hear and understand: not what goes into the mouth defiles a
man, but what comes out of the mouth, this defiles a man.' Then the disciples
came and said to him, 'Do you know that the Pharisees were offended when
they heard this saying?' He answered, 'Every plant which my heavenly Father
has not planted will be rooted up. Let them alone; they are blind guides. And
if a blind man leads a blind man, both will fall into a pit.' '' Jesus likened the
Pharisees to blind men.

Artists usually show a scene in the country with several shabby beggars blundering along, blind and helpless, each holding onto the shoulder of the one
before him for guidance. The first in line stumbles stupidly into a ditch, and it
is clear that the others will follow and fall into the pit also.

Example: Domenichino Fetti, Barber Institute, Birmingham University. (Waterhouse,
fig. 105)

BLIND ORION SEARCHING FOR THE RISING SUN. The story of Orion
is told in the *Bibliothēkē* by Apollodorus 1, 4:3–4. However, the story in this
painting is from an interpretation of Ovid by the 16th-century mythographer

Natales Comes. She interpreted the legends of the heroes and gods in terms of natural phenomena—sunshine, rain, storms and all that was connected with meteorology. Comes, in her *Mythologiae,* wrote the story of Orion, the helpless giant, whose blindness is his punishment for trying to rape a princess of Chios when drunk. Orion walks toward the east, carrying his bow, towering far above tiny humans, who scurry like mice about his feet and stare in awe at his size. He is led by Cedalion, one of Vulcan's apprentices, whom he had carried off while passing the forge of Vulcan. As Cedalion stands high on his shoulders searching for the sun, he leans forward and points, while Orion walks toward the east to regain his lost eyesight from the sun, because an oracle told him that if he went east to the very edge of the world, the rays of the rising sun would restore his sight. According to the legend, Orion was the son of three fathers, Jupiter, Neptune and Apollo, who, as a triad, represent a mixture of earth, water and air.

It is because of this that dark and threatening storm clouds descend upon the shoulders of the giant. Standing above Orion, upon the menacing clouds, is Diana, recognizable by her short tunic, her helmet, a crescent moon over her brow and her quiver. It was through her intercession that Orion was later placed in the sky. Therefore, under the constellation Orion one can expect storms and thunder and rain. (Actually Diana belongs to a later chapter in the Orion story and has nothing to do with his blindness, although one myth tells how Orion was killed by Diana, who later set his image among the stars.) Vulcan is depicted standing at the roadside, looking up at Orion, pointing toward the east.

Example: Nicolas Poussin, The Metropolitan Museum of Art, New York. (Friedlaender, fig. 84)

BOLE. During the 17th century, bole (bolus) was used as a material, a natural clay for the GROUND, mainly in oil painting. The most common bole is red and has been used by artists as a ground for gilding (overlaying with a thin layer of gold) since the Middle Ages. The term "bole ground" may refer to any ground in which a red earth pigment is applied. White bole is used in Chinese wall paintings. Baroque painters favored red bole grounds, especially for ALLA PRIMA paintings in which the dark shadows were thinly painted and the highlights were done in heavy IMPASTO, such as can be seen in the work of Caravaggio and his school. In many of the paintings of this school the dark ground can be seen, especially in thinly painted shadows, and the canvases have darkened over the years giving an extraordinary effect of obscurities and gloom. Technically, most masters consider a clay ground unsatisfactory because of its capacity for retaining moisture.

BOLOGNESE ACADEMY. Also called the Bolognese School and during the 17th century known as the *Accademia degli Incamminati,* this academy was the first significant school of art of its kind in the western world. Founded in Bologna by Lodovico and Agostino Carracci and other members of the family, the

school established its teachings on the premise that art could be taught to anyone who would persist and be willing to learn and that the materials of teaching must include not only the Greco-Roman and Renaissance traditions but also the study of anatomy and life drawing.

BONAVENTURA. *See* CORPSE OF ST. BONAVENTURA DISPLAYED.

BORRACHOS. *See* LOS BORRACHOS.

BORROMEO, CHARLES. *See* CHARLES BORROMEO.

BOZZETTO. A sculptor's preliminary work, usually small, made of clay or wax, which is meant to serve as a model for a larger work. Infrequently the term is used for a preliminary sketch for a larger painting.

BRUNO, ST. Bruno, a German monk, was born at Cologne about the year 1030 and died in 1101. At a young age he went to Rheims, France, to complete his education. He then returned to Cologne, where he was ordained and given a canonry in the collegiate church of St. Cunibert. In 1056, he was invited to become a professor of theology and grammar at Rheims, where he stayed for eighteen years. As his reputation as a teacher grew, he learned the truth about Manasses, a simoniacal archbishop (simony being the selling of church offices, ecclesiastical pardons and sacred things), and the man was suspended. During one period in his life, Bruno abandoned the active ecclesiastical life, resigned his benefice and renounced whatever he had in the world. In 1084 he persuaded some of his friends to accompany him into solitude in search for true peace and perfection. They traveled to the Grande Chartreuse, a desolate region in the Alps near Grenoble, and built a church on the summit with several cells near by. Some time later Bruno's little monastery became the mother house of the great Carthusian Order, which took its name from the desert of Chartreuse. Laws there were so strict that women could not go into the surrounding lands, nor could any person fish, drive cattle through the pastures or hunt any of the animals. Unlike in other religious orders, the monks had no gold or silver in their church, except for a silver chalice, and it was said that only the library was rich in manuscripts. In 1090, Pope Urban II, a former student, called Bruno to Rome as a counselor. Here he occupied a hermitage among the ruins of the baths of Diocletian. No one knows what part he played in the papal activities of the period; however, some time after this, Bruno went into Calabria and began establishing new monasteries. In his two Calabrian hermitages, St. Stephen's and St. Mary's, Bruno fostered that same strict spirit that guided the monks of the Grande Chartreuse. Some sources say Bruno was canonized in 1623; others say he has never been formally canonized, the Carthusians being against all kinds of publicity. In 1514, however, they ordained leave from Pope Leo X to keep his feast, and in 1674 Clement X extended it to the whole Western Church.

Bruno died in Italy in retirement at a monastery he had founded. *See also* AP-
PEARANCE OF THE VIRGIN TO ST. BRUNO.

Bruno is usually shown wearing the habit of the Carthusian Order, distin-
guished by a white scapular (a long front-and-back apron) tied at both sides.
His head is bent as a sign of humility and his hands are usually crossed over
his breast.

Example: Eustache Le Sueur, Kaiser-Friedrich Museum, Berlin. (Blunt, fig. 259)

**BURIAL OF PHOCION (*Landscape with the Woman of Megara Gathering
the Ashes of Megaron*).** Phocion was a 4th-century B.C. Athenian statesman and
general well known for his prudent, patriotic character. Although a man quick
to be contemptuous of the public's fickleness, Phocion demanded and received
respect. He was a man who controlled Athens by the force of his character; and,
as a result, he was elected general forty-five times. He made his military repu-
tation in Persia from 350 to 344 B.C. He fought bravely in campaigns in Euboea
where he served successfully against the forces of Philip of Macedon by de-
fending Megara and Byzantium. Here he forced Philip to abandon his siege of
the city. A brilliant strategist, Phocion was able to ward off a Macedonian attack
on Attica in the Lamina War. As a leader of the party that wanted peace with
the Macedonians, he was opposed by Demosthenes. When the Athenians did
not act on Alexander's demand for the surrender of Demosthenes, Phocion led
a successful embassy of conciliation to Alexander. Later, when Athenian de-
mocracy was restored, the democrats executed Phocion by forcing him to drink
a cup of hemlock.

Phocion's body is shown covered, on a stretcher, being carried to his place
of burial. *See also* FUNERAL OF PHOCION.

Example: Nicolas Poussin, The Louvre, Paris. (Blunt, fig. 241)

BURIAL OF SAINT LUCY. The story of Lucia, or Lucy, is told in the
GOLDEN LEGEND. Lucy, whose name means light, was a Christian virgin
martyr, the daughter of a noble family of Syracuse in Italy. She died during the
Roman Emperor Diocletian's persecution of Christians in the year 310. Although
Lucy is a historical figure, legend forms the basis of her depictions in art. The
miraculous healing of her mother, Euthicia, at the shrine of Saint Agatha, after
four years of suffering from an incurable issue of blood, caused Lucy and her
mother to give their riches, little by little, to the poor. Lucy's betrothed, being
a greedy person and furious over her almsgiving, denounced her to the magis-
trate Paschasius saying she was a Christian and did not obey the laws of the
empire. Paschasius summoned her immediately and commanded her to offer
sacrifice to the idols. But Lucy told him that the best sacrifice, the best way to
please God, was to help the poor. Further, she had nothing to offer God but
herself. Paschasius threatened to send her to a house of sin where, he promised
her, she would lose the Holy Ghost. When Lucy refused to move, she was tied
to a team of oxen to be dragged to a brothel, but her belief in God and her

desire to remain a virgin were so strong that she could not be moved. As described in the *Golden Legend*, ''Then Paschasius summoned panders, and said to them: 'Invite the crowd to have pleasure with this woman and let them abuse her body until she dies. But when the panders tried to carry her off, the Holy Ghost made her so heavy that they were unable to move her. Paschasius called for a thousand men, and had her hands and feet bound; but they did not succeed in lifting her. . . . The friends of Paschasius, seeing him grow more and more furious, plunged a sword into the saint's throat.'' Lucy remained alive until the priests came to bring her Holy Communion. She was buried on the spot of her death and a church was raised in her honor.

Lucy is shown lying on the ground dead, surrounded by a crowd of weeping mourners. Two men dig her grave while a priest gives her Holy Communion.

Example: Caravaggio, Santa Lucia, Syracuse. (Bottari, colorplate 68)

BURIAL OF ST. PETRONILLA. The story of Saint Petronilla is told in Voragine's GOLDEN LEGEND. A legendary martyr of the first century, she was, according to early Christian writers, the daughter of the apostle Peter. When judged to be too alluring and beautiful and fearing for her virtue because of her beauty, Peter arranged that she would be taken by a fever. But Titus said to him one day when he was with his apostles, that he who could heal the sick did not even make his own daughter, Petronilla, arise from her bed. Peter said it was better if she stayed in her bed sick. Yet, when he was visited by the other apostles and they asked him questions about her, he told her to get up and wait on them. She was cured instantly and made preparations to serve them. When she finished her work, Peter told her to get back in bed. And again the fever seized her. Later, when she turned to God, her father restored her health completely. When a noble man by the name of Flaccus fell in love with Petronilla and asked her to marry him, she wondered why he came with knights in armor to a defenseless woman? She told him that if he wanted her as a wife he should send maidens to take her to his house after three days had passed. At this time, deciding to choose death over marriage to a pagan, Petronilla began to fast and pray and she received the Holy Communion. After this she lay down on her bed, and within three days she died.

She is shown, young and beautiful, being carefully lowered into her grave. Above, God in heaven receives her as she kneels before him.

Example: Guercino, Capitoline Gallery, Rome. (Held and Posner, fig. 105)

BURIN. The burin, or graver, a short steel rod, is the engraver's primary tool for wood or metal. It is usually lozenge-shaped in section and cut obliquely at the end to provide a point. It has a short, rounded handle that is pushed by the palm of the hand while the fingers guide the point. Burin and graver are also the names used when referring to chipped flints used by Paleolithic man for marking cave walls, bones, wood, antlers and other materials on which they carved.

BURR. A term used in metal engraving to refer to the ridge of rough metal left on either side of the furrow made when the artist's BURIN is drawn across the surface. It is removed in line engraving, but in drypoint the artist keeps it intact so as to give the lines of the print a softer, more muted quality and a richer appearance.

C

CALLING OF ST. MATTHEW. Matthew, also known as Levi, is traditionally the author of the first gospel of the New Testament. By trade he was the tax collector of Capernaum, and one of his jobs was to collect the taxes due on ships and their goods. After a time he came to be known as a money-seeker, who had committed the sin of avarice many times by his "panting greed for filthy lucre [money]." The story of his calling by Christ is told in Matthew 9: 9: "As Jesus passed on from there, he saw a man called Matthew sitting at the tax office; and he said to him, 'Follow me.' And he rose and followed him." According to the GOLDEN LEGEND, "As soon as Christ called him, he quit his custom-house [or *teloneum*], leaving his tax accounts incomplete without fear of his masters, and devoted himself completely to Christ."

Matthew is shown seated at his desk in the customhouse. Money is spread before him and one of his helpers counts it. Tax payers may be shown with him. Christ enters the room and points to him. Perhaps Andrew and Peter are with him. Matthew usually looks up in astonishment and may be in the act of rising from his chair. *See also* MARTYRDOM OF ST. MATTHEW.

Example: Caravaggio, Contarelli Chapel, S. Luigi dei Francesi, Rome. (Bottari, figs. 31–34)

CAMERA OBSCURA. The camera obscura was used extensively by artists during the 17th century, the Latin words meaning "dark chamber." The camera itself was an apparatus that projected the image of a scene or an object on to a section of ground glass or a sheet of paper so that the outlines could be seen and then traced by an artist. It was made up of a room or a shuttered box with a tiny hole in one side through which light entered and formed an inverted image on the surface placed opposite the opening. The 4th-century B.C. Greek philosopher Aristotle noted the principle on which the camera obscura worked, having observed how the round shadow of the sun passed without deformity

through the angular pinhole spaces of wickerwork. The earliest astronomers were able to observe a solar eclipse with the aid of a camera obscura. During the Renaissance, Leonardo da Vinci was the first to see that the camera obscura functioned in a way similar to the human eye. But it was in the 17th century that Johannes Kepler gave the camera obscura its name and used it to record astronomical phenomena. (Kepler had a portable tent apparatus constructed for sketching landscapes.) The Dutch painter Johannes Torentius (1589–1644) used a dark chamber for still life painting and was tried and tortured after being suspected of witchcraft. Jan Vermeer used the camera obscura extensively. Also during the 17th century, Robert Hooke built a transportable camera obscura for landscape painters, so that by the following century the apparatus had become a virtual craze for both amateurs and professionals.

CARAVAGGISTI. Artists who painted in the manner of Caravaggio's dramatic contrasts of light and dark; painters who used a "dark manner," and painted "night pictures" during the 17th century. *See also* TENEBRISM and TENE-BRISMO.

CARD SHARPERS (*Card-Players*). According to moralists, card games were the distinct mark of a lazy, lethargic, useless nature. For this reason, card playing became an attribute of vice personified and was sometimes used in illustrations to teach a moral lesson. (The seven vices are sloth, envy, gluttony, anger, lust, covetousness and pride, with lust and covetousness being particularly chosen for the Church's censure.) In depicting the classical pantheon and the anonymous females that represented the virtues and vices, Baroque artists could refer to several dictionaries of mythography that were published towards the end of the Middle Ages and later. Authors of these dictionaries drew on antique and medieval sources, adding their own, sometimes exaggerated explanations of the emblems they presented. Cesare Ripa's *Iconologia,* written in Italian and published in 1593, was one of the most scholarly and influential. Ripa's work established the portrayal of many religious and secular allegories in the 17th and 18th centuries. During the 17th century paintings of card playing or gambling sometimes involved a young man, who, completely unsuspecting and innocently holding his cards, is, in fact, in the process of being cheated or robbed. The one who is cheating may have one hand on the table and the other behind his back (a symbol of deceit), or he may slip a card from under his belt. A third man, an accomplice, may lean over the table next to the innocent youth and hold up two or three fingers to indicate the number on the cards.

Example: Caravaggio, Private collection, New York. (Bottari, page 16)

CARICATURE. A term loosely used to denote different forms of pictorial grotesque, burlesque or ludicrous representation with a distortion or exaggeration of certain parts. Caricature is sometimes used when indicating any debased likeness whether intentionally or unintentionally comical. The word stems from the

Italian *caricare,* to load. According to BALDINUCCI, a 17th-century art historian, "the word signifies a method of making portraits aiming at the greatest possible resemblance of the whole of the person portrayed while yet, for the purpose of fun, and sometimes of mockery, disproportionately increasing and emphasizing the defects of the features, so that the portrait as a whole appears to be the sitter himself while its elements are all transformed." The genre and word concerning the genuine portrait caricature made their first appearance in the late 16th century in the artistic circle of the Carracci. Several Baroque painters of the BOLOGNESE ACADEMY, such as Domenichino and Guercino were meritorious caricaturists, but the greatest master of expression was Gian Lorenzo Bernini.

CARRYING OF THE CROSS (*Bearing of the Cross*). The story of Jesus carrying his cross from the house of Pilate and then on the road to Calvary is found in John 19:17: "So they took Jesus, and he went out bearing his own cross, to the place called the place of a skull, which is called in Hebrew Golgotha." It is only the gospel of John that says Christ was made to carry his own cross. The Procession or Ascent to Calvary, is also known as the Road to Calvary.

Artists follow the gospel of John the Evangelist and show Jesus bearing a cumbersome cross on his shoulders. He is usually depicted on his knees, struggling to regain his footing after having collapsed under the enormous weight. Sometimes Veronica is nearby holding the veil with which she wiped his face, the imprint of it preserved forever. The two thieves crucified with Jesus are never included, but a crowd of followers and hecklers and Roman soldiers on horseback may be shown.

Example: Nicolas Poussin, Drawing, Museum, Dijon. (Friedlaender, fig. 55)

CARTONCINI. *See* CARTOON.

CARTOON. A term in art history to indicate a full-size drawing made for the purpose of transferring a design to a tapestry or a fresco, or any kind of painting, or some other work. Although the earliest fresco painters drew freehand on the plastered wall or copied from a sketch done beforehand, the cartoon was indispensable in the drawings on such material as stained glass. It was possibly from this art that the painters found their inspiration. Giorgio Vasari (1511–1574), Italian painter, architect and biographer, describes the methods used by the early 15th-century artists on their frescoes in his *Lives of the Artists.* Their outlines, traced from cartoons, were either punctuated with pin pricks or indented. The cartoon was done on heavy paper with chalk or charcoal and sometimes highlighted with white or colored watercolors. Besides the ordinary cartoon, small oil paintings known as *cartoncini,* were made by painters during the Baroque. Peter Paul Rubens made great numbers of them.

CATHERINE, ST. The story of Catherine of Alexandria is told in Voragine's GOLDEN LEGEND. The earliest surviving history of her life dates from the 9th century. Most scholars believe her story has its roots in the history of Hypatia, a pagan philosopher of Alexandria, famous for her wisdom and learning. Hypatia died in 415 at the hands of a group of fanatical monks. The name Catherine comes from *catha,* meaning total, and *ruina,* meaning ruin; for, according to legend, the edifice of the Devil was destroyed by her; pride destroyed by her humility; carnal lust by her virginity; and worldly greed by her contempt of worldly possessions. Catherine was of royal birth, the daughter of King Costus, and, being extremely intelligent as a child, she was well educated. She converted to Christianity after becoming queen and was baptized by a wandering desert hermit who had become her mentor. One legend tells that the hermit gave Catherine the image of the Virgin and her Child. After this Catherine's prayers were so strong that the baby Jesus turned his face towards her and later, when her faith had become even stronger, placed a ring on her finger. In the desert Catherine had a vision of having a mystic marriage with Christ.

At this same time she was being watched by the emperor Maxentius in Alexandria for he found her provocative and more beautiful than any woman he had ever seen. He asked her to be his wife and not as a servant, but as his queen. When she refused, he commanded her to sacrifice to his idols or she would undergo the worst tortures and die. And Catherine answered, ''Whatever torments thou canst devise . . . delay them not, for I desire to offer my flesh and blood to Christ, as He also offered Himself for me. He in sooth is my God, my Lover, my Shepherd, and my only Spouse.'' Maxentius, furious, ordered that four wheels, studded with iron saws and sharp nails, be brought before him, and with this device he would have the virgin cut to pieces. Everyone agreed that the sight was so dreadful that other Christians would have given in to the emperor's wishes. Maxentius had ordered that two of the wheels should turn in one direction and the other two should turn in the opposite direction. In this way the wheels would crush and tear Catherine to pieces. But once the wheels began their grisly work, an angel of the Lord struck the monstrous machine and broke it apart ''with such violence that four thousand pagans were killed by its collapse.'' (Some accounts say a storm ensued and lightning destroyed the wheels and the pagans.) Maxentius then ordered that Catherine's breasts be torn off and that she be beheaded. Catherine exhorted the torturers not to delay. And they didn't. They led her from the city, cut off her breasts with sharp knives and beheaded her. Polyphyrius took her body to a monastery on Mt. Sinai, which still claims to possess it.

Catherine is always shown with a spoked wheel, either whole or broken. It is studded with spikes and may be held beside her, at her feet, partially hidden in her dress, or she may lean on it. She may hold the sword used at her execution and the martyr's palm. She may also hold the ring given her by the Infant Jesus, indicating her marriage with Christ. She may have her foot on a book representing Maxentius, or she may hold a book with the inscription ''*Ego me Christo*

sponsam tradidi,'' ''I have offered myself as a bride to Christ.'' Some artists depict her with a crown, and she may be richly dressed as an allusion to her royal birth. Being the patron of education, she may be surrounded with the symbols of learning—open books, a globe and mathematical instruments. She may accompany Catherine of Siena, Ursula, MARY MAGDALENE or Barbara. The most frequent subject is her mystic marriage to Christ. Because of Catherine's uncertain historicity, in 1969 she was removed from the Catholic Church Calendar. Still, among female saints, Catherine was second only to Mary Magdalene in popularity. She is not to be confused with Catherine of Siena (Catherine Benincasa, a Christian mystic and member of the Dominican Order), who lived during the 14th century.

Example: Caravaggio, Schloss Rohoncz Foundation Lugano. (Bottari, colorplate 24)

CECILIA, ST. Cecilia, also Cecily, was a Christian saint and virgin martyr who was put to death in 223 during the time of the Emperor Alexander, although some records indicate that she was killed in the time of Marcus Aurelius, who ruled about the year 220. According to Voragine's GOLDEN LEGEND, the name Cecilia comes from *coeli lilia,* which means lily of heaven, or *coecis via,* a way unto the blind. Cecilia was born into a noble Roman family, and from the earliest day of her youth, she was taught to be an exemplary Christian. She carried her Bible wherever she went, prayed most of every day and night and took a vow of chastity.

Nevertheless, her father decided she would marry a young Roman named Valerian. Having no control over this parental order, Cecilia fasted three days before her nuptial day and during the ceremony wore a hair shirt to mortify her flesh concealed under her gown of gold cloth. She told her new husband that night in the bridal chamber that she had an angel of God as her lover, that he guarded her body and that if he saw Valerian touch her in any way for profane love, he would strike him down. Valerian wanted to see the angel that watched over her, and Cecilia told him that for this he had to be baptized. After he agreed the angel appeared to both of them and crowned them with lilies and roses (symbols of purity). (Cecilia sometimes holds these flowers.) Tiburetius, Valerian's brother, who came into the room and smelled the scents of roses and lilies, also became a Christian after Cecilia persuaded him that worshipping the Roman idols was pointless. Later Valerian and Tiburtius were both executed by the Prefect Maximus, who, after seeing angels standing by them at the hour of their death, also became a Christian. He said he watched angels carry their souls to heaven. For this he was beaten to death with a leaded whip.

Cecilia buried Maximus with Valerian and Tiburtius. As Valerian's wife, she was ordered to sacrifice to idols or be put to death. She told the Prefect Almachius that it was better to die a happy death than to live an unhappy life. Some accounts say she was sentenced to be suffocated to death by steam in the bathroom of her own house. She was put in a boiling bath for a day and a night but she remained alive. Almachius commanded that she be beheaded in the bath,

and the swordsman struck her three times and left her there half dead because the law decreed that a fourth blow could not be given. She suffered for three days before dying, during which time Christians flocked to her side. She was buried next to the papal crypt in the catacomb of St. Callistus.

The story of Cecilia dates back to the end of the 5th century but has no basis in history. Cecilia is not mentioned in the period immediately following the persecutions. Her name does not appear in the poems of Damasus or Prudentius, in the writings of Ambrose or Jerome, nor in the *Depositio martyrum* of the 4th century. Also, what was later called the *titulus Sanctae Caeciliae* was originally known as the *titulus Caeciliae,* that is, the church founded by a woman named Cecilia. St. Cecilia is known today as the patron saint of music. At her wedding, while the musicians played, Cecilia sang to the Lord in her heart. According to an account of her life, on the day of her wedding Cecilia was led into the house of her betrothed to the sound of musical instruments, *cantantibus organis,* and she asked God to keep her soul and body pure. In Latin *organum* means any instrument, musical or otherwise.

Artists later identified the instrument with the organ, then often a portable type. The organ thus became her main attribute. During the 16th century the portable organ disappeared, and later artists depict her with a lute, harp, clavichord or some bowed instrument. These instruments may be played by angels who accompany her. She may look from her keyboard to a music book held by *putti* (*see* PUTTO). Some artists show Cecilia rejecting earthly instruments, and she may hold the organ away from her upside down, and other instruments, mainly those associated with BACCHUS—cymbals, tambourines, pipes—may be broken and strewn about her as she listens to angels singing overhead. Because musical instruments were in many cases associated with erotic symbols, their association with a virgin bride of Christ would be inappropriate.

Example: Nicolas Poussin, The Prado, Madrid. (Friedlaender, page 43)

CECILIA BEFORE THE JUDGE. CECILIA or Cecily, was a patrician girl of Rome who was raised as a Christian. When she was called upon to repudiate her faith, she converted those who came to induce her to sacrifice. But she was eventually brought before the judge in court and sentenced to be suffocated to death in the bathroom of her own house. Even though the furnace was given seven times the normal amount of fuel Cecilia remained there without harm. (Some accounts say she was immersed in a cauldron of boiling oil. Others say she was burned in a boiling bath for a day and a night.) She remained alive after a soldier struck her neck three times with his sword. Cecilia is shown arguing with the judge who points a condemning finger in her direction. Her hand is raised to indicate she will never sacrifice to Roman gods. A statue of the God she is to worship sits on a high plinth behind her. Incense burns before the idol. Behind Cecilia, men drag sacrificial beasts to the idol—one a ram and one a fattened calf. *See* CECILIA, ST.

Example: Domenico Zampieri Domenichino, S. Luigi de' Francesci, Rome. (Wittkower, fig. 29)

CECILIA DISTRIBUTING CLOTHES TO THE POOR. According to Voragine's GOLDEN LEGEND, CECILIA, after being struck down by an executioner and left for dead, lived for three days and gave everything she owned to the poor. She commended all those she had converted to Bishop Urban and told them she had obtained three days' delay so that she could commend herself and all others to God's beatitude, and that her house be consecrated as a church. Saint Urban laid her body to rest among the bishops, and, following her petition, consecrated her house as a church. Different sources date her martyrdom as occurring in 220 or 223. *See also* MARTYRS ST. CECILIA, ST. VALERIAN AND ST. TIBURTIO WITH AN ANGEL. Cecilia is shown as a young girl giving her possessions to a crowd of people.
Example: Domenico Zampieri Domenichino, S. Luigi dei Francesi, Rome. (Waterhouse, fig. 13)

CEPHALUS AND AURORA. *See* AURORA AND CEPHALUS.

CHALKS AND CRAYONS. Chalks are natural soft earth or stones, and crayons are sticks made from these, although often oil or wax is added. Ascanio Condivi, who wrote the *Life of Michelangelo* in 1553 (almost at dictation from the master), says that Michelangelo, when he was in Florence near the end of the 15th century, was asked to execute a drawing and used a pen; chalk was not then in general use. Red chalk first appears in Leonardo da Vinci's CARTOONS, or studies, for his "Horse" monument and his *Last Supper* (1500). Seeing the result and being impressed, Raphael and Michelangelo both began using chalks and crayons. Peter Paul Rubens, during the 17th century, also made effective use of the media.

CHANCELLOR SÉGUIER. Pierre Séguier, duc de Villemor, chancellor of France, lived from 1588 until 1672. He began as a counselor to the parliament of Paris and become chancellor in 1635. In 1639 he suppressed a revolt in Normandy and by 1642 presided over the trial of the French conspirator Marquis de Cinq Mars, who was later executed. In 1661 he arraigned Nicholas Fouquet, superintendent of finance under King Louis XIV, on charges of embezzlement. The trial lasted three years and ended in Fouquet's being condemned in 1664 to banishment. The king, however, resentful of Fouquet's Château Vaux-le-Vicomte after being made jealous by a magnificent party he attended there, changed the sentence to life imprisonment. A friend of Cardinal Mazarin, Séguier was instrumental in having the parliament accept Anne of Austria as regent for her infant son, Louis XIV. The chancellor is shown on a white horse as he appeared at the entry of Louis XIV and Marie-Thérèse into Paris in 1661. Two

umbrellas, one on each side of the horse supported by pages, are held over his head.

Example: Charles Le Brun, The Louvre, Paris. (Blunt, fig. 289)

CHARITY. From the Latin *Caritas,* Charity, one of the three "theological virtues," is mentioned in 1 Corinthians 13:13: "So now abide faith, hope, charity, these three: but the greatest of these is charity [love]." The early Church taught that charity was both the love of one's neighbor, *amor proximi,* and at the same time the love of God, *amor dei.* One, of course, has no worth without the other. The love of one's neighbor is found in Matthew 25:35–37, "for I was hungry and you gave me food, I was thirsty and you gave me drink, I was a stranger and you welcomed me, I was naked and you clothed me, I was sick and you visited me, I was in prison and you came to me."

Artists usually depict one act: for example, "I was naked and you clothed me" is illustrated with a beggar putting a shirt over his head while Charity stands or sits beside him with a bundle of clothes. Charity later came to be shown with a flame, usually coming from a vase held in her hand. Sometimes she holds a candle. She may also hold a flaming heart—an offering to God. During the 17th century, Charity is shown as a woman, and she may suckle a baby while others play about her. Her attribute at this time may be a pelican opening its own breast to feed its young.

Example: Jacques Blanchard. The Duke of Richmond and Gordon, Goodwood, Sussex. (Blunt, fig. 204)

CHARLES BORROMEO. Saint Charles Borromeo was born near Lago Maggiore, Italy, in 1538, the son of an aristocratic family of Lombardy. He died in 1584. At the age of twenty-two, in 1560, he was called to Rome by his uncle, Pius IV. Charles was at that time a student at Pavi. Within a short period, he was made cardinal-deacon, administrator of the Papal States and of the archdiocese of Milan and papal secretary of state. Charles lived a plain, ascetic life even though he was a wealthy man. He gave his money to the poor and cared for the sick. He fought for reform in the Church and reopened and became the guiding spirit for the Council of Trent in 1560. In 1563 he was ordained priest, received the pallium (a circular white wool band worn over the shoulders by archbishops) and was consecrated bishop for the See of Milan. By the time he was twenty-eight, he began reforms in the Church, his primary target being education of the clergy; yet so powerful were his enemies that he received opposition to the point of an attempted assassination. In 1576 he worked to relieve suffering during the black plague in Milan.

St. Charles is shown with dark skin, a high forehead and a prominently curved nose. His robes are those of a cardinal or bishop, or simply a cassock and a biretta (a square cap with three projections worn by Roman Catholic clergy). He may hold a crucifix or a skull, or they may be close by, and he may have a coarse rope of penance around his neck. He is usually depicted kneeling at

prayer, being presented to the Virgin Mary or envisioning God the Father and his dead Son held aloft by angels. He may hold a child in his arms, or he may be distributing clothes to the poor or administering the sacrament. Some artists show him at his desk in his study while fasting, yet contemplating the bread and wine—the body and blood of Christ—before him.

Example: Orazio Borgianni, S. Carlo alle Quattro Fontane, Rome. (Waterhouse, fig. 30)

CHARLES I AT THE HUNT (*Le Roi à la Chasse, Portrait of Charles I in Hunting Dress, Charles I Dismounted* **and, according to a bill drawn up by the artist, Anthony van Dyck,** *The King Hunting***).** Charles I was king of England, Scotland and Ireland from 1625 until 1649. Born in 1600, The ill-fated Stuart king was the second son of James I and Anne of Denmark. When his older brother, Henry, died in 1612, Charles became heir to the throne and in 1616 he was made prince of Wales. A dignified man, he was shy and popular until he married Henrietta Maria, sister of Louis XIII of France, a Catholic. As the years went by, Charles's reign gradually became a bitter struggle for supremacy between the king and Parliament. Their differences were so serious that the English Civil War resulted. Parliament controlled the money grants to the king and adopted the tactic of withholding grants until its grievances were corrected. In 1625, Parliament demanded ministers it could trust, refused money and was eventually dissolved by Charles. The Parliament of 1626 was dissolved when it began impeachment proceedings against Buckingham. Although Buckingham was assassinated in 1628, the parliamentary session of 1629 was bitter. After it closed, Charles governed without Parliament for eleven years. In 1637 the king tried to force episcopacy upon the Scots. His move was opposed by the Scottish Covenaters and this resulted in the Bishop's Wars. The war saw no decisive victories until Charles was defeated at Marston Moor in 1644 and Naseby in 1645. He gave himself up to the Scottish army in 1646 and was taken over by the English army leaders. In November of 1647 he escaped. But Parliament was now controlled by Charles's most powerful enemies, who put him on trial and convicted him of treason for levying war against Parliament. On January 30, 1649, the king was beheaded.

Charles's official state portrait, painted in 1635, depicts the king standing on a knoll with his horse, equerry and page. He exudes an air of extraordinary dignity and confidence as he seemingly overlooks a battlefield while being shaded by a tree extending over him like a royal umbrella. The river Thames forms part of the landscape behind him. Although the king pretends to be a nobleman out for an informal ride in his park, no one can mistake the princely poise and that air of absolute authority, that overbearing decisiveness his Parliament resented and eventually rose against. His person is imbedded in compositional devices, such as his arrogant, self-assertive stance, which is posed purposely to proclaim his royal eminence; yet upon closer observation, one notes that the trappings of rule are omitted. At the same time the portrait has the faint

air of romantic melancholy. The king wears informal riding clothes and seems ready to mount his horse and ride off to the chase; yet his hat is set at an imperious, even a rakish angle. Charles, the monarch, represents the correct model of an English gentleman. He is the epitome of the ''social ideal'' first put forth by Baldassare Castiglione in his slim volume *The Courtier.* He is shown as the ''Cavalier King'' at ease with himself and his surroundings.

Example: Anthony Van Dyck, The Louvre, Paris. (Held and Posner, fig. 221)

CHARLES LE BRUN. *See* LE BRUN, CHARLES.

CHIAROSCURIST. A term applied to those painters or followers of Caravaggio who painted in extreme shades of light and dark, that tenebristic manner for which the Italian artist was famous. *See* CHIAROSCURO and TENEBRISM.

CHIAROSCURO. In painting or drawing, the use of dark and light and especially the subtle nuances of light that produce an effect of volume. The term was first used by BALDINNUCI in 1681 to describe paintings, such as GRISAILLES, which are purely tonal monochrome and rely for their effect only on slight gradations between light and dark. *Claro* is used in reference to anything exposed to a direct light and also those colors that are luminous or sparkling in their natures. *Obscuro* refers to those colors that preserve their natural obscurity in even the dimmest light—armor gleaming from shadowed corners, muted scarlet velvets, deeply dark horses and translucent shades of brown. The grand master of chiaroscuro, not only during the Baroque but the acknowledged master for all periods, was Rembrandt.

CHILDREN OF BETHEL MOURNED BY THEIR MOTHERS. Bethel was an ancient city in central Palestine, today Baytin (Jordan), north of Palestine. Frequently mentioned in the Bible, Bethel was originally called Luz. According to Genesis 12:8, the first Palestinian altar was built there by Abraham: ''Thence he removed to the mountain on the east of Bethel, and pitched his tent, with Bethel on the west and Ai on the east; and there he built an altar to the Lord and called on the name of the Lord.'' The name Bethel was given first to Jacob's sacred stone as written in Genesis 35:14–15: ''And Jacob set up a pillar in the place where he [God] had spoken with him, a pillar of stone; and he poured out a drink offering on it, and poured oil on it. So Jacob called the name of the place where God had spoken with him, Bethel.'' It was a national shrine at the time of the Judges and temporarily harbored the Ark of the Covenant. But Bethel lost its importance as a Jewish shrine to Jerusalem: Jeroboam's attempt to establish Bethel as a rival religious capital failed. Later Bethel became increasingly associated with heathen worship, which explains its denunciation by Hosea and by Amos, who called it Beth-haven by way of mockery. According to Judges 20:24–26, ''So the people of Israel came near against the Benjaminites. . . . And Benjamin went against them out of Gibeah the second day, and felled to the

ground eighteen thousand men of the people of Israel; all these were men who drew the sword. Then all the people of Israel, the whole army, went up and came to Bethel and wept.'' In this scene women and children are shown dead, strewn about the ground. Those few still alive mourn the dead. Mothers cry for their dead children. Others are hurried away for burial.

Example: Laurent de la Hyre, Museum, Arras, France. (Held and Posner, fig. 162)

CHILDREN'S BACCHANAL. This is one of a number of erotic subjects from the Bacchic domain. Chubby children in an idyllic setting, push and shove a goat, the pagan symbol of lust. The goat was associated with the worship of BACCHUS, and, as is typical, the reluctant animal draws a chariot in which merrymaking, ecstatic children ride. A child also rides a goat. One child stands on a large urn and decorates a two-sided HERM, while another, lounging inside the urn, watches.

Example: Nicolas Poussin, Collection Marchese Incisa della Rocchetta, Rome. (Friedlaender, fig. 36)

CHINOISERIE. A term used to indicate Chinese wares, especially porcelain, lacquer and silk. Attempts to copy or reproduce these luxury articles goes back to the early centuries of Christian art. Motifs such as peacocks, phoenixes and dragons seen in Byzantine art were of Chinese origin. Chinoiserie, however, is properly a European style in arts and crafts that reflects poetic and fanciful notions of China, which from the time of Marco Polo have enchanted artists. During the 17th century, Louis XIV's *Trianon de Porcelaine,* built in a park at Versailles by Louis le Vau, became the prototype of later Chinese pagodas and kiosks throughout Europe. During the 17th century, JEAN BÉRAIN used the Chinese motif in his ARABESQUES and created the SINGERIE.

CHIONE SLAIN BY DIANA. The Greek equivalent of Diana is Artemis, one of the twelve gods and goddesses of Olympus, a ''lion unto women,'' a ''lady of wild things,'' who was universally worshipped in historical Greece. She is known as the virgin huntress who personifies chastity and is considered a friend and helper of women in childbirth. In her earlier, pre-Greek origins, her proper sphere was the earth, specifically those uncultivated parts, the wilderness, the hills and forests. Her functions were to guard wild beasts. Later she became the moon goddess, Luna, and was then not known for her chastity and goodness. The Romans worshipped her as Diana, the earth, Luna, the sky. (She is often confused with Selene and Hecate.) She was, according to myth, the daughter of Latona (Leto) and Jupiter (Zeus), the twin sister of Apollo. The story of Diana and Chione, from Ovid's *Metamorphoses* 11:321–28 is one of an act of vengeance. This scene dramatizes the climax wherein promiscuous Chione, a young girl of fourteen, endowed with extraordinary beauty, had one thousand suitors. She had been so foolish as to belittle and insult the beauty of the lovely and chaste Diana and also imply that she was sterile. As a result, Chione lies

dying, shot through the tongue by the angry goddess: "She had the boldness to prefer herself to Diana, and criticized the goddess's looks, whereupon Diana, roused to fierce wrath, took her revenge. 'You will find no fault with my actions!' she cried; and without delay bent her bow, shot an arrow from the string, and pierced with her shaft the tongue which had so well deserved it. That tongue fell silent—no sound, none of the words she attempted to form, issued from the girl's lips. As she was trying to speak, life and blood drained from her altogether."

Diana is shown carrying a bow, although she holds no arrow, having just shot it. She wears a short dress and on her back she carries her quiver filled with arrows. Her hunting dogs follow close to her heels. Chione has fallen to the ground, an arrow sticking out of her mouth. Putti (*see* PUTTO) perched beside her, cry and mourn her death. Her father, Daedalion, may be present, lamenting the daughter he has lost.

Example: Nicolas Poussin, Drawing, Royal Library, Windsor Castle, England. (Friedlaender, fig. 2.)

CHRIST AMID THE CHILDREN AND THE SICK. *See* HUNDRED GUILDER PRINT.

CHRIST AND ST. JOSEPH. Joseph, according to Voragine's GOLDEN LEGEND, was the descendant of Solomon and the son of Jacob (although according to the Law, he was the son of Heli and of the line of Nathan). He was a carpenter, the earthly husband of the Virgin Mary and the foster father of Jesus, a man of the house and family of David. According to St. Jerome, Joseph was chosen to be the Virgin's husband from many suitors when Mary was in her fourteenth year and he was already advanced in years. The sign from heaven that he was the chosen husband was the rod that he carried and finally placed on the altar in the temple where it burst into bloom. The apocryphal Book of James tells how a dove came forth from the rod and flew to Joseph's head. After the marriage, Joseph, since he did not beget Jesus, did not accept the fact of Mary's conception. But his suspicions were allayed when the archangel Gabriel appeared to him in a dream and provided him with an explanation. After this time, according to the *Golden Legend,* "he watched over her and she remained pure." It was Joseph who took his family to Egypt, after learning that Herod was determined to massacre all the children of Bethlehem so that the unknown child whom Herod feared would be sure to perish; and it was Joseph who, upon the return from Egypt where they had fled to escape the massacre, took the family to Nazareth. According to Matthew 2:23: "And he [Joseph] went and dwelt in a city called Nazareth, that what was spoken by the prophets might be fulfilled, 'He [Jesus] shall be called a Nazarene.' " The apocryphal book the History of Joseph the Carpenter tells us that Joseph died at age 111 with Mary and Jesus at his side.

Before the 16th-century COUNTER REFORMATION, artists painted Joseph

as an old man with a white beard. During the 17th century, after the influence of St. Teresa of Avila, Joseph's cult was promoted and his appearance changed. Artists showed him as younger, although mature. He is depicted as a carpenter and various tools may be scattered about him, or he works as a carpenter while Jesus, as a young boy, watches. His attributes are various carpenter's tools, a flowering rod and a lily (for chastity). He may lead the infant Jesus or hold him in his arms; or, if Jesus is shown as an older child, Joseph may be in the process of teaching him his trade.

Example: Georges de La Tour, The Louvre, Paris. (Blunt, fig. 219)

CHRIST AND THE ADULTEROUS WOMAN (*Woman Taken in Adultery*). The story of the woman who had been caught in the act of committing adultery is told in John 8:2–11. "Early in the morning he came again to the temple; all the people came to him, and he sat down and taught them. The scribes and the Pharisees brought a woman who had been caught in adultery, and placing her in their midst they said to him, 'Teacher, this woman has been caught in the act of adultery. Now in the law Moses commanded us to stone such. What do you say about her?' This they said to test him, that they might have some charge to bring against him. Jesus bent down and wrote with his finger on the ground. And as they continued to ask him, he stood up and said to them, 'Let him who is without sin among you be the first to throw a stone at her.' And once more he bent down and wrote with his finger on the ground. But when they heard it, they went away, one by one, beginning with the eldest, and Jesus was left alone with the woman standing before him. Jesus looked up and said to her, 'Woman, where are they? Has no one condemned you?' She said, 'No one, Lord.' And Jesus said, 'Neither do I condemn you; go, and do not sin again.'" The gospel gives no explanation of Christ's writing on the ground, though a medieval tradition had it that he was writing down the sins of the Pharisees.

Artists show various scenes in the story. The woman may kneel or stand before Christ. He is standing or sitting. Sometimes the apostle John is beside him. Christ may be depicted bending over writing with a finger in the sand. The Pharisees lean forward so that they may see what he is writing. The Pharisees may be shown leaving. The woman usually has one breast bared, the usual attribute of a courtesan. Several of the Pharisees have stones in their hands, and one may hold a book, the Ancient Law.

Example: Nicolas Poussin, The Louvre, Paris. (Friedlaender, fig. 67)

CHRIST AND THE WOMAN OF SAMARIA (*Christ and the Woman of Samaria at the Well* and *The Arched Print*). The story of the woman of Samaria is told in John 4:1–30: "Now when the Lord knew that the Pharisees had heard that Jesus was making and baptizing more disciples than John . . . he left Judea and departed again to Galilee. He had to pass through Samaria . . . Jacob's well was there, and so Jesus, . . . sat down beside the well. . . . There came a woman of Samaria to draw water. Jesus said to her, 'Give me a drink.' . . . The Samarian

woman said to him, 'How is it that you, a Jew, ask a drink of me, a woman of Samaria?' For Jews have no dealings with Samaritans. Jesus answered her, 'If you knew the gift of God, and who it is that is saying to you, 'Give me a drink,' you would have asked him, and he would have given you living water.' The woman said to him, 'Sir, you have nothing to draw with, and the well is deep; where do you get that living water? Are you greater than our father Jacob, who gave us the well, and drank from it himself, and his sons, and his cattle?' Jesus said to her, 'Every one who drinks of this water will thirst again, but whoever drinks of the water that I shall give him will never thirst; the water that I shall give him will become in him a spring of water welling up to eternal life.' '' The adulterous woman was amazed at Jesus' request for a drink, not only because it was not the custom for a Jew to address a woman he did not know, but because of the traditional hatred between Samaritans and Jews, which included their not using the same drinking vessels. Jesus used this event at Jacob's well to teach when he said everyone who drinks the water will be thirsty again, but whoever drinks the water I give him will never be thirsty again. The disciples returned to find Jesus talking to the woman and were surprised.

The scene depicted is usually a well in the shade of a spreading tree or beside a house where Jesus is sitting, his feet bare. He is speaking to a countrywoman who carries a pitcher. She may perhaps have one breast bare, the traditional attribute of an adulteress or a courtesan. The disciples may be shown approaching along the road, trudging up a hill, while in the background one may see the walls of the town.

Example: Rembrandt van Rijn, Etching, British Museum, London. (Gerson, figs. 272, 273)

CHRIST AS THE GOOD SHEPHERD. Christ shown as a shepherd, as protector of his flock, is a topic that was used frequently by the earliest Christians. The topic exists even in the catacombs, and it continued to be popular through the ages. Jesus is usually shown with a lamb or several sheep (his flock or followers). In Classical art, the Good Shepherd signified the virtue of philanthropy, but after the birth of Jesus, the Good Shepherd became the symbol for the devoted defender, the faithful guardian of the Christian flock, who said to his disciples, ''Feed my lambs; feed my sheep.'' Jesus, whether young or old, is always steadfast and constant; he is usually shown with a shepherd's staff and a flock of sheep, either in the background or closely surrounding him. He may wear a simple frock or the robes of a king.

Example: Bartolomé Esteban Murillo, The Prado, Madrid. (Ruskin, fig. 218)

CHRIST AT EMMAUS. *See* SUPPER AT EMMAUS.

CHRIST AT THE HOUSE OF MARY AND MARTHA (*Christ in the House of Martha and Mary*). The story of Christ in the house of Mary and Martha is told in Luke 10:38–42. This is the story of Martha, who scolded her sister,

MARY MAGDALENE, for sitting at Christ's feet listening to his teaching when there was much work to be done. But Christ told Martha that Mary was playing a better part. "Now as they went on their way, he entered a village; and a woman named Martha received him into her house, and she had a sister called Mary, who sat at the Lord's feet and listened to his teaching. But Martha was distracted with much serving; and she went to him and said, 'Lord, do you not care that my sister has left me to serve alone? Tell her then to help me.' But the Lord answered her, 'Martha, Martha, you are anxious and troubled about many things; one thing is needful. Mary has chosen the good portion, which shall not be taken away from her.' " Since Mary played the necessary, even the better part, her inscription is "*Optimam partem elegit.*" Martha is usually shown serving or cooking food, while Mary sits on the floor before Christ, who is seated on a chair. Some disciples or Lazarus, the brother of Mary and Martha, may be in the background.

Example: Jan Vermeer, National Gallery of Scotland, Edinburgh. (Rosenberg, Slive, ter Kuile, fig. 142)

CHRIST BEFORE THE HIGH PRIEST. The story of Christ before Caiaphas, the high priest, is told in Matthew 26:57–68, Mark 14:53–65 and Luke 22:66–71. When questioned, Christ's answer to Caiaphas was that he was the awaited Messiah and the Son of God, a statement that constituted blasphemy in Jewish law and was punishable by death—however, a sentence that, under the Romans, the Sanhedrin did not have the power to execute. "When day came, the assembly of the elders of the people gathered together, both chief priests and scribes; and they led him away to their council, and they said, 'If you are the Christ, tell us.' But he said to them, 'If I tell you, you will not believe; and if I ask you, you will not answer. But from now on the Son of man shall be seated on the right hand of the power of God.' And they all said, 'Are you the Son of God then?' And he said to them, 'You say that I am.' And they said, 'What further testimony do we need? We have heard it ourselves from his own lips.' " Jesus, his hands bound before him, his head bowed, stands before the council and the high priest. A candle illuminates the space between them and lights several of the priests and scribes.

Example: Gerrit van Honhorst, National Gallery, London. (Rosenberg, Slive, ter Kuile, fig. 15)

CHRIST CHASING THE MERCHANTS FROM THE TEMPLE. *See* CHRIST EXPELLING THE MONEY CHANGERS.

CHRIST DRIVING THE TRADERS OUT OF THE TEMPLE. *See* CHRIST EXPELLING THE MONEY CHANGERS.

CHRIST EXPELLING THE MONEY CHANGERS (*Christ Driving the Traders Out of the Temple, Christ Chasing the Merchants from the Temple***

and *Cleansing of the Temple*). The story of Christ driving the money changers from the temple is told in Matthew 21:12–13, Mark 11:15–18, Luke 19:45–46 and John 2:14–17. The Passover of the Jews was at hand when Jesus went to Jerusalem and entered the temple of God. "In the temple he found those who were selling oxen and sheep and pigeons, and the money-changers at their business. And making a whip of cords, he drove them all, with the sheep and oxen, out of the temple; and he poured out the coins of the money-changers and overturned their tables. And he told those who sold pigeons, 'Take these things away; you shall not make my Father's house a house of trade.' His disciples remembered that it was written, 'Zeal for thy house will consume me.' " The Temple in Jerusalem, intended as a house of prayer, had been turned into a marketplace by money changers and by traders in cattle, sheep and pigeons. According to Mark 11:17, it was "a den of robbers." Jesus became furious and drove them out.

Artists show Christ near the traders, wielding a whip that threatens the men who crouch beneath him. Some struggle toward the exit, driving their animals before them and overturning furniture in a melée of confusion. Some try to gather up their money or are grasping their purses. Only John mentions the whip, but it is customary to show it. The sheep and oxen (for the rich) and pigeons (for the poor) were sold as sacrificial animals. Because Christ's behavior was untypical, his act has suggested symbolic interpretations. Holy men of the Middle Ages said it was a foreshadowing of the mysterious horseman who had driven Heliodorus from the same temple some centuries earlier. Humanists during the Renaissance saw a pagan prefiguration of it in the fifth labor of Hercules, the cleansing of the Augean stables. During the Reformation, the theme symbolized Martin Luther's denunciation of the sale of papal indulgences. Christ is shown in a storm of rage, wielding a whip at the top of a falling pyramid of bodies—sheep, caged birds and men who scramble from his wrath.

Example: Rembrandt van Rijn and Luca Giordano, Chiesa dei Gerolamini, Naples. (Bazin, fig. 33)

CHRIST IN THE HOUSE OF MARTHA AND MARY. *See* CHRIST AT THE HOUSE OF MARY AND MARTHA.

CHRIST IN THE HOUSE OF SIMON. The story of Simon, one of Christ's twelve apostles, is told in Voragine's GOLDEN LEGEND. Simon had two surnames, Simon Zelotes and Simon the Cananean, the latter after Cana of Galilee, where Jesus changed water into wine. Both names have the same meaning, for Cana is interpreted Zeal. The son of Mary of Cleophas and Alpheus, Simon was known as the Zealot, the brother of Jude and James the Less. No mention of Simon appears in the gospels except that he was chosen among the apostles. Western tradition recognized in the Roman liturgy is that after preaching the gospel in Egypt, Simon joined St. Jude from Mesopotamia, and they traveled together for many years as missionaries to Syria and Mesopotamia. Both were

martyred there. Simon, according to the *Golden Legend,* was martyred by being sawn in half. The *Golden Legend* also says "it is found in several texts that he was nailed to the gibbet of the cross." This is told by Isidore in his *On the Death of the Apostles,* also by Eusebius in his *Ecclesiastical History* and by Bede in his commentary on the *Acts of the Apostles.* The *Golden Legend* tells us that after Simon preached in Egypt, he returned to Jerusalem, and after the death of his brother, James the Less, he was elected bishop of Jerusalem. It is added that before Simon's death he raised thirty dead men to life. These miracles occurred after he had ruled the church at Jerusalem for several years. By that time he was one hundred and twenty years old. During the reign of the Emperor Trajan, Atticus, the consul of Jerusalem, had him arrested, tormented and beaten. Finally, he told his soldiers to crucify him. He and all who were present marveled that an old man of such advanced years could bear the agony of crucifixion. Simon is usually shown with a saw or a cross. *Christ in the House of Simon* was painted for St. Martin des Champs and placed there in 1706.

Example: Jean Jouvenet, Saint Martin des Champs, Paris. (Blunt, page 386)

CHURRIGUERESQUE. A term used to indicate the more excessive and profuse architecture, decoration and ornament of the Baroque in Spain and Spanish America. The name derives from José de Churriguera, although it was not José but his Andalusian contemporary Hurtado and the architects and designers who followed them who created the most impressive works of the style. The style is characterized by its lavish and exuberant use of all the decorative forms developed by the Mannerist and Baroque architects of the past. The word "Churrigueresque" was originally created as a term of debasement by Neoclassical critics of the late 17th and 18th centuries. It was mainly a style of architectural ornament first used during the last quarter of the 17th century in the elaboration of interior decorative features such as stucco work and elaborately carved wood altarpieces. Soon the style extended to exteriors on the stone-carved decoration. Special emphasis was placed on decorative towers, fanciful façades and ornamented doorways.

CIBORIUM. *See* BALDACCHINO.

CIRCLES OF CONFUSION. The Dutch 17th-century artist Jan Vermeer is possibly the first painter in history to perceive the phenomenon photographers call "circles of confusion." These are circles or spots of colored light that in close view give the impression that the image is slightly out of focus. Upon stepping back, however, as if adjusting a lens, the color circles cohere and give an accurate illusion of a third dimension. It is possible that Vermeer saw these color spots projected by the primitive lenses of the CAMERA OBSCURA, an ancestor of the modern camera in which a tiny pinhole, acting as a lens, projects an image on a sheet of paper or ground glass so that the outlines can be traced. It is known that the artist used not only the camera obscura but also mirrors.

CIRCUMCISION, THE. The story of the circumcision of Christ, an operation required by Mosaic law as a token of the Covenant, is found in Luke 2:21. Circumcision, at this time, could be performed by the child's parents or by a priest of the Temple especially designated for the operation. According to Luke, "At the end of eight days, when he was circumcised, he was called Jesus, the name given by the angel before he was conceived in the womb." Although Luke does not describe the location, artists usually depict the scene in the Temple. Generally the Virgin Mary holds her child while the priest stands beside her. An attendant holds a tray from which the priest takes a knife. The circumcision was significant to the medieval Church as the first instance in which the blood of Christ was shed. While the theme occurred in Italian Renaissance painting, it flourished in the art of the COUNTER REFORMATION, especially in Jesuit churches. The SOCIETY OF JESUS, for whom Jesus' name had an honored holiness, laid emphasis on the feast of the Circumcision because of the association of the ceremony with the naming of the Child.

 Example: Fredericio Baroccio, The Louvre, Paris. (Waterhouse, fig. 1)

CIRE-PERDUE. Also called the "lost wax process," which is a method of hollow casting for creating a metal sculpture. The earliest figures were cast solid and therefore were small. The *cire-perdue* method is as follows: The artist covers a heat-proof core with wax and forms it to the desired shape. The wax is most often a duplicate of the figure modeled in clay and is produced by means of a plaster cast taken from the clay. The clay is covered with a heat-proof mold and the wax is heated and melted out. Liquid metal then is poured into the space left by the wax. When the metal hardens, both mold and cast are removed and a hollow metal shape, the figure the artist desires, remains. The inner core is constructed from a mixture of "grog," pulverized crockery or clay, and plaster of Paris molded in a rough, smaller facsimile of the shape desired. On this figure the wax is layered about one-half inch or less thick. The result is called the model. After this, metal pins are driven through the wax halfway into the core and left with their top halves protruding so as to keep the core in place. On the top of the model, sausage-like rods of wax are set obliquely so that their upper ends meet in a solid wax shape in the form of an upside-down cone. Around the lower sections of the figure and at all protruding points, longer and thinner wax rods are situated which move up and round to the cone at the top. The model is then covered completely in a mass of grog and plaster; thus the mold is formed. The entire structure of inner core, inner wax layer and outer mold is inverted so that the cone is at the bottom. The structure is heated and the wax burned away or melted out. There is now a hollow funnel where the cone was; the thick wax rods are now runners, and the thin ones are now air vents. The structure is turned so that the funnel is at the top and placed in a tight sandpit so that the mold will withstand great pressure. Molten metal is poured into the funnel. It slips through the runners until it fills all empty space between the core and the mold. All air is forced out through the small vents because that which

does not escape can cause the mold to burst. When the metal cools and the mold is broken off, the cast is cleaned, the runners of metal (metal filled the vents) are sawn off and the figure is ready to be chased, or embossed and cut and filed by the sculptor. The *Autobiography* of Florentine goldsmith Benvenuto Cellini (1558–1562) gives the classic account of bronze casting.

CLASSIC, CLASSICAL. These words were first used in reference to literature, and the present usage in the visual arts cannot be traced back beyond the 17th century when most scholars assumed that Greek and Roman art had set the standard for all future accomplishments. But each word has a different meaning. "Classic" indicates the best of its kind no matter the date. "Classical" Greek art refers to the art produced in the 5th century B.C. or more precisely around 432 B.C. The term "classical beauty" is used sometimes when referring to a facial or body type that is perfection when judged against the standards of a group or race or people.

CLAUDE GLASS. A type of glass that is used for reflecting landscapes in miniature; a small convex black glass that abstracts an artist's intended object from its surroundings and restrains and inhibits the colors so that the object is seen in more simplified and precise terms of light and shade. Claude Glass also reduces the intervals between the lights and darks and, by means of such tight focus on the subject, enables the painter to see the subject larger and to assess the minute color qualities and differences. Claude Glass was fashionable and in demand during the 17th century. Not only artists used the glass: the poet Thomas Gray carried one with him in his travels around Britain. The painter Claude Lorrain was said to have used Claude Glass. Also, when a Mrs. Merrifield discussed the glass with an Italian artist for *Practice of the Old Masters* (1849), he told her he possessed one that had belonged to the French painter Nicolas Poussin and before him to Bamboccio (Pieter van Laer). He added that a view reflected in this convex black glass looked "just like a Flemish landscape."

CLEOPATRA. One of the famous romantic heroines of her time, Cleopatra, queen of Egypt (69–30 B.C.), was actually one of many Cleopatras. Her name was commonly used in the Ptolemaic family. Cleopatra, the daughter of Ptolemy XI, was married to her younger brother, Ptolemy XII, at the age of seventeen, according to the family custom. Although she is usually thought of as being exceedingly beautiful, descriptions of her differ. According to Plutarch, "Her beauty, so we are told, was not of that incomparable kind which instantly captivates the beholder. But the charm of her presence was irresistible, and there was an attraction in her person and her talk, together with a peculiar force of character which pervaded her every word and action, and laid all who associated with her under its spell." She was an ambitious, intelligent and gracious queen who finally led a revolt against her brother. With the help of Julius Caesar, she won the kingdom, even though it remained a vassal of Rome. Her younger

brother-husband met his death by accidentally drowning in the Nile. Her next marriage was to her even younger brother, Ptolemy XIII, but at the same time she was the mistress of Caesar. She moved to Rome and had his son, Caesarion, who later became Ptolemy XIV. After the murder of Caesar, she returned to Egypt where she was visited in 42 B.C. by the Roman statesman and war leader Marc Antony. He had come to ask for an account of her actions, but, finding a woman of incredible charm, he fell in love with her. Cleopatra, ever conscious of her royalty and even her claims to divinity as the pharaoh's daughter, apparently planned to use Marc Antony to reestablish the real power of the Egyptian throne. According to Plutarch, "She had already seen for herself the power of her beauty to enchant Julius Caesar and the younger Pompey, and she expected to conquer Antony even more easily. For Caesar and Gnaeus Pompey had known her when she was still a young girl with no experience of the world, but she was to meet Antony at the age when a woman's beauty is at its most superb and her mind at its most mature." She married him in 36 B.C. Most Romans hated and feared the aggressive queen, and Octavian (later Augustus) planned to destroy the two lovers. In 31 B.C. they were defeated off Actium, and, after returning to Alexandria, they decided to defend themselves in Egypt. Failing, Antony killed himself by falling on his sword. Cleopatra also died purposely, from the bite of a poisonous snake, an asp.

Artists depict different episodes of Cleopatra's life. She may be shown at the banquet she held for Marc Antony in which he expressed surprise at its magnificence. After his comment, she is said to have taken off one of her priceless pearl earrings, casually dropped it in her glass of wine and watched it dissolve. She then drank the wine in a grand gesture of indifference to her riches. She is shown sitting at a table with Antony, holding the precious pearl over her goblet of wine between her finger and thumb. She may also be shown with Octavian during his visit after the battle of Actium in which he had defeated the queen and Marc Antony. Plutarch says Octavian visited the queen to comfort her, at which time she gave him a list of her treasures. Some artists show her death. Plutarch says "They saw her stone dead, lying upon a bed of gold, set out in all her royal ornaments. Iras, one of her women, lay dying at her feet, and Charmian, just ready to fall scarce able to hold up her head, was adjusting her mistress's diadem." Usually a basket of figs is included. The snake was said to have been concealed beneath the figs. Cleopatra may hold the small snake to her breast or it may crawl up her arm.

Example: Guido Reni, Pitti Gallery, Florence. (Held and Posner, colorplate 7)

COLLÈGE DES QUATRE NATIONS. Now the Institut de France, the large building shown in this engraving was designed for the executors of Cardinal Mazarin's will. A bold piece of planning for the time, it was placed on the south side of the Seine on the axis of the Square Court of the Louvre and was designed as part of the same grand scheme intended for the museum. This construction was one of the few buildings during the 17th century to display some of the

principles of Roman Baroque architecture. The church, domed with a lofty cupola, is flanked with wings curving forward to form a symmetrical semicircle and presents a particularly effective and dramatic façade. Louis Le Vau included a bridge, which was meant to join the college with the Louvre. This part of the scheme was not executed until the 19th century and then not on the grand scale originally intended but rather as the smaller Pont des Arts.

Example: Gabriel Pérelle, Engraving. (Blunt, fig. 269)

COLOR. During the Baroque, Sir Isaac Newton, in 1672, discovered that a beam of white light passed through a refracting prism will be scattered into its component chromatic rays and that these may be blended into white light. (Rays of light have no color.) We know now that any color in the visible spectrum and also white light can be matched by mixing various amounts of light from the three primary colors of the spectrum—red, yellow and blue. From these primaries an infinite number of colors may be produced. Some but not all spectral colors can be matched by combining two other colors. Differences in brightness also exist. Seventeenth-century artists such as Velázquez, Caravaggio, and Rembrandt, concentrated on an exaggerated CHIAROSCURO or produced dramatic extremes of light and dark known as TENEBRISM for an enhancement and heightening of illumination and brightness contrasts.

COMMUNION OF ST. JEROME. *See* JEROME.

COMMUNION OF THE APOSTLES. Communion is one of the seven sacraments, that which celebrates the Last Supper. The Communion of the Apostles is known as the EUCHARIST. The partaking of it is called communion. The last meal that Christ had with his apostles in Jerusalem before his arrest is described in Matthew 26:17–29, Mark 14:12–25, Luke 22:7–23 and John 13:21–30. According to Mark, "And as they were eating, he [Jesus] took bread, and blessed, and broke it, and gave it to them, and said, 'Take, this is my body.' And he took a cup, and when he had given thanks he gave it to them and they all drank of it. And he said to them, 'This is my blood of the covenant, which is poured out for many.' " The supper was an observance of the Jewish feast of the Passover, the "festival of freedom," honoring the exodus from Egypt of the Israelites. To Christians, Christ's words as he consecrated the bread and wine mark the beginning of the central rite of the Church. During the Last Supper, or Eucharist, Christ administered the first communion to his apostles and announced the betrayal by Judas, as related in Luke 22:21, "But behold the hand of him who betrays me is with me on the table."

Throughout the history of Christian art, the disciples are arranged around the table in various ways. The early Church showed the disciples seated around the curved side of a D-shaped table. Christ is at one end. He and his disciples recline, propped on the left elbow, leaving the right arm free, as was the later Jewish custom in observing the Passover ritual. (In the beginning the Passover

meal was eaten standing, just as the Israelites stood when eating on the eve of their exodus. The Romans reclined at meals, a gesture meant to identify a free man. This is why the recumbent posture was thought to be more appropriate for the Jewish celebration of freedom.) Nicolas Poussin shows the apostles in a reclining position. Usually a chalice, the eucharistic vessel, is placed on the table before Jesus. He may be in the act of consecrating the bread or handing a communion wafer to one of his apostles. Rarely, Jesus may stand with his apostles gathered about him.

Example: José Ribera, S. Martino, Naples. (Waterhouse, fig. 155)

COMPLEMENTARY AFTERIMAGE. Complementary colors are those that are separated the greatest distance when the colors are placed in their natural order around the circumference of a circle. They are those pairs of colors, such as red and green, that together embrace the entire spectrum. The complement of one of the three primary colors is a mixture of the other two. Using paint, they produce a shade of gray when mixed in the right proportions. Complementary colors produce the greatest corresponding intensification by simultaneous contrast when put side by side. The complementary afterimage is an image that is retained briefly by the eye after the stimulus of another color is removed. For example, if the eye is exposed to red for a period of time (about one minute), the eye, when removed from the red hue, will retain this color's complement—green—and an individual will see green instead of red for a short period of time. Similarly, if the eye is exposed to blue for a minute or so, the color orange will be retained by the eye. In the 17th century, the painter Jan Vermeer, far ahead of his time in color science, noted for the first time that shadows are not merely dark and colorless. He saw that adjoining colors affect one another and that, because of the complementary afterimage, blue beside green, for example, will shift toward violet, which is blue plus the afterimage red. It is thus that a shadow's color is determined.

Example: Jan Vermeer, *Woman at a Window,* The Metropolitan Museum of Art, New York. (Ruskin, colorplate 3–22)

CONFIRMATION. *See* SACRAMENT OF CONFIRMATION.

CONSPIRACY OF JULIUS CIVILIS. Julius Civilis was a noble Batavian, disfigured by the loss of one eye, who led a revolt against the Romans in A.D. 69. When Antonius Primus wrote to the nobleman that year, inviting him to create a diversion and thus prevent Vitellian reinforcements from going to Italy, Civilis incited a war of liberation under pretext of supporting Vespasian. He attacked the legionary camp of Vetera with help from Germans beyond the Rhine, but was not successful. The insurrection then spread and found support among Gallic tribes, including the Lingones and Treveri, during the winter of 69–70. According to Tacitus's *Historiae* IV, 13, the conspiracy began when

Julius Civilis "summoned the chief nobles and the most determined of the tribesmen to a sacred grove. Then, when he saw them excited by their revelry and the late hour of the night, he began to speak of the glorious past of the Batavi and to enumerate the wrongs they had suffered, the injustice and extortion and all the evils of their slavery." Civilis's zealous speech stirred his countrymen to a revolt that "was received with great approval, and he at once bound them all to union, using the barbarous ceremonies and strange oaths of his country."

The Batavi are shown taking an oath on Julius Civilis's wide, flat sword. (The sword oath was known in the 17th century—both Shakespeare and Vondel made reference to it.) Other artists who depicted this conspiracy showed the Batavi sealing their oath with a handshake. The version by Rembrandt, once extremely large (18' × 16'), was cut down, possibly by the artist himself, to make it more salable. The architecture has been completely subordinated in favor of diffused alabaster dreamlike coloring and a spectral, 17th-century CHIAROSCURO. The eerie light and shadowy vapors, the iridescent pale yellows and shadowy golds are important in bringing out the mysterious barbaric character of the conspiracy. Civilis's closed disfigured eye is shown, an unusual presentation. Most artists hid such infirmities by presenting a profile.

Example: Rembrandt van Rijn, National Museum, Stockholm. (Gerson, fig. 354; colorplate details, pp. 126–27)

CONTINENCE OF SCIPIO. Scipio, a famous family name in Roman history, usually refers to Scipio Africanus Major (the Elder), c.236–184/83 B.C. During his time as a military personage, in which he held various offices such as consul for 205 and *princeps senatus,* Scipio attained the most power ever held by a Roman general. He personified a new era in which Greek ideas became more important in Roman life. He asserted Rome's supremacy in Africa, Spain and the Hellenistic East. Even though a powerful man, he was brought down by the most trivial, petty jealousies and died sick and defeated. The story of the continence of Scipio is told in Petrarch's *Africa* 4:375–88. It is the tale of a magnanimous legendary act of clemency. After taking the Spanish city of New Carthage, Scipio was given, as the perfect prize of war, an extraordinarily beautiful woman, a Numidian princess. Shortly after she was presented to him, he learned that she was betrothed. In an act of great humanity and mercy, he called in her fiancé and gave her back to him untouched and unharmed. At the same time he used the situation to deliver a sermon on the moral honesty and virtue and fair principles of the Romans.

In art, the general is seen in his tent, outside the walls of New Carthage, and he is handing back the girl to her fiancé, who kneels before him. The pair may be shown standing before Scipio as he blesses their clasped hands. In the background, the bride's parents advance, followed by attendants carrying a ransom of golden vases, urns, goblets and chalices. Scipio returned the vessels to the

bridegroom as a wedding gift. In the 14th century, Petrarch composed his epic poem *Africa* to honor the memory of Scipio.

Example: Nicolas Poussin, Musée Condé, Chantilly. (Friedlaender, fig. 26)

CONTRAPPOSTO. The word used to indicate a stance in which the human figure is so posed that one part is turned in opposition to another part. Most often the hips and legs go one way and the chest and shoulders another. Such a placement creates a counter-positioning of the body about its central axis. This tendency is sometimes called weight shift. The weight of the body is usually put on one foot, which causes a tension on one side and a state of relaxation on the other. Contrapposto was discovered by the Greeks and is, in fact, one of the great achievements of Greek art. The theory was described by Polycleitos in his 5th century B.C. *Canon,* a treatise describing idealistic proportions of the human body. It was near the end of the 5th century B.C. that the Greeks began to free the standing rigidly posed figure from the frontal position, that same position used by the Egyptians. They discovered that the emotional expression of the symmetrical pose is strict and limited. The new scheme devised by the Greeks appeared in such statues as the *Kritios Boy,* c.480 B.C. The gravitational point stayed in the middle of the body, but nearly all of the weight of the torso rested upon one leg, and this leg stood obliquely. The pelvis was no longer horizontal, but sank down on the side of the resting leg, which now was bent at the knee. The chest and shoulders were turned slightly out of the vertical also. The head, instead of facing full front, was inclined sideways in the opposite direction.

Baroque sculpture and painting were deeply influenced by the work of Michelangelo in which contrapposto, the movement of masses one against the other, was powerful and dramatic. A new vitality was imparted to traditional religious figures when 17th-century artists used the twisted contrapposto of Michelanglo. The body was shown fraught with tensions and purposely protruding points, which caused a theatrical play of extreme light and shadow and induced the kind of emotion favored by Baroque artists.

CONVERSION OF ST. PAUL. Originally named Saul, Paul, late in life, became an apostle, though not one of the original twelve. He was born in Tarsus in Asia Minor on June 30, c.10 A.D. Although Jewish, he inherited Roman citizenship from his father. (Citizenship later gave him a martyr's swifter death by the sword rather than the slower death by crucifixion.) The story of his sudden conversion to Christianity is told in Acts of the Apostles 9:3–9. "Now as he journeyed he approached Damascus, and suddenly a light from heaven flashed about him. And he fell to the ground and heard a voice saying to him, 'Saul, Saul, why do you persecute me?' And he said, 'Who are you Lord?' And he said, 'I am Jesus, whom you are persecuting; but rise and enter the city, and you will be told what you are to do.' The men who were traveling with him stood speechless, hearing the voice but seeing no one. Saul arose from the

ground; and when his eyes were opened, he could see nothing; so they led him by the hand and brought him into Damascus. And for three days he was without sight, and neither ate nor drank.'' Paul, as Saul (before he was an apostle) saw the stoning of Stephen, the first martyr, Acts 7:58–60.

The earliest descriptions of Paul depict a man who was ugly, bald and short. Baroque artists showed him as tall with flowing hair and a white beard.

Example: Caravaggio, Cerasi Chapel, S. Maria del Popolo, Rome. (Bottari, fig. 44, 45 and p. 26)

CORONATION OF DAVID. The story of David and his triumphant fight with Goliath is told in I Samuel 17:38–51 (*see* TRIUMPH OF DAVID). Although there is no Old Testament reference to David's coronation, he is shown being crowned as the personification of virtue and strength. Victory, a beautiful woman, naked to her waist, holds in her left hand a laurel wreath over the head of the victorious hero of the Jews. In her right hand she holds the crown of David. A PUTTO reaches from below to touch it. David is seated before fluted columns. He leans on his large sword, which is in his right hand. In his left hand is the great gleaming shield of Goliath. Goliath's huge wounded head is on a pile of armor on David's left, the great injury on the giant's forehead patently obvious. At David's right, two *putti* play with his harp. Here David is crowned as both the man of battle and the inspirational poet of the Psalms.

Example: Nicolas Poussin, The Prado, Madrid. (Friedlaender, fig. 25)

CORPSE OF ST. BONAVENTURA DISPLAYED. An Italian scholastic theologian, cardinal, and mystic, Bonaventura (also Bonaventure) was born in 1221 near Viterbo, Italy, and died in 1274 on July 14–15 while attending the Second Council of Lyons, at which he was a papal legate. His original name was Giovanni di Fidanza. He was a doctor of the Church, called the Seraphic Doctor. He belonged to the Franciscan Order and eventually became its minister general. His biography of St. Francis has been much translated and is frequently called the ''official'' story of the saint's life. One legend tells that upon seeing Bonaventura rise from a deadly illness as a child, St. Francis exclaimed, ''Oh what good fortune'' (*'O buona ventura*), which is the origin of his name. Bonaventura was a man of deep spiritual humility, so much so that when his cardinal's hat was brought to him he asked the papal envoys to hang it on a limb in a tree as he was busy washing dishes. Legend tells that he felt himself unworthy to receive the sacrament and that it was handed to him by an angel. Among his theological and philosophic works are commentaries on the *Sentences* of Peter Lombard and the ''three little works'': *Breviloquium, Itinerarium mentis in Deum,* and *De reductione artium ad theologiam* (all since translated). His later mystical works concentrate on the teachings of Hugh of Saint Victor and St. Bernard of Clairvaux. He stressed complete dependence of all things upon God and he wrote counsels to mystic contemplation. In paintings Bonaventura wears a Franciscan habit, and some artists show a cope (large cape) over it. As the

bishop of Albano, he is depicted in full Episcopal robes. A red cardinal's hat hangs from a tree or lies at his feet. He holds a chalice or a cross or a book (in allusion to his writings). In death he is shown in full Episcopal dress, a cardinal's hat on his feet, a cross in his hands.

Example: Francisco Zurbarán, The Louvre, Paris. (Ruskin, fig. 2–8)

COUNCIL OF TRENT. The Council of Trent met in the 16th century, and the effects of its publications influenced artists of the 17th. The council met at Trent in northern Italy three times during the 16th century to solve the crisis of the Protestant Reformation: 1545–47 under Paul III, 1551–52 under Julius III, 1562–63 under Pius IV. The numbers attending the meetings varied. In the first sessions less than two hundred attended; in the second, even fewer, but in the third, more than the first two. Out of these councils came the issuance of the explicit account of the beliefs of the Church, published as the *Catechism of the Council of Trent* or *Roman Catechism.* The doctrinal canons of the council cover most of the controverted points in Roman Catholic dogma, and the council is often quoted in definitions. The reforms put forth were the most thorough in the history of the Church. The Catholic COUNTER REFORMATION was launched in the last session of the council, and under the guidance of the Jesuits, the Church began to take on a militant posture.

As a result of the council, in the new struggle against Protestantism, architecture, painting and sculpture were given special functions. Sculpture and painting, especially, were recognized as media for propaganda. Rules were written and it was stated that all imagery had to be truthful and clear. Any work that might arouse ''carnal desire'' was inadmissible in churches. Any depiction of Christ's suffering and explicit agony was desirable and proper. During the 17th century the Church made use of art, while Protestants denied it a place in their houses of worship. There was an increase in images depicting the life of the Virgin. Countless images of the Immaculate Conception sustained the belief that Mary had been conceived by God before all time, that she was free from the stain of original sin. Artists depicted saints in ecstasy, suffering horrible and savage martyrdoms and performing miracles. All the while, the new churches were made into edifices of magnificence and splendor. Architectural façades of grand proportions and astonishing, even theatrical shapes welcomed the faithful. The interiors became even more dazzling for the newly elaborate and stirring ritual. The worshiper was caught up in an unheard of emotional transport, carried away by a flooding appeal to all senses. The principles laid down by the Church for religious art remained valid in Italy, Spain and its colonies, Flanders, France, Austria and southern Germany.

COUNTER REFORMATION. The 16th-century movement known as the Counter Reformation arose mostly as a force against the Protestant Reformation of 1517. Roman Catholics shared the Protestants' arguments against the corrupt conditions within their Church at this time. The Catholic reformation was led

by conservatives who hoped to secure the Church against not only the new teachings of Protestant theology but also the liberalizing effects of the 15th century. As early as the 14th century, reforms had been called for in the ecclesiastical administration, everyday Christian life and even the clergy. A major factor in the decline in Christendom was the far-reaching concern with worldly affairs and pleasures and general laxity of the prelates, who, with their kings and princes, actually ran the Church. Their power was so formidable that during the only forceful papal effort at reform of the 15th century, the papal legate did not dare doubt the bishops. The first important reform measures failed.

Important changes began when Paul III became pope in 1524, and IGNATIUS OF LOYOLA and his friends took the vows that established the largest single religious order ever organized, the Society of Jesus, whose members are known as Jesuits. Especially devoted to the pope, the society was based on strict discipline. Thus, the reformers won the papacy, and the pope was provided with a determined host of helpers. The COUNCIL OF TRENT, which met in 1545, 1551 and 1562, became a pivotal feature of the Catholic Counter Reformation. The popes of the council were Paul III, Julius III and Pius IV. In 1563, at the conclusion of the council, the second period of the Counter Reformation opened. This lasted until 1590 under Popes St. Pius V, Gregory XIII and Sixtus V. Finally, the chief damaging force in church life, simony (the buying or selling of sacred or spiritual things, such as church offices and ecclesiastical pardons), including the preaching of some indulgences, was eradicated. Worship was stabilized and regulated; new educational mandates for parish priests were introduced and provided for; religious orders were reorganized; the life of the clergy was examined with a critical eye; and the government of the Holy See and the law of the church were restructured.

COUNTESS MATILDA RECEIVING POPE GREGORY VII AT CA-NOSSA. Saint Gregory, who died in 1085, was pope between 1073 and 1085. Born near Rome, he was named Hildebrand, or Ildebrando in Italian. As a Benedictine, Hildebrand attracted the attention of Gregory VI, who made him his chaplain. After this move, his rise was rapid. Under Leo IX, Hildebrand became administrator of the Patrimony of Peter, and in this office he recovered much of the ecclesiastical property held by Italian nobles and restored the papal finances. At about this time he began his program of reform directed at the widespread laxity and corruption in the church. Though opposed by noblemen and clergy, he continued his reforms with the support of Popes Victor II and Stephen IX. After passing new laws, he appointed legates to travel throughout Europe and enforce the laws. So strong was the opposition that they were met with violence nearly everywhere. Gregory saw the root of the evils afflicting the Church in the practice of lay investiture, whereby bishoprics and abbacies became the property of secular powers who used them for their own gain. By 1075 he had condemned this practice and its practitioners. Gregory's remaining struggles with the royal houses of Europe who were against the decree domi-

nated the remaining years of his pontificate. In Germany, Henry IV joined with the nobles against Gregory's reforms, and in an investiture argument with Gregory, Henry was excommunicated in 1076. The excommunication cost Henry much of his popularity, and in 1077 he humbled himself before Gregory at Canossa.

Canossa, a village in Emilia-Romagna in north-central Italy, in the Apennines, is the site of the ruins of the 10th-century castle of the powerful feudal family that took its name from the place. In the 10th and 11th centuries, they ruled over much of Emilia and Tuscany. Matilda, the countess of Tuscany, was the last of the family. Known as the Great Countess, she fortunately was an ardent supporter of Gregory. In January of 1077, the castle was the scene of penance done by the Holy Roman Emperor Henry IV to obtain from Gregory the withdrawal of his excommunication. Gregory was Matilda's guest at the castle. Here, Henry is said to have waited three days barefoot in the snow before being admitted to Gregory's presence.

Soon after this episode, Matilda made a donation of her lands to the Holy See. She married Duke Welf V of Bavaria in 1089, her first husband having died. After the expedition of the Holy Roman Emperor Henry V to Italy in 1110–11, Matilda willed her lands to him on her death, which occurred in 1116. The arguments over Matilda's lands played a great part in later conflicts between the popes and the emperors.

The events at Canossa are depicted with Countess Matilda shown on the loggia of her palace bowing low to receive the pope, who, dressed in splendid robes, blesses her. Men at arms can be seen in the distance. Noble ladies gesture toward the scene.

Example: Giovanni Francesco Romanelli, Vatican Palace. (Waterhouse, fig. 46)

CRAQUELURE. The spidery profusion of tiny cracks that appear on the surface of oil paint after a number of years when the varnish or pigment has become dry and brittle is known as craquelure. Some masters, such as Rembrandt, glazed their paintings with BITUMEN to give the work a glowing effect. In France these cracks were known as *craquelure anglaise.* Sometimes the network of cracks is circular, a type of craquelure known as "rivelling."

CROWN OF THORNS. The crown, a circular head ornament, has always symbolized sovereign dignity. A symbol of royalty, the crown is of ancient tradition in the Orient and in Egypt. The crowning of Jesus with thorns is told in Matthew 27:27–31, Mark 15:16–20 and John 19:2–3. According to Matthew, "Then the soldiers of the governor took Jesus into the praetorian, and they gathered the whole battalion before him. And they stripped him and put a scarlet robe upon him, and plaiting a crown of thorns they put it on his head, and put a reed in his right hand. And kneeling before him they mocked him, saying, 'Hail, King of the Jews!' And they spat upon him, and took the reed and struck him in the head." The crowning with thorns is one of the last of the series of

scenes included in the trial of Christ. It is the prelude to the ECCE HOMO. After this Christ was led away to be crucified. "And when they had mocked him, they stripped him of the [scarlet] robe, and put his own clothes on him, and led him away to crucify him."

Christ is usually shown with his hands tied; with lowered head he holds the reed "sceptre" of a king. The crown of thorns is on his brow and he may or may not wear the scarlet robe. The cult of the crown of thorns as a holy relic dates from the time of Louis IX, king of France, 1214–70, who brought back from Palestine the original crown of thorns. The church of Sainte-Chapelle in Paris was built especially to enshrine this relic.

Example: Caravaggio, Gallerie Civiche, Genoa. (Bottari, p. 29)

CRUCIFIXION. The story of the Crucifixion of Christ is told in Matthew 27: 33–56, Mark 15:22–41, Luke 23:33–49 and John 19:17–37. Luke says, "They came to the place which is called The Skull, there they crucified him, and the criminals, one on the right and one on the left and Jesus said, 'Father, forgive them; for they know not what they do.' And they cast lots to divide his garments. And the people stood by, watching; but the rulers scoffed at him, saying, 'He saved others; let him save himself, if he is the Christ of God, his Chosen One.' The soldiers also mocked him, coming up and offering him vinegar, and saying, 'If you are the king of the Jews, save yourself.' There was also an inscription over him, 'This is the King of the Jews.' " Jesus' death on the cross is central to the visual focus of Christian contemplation and also Christian art. The image and symbolism have varied from one period to another, but both remain true to the gospels. The Romans crucified both by tying and nailing. Only one mention is made by the gospels concerning the nails. John, 20:25, when speaking of Thomas, one of the twelve apostles, called "the twin," says "So the other disciples told him, 'We have seen the lord.' But he said to them, 'Unless I see in his hands the print of the nails, and place my finger in the mark of the nails, and place my hand in his side, I will not believe.' "

During the Baroque, Jesus was shown dead upon the cross. According to John, 19:30, "When Jesus had received the vinegar, he said, 'It is finished'; and he bowed his head and gave up his spirit." In COUNTER REFORMATION painting the inscription to be fastened to the cross, which was written by Pilate, is shown in the three languages mentioned by the gospel. Velázquez shows Hebrew at the top, then Greek and finally Latin, although this is not true to the gospels. According to John 19:19–20, "Pilate also wrote a title and put it on the cross; it read, 'Jesus of Nazareth, the King of the Jews.' . . . it was written in Hebrew, in Latin, and in Greek." Some artists, Nicolas Poussin, for example, show no inscription. The Crucifixion in art was depicted in many ways during the Baroque: for instance, the solitary figure on the cross, as in the work of Velázquez, and scenes crowded with people, as in the work of Poussin. In the latter, the two thieves are shown, one on each side of Jesus; the soldiers are gambling; Longinus, the Roman soldier who pierced Christ's side with his lance,

is shown astride his horse; the Virgin Mary is shown in a state of collapse, and soldiers and people swarm about the foot of the three crosses. Also included are ladders, shields, swords, hammers and horses.

Example: Diego Velázquez, The Prado, Madrid. (Brown, page 53)

CRUCIFIXION OF ST. PETER. Peter is sometimes called the "Prince of the Apostles." His story is told in Butler's *Lives of the Saints* and Voragine's GOLDEN LEGEND. Peter was a Galilean whose original home was at Bethsaida. He was married and made his living as a fisherman. One of the apostles, Andrew (*see* ANDREW ADORING HIS CROSS) was his brother. Peter's name was Simon Bariona, but Jesus called him Kephas, the Aramaic (the language Jesus spoke) equivalent of the Greek word that in English means Peter, or the rock. Peter's story is told in the New Testament by Matthew, Mark, Luke and John, although his later life is told in the Acts of the Apostles and allusions in his own epistles and those of St. Paul. No written account of the Passion of Peter has been found, and some scholars believe such an account never existed. Tradition says he was confined in the Mamertine prison. The church of San Pietro in Carcere has been built on the spot. Tertullian tells us that Peter was crucified, and Eusebius says that by his own request he was crucified head downwards. Voragine tells us that when Peter saw the cross before him he said that his master had come down from heaven to earth, and so was lifted up, crucified. But he, whom God had called from earth to heaven, wished to be crucified with his feet pointing toward heaven and his head pointing toward the earth. He had to be crucified with his head downward because he was not worthy to be crucified with his head up, in the manner of Jesus. And this was done: the cross was turned, so that he was fixed upside down. Peter was crucified either in a circus arena between two *metae,* the pair of turning-posts set in the ground at each end of the track, or on the Janiculum hill.

Most artists depict Peter already nailed to the cross with soldiers in the process of pushing the cross upright with Peter's head toward the ground. He is always depicted as a very old, but vigorous man, usually with white hair and sometimes a short beard. Peter was crucified by Nero in A.D. 64. His special attribute is a key or two keys—one gold, the key to heaven, and one iron (or silver), the key to hell. He may also be shown with a rooster (his denial of Christ) and a book (the gospel).

Example: Caravaggio, Cerasi Chapel, Santa Maria del Popolo, Rome. (Bottari, fig. 46)

CUMAEAN SIBYL. Sibyls were prophetesses in classical mythology. Ten are listed by Marcus Terentius Varro (116 B.C.–27? B.C.), a Roman scholar. The most famous was the Sibyl of Cumae in Campania, described by Virgil in *The Aeneid,* Book 6: "She spoke in front of the doors, her face was transfigured, her colour changed, her hair fell in disorder about her head and she stood there with heaving breast and her wild heart bursting in ecstasy. She seemed to grow in stature and speak as no mortal had even spoken." Aeneas, asked her as she

sat in the temple of Apollo, to show him the way to the underworld so that he could look upon the face of his father. She told him "the door of black Dis stands open night and day. But to retrace your steps and escape to the upper air, that is the task . . . hidden in a dark tree, there is a golden bough [of Proserpina] . . . no man may enter the hidden places of the earth before plucking the golden foliage and fruit from this tree."

In Ovid's *Metamorphoses,* the Sibyl has already lived seven generations when she is visited by Aeneas and tells him her story: "When I was still an innocent young girl, I was offered endless, eternal life, if I would yield myself to Phoebus, who was in love with me. While the god hoped for my consent, he was eager to bribe me with gifts, and said: 'Maiden of Cumae, choose what you wish, and you will have your desire!' I pointed to a heap of dust which had been swept together, and foolishly asked that I might have as many birthdays as there were grains of dust: but I forgot to ask for perpetual youth as well. Yet Phoebus offered me all those years, and eternal youth too, if I would suffer his love. I scorned his gift, and remained unwed. Now the happier time of life is fled, and with shaky steps comes sick old age, which I must long endure. For, as you see me now, I have lived through seven generations; in order to equal the number of grains of dust, it remains for me to see three hundred harvests, three hundred vintages. A time will come when I shall shrink from my present fine stature into a tiny creature, thanks to my length of days, and my limbs shriveled with age, will be reduced to a mere handful." Petronius adds to this in the *Satyricon* 48:8: Trimalchio claims to have seen the Sibyl hanging in a bottle at Cumae, and when children asked her (in Greek) what she desired, all she would reply was "I want to die."

Although the Sibyl was sometimes painted in the company of others, a solitary Sibyl of Cumae was painted during the Baroque by Rembrandt and others. She is sometimes shown well advanced into her life, bent and withered and hideously shrunken. Other artists depict her as the beauty she once was. With her usually is one of the fourteen still extant books of the so-called sibylline prophecy.

Example: Guercino (Giovanni Francesco Barbiere), Collection Denis Mahon, London. (Waterhouse, fig. 99)

CUPID AND PSYCHE. Cupid, the Roman god of love and the lover of Psyche (soul), is identified with the Greek Eros and the Latin Amor. A lesser figure in Roman and Greek mythology, he was a playful winged PUTTO who was widely represented in Hellenistic art, during the Renaissance and the 17th century. In earlier times he was also a symbol of the life after death promised by the Mysteries. His presence is symbolic in art. He is shown in many different kinds of paintings even though he may play no part in the story, because he is there to remind the viewer that the theme concerns love. Most often, Cupid is the symbol of lust and carnal love, and his ardor is indicated by his torch. Cupid, with his bow and a handful of arrows, is symbolic of the powers of love; and he is often blindfolded to illustrate how his victims are always chosen at random and also

as a reminder that darkness and the night are associated with sin. He can be cruel, and he stood from the time of the early Greeks for the deepest and most profound forces in man's nature. The story of Cupid and Psyche is a late antique fairy tale written by Lucius Apuleius in *The Golden Ass* during the 2d century A.D. It begins thus: "Once upon a time a king and queen had three very beautiful daughters, but much the most beautiful was the youngest, Psyche. People came from many lands to admire her, in the belief that she was Venus, or had succeeded her as goddess of love. This caused the rites of Venus to be neglected, and the goddess angrily bade her son Cupid wound Psyche so as to make her fall in love with some completely loathsome creature." Cupid, sent by Venus to cause Psyche to fall in love with some worthless being, fell so much in love with her himself that he had to ask Apollo for help. He had her taken to his palace where he saw her only after the sun had disappeared and he did not let her see him. He always left before daybreak. Psyche's two jealous sisters, brought to the palace by the west wind, told her that her husband was a fiendish reptile. They commanded her to kill him with a carving knife the next time she was in bed with him. But by the candlelight, she saw that he was the most handsome being alive—Cupid himself. When she touched the point of one of his thousand arrows, it pricked her, and the lamp she carried spilled a drop of burning oil upon his tender skin. "He woke, and immediately departed from her, and flew to the top of a cypress-tree. After pausing there with a reproachful message, he soared up into the air and was gone." And his palace vanished. "After vainly trying to drown herself—the river set her ashore—Psyche wandered off in aimless misery." She performed various impossible tasks set by Venus in the hope of winning Cupid back. Finally, Jupiter, hearing Cupid's pleas, felt sorry for Psyche and she was taken to heaven by Mercury and reunited with her love. Cupid asked Jupiter to make Psyche immortal so that they could be married on Olympus. Jupiter gave his consent and they married at a beautiful banquet.

Cupid is usually shown with a bow and arrow and quiver. He sometimes holds a torch, extinguished and upturned; this alludes to the transience, the impermanence of earthly pleasures. A globe may symbolize love's universality. His chariot may be drawn by four white horses or by goats, symbols for sexuality.

Example: Gregorio de Ferrari, Palazzo Granello, Genoa. (Waterhouse, fig. 195)

D

DAMMAR. As a vehicle used in painting, dammar is one of the malleable resins that is a product of certain Indian and Australian coniferous trees. It is used as a painting medium when mixed with fatty oils and also in making varnishes. When applied to the surface of a painting, it becomes transparent and will not yellow. It is, however, crumbly and easily crushed, and for this reason some artists mix it with amber varnish.

DANAË. In Greek mythology, Danaë was the daughter and only child of Acrisius, king of Argos. Being extremely beautiful, she was imprisoned by her father in a bronze tower after an oracle told the king that not only would he have no son, but that he would be killed by his daughter's son. (He was later accidentally killed by his daughter's son, Perseus, when throwing a discus.) In her chamber with only one window, far from suitors, Danaë was seen by Jupiter (Zeus), who visited her in the form of a shower of golden rain. Nine months later she gave birth to a son, Perseus. According to Ovid's *Metamorphoses* 4: 611, her father, Acrisius of Argos, "refused to believe that Perseus, the child whom Danaë conceived in a shower of golden rain, was the son of Jupiter." Acrisius learned of this, but could not put them both to death; instead, he sealed his daughter and the baby in a chest and cast them adrift in the sea. But they were later found by a fisherman named Dictys when the chest landed on the beach off the island of Scriphos. Dictys took Danaë and her baby home to his wife, and the couple decided they would care for Danaë and raise Perseus as if he were their own son.

Danaë became even more beautiful with the passing years and the tyrannical king Polydectes wanted her for his wife. He regarded Perseus as a hindrance to his plans. Therefore he had it made known that he would marry another woman. This meant that everyone would have to give him a gift. At the feast, Perseus was the only person there without a gift, but he promised to bring the head of

the gorgon Medusa to Polydectes as a gift. The king was pleased, knowing that Perseus would be killed in the attempt. Perseus, upon his successful return, went to the king's banquet hall and greeted those present with insults, then pulled out the Medusa head as his gift for the king and changed Polydectes and his friends into stone. Perseus then took his mother and set sail for his grandfather's kingdom of Argos. In art, Danaë rests under the canopy of a high bed and looks toward the dazzling light. The shower of gold, sometimes shown as gold coins, falls upon her from clouds or enters the picture from an upper corner. Danaë's attendant, an astonished old woman, may lean forward with her apron to catch the golden coins. Amoretti (*see* AMORETTO) and CUPIDS flutter about. A cupid with bound hands hovering above Danaë symbolizes chastity and alludes to the isolation to which the beautiful girl was condemned by her father.

Example: Rembrandt van Rijn, The Hermitage, St. Petersburg. (Rosenberg, Slive, ter Kuile, fig. 61)

DANCE BEFORE THE GOLDEN CALF. *See* ADORATION OF THE GOLDEN CALF.

DANCE TO THE MUSIC OF TIME. The topic, in general, is one that depicts the virtues of the mind, an illustration of the triumph of the mind over the uncontrollable fluctuations of fate and the calm, controlled acceptance of inescapable, inevitable death. This concept of the *honnête homme* was prevalent particularly among the French bourgeoisie of the 17th century, who were, in most cases, well educated, although not as wealthy and influential as the aristocracy. Nevertheless, the bourgeoisie formed a major part of French political life and culture. A winged Father Time is depicted seated playing a lyre (a PUTTO holds his attribute, the hour glass), while four HORAE, the hours, goddesses of the seasons, daughters of Helios, form a circle, facing the outside, and dance before a two-headed HERM. Above, AURORA flies through the heavens before the four-horse chariot of Helios as she draws back the curtain of night and thereby brings to the world the sun and another day, also bringing every living thing closer to death.

Example: Nicolas Poussin, The Wallace Collection, London. (Friedlaender, fig. 33)

DAUGHTERS OF LEUCIPPUS. *See* RAPE OF THE DAUGHTERS OF LEUCIPPUS.

DAVID BEFORE SAUL. *See* SAUL AND DAVID.

DAVID PLAYING THE HARP BEFORE SAUL. *See* SAUL AND DAVID.

DAVID WITH THE HEAD OF GOLIATH (*David*** and ***David and Goliath***).** The armies of the Israelites and the Philistines were fighting each other. Goliath of Gath, the monstrous Philistine champion, was over eight feet tall. He wore

a coat of mail, greaves of brass on his legs and a helmet of brass. He carried a spear like a weaver's beam. The story of David and Goliath is told in I Samuel 17:38–51 (the fight) and I Samuel 18:6–7 (the TRIUMPH OF DAVID). From I Samuel 17:38–51: "Saul clothes David with his armor. . . . And David put them off and put a staff in his hand and chose five smooth stones and put them in his shepherd's bag. His sling was in his hand, and he drew near the Philistine. . . . When the Philistine arose and came and drew near to meet David, David ran quickly toward the battle line to meet the Philistine. And David put his hand in his bag and took out a stone, and slung it, and struck the Philistine on his forehead; the stone sank into his forehead, and he fell on his face to the ground. So David prevailed over the Philistine with a sling and with a stone, and struck the Philistine, and killed him; there was no sword in the hand of David. Then David ran and stood over the Philistine, and took his sword and drew it out of its sheath, and killed him, and cut off his head with it." This was the signal for the Israelites to attack and they crushed the enemy. From I Samuel 18:6–7: "As they were coming home, when David returned from slaying the Philistine, the women came out of all the cities of Israel, singing and dancing, to meet King Saul, with timbrels, with songs of joy, and with instruments of music. And the women sang to one another as they made merry, 'Saul has slain his thousands, and David his ten thousands.' "

Both the fight and David's triumph are depicted by Baroque artists. David is shown holding Goliath's head by the hair in his hand. He may also hold it high on the point of a spear or sword.

Example: Caravaggio, Borghese Gallery, Rome. (Ruskin, fig. 1–6)

DEATH OF ADONIS. A beautiful young man of Cyprus, Adonis was born of incest between a girl named Martha and her father. Overwhelmed with guilt and shame, Martha invoked the gods and they changed her into a myrrh tree. In time the trunk cracked open and Adonis was born. He was loved by Venus (Aphrodite), and in Ovid's legend, he was killed by a boar while out hunting. The name Adonis is Semitic and means "Lord." The story of his death is told in Ovid's *Metamorphoses* 10:715–39: "By chance, his hounds came upon a well-marked trail and, following the scent, roused a wild boar from its lair. As it was about to emerge from the woods, the young grandson of Cinyras pierced its side with a slanting blow. Immediately the fierce boar dislodged the blood-stained spear, with the help of its crooked shout, and then pursued the panic-stricken huntsman as he was making for safety. It sank its teeth deep in his groin, bringing him down, mortally wounded, on the yellow sand. Venus, as she drove through the air in her light chariot drawn by winged swans, had not yet reached Cyprus. She recognized the groans of the dying Adonis from afar, and turned her white birds in his direction. As she looked down from on high she saw him, lying lifeless, his limbs still writhing in his own blood. Leaping down from her car, she tore at her bosom and at her hair, beat her breast with hands never meant for such a use and reproached the fates . . . she sprinkled

Adonis' blood with sweet-smelling nectar. . . . Within an hour a flower sprang up, the colour of blood, and in appearance like that of the pomegranate. . . . But the enjoyment of this flower is of brief duration: for it is so fragile, its petals so lightly attached, that it quickly falls, shaken from its stem by those same winds that give it its name, anemone.''

Venus is shown lamenting Adonis's death, pouring nectar on his blood, thus creating the anemone. Her two-wheeled car is behind her, and perched upon it are her two doves. A PUTTO helps her.

Example: Nicolas Poussin, Musée des Beaux-Arts, Caen. (Held and Posner, fig. 112)

DEATH OF CHIONE. From Ovid's *Metamorphoses,* this illustration from *Les métamorphoses d'Ovide,* published in Paris in 1619 by La Veuve Langelier, shows not only Diana (the Greek Artemis) swooping down from a heavy cloud-bank aiming her bow at Chione, who dies under a tree, but also of two earlier scenes that have been included in the composition: Chione receiving Apollo, Diana's twin brother carrying his bow, then Mercury, as her lovers. Mercury is identified by his winged sandals and his round winged hat (a *petasus,* with a low crown). His winged caduceus, or magic wand with the power to induce sleep, with two snakes entwined about it, is on the ground beside him. The illustration dramatizes the moment when the uninhibited and promiscuous Chione, who had been so indiscreet as to disparage the beauty of the virtuous Diana and then allude to her sterility, lies dying, shot through the tongue with an arrow. An eagle, sacred to Jupiter (Zeus) is perched on the cloud behind Diana. The eagle was the ancient symbol of victory and power and was depicted on the standards of the Roman legions. Diana wears a crescent moon over her brow alluding to her identification with the moon goddess, Luna (Selene). *See also* CHIONE SLAIN BY DIANA.

Example: Nicolas Poussin, Engraving, La Veuve Langelier, Paris. (Friedlaender, figs 1 and 2)

DEATH OF CLEOPATRA. After Octavian (Augustus) defeated Antony and CLEOPATRA at the battle of Actium, he invaded Egypt. Marc Antony's fleets joined Octavius and his calvary abandoned him and deserted to the enemy. Antony thought Cleopatra had betrayed him to the very men he fought for her sake. She fled in terror of his fury and sent word to him that she was dead. Never doubting the message he "stabbed himself with his own sword through the belly and fell upon the bed. But the wound did not kill him quickly." He learned that Cleopatra was still alive and ordered his slaves to take him to her. They did and she tore her dress and "beat and lacerated her breasts and smeared her face with the blood from his wounds."

Rather than accept defeat, Cleopatra, after being taken prisoner, took her own life. According to Plutarch "there arrived an Egyptian peasant carrying a basket, and when the guards asked him what was in it, he stripped away the leaves at the top and showed them that it was full of figs . . . the guards were astonished

at the size and beauty of the figs, whereupon the man smiled and invited them to take some. . . . She [Cleopatra] dismissed all her attendants except for two faithful waiting women, and closed the door. . . . When they opened the doors, they found Cleopatra lying dead upon a golden couch dressed in her royal robes.'' According to one account, ''the asp was carried in to her within the figs and lay hidden under the leaves in the basket, for Cleopatra had given orders that the snake should settle on her without her being aware of it. But when she picked up some of the figs, she caught sight of it and said, 'So here it is,' and, baring her arm, she held it out to be bitten. Others say it was carefully shut up in a pitcher and that Cleopatra provoked it by pricking it with a golden spindle, until it sprang out and fastened itself upon her arm. But the real truth nobody knows, for there is another story that she carried poison about with her in a hollow comb, which she kept hidden in her hair . . . and indeed the asp was never discovered, although some marks which might have been its trail are said to have been noticed on the beach on that side where the windows of the chamber looked out towards the sea.'' Cleopatra was found lying dead upon a golden couch dressed in her royal robes. Iras, one of her trusted waiting women, lay dying at her feet. Charmian, the other, could scarcely hold up her head and was arranging the crown which encircled her mistress's brow. When Cleopatra died she was thirty-nine years old and had reigned as queen for twenty-two years. She had been Marc Antony's partner in his empire for more than fourteen years. (He was fifty-six according to some accounts, fifty-three according to others.)

Cleopatra is shown unconscious while the tiny snake bites her arm. Women in waiting circle the chair, crying, wringing their hands, looking at the snake in astonishment.

Example: Guido Cagnacci, Kunsthistorisches Museum, Vienna. (Waterhouse, fig. 89)

DEATH OF GERMANICUS. The story of the death of Germanicus comes from the *Annals* of Tacitus (2:71–2). Germanicus was the son of Nero Claudius Drusus and nephew of the Emperor Tiberius. He was named after his campaigns against the Germanic tribes. In Tacitus's passage is the story of a noble and great Roman general who lived from 15 B.C. to A.D. 19, a man who passionately loved and defended his country, but succumbed to the intrigues of his enemies. Germanicus died in Syria, the victim of intrigue, while on a visit to the eastern provinces, possibly poisoned on order of the jealous emperor, Tiberius. Some accounts say he was poisoned by Piso, the governor of Syria.

In this topic, painters record the significance of a dying man's redemption through his friends' demonstration of love and faith. A soldier, as written by Tacitus, grasps the hand of the dying man. He is shown on his deathbed with Agrippina beside him stricken with grief. His loyal officers stand about him pledging themselves to avenge his death. (The sequel to Germanicus's death is told in Tacitus's *Annals,* 3:1.)

Example: Nicolas Poussin, The Minneapolis Institute of Arts. (Friedlaender, color-plate 2)

DEATH OF REGULUS. Marcus Atilius Regulus, a hero of classical history, died in 249 B.C. (some accounts say 250 B.C.). He was a Roman general in the First Punic War. (The Punic Wars were three conflicts in which Rome gradually superseded Carthage as the dominant power in the western Mediterranean.) While consul in 267 B.C., he conquered the Sallentini and captured Brundisium (now Brindisi). He became consul a second time in 256, won the naval battle of Ecnomus and defeated the Carthaginians at sea. The Romans had built some one hundred sixty vessels equipped with grapnels (small anchors with several claws), which helped to thwart their enemy's brilliant naval skill. This victory opened the way for the invasion of Africa, the preliminary battles at first finding success. Regulus defeated the Carthaginians and captured Tunis, but offered impossibly severe peace terms. In the spring of 255 the Carthaginians won a complete victory and captured Regulus. This disaster ended the African expedition. Later, Regulus was sent on parole to arrange an exchange of prisoners and to negotiate peace terms with the Romans. He advised the senate to decline the Punic terms for exchanging prisoners. Resisting persuasions to break his parole, he returned to Carthage where he died in captivity. Some accounts say he was tortured to death. But the story may have been invented to excuse the action of his widow in torturing Punic prisoners in Rome. The story of his death caused Regulus to become a famous Roman patriot-martyr.

He is shown inside a giant wooden barrel (only his head sticks out) into which foot-long iron spikes are being hammered. The lid, which will close him inside, is already filled with spikes. A small crowd has gathered to watch the torture that will continue until his death.

Example: Salvator Rosa, Museum of fine Arts, Richmond, Virginia. (Waterhouse, fig. 163)

DEATH OF SAPPHIRA. The story of Sapphira, discovered as she tried to cheat the Church, is told in Acts 5:1–11: "A man named Ananias with his wife Sapphira sold a piece of property, and with his wife's knowledge he kept back some of the proceeds, and brought only a part and laid it at the apostles' feet. But Peter said, 'Ananias, why has Satan filled your heart to lie to the Holy Spirit and to keep back part of the proceeds of the land? While it remained unsold, did it not remain your own? And after it was sold, was it not at your disposal? How is it that you have contrived this deed in your heart? You have not lied to me but to God.' When Ananias heard these words, he fell down and died. And great fear came upon all who heard it. The young men rose and wrapped him up and carried him out and buried him. After an interval of about three hours his wife came in, not knowing what had happened. And Peter said to her, 'Tell me whether you sold the land for so much.' And she said, 'Yes, for so much.' But Peter said to her, 'How is it that you have agreed together to tempt the Spirit of the Lord? Hark, the feet of those that have buried your husband are at the door, and they will carry you out.' Immediately she fell down at his feet

and died. When the young men came in they found her dead, and they carried her out and buried her beside her husband.''

Sapphira is depicted as she is miraculously felled by the words of the angry Peter, to the awe and astonishment of those who witnessed the scene. In wrath, Peter points in her direction and those about her offer aid—to no avail.

Example: Nicolas Pousson, The Louvre, Paris. (Friedlaender, fig. 68)

DEATH OF ST. BRUNO. BRUNO, the founder of the order of Carthusians, lived between c.1030 and 1101. Born at Cologne of a good family, he left home while still young to finish his education at Tours and also at the cathedral school of Rheims in France. He left Rheims after he discovered its archbishop was guilty of simony (selling church offices). After this he took several companions to the Grande Chartreuse, an uninhabited place in the mountains near Grenoble, where he founded the first Carthusian community. Later he was summoned to Italy by the pope and began establishing monasteries in Calabria. According to one source he was canonized in 1623. Other sources say he was never canonized.

During the 17th century, artists depict him wearing the habit of the order, with a white scapular (a long-front-and-back apron) tied at both sides. He is shown on a board bed in a room that has the appearance of a stable surrounded by monks dressed in the habit of his order. His hands are held in prayer on his chest. One monk holds a crucifix; others pray and kneel. A single candle, as is typical of the Baroque, lights the scene and creates the deep, theatrical shadows of TENEBRISM.

Example: Eustache Le Sueur, The Louvre, Paris. (Bazin, fig. 106)

DEATH OF ST. FRANCIS XAVIER. Saint Francis Xavier was born of noble parents in Navarre at the castle of Xavier, near Pamplona in 1506 and died in 1552. He was a Basque Jesuit missionary who was called the ''Apostle to the Indies'' and is considered one of the greatest of Christian missionaries. His native language was Basque. During a period of eleven years, his travels took him over many thousands of miles, and his successes in personal conversion and preaching were prodigious. As an individual he had a charisma, a combination of common sense and unusual deep mysticism. When eighteen-years old he went to Paris to study and became associated with SAINT IGNATIUS OF LOYOLA. He and five others vowed themselves to the service of God with Ignatius in Montmartre; this made them the nucleus of the SOCIETY OF JESUS. Xavier is, therefore, one of the original members of the society. In 1536 he went to Venice to work in hospitals there. The following years, in Venice, Xavier and Ignatius were ordained and received their priesthood. They went to Rome and worked for the society there until 1540, at which time Xavier left for Portugal to join a mission the king planned to send to Goa. He preached in Goa, where the Christians' scandalous behavior was a challenge, and was extremely successful. He gave mass to lepers and comforted slaves and prisoners. After five months he left to travel to the pearl fisheries of West India and spent

fifteen months on the coast from Ceylon northward, then returned to Goa and traveled to several other places. In the meantime, more Jesuits traveled to India, and Saint Francis placed them in missions he had established. In 1552 he returned to Goa and had decided to go to China with a Portuguese embassy. During this trip he died alone, except for a Chinese friend, in a primitive hut on the island of Changchuen (St. John) near the Canton River. Today he is buried at Goa. He was canonized in 1622. After Ignatius Loyola, Francis Xavier is the most popular of the Jesuit saints. So numerous were the individuals he baptized that at times he was scarcely able to move his arms from sheer fatigue.

Artists show St. Francis Xavier baptizing, curing the ill, and preaching. Paintings of him are found in Jesuit churches. He usually wears a white surplice over a black habit. His hair is dark and he is shown with a short black beard. He may carry a lily (the symbol of chastity) or a crucifix. Some artists show him near the couch of a dead man, whom he has just restored to life. Above his head a vision of Christ showing his wounds appears. (Nicolas Poussin's work in the Louvre shows this.) Francis's death scene sometimes depicts the saint alone in a hut. Others show him in the open with angels above and other missionary workers coming upon him. Some artists show the discovery of the body by natives of the Indies. They may wear feathers in their hair; at the time, this was the conventional costume of the American Indian, and artists did not distinguish them from the Indians of Asia. *See also* MIRACLES OF ST. FRANCIS XAVIER.

Example: Carlo Maratta, Jesuit church of Il Gesù, Rome. (Waterhouse, fig. 71)

DEATH OF ST. SCHOLASTICA. Scholastica, the sister of St. Benedict (the founder of the oldest western monastic order named after him), and, in fact, believed to be his twin, lived between c.480 and c.553. She settled near Monte Cassino at Plombariola and from her earliest years dedicated her life to religion. She only saw her brother once a year and, because she was not allowed to enter his monastery, he was known to go with some of his monks to meet her at a house not too far away. They spent their time conferring together on spiritual matters and in praise of God. A community of nuns grew up around her about five miles to the south of her brother's monastery. Though she never took vows, she is usually regarded as the first Benedictine nun. St. Gregory writes that St. Benedict governed nuns as well as monks, and it is possible that St. Scholastica could have been the nuns' abbess, under his direction. St. Gregory gives a description of the last visit between sister and brother. When it was over, feeling herself near death, Scholastica prayed for a storm when her brother said he could not pass a night away from his monastery even to be with her. Her prayer had scarcely ended when a violent thunderstorm arose with such lightning that St. Benedict and his companions were unable to step outside the door. He said, "God forgive you sister: what have you done?" And she answered, "I asked a favour of you and you refused it. I asked it of God, and He has granted it."

Scholastica died three days later. At her death Benedict saw her spirit leave her body in the form of a dove.

She is shown as a young woman dressed in black. She may hold a crucifix or a lily, the symbol of chastity. A dove may issue from her mouth (in accordance to Benedictine's vision of the dove leaving her body), or it may hover over her head or rest on her hand or on a book. Weeping friends gather about her while angels dip down from heaven to attend her.

Example: Gregorio de Ferrari, S. Stefano, Genoa. (Wittkower, fig. 240)

DEATH OF THE VIRGIN. The death of the Mother of God is also known in the Eastern Church as her Dormition. The story of her death is told in the GOLDEN LEGEND, an extended account based on the apocryphal works. The subject was popular from the 13th through the 17th century. According to the *Golden Legend,* Mary was not dead but merely sleeping during the three days until her Assumption (see ASSUMPTION OF THE VIRGIN); hence, the term "Dormition," meaning asleep or resting. It was said that an angel stood by her side in the midst of blinding light and greeted her as the blessed Virgin Mary, the Mother of God; the angel offered her a frond of the palm of paradise and told her the palm branch must be carried in front of her bier, the platform on which her coffin was placed. She was told that it would be three days before her soul would be called forth from her body, that her Son waited for her in heaven. The angel caused the apostles, who were traveling over the world, to be borne to the Virgin's door. And the apostles, seeing themselves gathered together, wondered and asked John why all the apostles of Jesus had been brought together. It was John who told them of Mary's pending departure from her body. He said that when she died, not one of them should weep for her, because seeing the apostles crying for the Lord's mother would cause the people to be greatly troubled and to comment that the very men who preach the resurrection to others fear death themselves. At about the third hour of the night, Jesus came from heaven with all the different ranks of angels, the multitude of martyrs, the great numbers of patriarchs, the congregations of confessors, and the special choir of virgins. All took their places before the magnificent and brilliant throne of the Virgin, and their voices rang high in sweet and solemn song. And Jesus told her she would be placed upon his throne in heaven. According to the *Golden Legend,* the Virgin, when she died, was probably seventy-two years old. But we read elsewhere that she lived but twelve years after her Son, and thus died at the age of sixty. This seems more likely, for, according to the *Ecclesiastical History,* the apostles preached in and about Judea for that length of time.

Artists show the Virgin's dead body on a couch or a bier or a pallet. In some works she may be alive and holding a lighted candle, in accordance with the old custom of placing a candle in the hands of a dying person, its light a symbol of the Christian faith. The twelve apostles are present. St. John may hold a palm, handed to him by the Virgin. More often he kneels or stands beside her

bed. One or even two women are widows, the Virgin's friends to whom she gave her robes. During the COUNTER REFORMATION it was taught that death took Mary without pain. Because of this she is sometimes shown during the Baroque period not on a bed but on a throne or a chair, her head fallen back. The apostles surround her.

Example: Caravaggio, The Louvre, Paris. (Bottari, figs. 56–57)

DEATH OF VIRGINIA. The story of Virginia (Verginia), murdered by her father to save her honor which was threatened by the decemvir Appius Claudius, is a case of corrupt justice defeated. It is told in Livy's *The Early History of Rome,* 3:44–48. Appius Claudius, one of a board of ten magistrates dating from the 5th century B.C. known as a decemvir (which council drew up the first Roman code of laws), announced to all that he would have no woman except a virgin. The object of his desire, a girl of humble birth, was the daughter of Lucius Verginius who was serving with distinction as a centurian on Algidus. His record, both military and civilian, was excellent and his wife and children had also been trained in high principles. Verginia would have nothing to do with Appius Claudius, so he instructed his man Marcus Claudius to claim the girl as his slave. At the time her father was away from Rome, and Appius wrote to his colleagues in command of the army telling them to refuse Verginius leave or to put him under arrest. The note arrived too late and Verginius returned. But Appius had already declared Verginia to be his slave. Verginia's father, stupefied at the monstrous decision over which he had no control, saw that he had no way to turn and made up his mind in a matter of moments. He told Appius that if he had spoken too harshly it was his heart that was to blame and thus he should be forgiven. He said the entire affair bewildered him, and to straighten it out a nurse had to be questioned in his child's presence. He agreed that if he found that he was not her father he would understand and go peacefully. It was thus that he took the nurse and Verginia to the New Shops by the shrine of Cloacina where he took a knife from a butcher, and telling Verginia there was only one way to make her free, he stabbed her to death. He then looked at the tribunal, Appius, and cursed him, saying he hoped the blood of Verginia might rest upon his head forever.

Appius Claudius is usually shown on the seat of judgment high above a crowd. Before him Verginius holds his daughter with the knife poised, or he holds her dead body. Appius's fellow conspirators are part of the crowd.

Example: Nicolas Poussin, Pen and bistre wash, Royal Library, Windsor Castle, England. (Friedlaender, fig. 28)

DECORUM. A Latin word, *decorum* is the equivalent of the Greek *harmotton* or *prepon.* It expressed one of the most prevalent aesthetic concepts of late classical antiquity, especially in Roman theories of rhetoric and poetics. The idea combined the two elements that the various aspects of a work of art shall be harmonious with each other and that there shall be agreement between the

work of art and those parts of reality that are seen in it. Plato, in his *Hippias Major,* exposed a paradox in the identification of beauty with suitability or what is appropriate. He condemned nonrelevance of melody, rhythm or style and asked for congruity of expression to occasion and subject. Expedience of style to purpose and subject was a major requirement with Isocrates and Aristotle. Aristotle's demand that the qualities of characters in dramatic art should be suitable to their class and station became the basis in Renaissance and later Neoclassical literary theory. In Horace, Cicero and later Roman critics, the principle of decorum became supreme. In his *De Orati,* i. 132, Cicero quotes the actor Roscius who believed that "a sense of fitness, of what is becoming, is the main thing in art, and yet the only thing which could not be taught by art." Horace does not use the word "decorum" in his *Ars Poetics,* however, the idea is a major principle throughout, and he states that "propriety or fitness was to be observed in a work as a whole and in its several parts; it applied to the form, the expression, and the characterization; it determined the choice of subject, the metre, the particular style or tone; while it also forbade the mixing of incongruous elements, the mingling of genres, the creation of characters that lacked verisimilitude, the improper use of the *deus ex machina,* and the like."

During the Baroque, the French artist Nicolas Poussin appeared as an intelligent and correct model of decorum. On the other hand, lack of decorum was the primary charge against such artists as Rembrandt and Caravaggio. Both introduced common low types into religious and noble stories and neglected the conventions of gesture, costume and setting that had, throughout the ages, come to be considered appropriate.

DEFEAT OF PORUS BY ALEXANDER. Alexander the Great, or Alexander III, 356–323 B.C., the son of Olympias and Philip II of Macedon, was king of Macedon and conqueror of much of Asia. He was fortunate in that his parents provided him with the supreme education of a perfect prince, with Aristotle as his tutor. After 330 B.C., Alexander, having conquered most of what became his empire, including Bactria and Sogdiana, went on from what is today Afghanistan and into North India. A few of the princes there received him favorably and his men encountered no fighting. This, however, was not the case at the Hydaspes (the present-day Jhelum River). Here he met, battled and defeated an army under the Indian king Porus. Artists show the wounded king brought before the triumphant Alexander, who appears immensely satisfied that he is the victor; at the same time, Alexander is impressed by the nobility and dignity of his enemy. Confident of Porus's loyalty in the future, Alexander grants him continued domain over his empire, an illustration of effusive royal leniency.

Example: Charles Le Brun, The Louvre, Paris. (Held and Posner, figs. 166–67)

DELUGE, THE (*The Flood*). The story of the Deluge is told in Genesis 7, 8: 1–19. The Lord said to Noah, " 'In seven days I will send rain upon the earth forty days and forty nights; and every living thing that I have made I will blot

out from the face of the ground.' The flood continued forty days upon the earth; and the waters increased, above the earth. The waters prevailed and increased greatly upon the earth; and the ark [built by Noah] floated on the face of the waters. And the waters prevailed so mightily upon the earth that all the high mountains under the whole heaven were covered; the waters prevailed above the mountains, covering them fifteen cubits [about 18–22 inches] deep. And all flesh died that moved upon the earth, birds, cattle, beasts, all swarming creatures that swarm upon the earth, and every man; everything on the dry land in whose nostrils was the breath of life died. . . . Only Noah was left, and those that were with him in the ark. And the waters prevailed upon the earth a hundred and fifty days.'' The water began to abate and at the end of a hundred and fifty days the waters had subsided. In the seventh month, on the seventeenth day, the ark came to rest upon the mountains of Ararat. The waters still subsided until on the first day of the tenth month, the tops of the mountains were seen. To determine whether the earth was habitable, Noah sent out a raven, but it did not return. Then he twice sent a dove, and after the second time out, the dove returned with a freshly plucked olive leaf. Noah took his family and the animals out of the ark so that they might "be fruitful and multiply, bring forth abundantly on the earth and multiply in it."

The sinful are shown struggling in the rising waters. The ark of Noah, the symbol of the Church, floats peacefully and steadily amid the terrible storm. A snake, the symbol of evil, slithers over rocks under a dark, water-laden sky.

Example: Nicolas Poussin, *Winter* scene from the *Four Seasons,* The Louvre, Paris. (Friedlaender, colorplate 47)

DE' MEDICI. *See* HENRY IV RECEIVING THE PORTRAIT OF MARIA DE' MEDICI.

DEMOCRITUS. Democritus, a Greek philosopher, was born at Abdera in Thrace. His birth and death dates are not exact and three sets are usually given: 460–457, 470–469, 500–497 (B.C.) The first is the date that agrees with Democritus's own words. Although a legend exists that he blinded himself (Tertullian, *Apologeticus* 46 d), so he would not be able to see or be tempted to enjoy beautiful women, *Plutarch* (*de curios* 521 d) denies it. Democritus was known in later antiquity as the "laughing philosopher," primarily because of the entertainment he found in the absurdities and stupidities of mankind. The townsmen of his birthplace, Abdera, were universally ignorant. Democritus's philosophy was used during the Baroque to support the idea that happy, joyful behavior was correct for a philosopher. His philosophy, though, is nearly impossible to separate from the views of Leucippus when it comes to the atomic theory. It was proposed to rescue the world of motion and plurality by asserting that empty space, "the non-existent," may serve to separate parts of what does exist from each other. According to the philosophy, the world has two ingredients: being, that is full and nonchanging, and nonbeing or empty space. The

pieces of real being, since it is their characteristic to be indivisible units, are called atoms. They are, supposedly, invisibly small, solid and undifferentiated in material; they are dissimilar to each other in size and shape only and possibly also in weight, and the only change they undergo is in their real and relative position through activity in space. Democritus states that the soul, which is the cause of life and feeling, is made of minute round atoms and is as fragile and impermanent as the body. It is important not to allow the fear of death to ruin life and to be aware of the limits of which man is uncontrollably confined. There must be moderation and good sense in selecting pleasures. In his writings he defends the infinite and delicate universe. Philosophers of the day preferred his opponent's arguments, and it wasn't until after the Renaissance that great honor was paid to him, by which time his books had been lost.

Democritus has for his attribute a terrestrial globe, although not all artists show it. If it is shown, he may point to it. He usually wears a black cloak.

Example: Antoine Coypel, The Louvre, Paris. (Held and Posner, fig. 169)

DENIAL OF ST. PETER. The story of the denial and repentance of Peter is told in Mark 14:61–72. After Jesus was arrested, the high priest Caiaphas questioned him. He said, " 'Are you the Christ, the Son of the Blessed?' And Jesus said, 'I am; and you will see the Son of man sitting at the right hand of Power, and coming with the clouds of heaven'. . . . And they all condemned him as deserving death. And some began to spit on him, and to cover his face, and to strike him, saying to him, 'Prophesy!' And the guards received him with blows. . . . And as Peter was below in the courtyard, one of the maids of the high priest came; and seeing Peter warming himself, she looked at him, and said, 'You also were with the Nazarene, Jesus.' But he denied it, saying, 'I neither know nor understand what you mean.' And he went out into the gateway. And the maid saw him, and began again to say to the bystanders, 'This man is one of them.' But again he denied it. And after a little while again the bystanders said to Peter, 'Certainly you are one of them; for you are a Galilean.' But he began to invoke a curse on himself and to swear, 'I do not know this man of whom you speak.' And immediately the cock crowed a second time. And Peter remembered how Jesus had said to him. 'Before the cock crows twice, you will deny me three times.' And he broke down and wept.''

Peter is shown as an old man with the serving maid speaking directly to him. Several bystanders watch. Some Italian and Spanish artists show his repentant weeping.

Example: Rembrandt van Rijn, Rijksmuseum, Amsterdam. (Rosenberg, Slive, ter Kuile, fig. 100)

DEPOSITION (*Deposition from the Cross* and *Descent from the Cross*). The removal of Christ's body from the cross is described in Matthew 27:57–58, Mark 15:42–46, Luke 23:50–56 and John 19:38–40. According to Luke, ''there was a man named Joseph from the Jewish town of Arimathea. He was a member

of the council, a good and righteous man, who had not consented to their purpose and deed, and he was looking for the kingdom of God. This man went to Pilate and asked for the body of Jesus. Then he took it down and wrapped it in a linen shroud, and hid Him in a rock-hewn tomb, where no one had ever yet been laid. It was the day of Preparation, and the sabbath was beginning. The women who had come with him from Galilee followed, and saw the tomb, and how his body was laid; and they returned, and prepared spices and ointments." The Deposition, or Descent from the Cross is the episode that follows the CRUCIFIXION.

Some artists, such as Rembrandt in his *Descent from the Cross,* show the nails being removed from the body by Nicodemus, who uses black pincers. Some show the body being lowered after the nails have been removed and the body is free. The development of the theme from the Renaissance through the Baroque is in the direction of more numerous figures and a greater display of movement. The INSTRUMENTS OF THE PASSION may be shown strewn on the ground: the nails, the crown of thorns and sometimes the sponge (for the vinegar) and the inscription INRI (Jesus of Nazareth King of the Jews) that was hung above his head on the cross. During the 17th century more emphasis was placed on MARY MAGDALENE (venerated as the personification of Christian penitence during the COUNTER REFORMATION). She may wipe Christ's feet, as she does at the crucifixion

Example: Caravaggio, Pinacoteca Vatican, Rome. (Bottari, figs. 49–50)

DESCENT FROM THE CROSS. *See* DEPOSITION.

DESIGN. BALDINUCCI defines design as "a visible demonstration by means of lines of those things which man has first conceived in his mind and pictures in the imagination, and which the practiced hand can make appear . . . it signifies also a configuration and composition of lines and shades which designates what remains to be coloured or otherwise executed and that represents a work already done." Also during the Baroque, Platonists, such as Giovanni Paolo Lomazzo, GIOVANNI PIETRO BELLORI and Federico Zuccaro identified DISEGNO with the idea of design. Zuccaro, in his 1607 *L'idea de' pittori, scultori e architetti,* pointed out what he referred to as *disegno interno,* or "idea" from *disegno esterno,* the execution of the idea in some medium (material) such as wood, stone or paint. On the other hand, the Aristotelians taught that design must be based on an acute observation of nature.

DESTRUCTION OF SODOM. Sodom or Sodoma is one of the principal Cities of the Plain in the Bible, the others being Gomorrah, Zeboiim, Admah and Zoar, all located near the southern portion of the Dead Sea. With the exception of Zoar, these cities were destroyed by fire from God because of their inhospitality and carnal wickedness. According to Genesis 13:13, 18:20–26 and 19:24–28, "the men of Sodom were wicked, great sinners against the Lord. . . . Then the

Lord said, 'Because the outcry against Sodom and Gomorrah is great and their sin is very grave, I will go down to see whether they have done altogether according to the outcry which has come to me; and if not, I will know.' '' It was at this time that Abraham became concerned: '' 'Wilt thou indeed destroy the righteous with the wicked? Suppose there are fifty righteous within the city; wilt thou then destroy the place and not spare it for the fifty righteous who are in it?' . . . and the Lord said, 'If I find at Sodom fifty righteous in the city I will spare the whole place for their sake'. . . . Then the Lord rained on Sodom and Gomorrah brimstone and fire from the Lord out of heaven; and he overthrew those cities, and all the valley, and all the inhabitants of the cities and what grew on the ground. . . . And Abraham went early in the morning to the place where he had stood before the Lord; and he looked down toward Sodom and Gomorrah and toward all the land of the valley, and beheld, and lo, the smoke of the land went up like the smoke of a furnace.''

In art, fire rains from storm-heavy heavens and the city burns in flames. Pediments, columns and stones crash to the ground.

Example: Monsù Desiderio (Didier Barra and Francesco de Nome), Bagnoli Sanfelice Collection, Naples. (Bazin, fig. 32)

DIANA AND ENDYMION. *See* LUNA AND ENDYMION.

DIANA HUNTING (*The Hunt of Diana*). The Greek goddess Artemis was known to the Romans by her Latin name, Diana. One of the twelve gods and goddesses of Olympus, she was, from Homer onward, the daughter of Zeus and Leto, the ''lady of wild things,'' and twin sister of Apollo, a huntress and a ''lion unto women.'' Her functions as a birth goddess and a bringer of fertility, to man and animals, together with health to their offspring when born, are obscure. She was worshipped with Apollo at Delos, and her most important sanctuaries were at Ephesus and at Brauron in Attica. She was associated, particularly in the Peloponnese, with the fruitfulness of trees. For the historical Greeks, she was a virgin, an extraordinary athletic goddess of chastity, associated with wild animals and uncultivated places and often combined with Hecate, or with Selene, the moon goddess. She was also sometimes a primitive birth goddess and was known to help women in childbirth. The Romans worshipped her as a triple deity, Diana (the earth), Hecate (the underworld), and Luna (the sky). She carried a bow and a quiver filled with arrows, and with these she not only brought natural death but also punished impiety.

She is depicted as tall and slender and usually wears a flowing dress, often with animal skins, and her long hair is tied back. She may have a crescent moon over her brow. Usually one hand carries her bow and the other is raised in the act of drawing an arrow from the quiver on her back. (Some artists show her with a javelin or spear.) She is usually accompanied by dogs, and she may pursue a stag. Sometimes Diana is in the company of nymphs and sometimes

satyrs, carrying spears. Some artists depict them returning from the hunt carrying animals and birds. Diana may be shown resting, her weapons lying about her on the ground along with dead animals.

Example: Domenichino (Domenico Zampieri), Borghese Gallery Rome. (Bazin, fig. 21)

DIOGENES. *See* LANDSCAPE WITH DIOGENES.

DISEGNO. An Italian word with a variety of meanings, of which the most important in terms of art history is drawing, and following that, design. The term *arti del disegno* is used to refer to the visual arts in general, not drawing alone.

DI SOTTO IN SÙ. Literally, from below upwards. A technique of perspective used by 17th-century ceiling painters to create the effect of the viewer looking up from a point below the subject.

DIVISION OF THE SPOILS. One of several GENRE themes depicting family life, a tavern, an inn and military life, including scenes of dividing up the plunders of war and the sometimes appalling excesses of the soldiery. "Spoils," became a subject after the horrors and disasters caused by the wars of religion of the 17th century were long past and the memories of cruel foraging soldiers mostly forgotten. The paintings were a picturesque and pleasing representation that gained great success with middle-class society. Soldiers and richly dressed ladies are depicted sitting and standing amid a plethora of obviously valuable pillage: expensive bowls, household vessels, trinkets, jewelry and other precious items that would catch the eye of a pirate. Everyone appears calm and sometimes even lethargic or inebriated.

Example: Jacob Duck, The Louvre, Paris. (Bazin, fig. 76)

DOMINE, QUO VADIS. The story of Peter's departure from Rome after the prompting of his fellow Christians at the height of the persecutions by Nero is told in Voragine's GOLDEN LEGEND. It seems that Peter, after being asked many times by his fellow apostles to leave Rome, did so and prepared to go. But when he arrived at one of the city gates, at the site of the church of Saint Mary ad Passus, according to Leo and Linus, he came face to face with Christ Himself; and he said to Him: " 'Lord, whither goest thou?' And Our Lord responded: 'I go to Rome, to be crucified anew!' 'To be crucified anew?' asked Peter. 'Yes!' said Our Lord. And Peter said: 'Then Lord, I too return to Rome, to be crucified with Thee!' " It was at this time that Jesus ascended to Heaven, and Peter stood at the place all in tears. Christ is shown carrying a cross, pointing towards Rome and speaking to Peter, who leans back in fright.

Example: Annibale Carracci, National Gallery, London. (Waterhouse fig. 7)

DOMINIC, ST. *See* APOTHEOSIS OF ST. DOMINIC and MADONNA OF THE ROSARY.

DOMINIC RESUSCITATING A CHILD. The story of St. Dominic, a Castilian churchman originally named Dominigo de Guzmán, is found in Voragine's GOLDEN LEGEND. Dominic was the founder of the Order of Preachers, also known as Dominican or Black Friars. He was born in 1170 in Calaroga, Spain, and he died in 1221 in Bologna. His tomb, decorated with scenes from his life, is in that city. Before his birth, his mother dreamed that she bore in her womb a tiny dog that grasped a lighted torch in its mouth. When the dog came out of her womb, it set the whole world on fire with the torch. When Dominic's godmother brought him into the world, she said she saw a star upon his forehead that was so bright it shed light upon the whole world. Possibly because of these signs Dominic found his vocation preaching against heresy. He traveled preaching and healing throughout Europe. The resurrection of Napoleon Orsini, the child resuscitated, is told in the *Golden Legend.* This young man, the nephew of Stephen the cardinal of Fossa Nova, was killed after being thrown from his horse into a ditch. After being taken out, he was placed at the feet of Saint Dominic, who prayed over him and brought him back to life.

Dominic is shown praying for the child while his parents pray and plead for his life. He wears a white tunic and a scapular underneath a long black cloak with a hood, the habit of the Dominicans. Angels above hold his book, the gospels, and a lily to indicate his chastity. He may have a star on or above his forehead (the light seen by his godmother at his baptism). A black and white dog nearby, watching the miracle, alludes to his mother's dream and may explain the pun on his name *"Domini canis."* He may hold a rosary (beads used to count the special sequence of prayers to the Virgin Mary), thought to have been instituted by him; this alludes to an ancient tradition that the saint received the rosary from the Virgin Mary in a vision.

Example: Alessandro Tiarini, S. Domenico, Bologna. (Blunt, fig. 37)

DORMITION. *See* DEATH OF THE VIRGIN.

DOUBTING THOMAS (*The Incredulity of Thomas*). The story of Thomas, also Syriac, the apostle, is told in Voragine's GOLDEN LEGEND. Thomas, who bore a resemblance to Christ, was called Diadems, which in Greek means "twin," or dividing or separating. He earned this name because "he set himself apart from the other disciples in his belief in the Resurrection." Thomas was a Jew and probably a Galilean of unpretentious birth. There exists no history as to the circumstances in which Jesus made him an apostle and little reliability as to the traditions concerning Thomas. The most persistent tradition is that he preached the gospel in India. As an apostle, Thomas did not want to be sent to India, but "God said to him: 'Thomas, go in peace and without fear, for I shall be thy guardian. And when thou hast converted India, thou shalt come to Me

with the palm of martyrdom.' '' And Thomas went as a skilled architect and drew up plans for a magnificent palace for the king of India. The king left and was gone for two years during which time Thomas preached and converted an "innumerable multitude to the faith." When the king returned and learned what Thomas had done, he imprisoned him, intending to have him and his partner, Abbanes, flayed and then burned alive. In the meantime the king's brother died but was returned to life on the fourth day after his death. He told his brother that the man in prison was a friend of God and that he had seen the palace Thomas built for him in heaven when he was there.

Thomas is best remembered for his disbelief after Jesus had risen from the dead and on the same day appeared to his disciples to reveal the truth of his Resurrection. Thomas was not with them and did not believe that Jesus had truly risen from the dead. The story of "Doubting Thomas" is told in John 20: 19–29: "Jesus came and stood among them and said to them, 'Peace be with you.' When he had said this, he showed them his hands and his side. Then the disciples were glad when they saw the Lord. Jesus said to them again. . . . 'Receive the Holy Spirit. If you forgive the sins of any, they are forgiven; if you retain the sins of any, they are retained.' Now Thomas, one of the twelve, called the Twin, was not with them when Jesus came. So the other disciples told him, 'We have seen the Lord.' But he said to them, 'Unless I see in his hands the print of the nails, and place my finger in the mark of the nails, and place my hand in his side, I will not believe.' Eight days later, his disciples were again in the house, and Thomas was with them. The doors were shut, but Jesus came and stood among them, and said, 'Peace be with you.' Then he said to Thomas, 'Put your finger here, and see my hands; and put out your hand and place it in my side; do not be faithless, but believing.' Thomas answered him, 'My Lord and my God!' Jesus said to him, 'Do you believe because you have seen me?' ''

Thomas is usually shown as a young man sometimes with a beard. Somewhere about him may be a ruler of a builder's set-square or a dagger or spear, the instrument of his martyrdom. Thomas is shown with two other apostles, who stare aghast as Jesus holds aside his robe and Thomas sticks his finger into the wound on his right side. This extremely popular subject was meant to reinforce the articles of Christian doctrine.

Example: Caravaggio, Neues Palais, Potsdam. (Held and Posner, fig. 86)

DR. FAUSTUS. Faustus is the Latin form of Faust. Johann Faust was a 16th-century German doctor, a magician and astrologer who traveled extensively, entertained with extraordinary accomplishments in magic and died under unexplainable circumstances. According to legend, Faust was an old philosopher who, after becoming dissatisfied with the limited nature of human knowledge, sold his soul to the devil in exchange for the power of magic, youth, knowledge and worldly experience. In several literary versions, the devil is personified by Mephistopheles. Innumerable folk tales and invented stories were attached to the name Faustus. The first printed version is the *Volksbuch* of 1587 by Johann

Spiess, the English translation of which became the basis of Christopher Marlowe's 1593 play *Dr. Faustus*. Several versions followed, some seriously developed art forms and others foolish comedies. Faust is represented as a quack, a scoundrel justly punished with eternal damnation. Some authors saw him as a symbol of man's endless and heroic striving for power and knowledge and therefore deserving of praise and salvation. The term "Faustian" has come to mean sacrificing spiritual values for material gains, insatiably striving for knowledge and mastery and constantly troubled and tormented by spiritual dissatisfaction or spiritual striving.

In the example below, an old scholar is depicted at the precise moment when an amazing otherworldly light, almost celestial, appears in his leaded glass window with comprehensible Christian symbols in it. The preternormal brilliance catches his eye and causes him, startled, to look up, to interrupt his work and rise from his desk.

Example: Rembrandt van Rijn, Etching, British Museum, London. (Rosenberg, Slive, ter Kuile, fig. 135)

DRUNKEN SILENUS. In Greek mythology, Silenus was a rural god, a part bestial and part human creature, a happy, fat drunkard who, although he lived life as a party in the forests and mountains, nevertheless was wise and had the gift of prophecy. In the beginning the Sileni were spirits of wild nature similar to satyrs, but by the 6th century B.C. Silenus appears in art as a bearded man with horse ears. At this time he becomes connected with the god of wine Dionysus (BACCHUS) and is sometimes said to have been his tutor, his adviser and companion. Silenus commands special knowledge and the wisdom that is inspired by alcohol; he is usually drunk as is told in the story of Midas. There are similar stories of his being captured and captivating his audience with fabulous tales, as in Virgil's *Eclogue* 6. He also becomes a comic drunkard, and sileni are sprinkled throughout the chorus in the comic satyr plays.

In Greek Hellenistic art, Silenus usually appears fat, jolly, witty and brazen, riding a donkey, rather than with the dignity he displays in the frescoes of the Villa dei Misteri at Pompeii. Some Baroque artists show Silenus riding in his own cart, drawn by a donkey. Socrates was sometimes compared with Silenus both for his ugliness and for his God-given wisdom; and in Plato's *Symposium,* Alcibiades compares Socrates with the tiny Silenus statuettes, or boxes that opened to reveal the figure of a god inside. Silenus appears in most BACCHANAL paintings. Rubens painted one in which Silenus is being helped along by satyrs and bacchants, or nymphs, who are all equally intoxicated. According to some myths, the Sileni were prophets; but according to others, they stayed perpetually comatose with alcohol and were unable to distinguish truth from fabrication. In some legends only one such creature appears, Silenus, described as the oldest of the satyrs, the son of Pan or Hermes. Silenus is usually depicted as jolly, fat, bearded, naked and drunk. Satyrs pour wine for him.

Example: José Ribera. Capodimonte Museum, Naples. (Ruskin, fig. 2–4)

E

ECCE HOMO. The words of Pontius Pilate, the Roman governor of Judea, "*Ecce Homo,*" or "Behold the Man," are found in John 19:4–6. "Pilate went out again, and said to them, 'Behold, I am bringing him out to you, that you may know that I find no crime in him.' So Jesus came out, wearing the crown of thorns and the purple robe. Pilate said to them, 'Here is the man.' And Jesus was brought out to the Jews gathered outside the judgment hall after he had been whipped and crowned with thorns. When the chief priests saw him they shouted for Jesus' crucifixion."

Ecce Homo can be depicted in two ways: as a devotional image, in which case Jesus is shown alone as a half-figure crowned with thorns; or as a narrative statement, in which many persons of the drama are shown in a town square or on the balcony of Pilate's *praetorium,* or judgment hall. Jesus is a young man sometimes wearing the emblems of a king given to him by the Roman soldiers. He may also clutch a reed meant to be a king's sceptre. His hands are usually tied in front of his body at the wrists, and he may have a knotted rope about his neck. Some artists show the marks of the Roman lash on his body. Usually his face is kind and sad, showing great compassion for those who torment him. An otherworldly light glows about his head.

Example: Rembrandt van Rijn, Etching, Pierpont Morgan Library, New York. (Held and Posner, fig. 254)

ECHO AND NARCISSUS. *See* NARCISSUS AND ECHO.

ÉCHOPPE. A type of needle used for etching that has the point cut off diagonally. Large in diameter, this tool was used extensively during the 17th century by artists such as Abraham Bosse, a French illustrator and engraver, and Jacques Callot, a French engraver from Nancy as well as others who preferred the effect produced, which was similar to that of the BURIN used in line engraving.

ECSTASY OF ST. MARGARET OF CORTONA. Margaret of Cortona, 1247–1297, was born the daughter of an Italian peasant farmer of Laviano in Tuscany. Her mother died when she was seven years old, and when her father remarried, the stepmother soon turned cruel, hard and unyielding, having neither patience nor sympathy for the pretty, happy child. Because of this Margaret, high-spirited and lovely, fell in love with a young, wealthy cavalier from Montepulciano. One night he induced her to elope with him to his castle in the mountains. Here she lived for nine years—openly in sin—and, wearing costly jewels and robes about town, caused malicious scandals. She bore one son for this man and they were happy together. One evening he failed to return from a visit to one of his estates. Margaret waited and watched for him until finally she saw his dog running towards the castle. She followed it back through the forests to an oak tree where, as the dog scratched, she was horrified to find the body of her lover, who had been murdered, mangled, thrown into a pit and buried under leaves.

Margaret saw in this ghastly situation the judgment of God against her iniquities and decided to leave Montepulciano. She gave her lover's relatives all that was his except for a few jewels, which she sold, then distributed the money to the poor. Dressed in a gown of penitence, she returned to her parent's home with her young son. When her father refused her, she went to Cortona, where she had heard she could receive help, to seek the aid of the Friars Minor. In Cortona two ladies recognized her pitiful plight, as she had no food and no roof over her head, and they took her to the Franciscans. At first she made her living by nursing, but she later gave this up to devote herself to prayer. But being young and still lovely, she fought temptations of the flesh for three years. After this she existed on charity.

As Margaret grew older, she began to spend her nights in prayer, seldom sleeping. She lay on the bare ground and ate only bread and raw vegetables and drank water. For constant and painful penance, she wore a thick hair shirt next to her skin and daily disciplined her body for her own sins and all the sins of mankind. She died at the age of fifty after spending twenty-nine years praying that her sins be forgiven. On the day of her death she was made a saint, and the people of Cortona began to build a church in her honor. The original church no longer exists, but St. Margaret's body is under the high altar in the present building. She was formally canonized in 1728. It was recorded that on one occasion, as Margaret prayed before a crucifix, the head of Christ bent forward to signify his forgiveness and she finally felt that she had been accepted into his arms.

Margaret is depicted as young and beautiful. She may wear a veil and the knotted girdle of the Franciscans. In ecstasy, she is shown kneeling, sometimes supported by angels before a vision of Christ, who is showing her the wounds in his hands. Her attribute is a dog, usually a small spaniel, the one that belonged to her lover.

Example: Giovanni Lanfranco, Palazzo Pitti, Florence. (Waterhouse, fig. 34)

ECSTASY OF ST. THERESA. The Ecstasy was a mystical experience of the Spanish Carmelite nun Theresa of Avila, who lived from 1515 to 1577. After being cited in the Bull of her canonization in 1622, it became a popular artistic subject in churches of her order, the Barefoot Carmelites. Theresa was a hard-working reformer who founded numerous monastic establishments and taught St. John of the Cross. In her famous book *Life,* written 1562–65 (one of many), she described her Ecstasy: "Beside me, on the left hand, appeared an angel in bodily form, such as I am not in the habit of seeing except very rarely. Though I often have visions of angels, I do not see them. . . . But it was our Lord's will that I should see this angel in the following way. He was not tall but short, and very beautiful; and his face was so aflame that he appeared to be one of the highest rank of angels, who seem to be all on fire. They must be of the kind called cherubim, but they do not tell me their names. I know very well that there is a great difference between some angels and others, and between these and others still, but I could not possibly explain it. In his hands I saw a great golden spear, and at the iron tip there appeared to be a point of fire. This he plunged into my heart several times so that it penetrated my entrails. When he pulled it out, I felt that he took them with it, and left me utterly consumed by the great love of God. The pain was so severe that it made me utter several moans. The sweetness caused by this intense pain is so extreme that one cannot possibly wish it to cease, nor is one's soul then content with anything but God. This is not a physical, but a spiritual pain, though the body has some share in it—even a considerable share. So gentle is this wooing which takes place between God and the soul that if anyone thinks I am lying, I pray God in His goodness, to grant him some experience of it."

The sculptured marble group of Theresa and the angel seems to hover in air on a cotton-like cloud, mysteriously illuminated, awash in light from a hidden stained glass window behind and above it. Theresa, transported, swoons and at the same time seems to strain forward and upward as if in the clutches of some unearthly force. Her mouth is open in that involuntary cry she herself mentioned and her eyes are shown below half-closed lids. The angel, standing on the cloud beside her, is in the act of withdrawing the arrow, having already pierced her body with it. His hand lifts her habit and prepares to implant the arrow in her breast once again.

Example: Gian Lorenzo Bernini, Marble, Cornaro Chapel, Santa Maria della Vittoria, (Hibbard, cover and figs. 69–72, 74)

ELIEZER AND REBECCA. *See* REBECCA AND ELIEZER AT THE WELL.

EMBARKATION OF ST. URSULA. The story of Ursula (Orsola in Italian), a legendary saint, is told in Voragine's GOLDEN LEGEND as the tale of "The Eleven Thousand Virgins." According to Voragine, a most Christian king named Norhus lived in Britain and had a daughter named Ursula. Her beauty

was so astonishing that even the king of England heard of her and declared that his happiness would be compete only after she became the wife of his only son. The young man was afire, delighted with the prospect of so lovely a wife. The king and his son therefore sent a solemn and most serious delegation to Ursula's father to ask for her hand. They lavished unlimited pledges and flattery upon her father, but added ugly threats if they should be forced to return empty-handed to their king. Ursula's father was against the union but she herself, inspired by God, said she would be able to yield to the king's demand. She decided that as a condition of marriage her suitor should find for her ten virgins as companions and should also give to her and to her new companions a thousand other virgins. Also, he was to make ready an entire fleet of ships for her and to allow her a delay of three years in which time she would devote to the practice of her virginity. She told the king that during these three years his son had to not only be baptized, but also instructed in the Christian faith. The young prince was delighted to consent.

The time to take the promised trip eventually arrived and a steady wind blew them to a port of Gaul, called Tiel. After this landing, they went to Cologne. It was here that an angel of the Lord appeared to Ursula in a dream and told her that they all would find the crown of martyrdom. Meanwhile two plotting captains of the Roman soldiery, named Maximus and Africanus, after viewing this marvelous multitude of virgins, dispatched messengers to their kinsman Julian, the prince of the nation of the Huns. They urged him to set his army against the virgins. Thus, when the unsuspecting virgins returned to Cologne, they found the city besieged by the Huns, who "put the whole multitude to death" (after trying unsuccessfully to ravish every single one). The prince of the Huns, however, was stupefied upon seeing Ursula, saying he had never witnessed such beauty. He said he would take her as his wife, certainly a great honor for her. However, she spurned him, and, seeing himself belittled before his men, he aimed an arrow at her breast and killed her. Ursula and her virgins were martyred in the year 238.

Ursula is usually shown as an exceptionally beautiful young girl holding an arrow. As she was the daughter of a king of Brittany, she may wear a crown and a cloak lined with ermine (which, because it is white may be a symbol of purity). The embarkation scenes show boats thronged with thousands of virgins in a harbor ready to set sail. Hundreds of virgins wait on the shore for their boat to dock.

Example: Claude Lorrain, National Gallery, London. (Blunt, fig. 247)

EMBARKATION OF THE QUEEN OF SHEBA. The story of the Queen of Sheba is told in I Kings 10:1–13. "Now when the queen of Sheba heard of the fame of Solomon concerning the name of the Lord, she came to test him with hard questions. She came to Jerusalem with a very great retinue, with camels bearing spices, and very much gold, and precious stones; and when she came to Solomon, she told him all that was on her mind. And Solomon answered all

her questions; there was nothing hidden from the king which he could not explain to her. And when the queen of Sheba had seen all the wisdom of Solomon, the house that he had built, the food of his table, the seating of his officials, and the attendance of his servants, their clothing, his cupbearers, and his burnt offerings which he offered at the house of the Lord, there was no more spirit in her. And she said to the king, 'The report was true which I heard in my own land of your affairs and of your wisdom, but I did not believe the reports until I came and with my own eyes had seen it; and behold, the half was not told me; your wisdom and prosperity surpass the report which I heard. Happy are your wives! Happy are these your servants who continually stand before you and hear your wisdom! Blessed be the Lord your God, who has delighted in you and set you on the throne of Israel! Because the Lord loved Israel for ever, he has made you king, that you may execute justice and righteousness.' Then she gave the king a hundred and twenty talents of gold, and a very great quantity of spices and precious stones; never again came such an abundance of spices as these which the queen of Sheba gave to King Solomon. . . . And King Solomon gave to the queen of Sheba all that she desired, whatever she asked besides what was given her by the bounty of King Solomon. So she turned and went back to her own land, with her servants.''

The real purpose of Sheba's visit to Solomon was to satisfy her curiosity about the incredible stories she had heard describing the wonders and wealth of his court. Sheba is included in the history of Christ's cross from the Garden of Eden down to the time of the Emperor Heraclius in the 7th century. The wood of the cross somehow ended up in Jerusalem where it was made into a bridge. Sheba, at the time of her visit to Solomon worshiped it, its future having been forecast to her in a vision. Rather than walk on the sacred wood, the queen waded through the stream. She traveled to Solomon with a magnificent camel train bringing spices, jewels and gold.

Some artists depict the queen and her attendants loading urns and pots containing gifts into ships at a port in preparation to set sail. The subject was seen as a prefiguration of the ADORATION OF THE KINGS.

Example: Claude Lorrain, National Gallery, London. (Bazin, fig. 115)

EMMAUS. *See* SUPPER AT EMMAUS.

ENDYMION. *See* LUNA AND ENDYMION.

ENTOMBMENT OF CHRIST (*Entombment*). The story of the Entombment of Jesus is told in Matthew 27:57–61, Mark 15:42–47, Luke 23:50–56 and John 19:38–42. According to Luke, ''there was a man named Joseph from the Jewish town of Arimathea. He was a member of the council, a good and righteous man who had not consented to their purpose and deed, and he was looking for the kingdom of God. This man went to Pilate and asked for the body of Jesus. Then he took it down and wrapped it in a linen shroud, and laid him in a rock-hewn

tomb, where no one had ever yet been laid. It was the day of Preparation, and the Sabbath was beginning. The women who had come with him from Galilee followed, and saw the tomb, and how his body was laid; then they returned, and prepared spices and ointments.'' The entombment is one episode from the PASSION OF CHRIST. Present were MARY MAGDALENE and Jesus's mother. John, in his gospel says, ''They took the body of Jesus, and bound it in linen cloths with the spices, as is the burial custom of the Jews. Now in the place where he was crucified there was a garden, and in the garden a new tomb where no one had ever been laid.''

Artists depict the scene so that it conforms to the account in the gospels. The action may take place in front of a hollow rock, which may have a neatly cut rectangular entrance. Joseph of Arimathaea may hold a sheet at the head of Jesus. The Virgin and John, the apostle who witnessed the CRUCIFIXION, may stand or kneel beside the body. Mary Magdalene, if she is included, may embrace Jesus' feet. Sometimes she is shown standing with her arms thrown toward heaven in a gesture of grief. Other holy women may be present. Some artists depict the body of Jesus being lowered into the tomb or, as in the case of Caravaggio, directly into the spectator's space.

Example: Annibale Carracci, Doria Pamphili Gallery, Rome. (Held and Posner, fig. 98)

ENTRANCE OF ST. IGNATIUS INTO PARADISE. Ignatius Loyola, c. 1491–1556, was born the son of an aristocrat at Loyola Castle near Azpeitia, Guipúzcoa, in northern Spain. He left his life at court to enter the army, and a wound in his leg rendered him permanently disabled. During his convalescence in 1521, he was converted to Christianity after reading the life of Christ and the lives of the saints. Thereafter, he turned his studies to religion. He wrote his famous *Spiritual Exercises* over a period of years early in the stages of his conversion. The exercises are a series of examinations of conscience, reflections and prayers grouped according to a traditional set of four steps leading to mystical union with God. While in Paris, Ignatius Loyola, along with Francis Xavier and five followers, took vows of chastity and poverty and founded what later became the SOCIETY OF JESUS. In time, this order, which received papal sanction, became identified with the Catholic COUNTER REFORMATION movement, although the society was not founded for this purpose. The objectives of the new society were primarily missionary work and the combating of Protestantism. Ignatius Loyola is buried in the Jesuit church of Il Gesù in Rome. He was canonized in 1622.

Loyola is usually depicted as middle-aged and balding. Most often he has a short, dark beard. He is shown in the black habit of the order and may hold a book inscribed *''Ad majorem Dei gloriam,''* or ''To the greater glory of God,'' the beginning words of the Rule. The monogram IHS or IHC (the first three letters of the name of Jesus, IHCUC in Greek) may appear in a halo or on a

tablet held by angels. Also present may be a heart crowned with thorns, the emblem of the Jesuits, the Sacred Heart. *See* also GLORY OF ST. IGNATIUS.
 Example: Andrea Pozzo, Ceiling fresco, S. Ignazio, Rome. (Bazin, fig. 25)

EOS. *See* AURORA.

EQUESTRIAN PORTRAIT OF THE CHANCELLOR SÉGUIER. *See* CHANCELLOR SÉGUIER.

ERASMUS, ST. *See* MARTYRDOM OF ST. ERASMUS.

ERMINIA AND THE SHEPHERDS (*Erminia and the Basket-Makers*). An episode from the 16th-century masterpiece *Jerusalem Delivered* (Italian, *Gerusalemme liberata*), an epic by Torquato Tasso of the exploits of Godfrey of Boulogne during the First Crusade. The story tells how Erminia, daughter of a Saracen king, loved the Christian Knight Tancred and, believing him to be wounded, began a long search for him. In order not to be discovered, she disguised herself in armor belonging to the female fighter Clorinda. During her travels, she met an old shepherd sitting outside his cottage playing a pipe. Close by his three sons sat weaving baskets. The shepherd explained to her the happiness of his remote tranquil life—a contrast to the fury of battle not too far away. To him Erminia and her armor indicated war and discord.
 As a suggestion of the goodness and integrity, the quiet and peace of the pastoral life, the theme was depicted by many Baroque painters. Usually the scene is a somewhat dark forest clearing. Erminia is shown in armor sometimes leading her horse. A shepherd playing a pipe may be close by. She may be in the act of taking off her armor, and the shepherd's wife and children help her. Baskets and bundles of willows for basket making are strewn about. Cattle and sheep graze contentedly.
 Example: Claude Lorrain, The Earl of Leicester, Holkham, Norfolk. (Blunt, fig. 248)

EROS TRIUMPHANT (*Amore Vincitore*). The son of Venus (Aphrodite), Eros (Cupid) was the Greek god of love and erotic attraction. Eros personified is not found in Homer, but the Homeric passages in which the word *eros* is used give an indication of the original significance. It is the uncontrollable physical desire that drives Zeus to Hera and Paris to Helen. A more elegant conception of this Eros, who stuns the mind and ravages the body, appears in the lyric poets of the 7th and 6th centuries B.C. Eros's power is prodigious. He brings peril wherever he wanders. Thus, artists picture him as unmanageable, cruel and sly. He is shown appearing suddenly, like a storm. Eros is playful, but he plays with confusion and frenzy. His presence symbolizes all the attractions of love that provoke and inflame and drive the object of his arrows mad with desire. He is beautiful and young. He walks over flowers and the roses are a "plant of Eros," of which he weaves his crown (when he wears one). He is charming and

warms the heart. He has been called by some poets "bitter-sweet." Eros had some old cults and enjoyed a lot of individual worship. He was always the god of burning lust, directed towards female as well as male beauty. Eros was also a god of fertility. Festivals were celebrated in his honor.

Artists depict Eros as erotic, voluptuous, wanton and always playful in a lewd manner. They usually present him as a reminder that the theme of the work is love. Sometimes he wears a blindfold, because love is blind and also as an allusion to the darkness that one associates with sin. He is shown with a bow and arrow and a quiver. He may hold a torch, extinguished, which signifies the passing of earthly sexual pleasures. A glove symbolizes his universality.

Example: Caravaggio, Kaiser-Friedrich-Museum, Berlin. (Bottari, fig. 28)

ESAU SELLING HIS BIRTHRIGHT. Esau (Hebrew meaning hairy), son of Isaac and Rebecca, was the twin brother of Jacob. He was born after Jacob, clutching his heel, a gesture taken symbolically as a sign that Jacob would supplant him. Esau was a hunter, a rough man of the fields. According to Genesis 25:25–26, "The first [child] came forth red, all his body like a hairy mantle; so they called his name Esau. Afterward his brother came forth, and his hand had taken hold of Esau's heel; so his name was called Jacob." Jacob got Esau's birthright by a bargain over a bowl of pottage. According to Genesis 25:29–34: "Once when Jacob was boiling pottage, Esau came in from the field, and he was famished. And Esau said to Jacob, 'Let me eat some of that red pottage, for I am famished!' (Therefore, his name was called Edom [in Hebrew ruddy].) Jacob said, 'First sell me your birthright.' Esau said, 'I am about to die; of what use is a birthright to me?' Jacob said, 'Swear to me first.' So he swore to him, and sold his birthright to Jacob. Then Jacob gave Esau bread and pottage of lentils, and he ate and drank and rose and went his way. Thus Esau despised his birthright." Traditionally, Esau is depicted as a coarse man, thought unworthy to inherit the mission of Abraham. He is called profane in the New Testament even though he was beloved of God and his descendants were regarded highly.

In the example below, Esau and Jacob, twins, are shown seated at a table. Jacob holds the bowl of pottage and shakes hands with his brother, who is recognized by the spear he holds.

Example: Giovanni Andrea de Ferrari, Palazzo Bianco, Genoa. (Waterhouse, fig. 185)

ESTHER AND AHASUERUS. The Book of Esther in the Old Testament tells the story of how a beautiful young Jewess, Esther (originally named Hadassah), interceded with the Persian king Ahasuerus (Xerxes) to prevent the massacre of her people. Ahasuerus, a powerful man, reigned from India to Ethiopia over one hundred and twenty-seven provinces. The Book of Esther is still read aloud in the synagogue during the Jewish festival of Purim, which commemorates the deliverance of the Jews. The story tells of the king who dismissed Vashti, his queen, because she had offended him. Haman, the king's chief minister was an

enemy of the Jews and had decreed that all the Jews in the Persian empire should be put to the sword. Mordecai, Esther's cousin who had raised her, asked Esther to intercede with the king. At this time it was impossible for anyone, even the queen, to enter the king's presence without a summons; if one did, the penalty was death. Esther took the chance and ended up as his queen. She put on her royal robes and entered the king's chamber. Ahasuerus received her and she asked him to save her people. She invited him to a banquet and her negotiation on behalf of her people succeeded. Haman was hanged on the gallows he had built for Mordecai.

Esther is shown in the act of pleading before king Ahasuerus, who welcomes her. She is beautifully dressed, and the king opens his arms to her while others look on.

Example: Bernardo Cavallino, Uffizi Gallery, Florence. (Waterhouse, fig. 157)

ETCHING. Etching is a kind of engraving in which the composition is incised into the plate with acid. The printmaker begins with a plate of copper. It is coated with a material compounded of bitumen, resin and beeswax that will resist the acid. The compound is placed on a heated plate, rolled flat with a leather roller and blackened with soot. The artist composes his design with a steel etching needle. The point cuts through the dark compound and exposes the bright metal beneath. The back and edges of the plate are coated with an acid-resistant varnish, known as ''stopping out varnish,'' and dipped in a bath of diluted acid, such as nitric, which eats into the metal wherever the metal has been pierced by the needle and the compound removed. If the artist desires any sections of the design to remain lighter than the rest, these areas may be painted over with varnish. The plate is immersed into the acid again, and the design is taken to a deeper depth. The ''stopping out'' process may be repeated many times if the artist wishes to produce several tones into the design. When the acid has done its work to the satisfaction of the artist, the compound is cleaned and the plate is inked and printed. Many methods of obtaining different tones exist, for example, the use of different chemicals.

Important to the history of etching are the 17th-century artists Jacques Callot and Abraham Bosse. Callot's work, especially, shows an extraordinary talent in the presentation of compositions crowded with people. Bosse produced GENRE subjects with simple and clear compositions. In 1645, Bosse published the first textbook on etching, *Traité des Manières de Graver en Taille Douce.* This slender volume is of interest because it describes the technical procedures of engravers and etchers during the Baroque. Bosse and Callot represented the old school. They regarded etching as a substitute for line engraving. They used the old hard etching ground containing linseed oil burned onto the plate and also the ÉCHOPPE, a tool with an oval cutting edge. The échoppe allows the etcher to imitate the swelling and diminishing line of the BURIN. During the 17th century the soft etching ground (used today) was introduced, and Bosse discussed its use in his treatise. Callot was the master of ''stopping out.'' Also,

during the 17th century, Hercules Seghers, a Dutchman, executed several technical experiments not only with various grounds of his own creation, but also with printing in color on linen fabrics and colored papers. Rembrandt, however, is considered the first of the modern etchers. He made some three hundred prints. He drew freely on the plate and corrected as he went, a break from the domination of line engraving. His earliest plates, the first dating from 1628, are in the medium of etching alone.

Example: Rembrandt van Rijn, *Six's Bridge,* British Museum, London (Rosenberg, Slive, ter Kuile, fig. 63)

ET IN ARCADIA EGO (*Arcadian Shepherds*). Two paintings on this subject by Nicolas Poussin exist, one shows the shepherds' discovery of a tomb monument in Arcadia; the second shows the shepherds meditating on the tomb. A third worthy of mention, the earliest painting of the subject, is by Guercino. The idea of "a tomb in Arcadia" goes back to Virgil. But during the Renaissance, the Neapolitan poet Sannazaro in his pastoral *Arcadia* (1502), described the tomb of a shepherd in Arcadia to which other shepherds came to make sacrifices. The title of the paintings, *"Et in Arcadia Ego,"* meaning "I, also, in Arcadia," is not ancient, as the phrase was not used before the 17th century. Controversy still exists as to a precise interpretation. The shepherds seem to have found the tomb by accident, and they are depicted in the midst of their surprise at seeing, in the shadow of trees, a sarcophagus with a skull (a MEMENTO MORI, or reminder of death) placed on its lid. One points to a half-hidden inscription. *See also* INSPIRATION OF THE POET

Example: Nicolas Poussin, The Louvre, Paris, and Devonshire Collection, Chatsworth. (Blunt, figs. 235 and 236)

EUCHARIST. The Eucharist, or Last Supper, is found in the gospels of Matthew 26:17–29, Mark 14:12–25, Luke 22:7–23 and John 13:21–30. Before the 17th century, the Last Supper usually illustrated the moment of Christ's announcement to the apostles' threat that Judas would betray him. However, the Reformation in 1517 caused the Church to defend the validity of its sacraments, and the connection between the Last Supper and the PASSION OF CHRIST as a whole was deemphasized. Artists then began to show Christ either consecrating the bread, or giving communion to the apostles. The liturgical moment of consecration is depicted with the apostles gathered around Jesus, their priest. Some of the apostles still react to Jesus's earlier warning that one of them would betray him. In the background, according to John 13:30, Judas leaves the table after Jesus said to him, according to John 13:27, "What you are going to do, do quickly." Judas can be seen disappearing into deep shadows. Attention is focused on the sacramental climax of the Eucharist, the consecration of the Host, when with a dramatic gesture, Jesus points to himself saying, "This is my body which is given for you. Do this in remembrance of me" (Luke 22:19).

The scene is set in a darkened room of the most severe simplicity, without

decoration, and articulated in the back of the figures with unfluted Doric pilasters on high Roman plinths. The apostles are reclining on couches, instead of being seated on chairs, around the table—a point of archaeological accuracy to which some artists attached great importance. They are dressed in Roman togas. Some of the apostles eat the bread, others show their realization of the significance of what is happening by gestures of astonishment. John the Beloved, especially, is shown as sorrowful, as he remembers Jesus's former words about Judas.

Example: Nicolas Poussin, The Duke of Sutherland, on loan to the National Galleries of Scotland, Edinburgh. (Blunt, fig. 237)

EUDAMIDAS. *See* TESTAMENT OF EUDAMIDAS.

EUROPA. *See* RAPE OF EUROPA.

EXPULSION OF HAGAR (*The Banishment of Hagar and Ishmael***).** The story of Hagar is told in Genesis 21:9–21. Abraham's first son was Ishmael, whose mother was Hagar, one of Sarah's Egyptian handmaidens. When Sarah's son Isaac was born, Ishmael played with him. "But Sarah saw the son of Hagar the Egyptian, whom she had bore to Abraham, playing with her son Isaac. So she said to Abraham, 'Cast out this slave woman with her son; for the son of this slave woman shall not be heir with my son Isaac.' . . . So Abraham rose early in the morning, and took bread and a skin of water, and gave it to Hagar, putting it on her shoulder, along with the child, and sent her away. And she departed, and wandered in the wilderness of Beersheba. When the water in the skin was gone, she cast the child under one of the bushes. Then she went, and sat down over against him a good way off, about the distance of a bowshot; for she said, 'Let me not look upon the death of the child.' And as she sat over against him, the child lifted up his voice and wept. And God heard the voice of the lad; and the angel of God called to Hagar from heaven."

The angel traditionally is the archangel Michael, who told Hagar of a well of water nearby so that she and Ishmael were saved. The distressed Hagar is shown standing before her weeping child, while Abraham tells her to go. Sarah stands in the background. The appearance of the angel might also be depicted. Both scenes were popular during the 17th century in Dutch and Italian painting.

Example: Guercino, Brera Gallery, Milan. (Held and Posner, fig. 106)

EXTREME UNCTION. One of the acts conferring grace known as the Christian sacraments. While the Protestants usually recognize two sacraments, baptism and communion, the Catholics recognize seven: confirmation, confession, extreme unction, holy orders, matrimony, baptism and communion. Extreme Unction is also known as "anointing of the sick." A sick or dying person is anointed on the eyes, nostrils, lips, ears, feet, hands, and sometimes, in the case of men, the loins, by a priest as he recites absolutions for any sins the person might have committed. The Roman Catholic Church teaches that through ex-

treme unction, the sick and dying receive health of soul, remission of sins, and, if God wills, health of body. The sacrament is given only to persons seriously ill and dying from internal causes. The main New Testament text for anointing of the sick is James 5:14–15: "Is any among you sick? Let him call for the elders of the church, and let them pray over him, anointing him with oil in the name of the Lord; and the prayer of faith will save the sick man, and the Lord will raise him up; and if he has committed sins, he will be forgiven."

During the COUNTER REFORMATION, the portrayal of the sacraments flourished, a reaction to Protestantism, which denied the sacramental validity of penance and which did not agree with the Catholic Church on the interpretation of the EUCHARIST. The dying man is shown, a stiff gray figure, stretched out and surrounded by mourners and a priest. A shield hangs above him with the monogram of Christ, indicating that the warrior was not only noble, but a Christian as well—a *miles christianus*. The bed on which the man dies is placed on a platform *all'antica* (in the ancient manner). From the ancients also are the gestures and actions of the mourners. The priest anoints the hand, not the head, of the dying man. The scene is lit by candles, required by the liturgy, and dim daylight. The lesser figures blend into dim shadows and the more important elements are highlighted in the typical Baroque manner.

Example: Nicolas Poussin, Collection Earl of Ellesmere, on loan to the National Galleries of Scotland, Edinburgh. (Friedlaender, colorplate 29)

F

FABLE OF ARACHNE. *See* LAS HILANDERAS.

FAIENCE. Faience is a type of partly baked earthenware that is coated with an opaque white glaze containing tin oxide and a clear lead glaze added before the final firing. It was discovered in the Near East. Because the process causes clearer painted designs and preserves them during firing, the art spread to Spain and then to the rest of Europe where it acquired different names. The Dutch and English called it Delftware and the Italians called their version MAIOLICA. German and French faience in the 17th century closely resembled Maiolica, although its finish was improved based on the Delftware process. During the 17th century, the artists of Louis XIV developed a unique Baroque style based on the work of Nicolas Poussin, the founder of French Classical painting, and Simon Vouet, whose style of illusionist decoration was perfect for his day.

FALL OF SIMON MAGUS. Simon Magus was a Samaritan sorcerer with a large following. He was first heard of in Jerusalem and, after seeing the healing powers of the apostles, he tried to purchase it from them. From this episode comes the term simony (the buying and selling of church offices and such). Supposedly he founded a Gnostic sect. His story is found in Voragine's GOLDEN LEGEND. According to Acts 8:9–24, "There was a man named Simon who had previously practiced magic in the city and amazed the nation of Samaria. . . . But when they believed Philip as he preached good news about the kingdom of God and the name of Jesus Christ, they were baptized, both men and women. Even Simon himself believed, and after being baptized he continued with Philip. And seeing signs and great miracles performed, he was amazed. When the apostles at Jerusalem heard that Samaria had received the word of God, they sent to them Peter and John . . . they laid their hands on them and they received the Holy Spirit. Now when Simon saw that the spirit was

given through the laying on of the apostles' hands, he offered them money, saying, 'Give me also this power, that any one on whom I lay my hands may receive the Holy Spirit.' But Peter said to him, 'Your silver perish with you, because you thought you could obtain the gift of God with money.' '' The *Golden Legend* tells how Magus challenged Peter and Paul to various kinds of skills. Frustrated when he could not restore the dead to life after the apostles had succeeded, Simon went to the top of a tall tower, or, according to Linus, up the summit of the Capitoline hill in Rome. From this hill he took off in flight wearing a crown of laurel. And Nero told the apostles that Simon had told him they were both impostors. At this time Peter asked Paul to lift up his head and look, and he saw Simon flying back and forth here and there. Then Paul told Peter not to remain there any longer, not even to finish his work, because God called them. Impatient with the whole proceedings, Peter told the angels of Satan who held the man up in the air to drop him, and they did. Simon was thrown to earth and he died, his skull split open.

Peter may be shown refusing the silver offered by Simon, restoring a young man to life and, with Paul, arguing before the emperor Nero. Simon is also shown falling from the sky, while Peter and Paul pray to heaven and Nero and his courtiers and a great crowd watch. Astonished demons fly away.

Example: Francesco Solimena, St. Paolo Maggiore, Naples. (Waterhouse, fig. 171)

FALLERII, SCHOOLMASTER OF. *See* SCHOOLMASTER OF THE FALLERII.

FAMILY OF DARIUS BEFORE ALEXANDER. In 333 B.C. Alexander the Great entered northern Syria, and on the plain of Issus in Cilicia, Darius III, the king of ancient Persia, was defeated after underestimating Alexander's superior strength. According to some scholars Darius, after using the wrong battle tactics, was wounded by Alexander himself. Nevertheless, he fled to Ecbatana and then eastward to Bactria. It was there that the satrap Bessus had him murdered and the Persian empire was brought to an end. Darius's mother, his wife and two daughters were taken captive by Alexander on the plain of Issus. He is noted for having treated them with respect and grace.

Alexander's splendid tent may be shown on the battlefield and others may be in the background. Darius's mother, Sisygambis, kneels before Alexander. He may have his hand out to help her rise. Stateira, Darius's wife, and her daughters are with the rest of the onlookers, all seemingly pleading with Alexander. Soldiers and servants may watch with concern also. An account by Diodorus Siculus tells how Sisygambis first knelt before Alexander's friend Haephestion and was mortified and bewildered when she discovered her error. In a short time Alexander courteously corrected the situation and put her at ease. *See also* BATTLE OF ISSUS.

Example: Charles Le Brun, From an engraving, The Louvre, Paris. (Blunt, fig. 290)

FAMILY OF PHILIP IV. *See* LAS MENINAS.

FAUSTUS. *See* DR. FAUSTUS.

FEAST OF ESTHER. *See* ESTHER AND AHASUERUS.

FEAST OF THE ASCENSION, VENICE. ASCENSION is the word used for the last appearance of Christ to his apostles after his Resurrection. According to Acts 1:9–11, "as they [the apostles] looked on, he was lifted up, and a cloud took him out of their sight. And while they were gazing into heaven as he went, behold, two men stood by them in white robes, and said, 'Men of Galilee, why do you stand looking into heaven? This Jesus, who was taken up from you into heaven, will come in the same way as you saw him go into heaven.' " This occurred forty days after his Resurrection, as he stood with his apostles on the Mount of Olives (mountain called Olivet) on the side toward Bethany. The translation of the name of this mountain is "the mountain of the three lights," because at night it was lighted from the west by the fire that burned continually upon the altar of the Temple, and in the morning it received the first rays of the sun from the east, and, further, it bore a large quantity of oil, a source of light. "The Ascension of Our Lord" is also described in detail in Voragine's GOLDEN LEGEND.

The festival held in honor of the event in Venice, is depicted with lavishly decked out barges in which beautifully dressed Venetians are floating.

Example: Canaletto (Giovanni Antonio Canale), Aldo Crespi Collection, Milan (Bazin, fig. 140)

FERRY BOAT OF ANTWERP (*St. Peter Finding the Stater*). A stater is one of any gold or silver coins of ancient Persia and Greece. The subject involving the stater here is actually the "Finding of the Tribute Money," or the Tribute to Caesar. The story of the Tribute Money is found in Matthew 22:15–22, Mark 12:13–17 and Luke 20:20–26. According to Mark, "they sent to him [Jesus] some of the Pharisees and some of the Herodians, to entrap him in his talk. And they came and said to him, 'Teacher, we know that you are true, and care for no man; for you do not regard the position of men, but truly teach the way of God. Is it lawful to pay taxes to Caesar, or not? Should we pay them, or should we not?' But knowing their hypocrisy, he said to them, 'Why put me to the test? Bring me a coin, and let me look at it.' And they brought one. And he said to them, 'Whose likeness and inscription is this?' They said to him, 'Caesar's.' Jesus said to them, 'Render to Caesar the things that are Caesar's, and to God the things that are God's.' "

The story of the stater also appears in Matthew 17:24–27: "When they [the apostles] came to Capernaum, the collectors of the half-shekel tax went up to Peter and said, 'Does not your teacher pay the tax?' He said, 'Yes.' And when he came home, Jesus spoke to him first saying, 'What do you think, Simon?

From whom do kings of the earth take toll or tribute? From their sons or from others?' And when he said, 'From others,' Jesus said to him, 'Then the sons are free. However, not to give offense to them, go the sea and cast a hook and take the first fish that comes up, and when you open its mouth you will find a shekel; take that and give it to them for me and for yourself.' ''

A ferry boat is depicted ready to push off; the sail is being hoisted. It is crammed with a crowd of every kind of person, including old men, sailors, Negroes, a crying baby, a horse, a crabby cow and even a woman holding her hat against the wind. Peter, finding the money, is shown leaning over the edge of the boat.

Example: Jacob Jordaens, Statens Museum for Kunst, Copenhagen. (Held and Posner, fig. 224)

FESTIVAL OF PAN. *See* BACCHANAL.

FIAMMINGO. The name (Flemming in English) given to or adopted by some Flemish artists who worked in Italy, especially in Rome, during the 17th century, at which time their numbers were numerous. Although there were few brilliant masters among them, their collective efforts are recognized as significant. The most noteworthy was the sculptor Frans Duquesnoy, who sometimes signed himself ''Fiammingo,'' and is well known by that name.

FIGHTING CARD PLAYERS. According to 17th-century moralists, cards and card games were symbols of a lazy nature in which sexual appetite thrives and blooms. For this reason, cards became an attribute of Vice personified. Common, low gnome-like types are shown in the cellar of a dim tavern-like establishment. They pull each other's hair and swing pots and their fists.

Example: Adriaen Brouwer, Ältere Pinakothek, Munich. (Rosenberg, Slive, ter Kuile, fig. 130)

FIGHT OF CENTAURS AND LAPITHS (*Battle of Lapiths and Centaurs***).** Centaurs were a tribe of wild creatures, half-horse, half-human. They lived in mountain forests, especially in Thessaly. They originated early, possibly as far back as pre-Homeric Greece. For the Greeks, they represented primitive desires and antisocial habits. They were frequently drunk and loved to fight and chase women. The Lapiths were a primitive mountain tribe in Thessaly, related to the centaurs through common descent from Ixion. In Homer, the king of the Lapiths was Pirithous. He is mentioned as fighting the centaurs at his wedding with Hippodame, daughter of Butes; in later legends, he is usually associated with his close friend Theseus, king of Athens. The fight between the centaurs and Lapiths is related in Ovid's *Metamorphoses* 12:210–535: ''Now Pirithous, bold Ixion's son, on the occasion of his marriage to Hippodame, had invited the fierce cloud-born centaurs to take their place at tables set out in order in a tree-sheltered cave. The princes of Thessaly were present. . . . Now they were singing

the marriage hymn, the great hall was thick with smoke from the fires, when the bride appeared, surrounded by her many attendants, young wives and matrons, surpassing them all in her loveliness. We declared that Pirithous was a lucky man to have such a bride, and thereby all but brought to nothing the good fortune we predicted for him: for the sight of the bride, no less than the wine, inflamed the passions of Eurytus, fiercest of all the fierce centaurs. Under the sway of drunken frenzy, intensified by lust, he lost all control of himself. Immediately the wedding feast was thrown into confusion, as tables were overturned, and the new bride was violently dragged off by the hair. Eurytus seized Hippodame, and others carried off whichever girl they fancied, or whichever one they could. It was like the scene in a captured city—the palace echoed with women's shrieks. . . . As the battle began, goblets were hurled, and went flying through the air, along with fragile jugs and curved basins, once the panoply of a feast, but now employed for war and slaughter.''

A banquet is shown in complete chaos and turmoil. Lapiths, with drawn swords, fight the centaurs, who each try to make off with a woman. Hippodame struggles to free herself from the arms of the centaur Eurytus in the center of a ruined wedding banquet, tables and food askew. A warrior in armor holding forth his sword may be Theseus. To the ancients and later civilizations the theme symbolized the victory of education and civilization over savagery and barbarism.

Example: Antonio Molinari, Palazzo Rezzonico, Venice. (Wittkower, fig. 233)

FINDING OF MOSES. *See* MOSES FOUND BY THE PHARAOH'S DAUGHTER.

FLAGELLATION. The story of Christ's scourging, or the whipping ordered by Pontius Pilate, the governor of Judea, just before he was taken to be crucified, is mentioned in one verse by all four evangelists: Matthew 27–26, Mark 15:15, Luke 23:16 and John 19:1. John says, ''Then Pilate took Jesus and scourged him.'' Matthew says, ''Then he released for them Barabbas, and having scourged Jesus, delivered him to be crucified.'' Later Christian writers gave these sentences a great deal of attention, and, possibly because of this, the subject has been popular with artists. Concern was also given the exact number of strokes administered. According to St. Bridget of Sweden, Jesus received over five thousand. Jewish law prescribed forty.

Jesus is usually shown in front of a column, his hands bound behind his back, and he appears to receive the strokes on the front of his body. Showing him receiving the lash on his back while leaving his face visible to the spectator always posed a problem to artists. Usually two or three cruel-appearing Roman soldiers administer the punishment. They may not be dressed as soldiers, and they use the Roman thong whip or birches. Jesus, naked except for a loin cloth, slumps with his CROWN OF THORNS in place. Pilate may be shown on his

seat of judgment, possibly wearing a crown of laurel, the Roman emblem of his authority.

Example: Caravaggio, San Domenico Maggiore, Naples. (Bottari, fig. 76)

FLIGHT FROM SODOM. *See* DESTRUCTION OF SODOM.

FLIGHT INTO EGYPT. This religious subject was especially favored by 17th-century Baroque painters known as CHIAROSCURISTS, as it gave them opportunity to use the theatrical effect of dramatic lights and darks or to isolate the Holy Family with a single, strong light. Its presentation as a night scene was the invention of the chiaroscurists. The story of the flight into Egypt is told in Matthew 2:13–15. Joseph, the earthly husband of Mary, was warned in a dream that Herod was searching for the infant Jesus and sought to kill him (*see* MASSACRE OF THE INNOCENTS). "An angel of the Lord appeared to Joseph in a dream and said, 'Rise, take the child and his mother and flee to Egypt, and remain there till I tell you; for Herod is about to search for the child, to destroy him.' " Joseph took the baby and his mother to Egypt where they stayed until they heard that Herod was dead. This was to fulfill the prophecy "Out of Egypt have I called my son." The story may form part of the narrative cycle of the Seven Sorrows of the Virgin.

Artists usually depict only the Virgin Mary carrying the infant Christ in her arms and riding a donkey, with Joseph leading the animal. Some scenes show angels guarding the travelers, and other persons may be included (the three sons of Joseph and the midwife, Salome). Some artists may omit the donkey and show the travelers on foot. Also, some French and Italian Baroque artists show the Holy Family leaving in a boat, ready to be ferried across a river. Some versions may show angels bearing a cross, floating in the clouds above, an allusion to Jesus's sacrifice. Night time versions, such as Rembrandt's, are shown in accordance with the account in Matthew. Rarely, the moment of departure is shown in which the Virgin Mary makes her farewells or waits under a tree while Joseph readies the donkey.

Example: Rembrandt van Rijn, Musée des Beaux-Arts, Paris. (Copplestone, color-plate 31)

FLIGHT INTO EGYPT IN A BOAT. The Holy Family, the Virgin Mary, Joseph, her husband, and Jesus, are shown entering a boat with their donkey. Jesus, a small child being helped into the boat by Joseph, pauses to look above his head at four floating angels. They seem to emerge from storm clouds with a large dark cross in the sky, an allusion to his sacrifice that he recognizes. The bearded ferryman with a characteristic band around his forehead is Christophros. He is not Charon on the River Styx, as some scholars have suggested; nor is he a symbol of Charon.

Example: Poussin, Dulwich College Picture Gallery, London (Friedlaender, fig. 31)

FLORA. The ancient Roman goddess of flowering and blossoming plants and fruits and of springtime, Flora had an April festival, *Ludi Florales,* which, according to Ovid's *Fasti,* was celebrated with wild and drunken abandon. Farces, or low comedy (*mimi*) of a highly indecent character, were included. Her festival, however, is not in the "calendar of Numa," and therefore was movable, or *conceptiuae.* Ovid also tells the legend that the earth nymph (the Greek goddess of flowers) Chloris was chased by Zephyr, the west wind of springtime, and when he caught and embraced her, she changed into Flora, with flowers spilling from her lips with every breath and scattering like raindrops over the countryside. Flora followed the footsteps of Zephyr in the spring, sprinkling his path with a profusion of blossoms and buds.

Flora usually holds a flower arrangement, and some artists show her hair festooned, crowned or simply garlanded with flowers.

Example: Rembrandt van Rijn, Metropolitan Museum of Art, New York. (Ruskin, fig. 3–52)

FLORA'S CHARIOT OF FOOLS (*Flora's Mallewagen*). *Flora's Chariot of Fools* is a satirical allegory on the mad tulip speculations of the 1630s. In Holland during the 17th century, the wild speculation on tulip bulbs grew to such absurd proportions that the episode became known as tulipomania. A single special tulip bulb sometimes brought the equivalent of several thousand dollars, and the prices kept increasing until finally the government was forced to interfere. A bare-breasted Flora, her hair embellished with flowers, is shown atop a wagon with large cumbersome wheels (in this case her Mallewagen) with blooming tulips in both hands. No animals pull the wagon. Tulips are strewn over the ground. The "fools" or wealthy speculators, both men and women, ride with her and others follow.

Example: Crispijn de Passe, Engraving after Hendrick Gerrisz Pot, Rijksmuseum, Amsterdam. (Held and Posner, fig. 232)

FORESHORTENING. During the Baroque, extremes in perspective were used, foreshortening being one of them. This type of view represents the visual contraction of an object that extends back in space at an angle to the perpendicular plane of viewing. In the most extreme cases, this view causes an arm, for example, to seem as if it comes directly out of the picture and into the space of the spectator.

Example: Caravaggio, *Supper at Emmaus,* National Gallery, London. (Bottari, fig. 29)

FORTUNETELLER, THE. Fortune-telling is associated with the Roman goddess of fortune. Originally Fortune was a goddess of fertility, but she was later identified with Tyche, the Greek goddess of chance. Fortune-telling, or divination, is the practice of foreseeing future events or acquiring private knowledge through omens, foreshadowings, portents, oracles and even from godlike sources. Based on the belief in disclosures offered to humans by the gods,

fortune-telling occupies itself with extrarational forms of knowledge. Its reason for existence is to reveal those things in life that neither science nor reason can explain. Before it spread through the Greco-Roman world, various branches of fortune-telling, as practiced by the Chaldaeans, were considered superior to all other sciences. The most portentous were the study of water and water patterns, the flight orders of birds, the study of the configurations of the entrails of sacrificial animals (haruspication) and the inspections of animals' shoulder blades (scapulimancy). The greatest trust, however, was the confidence the Greeks placed in the shrewdness of the oracle. Fortune-telling was indispensable to all the religions of classical antiquity; no state and very few individuals would have dared venture any significant action without first consulting the gods. Fortune-telling has persisted through the centuries and exists in the reading of palms, or palmistry, as well as astrology and crystal gazing.

During the 17th century the fortune-teller was alive and well. Gypsy seers were in abundance and made a good living. Artists show the gypsy fortune-teller as old, withered and shriveled. She may hold the attention of her target, while one of her companions surreptitiously steals his wallet and another cuts a costly gold chain from his shoulder.

Example: Georges de La Tour. The Metropolitan Museum of Art, New York. (Ruskin, fig. 5–12)

FOUR EVANGELISTS. The four evangelists are Matthew, Mark, Luke and John. They are often symbolized by an angel, a winged lion, a winged ox and an eagle, respectively. The source of this convention was from Ezekiel 1:5–14: "And from the midst of it [a great cloud] came the likeness of four living creatures. And this was their appearance: they had the form of men, but each had four faces and each of them had four wings. Their legs were straight, and the soles of their feet were like the sole of a calf's foot." Another source of the Four Evangelists' symbols is Revelation 4:7–8, which describes the same living creatures surrounding the throne of God: "And round the throne [of God], on each side of the throne, are four living creatures, full of eyes in front and behind: the first living creature like a lion, the second living creature like an ox, the third living creature with the face of a man, and the fourth living creature like a flying eagle. And the four living creatures, each of them with six wings, are full of eyes all round and within, and day and night they never cease to sing." These four creatures are sometimes known as the "apocalyptic beasts." Medieval scholars gave these explanations for the four evangelists as the "beasts" in the gospels themselves: The angel represents Matthew because his gospel begins with the tree of the ancestors of Christ. Mark begins his gospel with the voice crying in the wilderness, an allusion to a lion. Luke, the ox, a sacrificial animal, is found in the beginning of his gospel with the account of the sacrifice of the priest Zacharias. John is represented by the eagle, which, of all birds, flies closest to heaven, because John's vision of God was closest and distinct from others.

In art following the Renaissance, the symbols of the evangelists survived as attributes identifying the four human figures. Matthew, for example, is recognized by the angel who dictates the gospel as he writes. They occupy places such as the four pendentives that support a dome. They are combined with other groups, especially the four Doctors of the Church: Gregory the Great, Jerome, Augustine and Ambrose. And they are seen with the four greater prophets: Daniel, Ezekiel, Jeremiah and Isaiah.

Example: Caravaggio, *St. Matthew and the Angel,* Contarelli Chapel, San Luigi dei Francesi, Rome. (Bottari, figs. 42, 43)

FOUR MUSES WITH PEGASUS (*Four Muses with Pegasus in the Background*). In Greek mythology, Pegasus was the winged horse that carried the thunderbolt of Zeus. He was born from the blood of the dying MEDUSA when Perseus beheaded her. Pegasus was the mount of Perseus when he rescued ANDROMEDA, and of Bellerophon when he killed the Chimaera (a monster with the body of a goat, the head of a lion and the tail of a dragon). He was said to have been caught by Bellerophon with a golden bridle when he was drinking at the spring of Pirene, which is still to be seen in the ruins of Old Corinth; and a "Pegasus Untamed" was the symbol for the city on the coins of Corinth. He is said to have thrown Bellerophon when urged to fly to heaven. He may also be shown ridden by AURORA. Pegasus was made a symbol of Fame by the 6th-century mythographer Fulgentius, and because both are winged, he is seen among the muses, sometimes on Mount PARNASSUS. He was beloved by the muses for creating the spring of Hippocrene on Mount Helicon by a stamp of his magic hoof. In fact, he was said to have stamped many famous sources out of the earth with his hoof. In Roman times, Pegasus became a symbol of immortality. The muses were the goddesses of creative inspiration in song, poetry and other arts. They were the companions of Apollo, the daughters of Jupiter and the titaness Mnemosyne (Memory), who had lain together for nine consecutive nights. The muses were originally nymphs who presided over springs. They had the power to inspire, especially Hippocrene and Aganippe on Mount Helicon, and the Castalian spring on Mount Parnassus.

Pegasus is shown white and dazzling, leaping from the muses, who play their instruments. More musical instruments are strewn and stacked in the foreground.

Example: Caesar Boëtius van Everdingen, Huis ten Bos, The Hague. (Rosenberg, Slive, ter Kuile, fig. 239)

FOUR PHILOSOPHERS. Shown here is a self-portrait of Peter Paul Rubens on the left; the artist's brother, Philip Rubens; Justus Lipsius, the Flemish authority on Roman literature, antiquities and history (who had died a few years earlier); and Jan Wouverius, pupil of Lipsius and a Flemish humanist scholar.

Example: Peter Paul Rubens, Palatine Gallery, Pitti Palace, Florence. (Ruskin, fig. 3–2)

FRANCIS IN ECSTASY. Saint Francis of Assisi (1182?–1226) was the founder of the Franciscans and one of the greatest Christian saints. He was born in Assisi, Umbria, Italy. His baptismal name was Giovanni (John); his father, a wealthy merchant, was named Pietro di Bernardone, and his mother was called Pica. From his birth, however, Giovanni di Bernardone was called Francesco, or Francis, because the child was born while his father was in France. Although Francis's early life was uneventful, at age twenty he was taken prisoner in a battle between Perugia and Assisi and spent a year in prison (cheerfully, it is said) in Perugia. Two years after his release, he left for the wars in Apulia, but he was struck down with a long and suffering sickness and had to return home. On his recovery, he bought himself expensive new clothes, and riding out one day beautifully dressed, he met a beggar. He was so moved with compassion that he changed clothes with him. At Spoleto, Francis was sick again, and as he lay suffering, a heavenly voice told him to "serve the master rather than the man." These events turned him completely from his worldly life. He became an ascetic and began dressing in rags. In 1209, while hearing the gospel of Matthew 10:7–10, in which the apostles are urged to go forth on their mission, Francis interpreted this as a call and he set out to preach. A little group formed around him, and they went to Rome to see Pope Innocent III, who gave them permission to live in the manner of poverty Francis had exemplified. It was in this way that the Franciscan Order of friars was founded; before long it had expanded tremendously. In 1224, two years before his death, his "Ecstasy," or the most famous event of his life, occurred. According to Thomas of Celano, Francis was at prayer when he saw a vision of a man like a seraph (angel) with six wings, his arms outstretched and his feet together, so that his body formed the shape of a cross. While contemplating this vision, Francis received the stigmata, the five wounds of Christ, from which he suffered physical pain for the rest of his life. By this time he was also blind.

Francis is usually recognized by his stigmata, the wounds on his feet, one in each hand and his side. His earliest biographer describes him as being of fragile physique, with rapidly failing eyesight and unkempt beard. His attributes are a skull (to remind man of his immortality), a lily (for chastity), and a crucifix (to which he prayed). He is shown swooning, delicately held by an angel. His hands are clutched tightly as if in pain.

Example: Caravaggio, Wadsworth Atheneum, Hartford, Connecticut. (Bottari, p. 21)

FRANCIS XAVIER. *See* DEATH OF ST. FRANCIS XAVIER and MIRACLES OF ST. FRANCIS XAVIER.

FROTTIE. The French *frottis* means a thin wash of color; *frottage* is rubbing or polishing. The semiopaque or transparent additions of color with which some painters begin their works are called *frottie*. Sometimes English painters call this method "rubbing in," because the thinned color is rubbed lightly over the prepared surface. *Frotties* can be observed in the most sparsely executed portions

of the underpainting, especially in passages of shadow and in backgrounds painted thinly. They are especially visible in Velázquez's portrait of *Pope Innocent X.*

Example: Diego Velázquez, Doria Gallery, Rome. (Brown, pp. 158,159)

FUNERAL OF PHOCION. Phocion was an Athenian general and statesman who lived in the 4th century B.C. He was a Stoic hero, a model of civic virtue in his private and public life—a typical Stoic *exemplum virtutis,* similar to the Roman Cato. He commanded such respect from the people because of his impeccable behavior, and his military abilities were so astonishing, that he was elected general forty-five times. He saved the town of Athens from destruction many times. With the force of a strong character, he made his military reputation in the service of Persia. He became popular after campaigns in Euboea by defending Megara and Byzantium and by successfully repelling a Macedonian attack on Attica in the Lamian War. Seeing the military strength of Macedonia, Phocion insisted that Athens treat for terms when out-maneuvered before the battle of Chaeronea. After the defeat, he helped Demades in preserving peace with Alexander and Philip and tried to prevent Athens from joining in the Lamian War.

Somehow, in an error of judgment, his one grand mistake, he allowed Cassander's general Nicanor to seize the Piraeus. After the dust had settled, and democracy restored, Phocion, because of his courageous dedication to truth, was falsely condemned for treason by his enemies in Athens's lower classes and forced to die a traitor's death in the year 318 B.C. Like Socrates, he drank the poisonous cup of hemlock; he was then cremated. Phocion's life is a study of a man honored and respected, yet at the mercy of the ingratitude of his people. After his death, when the city would not allow his burial within the city walls, Phocion's body was taken to the distant funeral pyre near Megara. His devoted wife later clandestinely gathered his ashes. With the advent of a new and just regime, his ashes were given the deserved honor of burial within the city of Athens.

Two men are shown on a road carrying the corpse of Phocion to Megara. Athens lies behind them. The bastioned Acropolis is shown on a hill far beyond, and two temples are visible within the city. A line of figures before one of them is the procession of cavaliers in honor of Zeus, which Plutarch, in his *Life of Phocion,* tells us occurred on the day of Phocion's execution. In *The Ashes of Phocion Collected by His Widow,* Phocion's widow is shown bent and gathering his ashes.

Example: Nicolas Poussin, The Louvre, Paris. (Friedlaender, colorplate 39)

G

GALLERY VARNISH. Before paintings were displayed with the protective benefits of glass, as in the early days of the National Gallery in London, many of the best works were coated with layers of a preparation known as "gallery varnish" for protection against the effects of pollution. The varnish is a mixture of mastic in turpentine with boiled linseed oil. When first used, the varnish gave the canvases a warm golden glow, which was considered appropriate to the Old Masters. Soon, however, it darkened considerably and became nearly opaque. In 1853, gallery varnish was condemned by the Select Committee that reported on the National Gallery that year. All paintings that had been coated with it remained covered in their dull murky coating until the 1940s when solutions were discovered for removing it.

GANYMEDE. *See* RAPE OF GANYMEDE.

GATHERING OF THE ASHES OF PHOCION. *See* FUNERAL OF PHOCION.

GATHERING OF THE MANNA. The story of the gathering of the manna is told in Exodus 16:13–19 and Numbers 11:7–9. The Israelites in the desert, fearing that if they didn't find food soon they would starve, had begun to speak against Aaron and Moses. But God promised to provide food. Exodus describes the scene as follows: "And in the morning dew lay round about the camp. And when the dew had gone up, there was on the face of the wilderness a fine, flake-like thing, fine as hoarfrost on the ground. When the people of Israel saw it, they said to one another, 'What is it?' For they did not know what it was. And Moses said to them, 'It is the bread which the Lord has given you to eat. This is what the Lord has commanded: Gather of it, every man of you, as much as he can eat; you shall take an omer apiece, according to the number of the persons

whom each of you has in his tent.' And the people of Israel did so; they gathered, some more, some less.'' It tasted delicious, but they did not know what it was. They named it *manna,* which could come from the Hebrew meaning ''What is it?'' The subject was seen as a prefiguration of the EUCHARIST, or Christ feeding the multitude. Although Josephus believed that manna was a honeydew or an edible lichen, it has now been identified as the sweet secretion of insects. According to Numbers, ''the manna was like coriander seed, and its appearance like that of bellium. The people went about and gathered it, and ground it in mills or beat it in mortars, and boiled it in pots, and made cakes of it; and the taste of it was like the taste of cakes baked with oil.''

As the Israelites thought the manna fell from the sky like dew, artists sometimes show them holding baskets in the air as if to catch it. Otherwise, they gather it from the ground. Or the scene of the starving Jews may be depicted, moments before their salvation by the manna.

Example: Nicolas Poussin, The Louvre, Paris. (Friedlaender, colorplate 25)

GENRE. A term used in criticism and art history to indicate paintings that show scenes from daily life, especially the everyday subject matter popular with Dutch Baroque painters. In fact, the history of genre in Holland during the 17th century is almost synonymous with the history of Dutch painting. Jan Steen's *The World Upside-Down* is a good example, as are his crowded scenes at places such as a local village inn. The rest of Europe during this time had nothing with which to compete. The French brothers Antoine, Louis and Mathieu Le Nain's peasants, serious and solid, are far removed from the Dutch partygoers. Caravaggio's naturalism still centered around religious painting (except rare examples such as his CARD SHARPERS and *Soldier and Gypsy*).

Example: Jan Steen, Kunsthistorisches Museum, Vienna. (Hartt, fig. 980)

GERMANICUS. *See* DEATH OF GERMANICUS.

GLAZE. A transparent or semitransparent layer or series of layers applied over another ground of color so that the light passing through is reflected back by the smooth surface of the picture and the colors are modified and made more beautiful. Glazing was used for oil painting in 15th-century Italy and thereafter until the 19th century. The effect of paint seen through a glaze is not the same as any effect gained by mixing the two pigments in direct painting. A glaze brings a special luminosity and depth to a surface and causes the under-colors to appear warm and sensuous rather than cool and flat.

GLORY OF ST. IGNATIUS (*The Glorification of St. Ignatius***).** The story of Ignatius of Loyola is told in Butler's *Lives of the Saints*. St. Ignatius is best known as the founder of the SOCIETY OF JESUS in 1556. He was born c.1491 in the castle of Loyola at Azpeitia, in Guipuzcoa, a section of Biscay in northern Spain near the Pyrenees mountains between France and Spain, and he died in

1556. His father was head of one of the most ancient and noble families of Spain. Ignatius entered the military, but his career came to an end at the siege of Pampeluna, when a cannon ball broke his right shin. The bone was set incorrectly and broken again, he limped for the rest of his life. During his convalescence, he read the legends of Christ and the saints, and these books changed his life. Soon afterwards, he began to write his *Spiritual Exercises,* a book that became influential and famous. Ignatius's Order of the Society of Jesus became identified with the Catholic COUNTER REFORMATION movement and the combating of Protestantism. During the fifteen years that Ignatius directed his order, he saw it grow from ten members to one thousand. He was canonized in 1622, and Pope Pius XI declared him the heavenly patron of spiritual exercises and retreats.

Ignatius is usually depicted as a man in his middle years, balding and with a dark beard. He wears black, the color of the habit of the order. He may have as an attribute a book with the inscription *Ad majorem Dei gloriam,* "To the greater glory of God," the opening words of his Rule. The monogram of the Order is IHS, the first three letters of the name Jesus (IHSUS) in Greek. This may be close by, in a halo or on a tablet held by angels. The Sacred Heart, the heart crowned with thorns that is the emblem of the Jesuits, may also be present. Apotheosis or deification or glorification was revived during the 17th century in the decoration of Baroque churches, as seen in their sometimes fantastic illusionistic ceilings. In Sant' Ignazio in Rome, such a glorification of man, an apotheosis, was done for Ignatius, who is shown being received into heaven, born on clouds. *See also* ALLEGORY OF THE MISSIONARY WORK OF THE JESUITS.

Example: Fra Andrea Pozzo, Ceiling fresco in the nave of Sant' Ignazio, Rome. (Bazin, fig. 25)

GOBELINS, MANUFACTURE NATIONALE DES. The Gobelins is a state-controlled tapestry manufactory in Paris, originally founded by Jean Gobelin in the mid-15th century as a dye works. During the Baroque, in 1662, LOUIS XIV purchased the manufactory, and Jean Baptiste Colbert, comptroller general of finances, united craftsmen there whose duty was to produce furniture and tapestries. From 1663 until 1690, CHARLES LE BRUN, the French architect, painter and decorator, who was also a skilled administrator, was the director and chief designer. From 1694 to 1697 the factory closed temporarily, after which the Gobelins specialized in weaving tapestries. The Gobelins has become known worldwide for craftsmanship, special dyes and use of only the best materials. A blue dye, known as "Gobelin blue" originated there. Many of the Gobelin tapestries are famous, including a set based on copies of Raphael's frescoes in the Vatican and the fourteen large works celebrating the accomplishments of Louis XIV.

GODS OF OLYMPUS. Mount Olympus was the home of Zeus and the immortal royal family. They mirrored what the Greeks admired most: beauty, in-

telligence, strength. Their accomplishments and adventures were far above and beyond those of ordinary mortals, although most had tragic failings that in some cases ruined them.

The Olympian gods included Zeus (Latin Jupiter and Jove), the supreme deity. He became the All-Father, who populated the earth and the heavens with his frequent and successful promiscuous adventures. Hera (Latin Juno), Zeus's fiercely jealous wife, was the protectress of marriage and childbirth. Poseidon (Latin Neptune), god of the sea and of horses, was Zeus's brother. Moody and hateful, he carried a trident and traveled with the most grotesque monsters of the deep and sensuous sea nymphs.

Zeus's full sister was Demeter (Latin Ceres), the goddess of fertility and vegetation. Capricious and irresponsible, she had many lovers, including Zeus. Her daughter was Persephone (Latin, Greek Proserpina), who was taken by force to Hades (*see* PLUTO AND PROSERPINA). The son of Zeus was Apollo, also called Phoebus Apollo, the god of intelligence, of light, of the arts and of healing. He had innumerable love affairs, although not all successful. His twin sister was Artemis (Latin Diana), the daughter of Zeus, a virgin huntress and the goddess of chastity. Aphrodite (Latin Venus) was the goddess of love and beauty, of emotions and sex. Athena (Latin Minerva), the virgin goddess of wisdom, was born from the head of Zeus as a fully armed warrior after the god had swallowed the titaness Metis. Hestia (Latin Vesta), was the virgin goddess of the hearth, peace and the family.

Ares (Latin Mars), the god of war, was the son of Hera and Zeus and delighted in killing, although he was a known coward. Hephaestus (Latin Vulcan, the deity of volcanic fire) was the ugly, lame god of crafts. Hermes (Latin Mercury) ruled good fortune and wealth, was the patron of thievery and commerce, guided men on their journeys and promoted fertility. A god of sleep, he was the messenger of the gods. Hades (Latin Pluto and Dis), being the brother of Zeus, is sometimes included among the Olympians. A dark, stern, inexorable god, he ruled the underworld and his kingdom was lifeless and gray.

Example: Giovanni Lanfranco. Ceiling fresco, Villa Borghese, Rome. (Wittkower, fig. 34)

GOLDEN LEGEND. *The Golden Legend,* a collection of the lives of the saints, was written in the 13th century by Jacobus da Voragine. Its early translation from Latin into the vernacular languages brought forth scorn from some Renaissance humanists. Their opinions, however, did not diminish the popularity of the book. Even though a hagiology—a history or description of sacred persons including the Virgin Mary—it is also a devotional book and presents an ideal of saintly living.

GOLDEN SECTION or **GOLDEN MEAN.** A proportion derived from the division of a line so that the shorter part is to the longer part as the longer part is to the whole. Algebraically, it may be expressed as $a/b = b/(a + b)$. Most

historians believe that Plato began a story of "The Section" as a subject in itself. Euclid called the section "the extreme and mean ratio." In composition, these proportions are the most aesthetically pleasing. It is thought that the Golden Section is superior to all other proportions. In fact, experiments are said to show that people involuntarily prefer proportions that are closest to the Golden Section. This ratio is not to be confused with *La Section d'Or,* which was the collective name used by a group of Cubist painters who exhibited together in 1912 in Paris.

GOLIATH. *See* DAVID WITH THE HEAD OF GOLIATH.

GOOD SAMARITAN. Taken from Luke 10:30–37, this parable is meant to illustrate love of one's neighbor. According to the words of Jesus, "A man was going down from Jerusalem to Jericho, and he fell among robbers, who stripped him and beat him, and departed, leaving him half dead. Now by chance a priest was going down that road; and when he saw him he passed by on the other side. So likewise a Levite, when he came to the place and saw him, passed by on the other side. But a Samaritan [the traditional enemy of the Jews], as he journeyed, came to where he was; and when he saw him, he had compassion, and went to him and bound up his wounds, pouring on oil and wine, then he set him on his own beast and brought him to an inn, and took care of him." Writers, following Augustine, drew another moral from the account; the traveler personified Man who left Paradise (Jerusalem) and was overcome by sin. Judaism (the priest and the Levite) was not able to redeem him, but Christ (the Samaritan) gave him salvation through the Church (the inn).

The arrival at the inn may be shown, at which time the unfortunate man is being helped into the building. A young boy may hold the Samaritan's horse. The Samaritan walks toward the innkeeper or stands before him at the door with his purse in his hand. Also depicted may be the traveler lying by the roadside being tended by the Samaritan, who pours wine or oil on his wounds or bandages them. The Levite and the priest may be shown scurrying off in the distance.

Example: Rembrandt Van Rijn, Wallace Collection, London. (Copplestone, colorplate 32)

GOUACHE. Gouache is an opaque watercolor paint sometimes known as body color. Unlike in transparent watercolor painting, in gouache the pigments are held with glue, and white pigment is used to obtain the lighter tones. The amount of white added determines the degree of opacity; generally, sufficient white pigment is used to prevent the reflection of the ground through the paint. This causes the color to lack the luminosity of transparent watercolor painting. Gouache can be traced back to ancient Egypt, where pigments were bound with honey or tragacanth glue. The technique was used during the Middle Ages, the Renaissance and thereafter.

GRANDES MISÉRIES DE LA GUERRE. The conflict historians call the Thirty Years' War raged between 1618 and 1648. It was the last and most devastating of the wars of religion between Protestants and Catholics which, begun a century before, spread ruin throughout Italy, France and the Germanies. Callot's etchings *Grandes Miséries de la Guerre* are a record of the times. In one print, he shows a mass execution by hanging. The dead men are either defeated peasant rebels or war prisoners. The scene occurs in the presence of a highly disciplined army, brought up on parade with muskets, banners and lances held high. Their tents are shown in the background. Hanged men sway in clusters from the long branches of a giant, cross-shaped tree. A monk waving a crucifix, climbs a ladder, admonishing to the end a man around whose neck a fat noose is being forced. Another condemned man at the foot of the ladder kneels before a priest as he waits for absolution. Men roll dice on a drumhead for the pitiful belongings of the dead men. In the right foreground, a man, bound and ready for execution, is consoled by a priest. The *Miséries* prints are the first truly realistic, pictorial record of the human disaster of war.

Example: Jacques Callot, Series of etchings, Bibliothèque Nationale, Paris. (Blunt, fig. 152)

GRAND MANNER. A "lofty" manner of history painting as favored by the academies, notable in Sir Joshua Reynolds's *Discourses on Art* (1770 and 1771), in which he states that "the *gusto grande* of the Italians and the *beau idéal* of the French, and the great *style, genius* and *taste* among the English, are but different appellations of the same thing." Reynolds based his observations on the Bolognese, Florentine and Roman schools, thinking specifically of the French 17th-century masters, such as CHARLES LE BRUN and Nicolas Poussin. He felt that the Venetians did not express this character because in history painting "there are two distinct styles . . . the grand, and the splendid or ornamental." These distinctions can be traced back to the classical handbooks of rhetoric, which distinguished between the plain, the forcible, the elegant and the elevated style. It was in Baroque Italy that such categories were first recognized and applied to painting. In his *Life of Domenichino,* BELLORI quotes from a treatise by Agucchi attributing to Michelangelo *lo stile grande* and includes in the notes of Poussin a treatise on *la maniera magnifica,* which Anthony Blunt states derived from a 17th-century historian.

GRAPHIC ART. The means of painting, drawing, engraving, etching, woodcutting and other processes for making prints are known as graphic art. During the 17th century, professional engravers produced a vast output of prints. Anthony Van Dyck excelled in portraiture; Piranesi and Canaletto were successful in topographical art; Jacob van Ruisdael and Claude Lorrain excelled in landscape. The greatest output was achieved by Rembrandt, who produced more than three hundred plates for printing that have been proven to be authentic.

GRAVER. *See* BURIN.

GREGORY AND THE MIRACLE OF THE CORPORAL (*Miracle of St. Gregory*). Saint Gregory was a pope and a Doctor of the Church. He lived c. 540 to 604 and was the first pope who had been a monk. As pope, he was an extraordinary administrator. He established the form of the Roman liturgy and its music, the Gregorian chant. He helped to lay the foundations of Christianity in England, and he instituted the rule of celibacy for the clergy. The story, not too well known, of Gregory's miracle of the corporal is taken from Paulus Diaconus and illustrates how the cloth with which the chalice had been polished is torn with a knife by the pope and begins to bleed. The stranger who had not believed in the magic qualities of the cloth, fearfully sinks to his knees in astonishment, now convinced. His two companions are equally stupefied and amazed. The pope and his deacons, believing in the powers of the cloth, are unmoved.

Gregory is usually shown as a tall, beardless, dark-haired man, who wears papal vestments, including the tiara and pontifical crosier with its three transverses. His main attribute is a dove, the symbol of the Holy Ghost, which perches on his shoulder or hovers at his ear. The dove suggests the divine inspiration of his writings. Sometimes his secretary may be seen looking at it in adoration or wonder. *See also* COUNTESS MATILDA RECEIVING POPE GREGORY VII AT CANOSSA.

Example: Andrea Sacchi, Vatican Pinacoteca, Rome. (Wittkower, fig. 159)

GRISAILLE. Painting that is monochrome in mainly neutral grays or grayish colors, often used for special effects of modeling and also to imitate sculpture. Artists may use all the tones available, and in this sense grisaille should not be confused with *en camaïeu,* which is limited to two or three tones. During the 17th century, Peter Paul Rubens and painters of his school used monochrome techniques in drawing compositions for engravers.

GROTESQUE. In art a mixture of animal forms with floral ornament and human forms used during the 17th century was known as grotesque. From the Italian *grotta,* grotesque ornament can be found in Roman buildings, such as the *Domus Aurea* of Nero. Through the centuries, grotesque decoration came to mean anything bizarre or out of the ordinary. By the end of the 19th century, Santayana in his *The Sense of Beauty,* had defined it as "the suggestively monstrous."

GROUND. A term used to indicate the surface on which a drawing or painting is executed: for example, the plaster on which a fresco is done. In its correct technical use, however, "ground" means a prepared surface on which colors are applied, its purpose being to isolate the paint from the support (such as the canvas) so as to prevent chemical interaction, render the support less absorbent and bring the colors to their extreme of brilliance. The ground also provides a

smooth and satisfactory surface on which the artist is able to draw or paint. It is necessary for the ground to be durable so as not to crack or flake and not to be too absorbent. During the 17th century, Peter Paul Rubens sometimes laid a coat of ground charcoal and white over his gypsum ground. He also used gray grounds. Other Baroque masters used brown or red pigment in oil-based grounds to paint a ground. Some used a drop or so of pigment when applying the last coat, or *imprimatura,* of the ground. Imprimatura, applied after the preliminary drawing had been made in color or India ink, is the toning of a white ground with a glaze of transparent color such as yellow, red or brown, gray or green. A ground of any color reduces the color range of the painting, weakens contrasts and requires more opaque paint.

H

HAGAR AND ISHMAEL. *See* EXPULSION OF HAGAR.

HAMAN'S DISMISSAL. *See* ESTHER AND AHASUERUS.

HANGING TREE (*Hangman's Tree*). *See* GRANDES MISÉRIES DE LA GUERRE.

HEALING OF THE BLIND OF JERICHO. The story of Jesus healing the blind at Jericho is found in the Gospel of Matthew 9:27–31. "And as Jesus passed on from there, two blind men followed him, crying aloud, 'Have mercy on us, Son of David.' When he entered the house the blind men came to him; and Jesus said to them, 'Do you believe that I am able to do this?' They said to him, 'Yes Lord.' Then he touched their eyes saying, 'According to your faith be it done to you.' And their eyes were opened."

Christ is shown healing two blind men by touching their eyes. He lays his hand on the first blind man's forehead, pressing the eye with his thumb. The second blind man stretches his arms forward, full of hope, as he gropes his way toward the miracle that occurs before him. The faces of three of the bystanders show a mixture of incredulity and interest; the fourth, an old Hebrew, bends down to study the event even more closely. Jesus' three companions (on the right) observe the miracle with total devotion and understanding. A woman passing by, holding a child, looks on in wonder. The city of Jericho, from which Jesus has just departed, is shown with its towering fortress in the background.

Example: Nicolas Poussin, The Louvre, Paris. (Friedlaender, colorplate 34)

HELIODORUS EXPELLED FROM THE TEMPLE. Heliodorus was an official of the Seleucid court during the last centuries before the Christian era when the Jews of Palestine were dominated by the Syrian Seleucid kings. He

was sent to Jerusalem to take the wealth from Solomon's Temple. The story of his expulsion is told in 2 Maccabees 3:24–28. ''When he arrived at the treasury with his bodyguard, then and there the Sovereign of spirits and of all authority caused so great a manifestation that all who had been so bold as to accompany him were astounded by the power of God, and became faint with terror. For there appeared to them a magnificently caparisoned horse, with a rider of frightening mien, and it rushed furiously at Heliodorus and struck at him with its front hoofs. Its rider was seen to have armor and weapons of gold. Two young men also appeared to him, remarkably strong, gloriously beautiful and splendidly dressed, who stood on each side of him and scourged him continuously, inflicting many blows on him. When he suddenly fell to the ground and deep darkness came over him, his men took him up and put him on a stretcher and carried him away, this man who had just entered the aforesaid treasury with a great retinue and all his bodyguard but was now unable to help himself; and they recognized clearly the sovereign power of God.''

Heliodorus has collapsed, as the rider's two companions, shown as angels, scourge him. The topic has been seen as a prefiguration of Christ driving the money changers from the Temple (*See* CHRIST EXPELLING THE MONEY CHANGERS).

Example: Francesco Solimena, Church of Gesù Nuovo, Naples. (Waterhouse, fig. 170)

HENDRICKJE STOFFELS. Rembrandt's devoted love and housekeeper (his wife had died in 1642), Hendrickje Stoffles joined the household in 1649. In Rembrandt's later years, she and Titus, the artist's son, formed a business partnership to shield him from bankruptcy and from his creditors. Officially, they employed him and sold his paintings. This partnership saved the artist from complete destitution. Hendrickje died in 1663, leaving him the one child they had had together, Cornelia. Here Hendrickje is shown informally, although elegantly dressed in a fur coat. She wears precious earrings and large pearls as well as bracelets and a brooch. Her hair is held by red ribbons. Except for her large, sad eyes, her face lacks all expression. She looks out at the spectator with a certain melancholy.

Example: Rembrandt van Rijn, Staatliche Museen, Berlin-Dahlem. (Rosenberg, Slive, ter Kuile, fig. 81)

HENRY IV RECEIVING THE PORTRAIT OF MARIA DE' MEDICI (*The Presentation of the Portrait*). One of the cycle of the life of Maria de' Medici, Henry IV receiving her portrait is an illustration of the king who falls in love with a painted image. Possibly the most popular king among the French, a man known for his concern for the common people, Henry IV was king of France from 1589 until 1610 and also Henry III of Navarre from 1572 until 1610. Some historians believe he was probably the greatest king France was ever to know. He was the son of Antoine de Bourbon and Jeanne D'Albret, first of the Bourbon kings of France. Although raised as a Protestant, he was forced

to give up the faith to save his life during the massacre of the Huguenots, the Saint Bartholomew's Day Massacre. As a result, he was a prisoner of the court until 1576, when he escaped, returned to Protestantism and joined the combined moderate Roman Catholic and Protestant forces in the fifth of the Wars of Religion. He became the legal heir to the throne after the death of Francis, duke of Aleçon, in 1584. Henry was able to restore some measure of financial order. He founded new industries, built canals and roads, expanded foreign trade through commercial treaties with Turkey, England and Spain, encouraged agriculture and fostered the colonization of Canada. In 1600 he married Marie de' Medici, his second wife. His first wife, Marguerite de Valois, who had borne him no heir, agreed to an annulment to make way for her successor. Marie was the daughter of Francesco de' Medici, grand duke of Tuscany. She became regent for her young son, Louis III, after Henry's assassination in 1610.

The Presentation of the Portrait illustrates that time before the marriage when King Henry IV views the portrait of his future wife. The portrait is held before Henry by two winged emissaries of Juno, Hymen, the god of marriage, and Cupid. Juno, sitting beside Jupiter, looks down from fluffy clouds, the perfect model of nuptial bliss. Jupiter's eagle and thunderbolts are at his side; Juno's chariot and peacocks are at her side. *Putti* (see PUTTO) below hurriedly remove the instruments of war, among which armor and a shield are visible. This indicates that Henry had to take time from one of his military campaigns to view the portrait of his future wife. The helmeted figure behind Henry is France herself. She is favorable in her admiration for the Florentine princess who will be the future queen. Dark columns, the smokes of battle, unfurl in the background.

Example: Peter Paul Rubens, The Louvre, Paris. (Held and Posner, fig. 211)

HERCULES AND ACHELOUS. *See* LANDSCAPE WITH HERCULES AND ACHELOUS.

HERCULES AND CACUS.

The story of Hercules and Cacus is part of the legendary history of the founding of Rome. It is told by Livy in his *Early History of Rome.* Cacus, a savage fire-breathing giant, was the son of Vulcan (Volcanus). In some legends he has a sister, Caca, and lives in a cave on the Palatine hill in Rome. Hercules, returning home one evening with Geryon's cattle, drove them across the River Tiber, then found a place and lay down to sleep. The oxen, especially beautiful to look upon, caught the eye of the ferocious giant Cacus. He decided to steal them, but he knew that when he drove the cattle into his cave—as any herder might do—their tracks would tell their master exactly where they were. Therefore, he decided to drive them backwards by their tails and hide them in his cavern. When Hercules awoke at dawn and looked upon his herd, he saw that some of his oxen were missing. Rushing to the nearest cave, he noticed that all the tracks led outwards and, as far as he could determine, went nowhere. The strange situation was so full of misgivings that he

began driving the rest of his herd away from the ghostly spot; but as he did, some of the animals began to call their companions. The stolen beasts answered from the cave, and Hercules turned, walked towards the cave and confronted the giant. Cacus tried to stop him, but Hercules hit him with his club and Cacus, calling to his friends for help, died on the spot.

Virgil, in the *Aeneid* 8:258–349, locates the cave on the Aventine and tells the tale of how Cacus terrified the countryside with his brigandage until he stole the cattle of Geryon from Heracles and dragged them backwards into his cave. Servius says that Cacus was betrayed by his sister, Caca, and, as a reward, she was given a shrine *"in quo ei pervigili igne sicut Vestae sacrificabatur."* Hercules heard the cattle's cries and tracked them into the cave where he killed Cacus. According to the *Aeneid,* Book 8, "Here was once a cave with depths no ray of sun could reach, where Cacus lived, a bestial form. . . . Hercules appeared, still flushed with pride in spoils he took when slaughtering Geryon, the triple-bodied giant, and as conqueror he drove the giant's bulls this way before him. . . . Cacus's blood-thirsty mind, madly aroused to leave no crookedness untried, no crime unventured, turned four bulls out of their grounds, four heifers, too, all of the handsomest. But not to leave their hoof-tracks going away, he held their tails and pulled the cattle backward—traces of passage thus reversed . . . the oxen bellowed . . . filling the wood with protest. [In the cave] he caught and pinioned Cacus as the monster belched his fires in vain: fastening on his throat he choked him till his eyes burst out, his gullet whitened and dried up with loss of blood. Soon the black den was cleared, the doors torn off, the stolen cattle . . . revealed in the light of day."

Hercules may be shown wielding his club at Cacus, who may be dragging a bull by the tail. Or, Hercules may be depicted wrestling with Cacus. Some artists show Cacus already knocked down, raising one hand in self-defense against the killing blow. Also, Hercules may be shown resting on his club with Cacus dead at his feet. One of Hercules's companions may lead a bull from the cave while the heifers are being driven away in the background. Tiber, the river god, may recline on his urn by the water's edge.

Example: Sebastiano Ricci, Marucelli Palace, Florence. (Ruskin, fig 1–54)

HERCULES AND DEJANIRA. The story of Hercules and Dejanira (also spelled Deianira and Deianeira) is found in Ovid's *Metamorphoses,* Book 9. It involves Achelous, a river god, and Hercules and the daughter of the river god Oeneus, and is one episode in the events leading to Hercules's death. "Perhaps you have heard tell of Deianira? She was a most lovely girl who, in days gone by, roused jealous hopes in the hearts of many suitors and I, along with the rest, went to the house of the man I hoped would be my father-in-law. 'Son of Parthaon,' I said, 'take me as your daughter's husband.' My words were echoed by Hercules, whereupon the other suitors left the field to us two." The two men fought for Deianira, and even though Achelous changed to a serpent and then a bull, Hercules defeated him. In the course of the fight, Hercules broke off one

of the bull's horns. " 'I transformed myself into a bull . . . and as such renewed the fight. My adversary, attacking from the left, flung his arms round the bulging muscles of my neck. As I charged away, he followed close beside me, dragging at my head, till he forced my horns into the hard ground, and laid me prostrate in the deep dust. Nor was this enough: as he grasped my stiff horn in his cruel hand, he broke and tore it off, mutilating my brow. But the naiads filled it with fruits and fragrant flowers, and sanctified it, and now my horn enriches the Goddess of Plenty.' "

Hercules is shown carrying Deianira away while Achelous writhes on the ground. One of the nymphs watching the contest makes a cornucopia from one of Achelous's broken horns.

Example: Nicolas Poussin, Drawing. Royal Library, Windsor Castle, England. (Friedlaender, fig. 45)

HERCULES AND THE HORSES OF DIOMEDES (*Mares of Diomedes*). In Greek mythology, Hercules of Tiryns (the Greek Heracles) was a hero, the personification of physical strength and courage. His twelve labors, feats that illustrate his triumph over evil against the worst circumstances, reflect his dual nature as hero and god. Because he had offended the Olympians, the Delphic oracle ordered Hercules to serve the king of Tiryns, Eurystheus, for twelve years and to undertake any task asked of him, regardless of the degree of difficulty. Thus, a god was ordered to serve a mortal in a menial role. As Hercules's eighth labor, King Eurystheus (the cowardly cousin of Hercules) ordered Hercules to bring the flesh-eating mares of the Thracian king, Diomedes, to Tiryns. The mares, untamed and savage, ate human flesh and were fed in bronze troughs. Because of their prodigious power and viciousness, they were kept harnessed by immense iron chains. Hercules, with friends, took the mares, but in the battle for them, King Diomedes, their owner, was killed. Hercules fed his body to the ferocious mares and they became tame. Diomedes's death was appropriate because he had been the one who had taught the mares to eat human flesh. After Hercules took the mares to king Eurystheus, the king of Mycenae and Tiryns dedicated them to his patron goddess, Hera.

Hercules is portrayed with a massive physique. Some artists emphasized his physical size by drawing the head disproportionately small, a device used by Michelangelo. Sometimes he wears a beard and sometimes not. He carries a club, which is a symbol of his virtue, and the lion skin won in his first labor (the Nemean lion he strangled to death). Some artists show him wearing the lion's skin.

Example: Charles Le Brun, Art Gallery, Nottingham. (Blunt, fig. 286)

HERM. Thought to be Hermes, the Herm is a sculptured image of a god which, during classical antiquity, developed a typical form. The Herm, most often a man, usually has the bearded or unbearded face, armless torso and phallus of a man set on a rectangular pillar that sometimes ends in a near point and other

times is set on a base or plinth. Herms were used in gardens, by the roadside or sometimes they stood in doorways and were used for the protection of vine-yards and orchards. From vase painting, scholars have deduced that the image of Herm was used in the performance of the "sacred marriage" ritual in the Dionysiac mysteries, which were connected with fertility and purification. Usually Herms were set in erotic scenes of Bacchanalian revelry and of the festivals of Priapus and Pan. *See also* BACCHANALIAN REVEL BEFORE A TERM OF PAN.

Example: Nicolas Poussin, *Realm of Flora,* Gallery, Dresden. (Friedlaender, color-plate 17)

HOLOFERNES. *See* JUDITH AND MAIDSERVANT WITH THE HEAD OF HOLOFERNES.

HOLY FAMILY. The subject of the Holy Family occurs late in Christian art and is seldom seen before the Renaissance. The theme of a Holy Family is used to denote various combinations of figures taken from the Bible, which may be depicted either in a typical devotional attitude or as a narrative account of the times in the life of Jesus after Joseph and Mary return with him from Egypt and on their way to live in Nazareth. Mary may be shown with Jesus and St. John the Baptist. This combination became popular with artists during the 17th century. John, or "the Baptist," as he is sometimes called, is usually shown looking at Jesus, who sometimes blesses him. John may be naked or wear a tunic of animal skins and/or hold a small reed cross. On their return from Egypt, Mary, Joseph and Jesus stayed with Elizabeth, Mary's cousin, and Elizabeth's little son, John (later to become the Baptist). John showed great respect for Jesus even though both were young, John being only six months older.

John may be shown kneeling before Jesus, watching him in adoration. Elizabeth may be included. No scriptural authority exists for showing John and Jesus together before Jesus was baptized by John. Mary is also shown with her child and St. Anne, her mother. She is depicted sometimes with her husband, Joseph, and Jesus. The idea of Joseph became popular at the end of the 15th century. Devotional writers (especially the Jesuits) of the 16th century and later developed the idea of an earthly trinity corresponding to the heavenly Trinity of the Father, the Son, and the Holy Ghost, in which case the two trinities would be depicted together using the one figure of Jesus to serve both.

During the 17th century, Joseph is shown in domestic scenes, for example, as a carpenter, and may be working with Jesus as an older boy. Various symbolic objects may be included. Fruit, in a basket or held by John or Jesus, may include an apple—traditionally the fruit of the Tree of Knowledge, which alludes to Jesus as the future redeemer of mankind from original sin. The EUCHARIST is alluded to by grapes, symbolizing the blood of Christ. It was Augustine who said, "Jesus is the grape of the Promised Land, the bunch that has been put under the wine-press." Black grapes, if included, possibly symbolize John's

account of Jesus's wounds on the cross. Grapes with corn allude to the wine and bread of the Eucharist. Cherries, known as the fruit of paradise and given as a reward for goodness, symbolize heaven. The Resurrection is signified by the pomegranate. A nut may be included, usually the open half of a walnut. This idea was discussed by Augustine. He said the shell of the nut was the wood of Jesus' cross, the outer green case the flesh of Christ and the kernel inside, his divine nature. A vessel of any sort is included to contain wine and, thus, has the same meaning as the grape.

The bird, which even in antiquity symbolized the soul of man that flew out of his body at death, is used in Christian iconography to symbolize the soul. Jesus may hold a bird, often a goldfinch. A legend exists that the goldfinch saw Jesus as he carried his cross on the road to Calvary. It swooped down and plucked a thorn from his forehead, and in the process, a drop of the Savior's blood splashed on its feathers. During the Baroque, artists used fruit in still life paintings, and they retained their meaning as statements of Christian belief.

Example: Rembrandt van Rijn, Ältere Pinakothek, Munich. (Rosenberg, Slive, ter Kuile, fig. 58)

HOLY FAMILY ARRIVING AT AN INN (*Holy Family Descending at the Inn*). The HOLY FAMILY, in which various holy figures may be included, shows Mary, Jesus, her son, and Joseph, her husband. A groom holds the donkey on which Mary and Jesus have been riding, while Joseph provides a high stool so that Mary can descend. The child, extremely tiny, is obviously newborn. The scene is placid and silent, the stable before Mary is in need of repair. A hammer and other blacksmith's tools peer from a bucket and reveal the informality of the situation. Sheep graze under the eye of their caretaker in the background. Above, in a loft, looking down upon the Holy Family, a woman, apparently happy and content with two robust children, leans from a loft. A cloth, meant to underscore the simplicity of the event, hangs indecorously on one side of her window, while doves perch to her left and they too watch the family. A cat, perched below the doves, watches in solemn reverence.

Example: Giovanni da San Giovanni, Istituto di Belle Arti, Florence. (Waterhouse, fig. 135)

HOLY FAMILY IN EGYPT. The story of the HOLY FAMILY, Jesus, Mary and Joseph, and their FLIGHT INTO EGYPT is told in Matthew 2:13–15 and 2:19–20. Although the gospels tell nothing of the family's stay in Egypt, their food, their places of rest or friends, artists depict the family being cared for by Egyptians. Mary is seated on the ground, with her child on her lap, taking food from an offered bowl, and Joseph holds a bowl while a woman pours wine for him. Shards of broken images about the family allude to a story from the apocryphal gospel of Pseudo-Matthew that tells the story of the party reaching the town of Sotinen, Egypt. Here Jesus and the Virgin entered a temple. As they walked inside, statues of the Egyptian pagan gods crashed to the ground and

shattered. The *Holy Family in Egypt* should not be confused with the REST ON THE FLIGHT INTO EGYPT, when the family sat under a palm tree. While they rested, the palm tree bent its branches at Jesus' command so that the fruit could be gathered. The palm tree's frond is the emblem of the Christian martyr. It is interesting to note that the meeting of Mary, Jesus and Joseph with the young JOHN THE BAPTIST is supposed to have taken place on the return from Egypt.

Example: Nicolas Poussin, The Hermitage, St. Petersburg. (Blunt, fig. 242)

HOLY FAMILY ON THE STEPS. The theme of the HOLY FAMILY, that is the Virgin Mary with her husband, Joseph, and the infant Jesus, occurs late in Christian art. It becomes popular in the 15th century, when it is seen in the painting of both northern and southern Europe, and continues through the 17th. The term "Holy Family" is used to indicate several combinations of sacred figures—the Virgin and child with St. JOHN THE BAPTIST, or with St. Anne, mother of the Virgin, or with Elizabeth and St. John the Baptist—and may be thought of either as devotional or as a narrative account of the childhood of Jesus after the family returned from Egypt. It was after this that Joseph took his family and settled in Nazareth. Matthew 2:23 tells us "And he went and dwelt in a city called Nazareth, that what was spoken by the prophets might be fulfilled, 'He shall be called a Nazarene.' "

The Virgin is seen holding her child, while Elizabeth (shown as an older woman) and her son, John the Baptist (portrayed somewhat larger as he was born earlier), look on. Jesus reaches forward to bless the baby John. Joseph, sitting to the left of Mary, is identifiable by his staff. The theme of Jesus shown with John (for which there is no Biblical account) first occurs during the Italian Renaissance.

Example: Nicolas Poussin, National Gallery, Washington, D.C. (Blunt, fig. 240)

HOLY FAMILY WITH ANGELS. The theme of the HOLY FAMILY does not appear until the 15th century, after which time the subject may be a combination of several holy figures. These figures, depicted in various situations, may be shown either in a solemn devotional attitude or as a narrative story of some period in the life of Jesus after the family's return from Egypt. (The return is described in Matthew 2:22–23.) The *Holy Family with Angels* shows Mary as a protective, adoring, devout mother, bent, as any new mother would be, over her precious new child, who sleeps soundly in a cradle. The scene is a peaceful, humble interior sanctified by faith. Mary reaches tenderly to cover the top of the rocker as if to shield Jesus from a glow of light that might wake him. Joseph, standing reverently in gloom and shadows, watches. Angels watch in humble and grave respect.

Example: Rembrandt van Rijn, The Hermitage, St. Petersburg. (Rosenberg, Slive, ter Kuile, fig. 73)

HOLY FAMILY WITH ST. ELISABETH AND INFANT ST. JOHN. The HOLY FAMILY comprises, primarily, the Virgin Mary, her child, the infant Jesus, and Joseph, her husband. Included here are St. Elizabeth (or Elisabeth), a kinswoman of the Virgin, and Elizabeth's son, St. John, later to become "the Baptist." Jesus and John, who is always depicted as somewhat the older of the two, are usually shown playing quietly together while their mothers look on serenely. There is no biblical basis for this scene. Joseph is usually shown in shadows as a secondary figure. Mary is quite young, while Elizabeth is advanced in age. John the Baptist forms a link between the Old and New Testaments and is regarded as the last in the line of Old Testament prophets and first of the saints of the New. A preacher who lived in the desert, he baptized those who came to him in the River Jordan. When he baptized Jesus, the Holy Spirit, in the form of a dove, was seen to descend from heaven and hover over his head. His story is found in the New Testament in the gospel of Mark.

Example: Nicolas Poussin, The Louvre, Paris. (Friedlaender, fig. 243)

HOLY FAMILY WITH ST. FRANCIS. Francis of Assisi (baptized Giovanni or John), who lived c.1182–1226, was the founder of the Order of Friars Minor, or Franciscans. He was born in Assisi, Umbria, Italy. Two years before his death, he received the stigmata (the five marks corresponding to the wounds Jesus received on the cross). This is the first known appearance of the stigmata and the only one that is celebrated liturgically in the Western Church (*see* FRANCIS IN ECSTASY). Artists show Francis wearing a gray or brown habit. He is distinguished by three knots representing the religious vows of obedience, chastity and poverty. He has been described as being of small physique, with an unkempt beard and poor eyesight, although artists usually don't depict him this way. He is readily recognized by the stigmata on his hands, his feet and his side. Sometimes the cut of the lance shows through a slit in his habit. He may have a lily, indicating his chastity, a crucifix and a skull (as a reminder of man's mortality and brief time on earth). During the 17th century, St. Francis is often shown at prayer. When shown with the HOLY FAMILY, he is usually beside St. Joseph, the husband of the Virgin Mary.

Example: Lodovico Carracci, Museo Civico, Cento, Italy. (Wittkower, fig. 17)

HOMER DICTATING HIS POETRY (*Homer Dictating to a Scribe*). A principal figure of ancient Greek literature, Homer was the first European poet. The *Iliad* and the *Odyssey,* two epic poems, are attributed to him. They were written in a literary type of Greek, Ionic in basis with Aeolic admixtures. Together, these two poems are ranked among the great works of Western literature and constitute the prototype for all subsequent epic poetry. The "Homeric question" was the major dispute of scholarship during the 19th century. Literary scholars attempted to analyze the two works by various tests, most often to show that they were strung together from older narrative poems. Most modern scholars agree that there was a poet named Homer who lived in Asia Minor before 700

B.C. and that he wrote for an aristocratic society. They agree that the *Iliad* and the *Odyssey* are each the work of one poet. In ancient times, legends about Homer were numerous. His birthplace has always been disputed, but Smyrna or Chios are the most likely sites. Most descriptions of Homer say he was a blind Greek poet. In antiquity it was told that his blindness was a punishment for having slandered Helen of Troy.

Artists depict Homer as a white-haired old man with sightless eyes and noble features. He wears a laurel crown. A youth may sit close to him, taking down his words on a tablet with a stylus (attributes of Calliope, the muse of epic poetry). He may have two books in his hands, the *Iliad* and the *Odyssey*. He may hold or play a stringed instrument, generally of the violin family. This is an allusion to the ancient practice of accompanying the recitation of poetry with a background of music (the lyre in Greece). Rembrandt used as his model a Hellenistic bust of the poet, which he had also used in his ARISTOTLE WITH THE BUST OF HOMER. He shows the blind poet beating out the rhythm of the lines to follow a fixed meter while he dictates the text. Originally, the figure of Homer was accompanied by a scribe or pupil who wrote down his words, but a fire in the 18th century burned the right half of the canvas. The complete version is now known only through one of Rembrandt's drawings.

Example: Rembrandt van Rijn, Mauritshuis, The Hague. (Held and Posner, fig. 260)

HORAE. Goddesses of Spring, Summer, Autumn, Winter, horae were the seasons in Greek mythology. They appeared with the changes of seasons and were thought to make plants and flowers grow. Because they had this power, they were always welcome guests at births and marriages of Olympians and heroes. Horae are usually shown carrying fruit and flowers and in attendance to other gods. Their numbers may vary, but there usually are at least three. During the 17th century, they are depicted as the female attendants of AURORA and also of Selene.

In painting, the horae are first shown on *The François Vase* (an Archaic Krater named after its discoverer) by Ergotimos and Kleitas, c. 575 B.C., although without any individualizing attributes. Later season-horae are sometimes distinguished from each other by attributive animals and plants. *See also* DANCE TO THE MUSIC OF TIME.

Example: Nicolas Poussin. The Wallace Collection, London. (Friedlaender, fig. 33)

HUNDRED GUILDER PRINT (*Christ amid the Children and the Sick* and *Christ Healing the Sick*). An etching by Rembrandt, this work shows Christ among the sick. The title *Hundred Guilder Print* has never been fully explained, although tradition has it that this was the price, which was inordinately high, given when Rembrandt first sold it. According to one account recorded by the 18th-century art dealer and collector P.J. Mariette in his *Abecedario,* it was Rembrandt himself who paid this extravagant price for an impression of his own print. Many historians dispute this belief in view of the rate of exchange pre-

vailing at the time. The topic of *Christ Healing the Sick,* illustrates passages from Matthew 19:1–2, 13–15. "He [Jesus] went away from Galilee and entered the region of Judea beyond the Jordan; and large crowds followed him, and he healed them there.... Then children were brought to him that he might lay his hands on them and pray. The disciples rebuked the people; but Jesus said, 'Let the children come to me, and do not hinder them; for to such belongs the kingdom of heaven.' And he laid his hands on them and went away."

This same chapter of Matthew has the story of the rich young man who could not decide whether or not to give his possessions to the poor and follow Christ's teachings. The young man is seated on the left in rich clothes. Also, on the upper left, are the Pharisees, arguing among themselves, but not with Jesus, as in the Bible. Jesus is shown standing in the middle of the crowd, while a feeling of warmth and peace seems to emanate from him, spreading a kind of balm on the sick and suffering souls of the poor, the humble, the diseased. A hypnotic devoutness and a feeling of extreme and intimate spiritual union are due to Rembrandt's ethereal lights and shadows that diffuse the entire scene. It is a curious CHIAROSCURO that, by its sensuous and subtle gradations and floating feelings, transforms the hopes of the people and the miracles of Jesus into reality. Rembrandt was a Mennonite, and his tender, yet forceful Christ in this 1648 print is possibly due to the fact of his indulgence in silent prayer and precepts that support the sanctity of human life.

Example: Rembrandt van Rijn, Etching, British Museum, London. (Copplestone, fig. 7)

HUNT OF DIANA, THE. *See* DIANA HUNTING.

HYLAS AND NYMPHS. In Greek mythology, Hylas is the comely youth, the companion and squire of Heracles (Roman Hercules), the most popular of all Greek heroes. He accompanied Heracles during the expedition of the Argonauts, which, according to later accounts, took the Argonauts up the Danube and down the Rhône as well as to Lake Tritonis in Libya. His story is told by Theocritus in his *Idylls* 13. One evening, after they made landfall at Cius, Hylas went off to find fresh water for their supper. During his search, he came upon a spring where naiads, the nymphs of streams and fountains, splashed and played in the water. Captivated by his beauty, the nymphs pulled him down into the water to be their companion and no one ever saw him again. The Argonauts left on the *Argo* without Hylas or Heracles, as Heracles went to search for Hylas and remained at Cius.

The scene is a pool, usually shown in shadowed moonlight under a storm of rolling clouds. Hylas, young and beautiful, is in the water or on the bank, trying to resist the charms of several naked nymphs who compete for his attention. His pitcher, meant for the water, usually lies nearby. Gorgeous, sensuous nymphs lounge about in the water and watch with satisfaction as their sisters capture Hylas.

Example: Francesco Furini, Palazzo Pitti, Florence. (Waterhouse, fig. 137)

I

ICONOGRAPHY. Iconography is the illustration of a subject by pictures or other visual representations, or art representing legendary or religious subjects with the use of conventional, agreed-upon images and symbols that may be hundreds of years old. An artist may paint a lily to represent purity and chastity, for example. The imagery selected hopefully conveys the meaning of the work of art or is used to identify its figures and settings and objects. It often may feature items fixed (as in religious art) by convention and time. For example, a musical instrument, a wine glass and playing cards may suggest to the viewer a pleasant party or event. On the other hand, a lily, a book and a dove may suggest the Virgin Mary. St. Sebastian is identified by one or more arrows because he was martyred by being shot with arrows. St. Lawrence has a grill in close proximity because he was martyred by being roasted on a grill. St. Bartholomew holds a knife because he was martyred by being flayed alive.

IDEAL. The term ''ideal,'' derived from classical antiquity, is used by art historians to indicate those works of art that reproduce the best of nature but improve on it, eliminating all imperfections. In another sense, ''ideal,'' as used by Plato in his Theory of Ideas, is used to indicate that all perceptible objects are imperfect copies approximating to imperceptible and unchanging Ideas and Forms. Plato argued that painting is a copy of a copy. The Neoplatonist Plotinus argued that the work of art directly mirrors the essence of the Idea. During the Baroque, BELLORI delivered a lecture before the Academy of St. Luke in Rome, in 1664, in which he presented the true artist as being conceived as the seer who looks upon eternal truths and reveals them to mortal men. It is that ability that separates him from the mere copyist. He argued that this gift can only be developed through the study of ancient marbles, which were the first ''ideal'' objects on earth. Nicolas Poussin was taken as the exemplification of

this doctrine, and his example became binding for the French Academy of the 17th century.

IGNATIUS OF LOYOLA. *See* ENTRANCE OF ST. IGNATIUS INTO PARADISE; *see also* GLORY OF SAINT IGNATIUS.

IL DISINGANNO. The Christian sinner *Il Disinganno* is shown trying to free himself from the hopeless tangle of the vicious nets of sin and error with the help of Faith (Latin Fides). The winged Faith has one foot resting on a giant block of stone, symbolizing her substantial, unbreakable, loyal foundation. An open book, which may be at her feet, represents the scriptures and may have a cross upon it. Faith holds a candle, which is meant to symbolize the light of faith. If she wears a helmet it is to protect her against the continuous onslaught of nonbelievers.

Example: Francesco Queirolo, Capella Sansevero, Naples. (Bazin, fig. 135)

ILLUSIONISM. Painting and decoration presented as an illusion to fool the eye was well known to the Greeks in the Hellenistic age (c. 323–30 B.C.) and was admired in imperial Rome. Baroque illusionism was anticipated by these works but more especially by the various styles of illusory wall-paintings, or painted imitations of decorative moldings or marbles as well as the extensive false vistas found in Pompeian painting. Mantegna's ceiling painting in the Camera degli Sposi of the Castello del Corte at Mantua (1474) is a forerunner of extraordinary 17th-century illusionistic ceiling painting, the culmination of which is probably Andrea Pozzo's nave vault in the Church of St. Ignatius, Rome, executed about 1690. Here one finds QUADRATURA at its extreme and also a daring use of TROMPE L'OEIL. Also Francesco Borromini's portico at the Palazzo Spada in Rome appears, because of illusionism, to extend much further than it actually does. (Borromini was the leading architect of the Roman Baroque 1599–1667.)

"Illusionism" is also used when referring to techniques used for the building and painting of 17th-century Dutch peep-show cabinets. These constructions afforded entertaining examples of visual deception made possible by means of a rigorous application of the principles of scientific linear one-point perspective, particularly the principle of the one eye point on a horizon. Van Hoogstraten, a Dutch painter of GENRE scenes and also a pupil of Rembrandt, whose work is now in the National Gallery in London, is a good example of "perspective boxes." Through these he displayed a painted toy world seen through a peep hole. Carel Fabritius was another Dutch 17th-century artist especially interested in difficult problems of perspective and illusionism.

Example: Samuel van Hoogstraten, *A Man at a Window,* Kunsthistorisches Museum, Vienna. (Rosenberg, Slive, ter Kuile, fig. 112)

IMMACULATE CONCEPTION. The Virgin Mary was chosen to be the vessel of Christ's Incarnation. This theme made a late appearance in Christian art, possibly because of the difficulty of establishing a representational type for a concept that was abstract to the extreme. The Immaculate Conception was first widely shown in the 16th century. During the 17th century, especially in Spanish art, the COUNTER REFORMATION provided the stimulus for a true veneration of Mary, and this led artists to establish a new type of Immaculate Conception. The new idea was based on the pregnant "Woman of the Apocalypse," described in Revelation 12:1–2. "And a great portent appeared in heaven, a woman clothed with the sun, with the moon under her feet, and on her head a crown of twelve stars; she was with child and she cried out in her pangs of birth, in anguish for delivery."

This new form was summarized by the Spanish writer, painter and art-censor to the Spanish Inquisition, FRANCISCO PACHECO, in his 1649 *Art of Painting* (1649). Pacheco wrote that the Virgin should be seen as a young woman, of only twelve or thirteen years, that she should be wearing a white robe and a blue cloak, and that her hands should be together in prayer or folded reverently on her breast. A moon (an old symbol of purity) should be shown as a crescent, with the pointed ends down. She would have around her waist a Franciscan girdle with the typical three knots. God, the Father, could be included, looking down from heaven and perhaps accompanied by the inscription *Tota pulchra es, amica mea, et macula non est in te,* "You are beautiful, my dearest, beautiful without a flaw." (This is taken from The Song of Solomon, 4:1, which says "Behold, you are beautiful, my love, behold, you are beautiful! Your eyes are doves behind your veil. Your hair is like a flock of goats, moving down the slopes of Gilead.")

Example: Diego Velázquez, National Gallery, London. (Brown, 50)

IMPASTO. A term used in painting to indicate a method of using oil paint in which the pigment is applied in thick solid masses and sometimes heavy lumps, in contrast to glazes and scumbles. Many Baroque artists, such as Peter Paul Rubens and Rembrandt, used impasto to achieve the extremes they desired for the dramatic dazzles of light and dark and for the crusty brilliance of highlighting—golds or scarlets—as seen shining upon a shadowed or unlit background.

IMPRIMATURA. Some artists during the Baroque and even as early as the Gothic toned their white GROUNDS with a thin GLAZE of transparent color. This application reduced the absorbent quality of the ground and could also be used as a middle tone in the painting. Imprimatura could be any color but was usually a warm yellow, red, brown or sometimes green or gray according to the intended result. Application was done with various media, such as glue size (gelatine or purified glue using for filling porous surfaces), oil tempera or resin oil (secretions from trees). Artists in the north, such as Jan van Eyck, applied the imprimatura after the preliminary sketch had been made in Indian ink or

some color on the canvas or the wood panel. Other painters used imprimatura over GRISAILLE underpaintings.

INNOCENTS. *See* MASSACRE OF THE INNOCENTS.

INSPIRATION OF ANACREON. Earlier known as INSPIRATION OF THE POET, this painting was renamed *Inspiration of Anacreon* in the 18th century. Anacreon was a Greek lyric poet of light and fanciful earthly verse, especially remarkable for his combinations of wit and imagination. He wrote in an Ionic vernacular with only some traces of Aeolic or Homeric language. His metres were simple and easy to comprehend. Of all his iambic poems (satirical verse written in iambs), the most popular example is his cruel poem on Artemon. His elegiacs contain dedications, epitaphs and commemorative poems. His poetry was concerned mostly with pleasure and living the good life. He was born at Teos, c.570 B.C., the son of Scythinus. He died at an advanced age due to, it was said, suffocation from a grape seed sticking in his throat. *Inspiration of Anacreon* reveals Anacreon as the intellectual spirit, the unfulfilled, solitary hero, the poet who must painfully wait for inspiration and when it comes, work in loneliness. He suffers, sad and unattended. Anacreon is being inspired by Apollo and the muse Euterpe who, as the protectress of lyric poetry, holds her flute.
 Example: Nicolas Poussin, Landesmuseum, Hanover. (Friedlaender, fig. 32)

INSPIRATION OF THE POET (*Apollo and Vergil*). The muse Euterpe, the protectress of lyric poetry, crowned with laurel, holds her flute and leans on a tree to assist Apollo in inspiring a poet. The poet, listening ecstatically and looking to the heavens, holds a tablet in one hand and a pen in the other. As he sends forth inspiration, Apollo holds his lyre and wears a crown of laurel leaves. It has been suggested that the poet is possibly Anacreon, the Greek poet of light and earthly verse, although most scholars who accept the idea as understandable, agree that it is not correct. The poet is being crowned by a PUTTO with laurel leaves.
 Example: Nicolas Poussin, The Louvre, Paris. (Friedlaender, colorplate 16)

INSTRUMENTS OF THE PASSION. The objects of Christ's passion—the CROWN OF THORNS, lance, nails, whip, sponge for the vinegar—are found in different religious situations. Christ may simply hold any or all of them, or they may be carried by angels surrounding the Virgin Mary or Christ. The nails may be held on a cloth by an angel, the objects being too holy even for the pristine hands of an angel. *See* PASSION OF CHRIST.

ISAAC BLESSING JACOB (*The Stolen Blessing*). The story of Isaac blessing Jacob is told in Genesis 27: "When Isaac was old and his eyes were dim so that he could not see, he called Esau his older son, and said to him, 'My son'

and he answered, 'Here I am.' He said, 'Behold I am old; I do not know the day of my death. Now then take your weapons, your quiver and your bow, and go out to the field, and hunt game for me, and prepare for me savoury food, such as I love, and bring it to me that I may eat; that I may bless you before I die.' Rebekah was listening when Isaac spoke so when Esau went to the field to hunt, Rebekah said to her son Jacob, 'I heard your father speak to your brother Esau. . . . Now my son, go to the block and fetch me two good kids, that I may prepare from them savoury food for your father and you shall bring it to your father to eat, so that he may bless you before he dies.' But Jacob said 'Behold my brother Esau is a hairy man, and I am a smooth man' . . . then Rebekah took the best garments of Esau her older son and put them on Jacob her younger son; and the skins of the kids she put upon his hands and upon the smooth part of his neck and she gave the savoury food and the bread which she had prepared into the hand of her son Jacob. So he went in to his father . . . he came near and kissed him; and he smelled the smell of his garments and blessed him.''

The blessing once given, could not be undone. Jacob thus was given authority over his brother and all their tribe. Jacob then ran from his brother's anger. Isaac is shown propped up in bed. He is old and blind. Jacob kneels at his bedside, while Rebecca stands behind her favorite son with a hand on his shoulder.

Example: Govert Flinck, Rijksmuseum, Amsterdam. (Rosenberg, Slive, ter Kuile, fig. 108)

ISRAELITES WORSHIPPING THE GOLDEN CALF. *See* ADORATION OF THE GOLDEN CALF.

J

JACOB'S DREAM. The story of Jacob's dream is told in Genesis 28:10–15. "Jacob left Beersheba and went toward Haran. And he came to a certain place, and stayed there that night, because the sun had set. Taking one of the stones of the place, he put it under his head and lay down in that place to sleep. And he dreamed that there was a ladder set up on the earth, and the top of it reached to heaven; and behold, the angels of God were ascending and descending on it! And behold, the Lord stood above it and said, 'I am the Lord, the God of Abraham your father and the God of Isaac; the land on which you lie I will give to you and to your descendants; and your descendants shall be like the dust of the earth, and you shall spread abroad to the west and to the east and to the north and to the south; and by you and your descendants shall all the families of the earth bless themselves. Behold, I am with you and will keep you wherever you go, and will bring you back to this land; for I will not leave you until I have done that of which I have spoken to you.' Then Jacob awoke from his sleep and said, 'Surely the Lord is in this place; and I did not know it.' "

Jacob lies asleep on the ground, his head on a large rock, an angel before him pointing to heaven. God in heaven spoke to him and promised the land to his descendants, the Israelites. When Jacob awoke he built a column from the stones and poured a libation of oil over it and called it Bethel, the house of God.

Example: José Ribera, The Prado, Madrid. (Rosenberg, Slive, ter Kuile, fig. 110)

JACOB TRIP. Rembrandt painted Jacob Trip when he was eighty-seven years old. The old man is shown dressed in a cloak and skull cap, a type of cap that was popular in the latter part of the 17th century, especially among artists and scholars. Trip was the patriarch of a wealthy and prominent family whose many businesses included arms factories, iron mines and financial dealings. His three

sons and his brother lived and worked in Amsterdam, while Trip remained in his native Dordrecht, a city near Rotterdam.

Example: Rembrandt van Rijn, National Gallery, London.

JOHN THE BAPTIST. Giovanni Battista (Italian), or John the Baptist (died c.28–30), is regarded as the last in the line of Old Testament Jewish prophets and the forerunner of Jesus, the first of the saints in the New. He was the son of Elizabeth and Zacharias. Elizabeth was a kinswoman of the Virgin Mary and his birth was miraculously foretold. After a time of solitude, living an ascetic life in the desert, he received a divine call to preach repentance to the people of the Jordan valley in preparation for the Messiah. In the Jordan River, he baptized all who came to him in a penitent spirit. He baptized his followers, and he baptized Jesus, whom he recognized as the Son of God when during the baptism the Holy Ghost was seen to hover over Christ's head. He angered the aristocracy and offended Herodias, the wife of Herod by rebuking her publicly. For this, Herod Antipas, the son of Herod the Great, had John imprisoned. John was beheaded later as the consequence of a promise made by the tetrarch to his stepdaughter SALOME, who had danced before him and pleased him. He promised her she could have anything she wanted. Her mother told her to ask for the head of the Baptist on a dish. Herod kept his promise. John the Baptist is the only saint other than the Virgin Mary whose birthday is celebrated, on June 24. The feast of the beheading is August 29.

Example: Caravaggio, Galleria Capitolina, Rome. (Bottari, fig. 30)

JOHN THE BAPTIST IN THE WILDERNESS. Luke 1:80 mentions briefly JOHN THE BAPTIST in the Wilderness: "And the child grew and became strong in spirit and he was in the wilderness till the day of his manifestation to Israel." John is usually shown leaving his parents and, guided by an angel, walking into the desert. Some artists show him alone, a lamb (symbol for Jesus) at his feet as he sits in a forest. He is usually in prayer or he meditates. Some 17th-century artists show him as a handsome young man or an especially pretty child. He may be accompanied by the young Jesus.

Example: Salvator Rosa. Art Gallery and Museum, Glasgow. (Ruskin, fig. 1–49)

JOHN THE BAPTIST PREACHING. Luke 3:1–17 tells of John the Baptist's preaching. "In the fifteenth year of the reign of Tiberius Caesar, Pontius Pilate being governor of Judea, and Herod being tetrarch [governor] of Galilee . . . the word of God came to John the son of Zechariah in the wilderness; and he went into all the region about the Jordan, preaching a baptism of repentance for the forgiveness of sins. . . . He said therefore to the multitudes that came out to be baptized by him, 'You brood of vipers! Who warned you to flee from the wrath to come? Bear fruits that befit repentance, and do not begin to say to yourselves, "We have Abraham as our father"; for I tell you. God is able from these stones to raise up children to Abraham. Even now the ax is laid to the root of the trees;

every tree therefore that does not bear good fruit is cut down and thrown into the fire.' ''

John usually stands on a rock or on something that places him above the multitude. Usually thin and dressed in a tunic of animals' skins, he is surrounded by listeners as he preaches to them. He may have a scroll that reads *Vox clamantis in deserto;* ''A voice crying aloud in the wilderness.''

Example: Joseph Parrocel, Museum, Arras, France. (Blunt, fig. 328)

JOHN THE EVANGELIST. Saint John was one of the twelve disciples of Christ, and traditionally, the author of the fourth Gospel, three epistles and the Revelation. He and his brother, James the Greater, were sons of Zebedee. Jesus called them Boanerges, or ''Sons of Thunder.'' John was one of the first to be called by Jesus, and he and his brother, James, along with Peter, were the closest to Jesus. They witnessed the Transfiguration and accompanied Jesus to Gethsemane. John is the disciple to whom Jesus, in his dying moments, committed his mother. According to the GOLDEN LEGEND, he was immersed in a vat of boiling oil during the persecutions of the Christians under the Roman emperor Domitian, but emerged unharmed. According to second-century scholars, John died (c.100) at an old age at Ephesus, where he had lived except for a short visit to Rome and during his period of exile on the island of Patmos in the Aegean sea. (The monastery of St. John was founded there in the 11th century to commemorate his exile.)

Supposedly, John dug his own grave in the shape of a cross. Some artists show him walking into it. John's symbol as an Evangelist is the eagle, which is shown close by, and he may hold a pen and a large book, his gospel. He may hold a chalice, which refers to the legend that tells how the priest of the temple of Diana of Ephesus gave John a cup of poison to drink to test his power of faith. The chalice may be seen with a snake, which symbolizes Satan. (The chalice symbolizes Christian faith.) John is usually shown either as the apostle, in which case he is young, graceful, has long wavy hair and may be beardless, or he is old and has a gray beard. *See also* LANDSCAPE WITH ST. JOHN ON PATMOS.

Example: Domenico Zampieri Domenichino, S. Andrea della Valle, Rome. (Waterhouse, fig. 14)

JOLLY TOPERS. *See* LOS BORRACHOS.

JOSEPH MAKING HIMSELF KNOWN TO HIS BRETHREN (*Joseph and His Brethren***).** Joseph was the son of Jacob and Rachel. His long story is told in Genesis 37, 39, 40. His older brothers were actually half-brothers, the sons of Leah or of handmaidens. They hated him because he was favored, and one day they took his coat and threw him into a pit, then plotted to sell him into slavery. They smeared Joseph's coat with kid's blood and gave it to their father, who believed their tale that Joseph had been torn to pieces by a wild beast.

Joseph was purchased by Potiphar, captain of Pharoah's guard and made steward of his household. But Potiphar's wife wanted him. "Now Joseph was handsome and good-looking. And after a time his master's wife cast her eyes upon Joseph and said, 'Lie with me.' But he refused." She continued until one day he left his garment in her hand and fled the house, whereupon "she called to the men of her household and said to them, 'See, he has brought among us a Hebrew to insult us; he came in to me to lie with me, and I cried out in a loud voice; and when he heard that I lifted up my voice he left his garment and fled and got out of the house.' " For this, Potiphar had Joseph put in prison. While there Joseph interpreted the dreams of Pharoah's butler and baker. Two years later, when Pharoah was troubled by dreams, the butler had Joseph interpret his dreams. When he was thirty years old, in recognition of the interpretation, Joseph entered the service of the Pharoah.

Later, Jacob sent his sons to Egypt to buy corn, all except Benjamin, the youngest. Joseph recognized them, but did not reveal himself at this time. He instead took one of his brothers hostage and demanded that they bring Benjamin to him. They did this, but when they began their second journey home, their sacks loaded with corn, Joseph secretly put his silver cup in Benjamin's sack. Then he sent his servants to search the brothers, and when the cup was found, the brothers were brought back to him. Unable to keep up his pretense, he made himself known to his brothers. Being a kind man, he forgave them their past misdeed. "Then Joseph could not control himself before all those who stood by him; and he cried, 'Make every one go out from me,' So no one stayed with him when Joseph made himself known to his brothers. . . . And Joseph said to his brothers, 'I am Joseph; is my father still alive?' But his brothers could not answer him, for they were dismayed at his presence. . . . Then he fell upon his brother Benjamin's neck and wept; and Benjamin wept upon his neck. And he kissed all his brothers and wept upon them; and after that his brothers talked to him."

Joseph is shown young and handsome, in the act of revealing himself to his brothers. They fall to their knees speechless. Benjamin, the youngest, stands staring at him also.

Example: Pier Francesco Mola, Gallery, Palazzo del Quirinale, Rome. (Wittkower, fig. 209)

JUDAS RETURNING THE PIECES OF SILVER (*The Remorse of Judas*).
Judas Iscariot was one of the twelve apostles, the one who was given thirty pieces of silver to betray Christ. The story of the return of the thirty pieces of silver for which Judas betrayed Christ is told in Matthew 27:3–9. "When Judas, his [Christ's] betrayer, saw that he was condemned, he repented and brought back the thirty pieces of silver to the chief priests and the elders, saying, 'I have sinned in betraying innocent blood.' They said, 'What is that to us? See to it yourself.' And throwing down the pieces of silver in the temple, he departed; and he went and hanged himself [in a tree]. But the chief priests, taking the

pieces of silver, said, 'It is not lawful to put them into the treasury, since they are blood money.' So they took counsel, and bought with them the potter's field, to bury strangers in. Therefore that field has been called the Field of Blood to this day." Judas's action was predicted by Jesus at the EUCHARIST, or Last Supper.

Judas is shown before the high priest Caiaphas while other elders watch in astonishment. He may hold out the money, although some artists show him in ebony shadows, and he may be in the act of throwing the coins down, or the pieces of silver may be scattered over the floor before him. Caiaphas, his arm in the air, his palm twisted, is indicating his refusal.

Example: Rembrandt van Rijn, Collection Marchioness of Normandy, London. (Held and Posner, fig. 255)

JUDGMENT OF PARIS. Paris was one of the sons of Priam, the king who ruled the fortified city of Troy. (He had fifty or more children). Paris is said to have been the one responsible for the Trojan War by abducting Helen from Menelaus. Even before his birth, his mother, Hecuba, had a nightmare of a deadly firebrand and seers interpreted the dream to mean that her unborn child would cause Troy to be devastated and burned to the ground, its inhabitants killed. Because of this the baby was given to a shepherd, who was instructed to expose him on Mt. Ida where he would die. He survived, however, nursed by a she-bear and married Oenone, daughter of the river god Oeneus.

At the MARRIAGE OF PELEUS AND THETIS, the goddess of strife, Eris, who had not been invited to the wedding threw down among the guests a golden apple with "for the fairest" written upon it. Three goddesses claimed the apple and asked Zeus (Jupiter) to judge who was the fairest, but Zeus said he would not choose between them and ordered his messenger, Mercury, to take them to Paris, who could make the judgment. Following this decision, much bribery took pace. Paris was offered a kingship with riches and land by Hera (Juno). Athena (Minerva) offered him wisdom and invincible valor in war. Aphrodite (Venus) told him she would reward him with the love of any woman he wanted and described Helen, the wife of Menelaus, king of Sparta. Paris awarded the apple to Aphrodite and at the same time made enemies of Hera and Athena, both of whom promised to destroy him and demolish Troy. Paris abandoned Oenone, sailed to Troy and established himself as a prince, the son of Priam and Hecuba. Then he sailed for Sparta and abducted Helen during her husband's absence and took her back to Troy—the act that began the Trojan War.

Paris is a rather unheroic figure, though not spoken of critically. In the duel he fights with Menelaus for Helen he was taken from the battlefield by Aphrodite. Later legend introduced the "Judgment," which is portrayed by Rubens. The contest shows Paris as a shepherd holding the golden apple, advised by Mercury, who is identified by his winged helmet and his caduceus or magic wand with two snakes entwining it. Paris judges the three naked goddesses, who twist and turn sensuously before him to display their beauty. Hera is identified

by the peacock, which was sacred to her in antiquity. Athena's spear, shield and helmet may be close by.

Example: Peter Paul Rubens, National Gallery, London. (Held and Posner, color-plate 25)

JUDGMENT OF SOLOMON. The story of Solomon is told in I Kings 3:16–28. Solomon was the third king of the united Israel, who lived from c. 970 until 931 B.C. He was the son of David and Bathsheba and his wisdom was proverbial. His court was known for its luxury and beauty. Solomon was an Old Testament "type" of Christ. On one occasion he was called upon to judge between the claims of two prostitutes who lived in one house, each of whom had given birth to a child at the same time. One child had died and each woman claimed that the living baby belonged to her. According to I Kings, "Then two harlots came to the king, and stood before him. The one woman said, 'Oh, my lord, this woman and I dwell in the same house; and I gave birth to a child while she was in the house. Then on the third day after I was delivered, this woman also gave birth; and we were alone; there was no one else with us in the house. . . . And this woman's son died in the night, because she lay on it. And she arose at midnight, and took my son from beside me.' . . . And the king said, 'Bring me a sword.' So a sword was brought before the king. And the king said, 'Divide the living child in two, and give half to the one, and half to the other.' '' The woman whose son was alive told Solomon to give the other woman the living child. And the king, having succeeded with his subtle psychological test, said, " 'Give the living child to the first woman, and by no means slay it; she is its mother.' ''

The scene shows Solomon high on his throne above the women and courtiers. An executioner stands holding the living child by one foot, usually upside down, in the air with one hand and his sword in the other. The dead child is either on the floor or held by one of the women. The moment usually depicted is when the rightful mother, rather than see her infant killed, tells Solomon to give the other woman the living child. Solomon's throne is ivory overlaid with gold with six steps, each with a lion on either side.

Example: Nicolas Poussin, The Louvre, Paris. (Friedlaender, colorplate 33)

JUDITH AND MAIDSERVANT WITH THE HEAD OF HOLOFERNES (*Judith Beheading Holofernes, Judith Slaying Holofernes,* **and** *Judith with the Head of Holofernes*). The story of Judith is found in Old Testament Apocrypha. She is a symbol of the Jews' struggle against their oppressors in the near east led by Nebuchadnezzar, king of the Assyrians. Holofernes, his second in command and chief general of his army, was ordered to take one hundred and twenty thousand foot soldiers and twelve thousand cavalry and attack the whole west country because the people there had disobeyed the king's orders. When the Assyrians attacked the Jewish city of Bethulia, Judith, a beautiful and rich widow, thought of a way to save them. "She removed the sackcloth which she

had been wearing, and took off her widow's garments, and bathed her body with water, and anointed herself with precious ointment, and combed her hair and put on a tiara, and arrayed herself in her gayest apparel, which she used to wear while her husband Manasseh was living. And she put sandals on her feet, and put on her anklet some bracelets and rings, and her earrings and all her ornaments, and made herself very beautiful, to entice the eyes of all men who might see her'' (10:3–5).

Judith and her maid servant went straight to the Assyrian lines. Under pretense of having deserted her people and because of her beauty and wisdom of words, she gained access to Holofernes. She told him of a false plan for overcoming the Jews. She was so beautiful that Holofernes kept her in the camp for several days and planned a banquet for her. When it was over and they were alone in his tent, he intended to seduce her. ''Then Judith came in and lay down and Holofernes' heart was ravished with her and he was moved with great desire to possess her; for he had been waiting for an opportunity to deceive her, even since the day he first saw her. . . . And Holofernes was greatly pleased with her, and drank a great quantity of wine, much more than he had ever drunk in any one day since he was born'' (12:16–20). This was Judith's opportunity. ''She went up to the post at the end of the bed, above Holofernes head, and took down his sword that hung there. She came close to his bed and took hold of the hair of his head and said, 'Give me strength this day, O Lord, God of Israel!' And she struck his neck twice with all her might and severed his head from his body. Then she tumbled his body off the bed and pulled down the canopy from the posts; after a moment she went out, and gave Holofernes' head to her maid, who placed it in her food bag.'' Judith and her maid walked back to Bethulia before Holofernes's dead body was discovered. The Assyrians, without their general, fled, pursued by the Israelites.

The image of Judith slaying Holofernes occurs first in the Middle Ages, but the subject became popular during the Renaissance and was painted frequently during the Baroque. The theme is sometimes seen as an expression of victory over sin. Several episodes from the story have been depicted, but the most common shows Judith in the act of cutting off the chief general's head with his own long, sharp sword. Her maid usually stands to the side holding a sack.

Example: Artemisia Gentileschi, Institute of the Arts, Detroit. (Wittkower, fig. 242)

K

KATHERINE. *See* CATHERINE, ST.

KERMESSE. Also Kermis and Kirmess, this is the term used to indicate the annual celebration of the feast day of the local patron saint and also applied to carnivals or fairs held on the same day in the Low Countries. Usually the activities were held outdoors. Artists sometimes transform this harvest festival into a peasant BACCHANAL, probably recalling Horace's *Odes,* I 37: "*nunc est bibendum nunc pede libero/pulsanda tellus,*" "Now is the time for drinking, for stomping the ground with an unrestrained foot." Crowds of sturdy peasants are shown eating and drinking. They dance gracefully under a huge tree with unrestrained exuberance. They lay about the ground in the open and under trees in complete abandon. Empty wine jugs lay scattered about and a dog feasts on leftovers.
 Example: Peter Paul Rubens, The Louvre, Paris. (Held and Posner, fig. 218)

KERMIS. *See* KERMESSE.

KINGDOM OF FLORA (*The Realm of Flora*). FLORA was the ancient Italian goddess of flowers, fruits and springtime; however she was not considered important and was not given a temple in Rome until the mid-third century B.C. According to Ovid's *Fasti,* she was worshipped at her April festival (*Ludi Florales*) with drunken abandon and licentiousness. Ovid also tells the legend that the earth nymph Chloris (the Greek goddess of flowers) was pursued by Zephyr and changed into Flora. Flowers came from her breath, and she spread them over the forests and hills. Ovid tells of Flora's gift from Zephyr, a garden filled with flowers.
 Flora is shown dancing through the garden dropping flowers here and there. Surrounding her are figures from myth who were changed into flowers after

their death. Ajax is shown throwing himself on his sword; he had become insane and killed himself after losing his claim to the arms of the dead Achilles. Ajax was turned into larkspur. According to Ovid's *Metamorphoses* 13:382–98, "Grief and rage conquered the unconquered Ajax. He snatched out his sword, and cried: 'This, at any rate is mine! Or does Ulysses demand to have it too? This is what I need, to use it on myself. The blade so often steeped in Trojan blood will now stream with its master's own, that none may conquer Ajax save himself!' So he spoke and, where there was a vulnerable spot, buried the deadly sword in his breast, till then unwounded. His hands had not the strength to pull away the weapon he had implanted: blood itself flowed out the sword. Then the earth, crimsoned with his gore, produced from the green turf that purple flower which had previously sprung up from Hyacinthus' blood. In the heart of its petals letters are traced, which apply to the boy and the hero alike, for they record the sound of the hero's name, and of the boy's cry of distress." Narcissus lingers longingly over his reflection in an urn. Clytie, who turned into a sunflower, looks with hopeless love at the sun god. She turns her head daily to follow his path through the heavens. According to *Metamorphoses* 4:256–70, "the lord of light did not go near her anymore—his affection for her was at an end. From that day she wasted away, for she had been quite mad with love. . . . For nine days she tasted neither food nor drink . . . She never stirred from the ground: all she did was to gaze on the face of the sungod, as he journeyed on, and turn her own face to follow him. Her limbs, they say, became rooted to the earth, and a wan pallor spread over part of her complexion as she changed into a bloodless plant: but in part her rosy flush remained, and a flower like a violet grew over her face, though held fast by its roots, this flower still turns to the sun." Hyacinthus is depicted touching his hand to his wounded head. Adonis, an anemone, with his hunting dogs and spear, pulls his cloak aside to show his wounded thigh. Similax and Crocus, the nymph and the beautiful youth, are shown reclining in one corner enjoying each other's company. For his impatience, Crocus was changed to the flower that bears his name; Similax was turned into a yew tree. A HERM watches over the scene. Apollo races his golden chariot pulled by four white horses across the heavens. A pergola (a tunnel-shaped structure of latticework), covered with climbing vines and flowers marks the boundaries of the garden.

Example: Nicolas Poussin, Dresden Gallery. (Blunt, fig. 232)

L

LAMENTATION. "Lamentation" is the term used to explain the scene immediately following the DEPOSITION or Descent from the Cross, at which time the body of the dead Christ had been taken down from the cross and laid stretched out in the foreground, either on a block of stone depicted to resemble an altar or simply on the ground. The dead Christ is surrounded by mourners, of which the principal participants are his mother, the Virgin Mary; MARY MAGDALENE, recognized by her long hair and sometimes her jar; St. JOHN THE EVANGELIST, usually quite young; and Joseph of Arimathaea, the "man of means" who took the body of Jesus and provided a tomb for him. According to John 19:38–39, "Joseph of Arimathaea, who was a disciple of Jesus, but secretly, for fear of the Jews, asked Pilate that he might take away the body of Jesus, and Pilate gave him leave. So he came and took away his body. Nicodemus also, who had at first come to him by night, came bringing a mixture of myrrh and aloes, about a hundred pounds' weight." Nicodemus may be shown close by with a jar of spices.

The gospels mention neither a Lamentation nor a Pietà, but the subject has been found in the Byzantine painters' guide and in the mystical literature of the 13th and 14th centuries. It is first seen in Byzantine art of the 12th century. Usually the Virgin holds Jesus' head, and Joseph of Arimathaea may hold a linen cloth. In the background may be seen the tomb—open, the lid leaning to one side. During the Catholic COUNTER REFORMATION, the dead Christ is most often seen lying on the ground on a cloth, his head held by his mother who may also be closing his eyes or removing the CROWN OF THORNS. Angels may be present, their hands raised in prayer, crying, contemplating the body or supporting it by the arms. *See also* PIETÀ.

Example: Nicolas Poussin, Pinakothek, Munich. (Friedlaender, colorplate 5)

LANDSCAPE WITH A SNAKE. *See* LANDSCAPE WITH ORPHEUS AND EURYDICE.

LANDSCAPE WITH CHRIST APPEARING TO THE MAGDALEN. The story of Christ appearing to MARY MAGDALENE is told in John 20:11–17. "Mary stood weeping outside the tomb, and as she wept she stooped to look into the tomb; and she saw two angels in white sitting where the body of Jesus had lain, one at the head and one at the feet. They said to her, 'Woman, why are you weeping?' she said to them, 'Because they have taken away my Lord, and I do not know where they have laid him.' Saying this, she turned round and saw Jesus standing, but she did not know that it was Jesus. Jesus said to her, 'Woman, why are you weeping? Whom do you seek?' Supposing him to be the gardener, she said to him, 'Sir if you have carried him away, tell me where you have laid him, and I will take him away.' Jesus said to her, 'Mary,' She turned and said to him in Hebrew, 'Rabboni! [which means Teacher].' Jesus said to her, 'Do not hold me [Noli me tangere], for I have not yet ascended to the Father; but go to my brethren and say to them, I am ascending to my Father and your Father to my God and your God.' "

Mary Magdalene, known as "The Magdalen," is the image of the repentant sinner in art from the Middle Ages onwards. As a reformed courtesan, she is particularly suited to foster devotion to the sacrament of penance. Mary Magdalene's attribute is her jar of ointment with which she anointed Christ's feet, and she holds it in her hand or it is placed near her feet. She usually has long hair. She may wear a simple cloak (in contrast to her jewels and expensive costumes before her conversion), or she may be completely naked, covered only by her long hair. She is sometimes kneeling or bending forward towards Christ, who draws back. He carries a hoe or spade, which refers to the fact that the Magdalene mistook him for the gardener. Close by may be a crucifix, a skull, a CROWN OF THORNS and a whip. During the 17th century, she was depicted most often raising her face towards heaven. A cave may be nearby, an allusion to the legend that she spent her last years in retreat in a cave at Sainte-Baume in France. The story of her pilgrimage to France originated in France in the 11th century and is told in Voragine's GOLDEN LEGEND.

Example: Claude Lorrain, Städelisches Kunstinstitut, Frankfurt. (Held and Posner, fig. 118)

LANDSCAPE WITH DIOGENES. A Greek philosopher who lived in Athens and, according to some scholars, Corinth, Diogenes lived c.400 to c.325 B.C. He was the son of Hicesias of Sinope and the founder of the Cynic sect. He lived in extreme poverty and austerity and rejected all ordinary conventions, in fact, he made his home in a tub. After watching a child drink water from his cupped hands, Diogenes threw away his drinking cup. His main philosophies were: Happiness is found by satisfying only one's natural needs and by taking care of them in the easiest and cheapest way. All that is natural cannot be indecent or dishonorable and therefore should be done when one feels like it, even in public. Conventions that are contrary to these beliefs are not natural and should not be followed. Diogenes lived by his own principles. His dialogues

and tragedies were written in order to show that the tragic heroes could have avoided unhappiness by following his principles. Plutarch's *Lives* (33:14) describes a visit from Alexander the Great, who invited the philosopher to ask for any favor, which would be granted. Alexander was surprised when Diogenes asked him to move because he was shading him from the sun.

Artists who depict this scene show Alexander, having dismounted his horse, Bucephalus, standing in front of Diogenes, who sits beside his tub gesturing to Alexander to move. During the 17th century, the most popular scenes of Diogenes show him "looking for an honest man." The scene may be a marketplace with crowds of people and Diogenes in the middle of them holding high a lighted lantern. Other versions show the philosopher holding a lamp, the symbol of his search for virtue or truth.

Example: Nicolas Poussin, the Louvre, Paris. (Friedlaender, fig. 73)

LANDSCAPE WITH HERCULES AND ACHELOUS. Hercules (Roman, Heracles or Herakles in Greek) was the most famous of all Greek heroes. Defender of the earth, gods throughout Greece worshipped him, especially in southern Greece and in the Argolid, although he is more properly a hero than a god. He may have been a lord of Tiryn in Mycenaean times under the service of the king of Argos. He was said to be the son of Zeus and Alcmene, the wife of Amphitryon, although as a grandson of Amphitryon's father, he is sometimes called Alcides. Hercules's extraordinary strength was displayed while still a baby when he strangled two snakes that Hera had sent to his cradle to kill him. His stories derive from his courage and strength, the most famous being his Twelve Labors, which he had to perform for King Eurystheus of Argos after he had killed his own children in a fit of insanity sent by Hera. The story of Hercules wrestling with Achelous is told by Ovid in the *Metamorphoses* 9:85–92. It involves Deianeira, the daughter of the river god Oeneus, who had two suitors, Hercules and Achelous, another river god. (*see* HERCULES AND DEJANIRA.) As they fought for her, Achelous changed shape, first into a serpent, then a bull. But Hercules overcame him.

Some artists show two human figures fighting, but most often Hercules fights a bull. He usually grasps its horns, twists it to the ground and has his knee in its back. His quiver and club are to one side. Nymphs may be in the background making a cornucopia from Achelous's broken horn.

Example: Domenico Zampieri Domenichino, The Louvre, Paris. (Ruskin, fig. 1–28)

LANDSCAPE WITH HERCULES AND CACUS. *See* HERCULES AND CACUS.

LANDSCAPE WITH ORION. In Greek mythology, Orion was the gigantic, handsome son of Poseidon, a hunter of Boeotia. He courted a beautiful young girl named Merope, a princess of Chios. One day, drunk and impatient at her father's impossible conditions, he raped her. In retaliation, her father punished

Orion by blinding him, then threw him out. After visiting an oracle, Orion traveled east to the furthest part of the world where Helios arose from the ocean, where the rays of Helios would give him back his sight. During his journey east, he passed the forge of Vulcan and took the apprentice Cedalion to guide him to the ocean. Dawn fell in love with Orion and they made love. Helios cured his sight. After this Orion decided to hunt for Merope's father and get revenge. Artemis (Diana) dissuaded him and he became her hunting partner. Apollo, Artemis's brother, feared for her chastity and sent a vicious scorpion after Orion. Unable to subdue the monster, Orion set out over water. Apollo went to Artemis and persuaded her to shoot the bobbing object he pointed out floating on the waves. When she shot, she sent an arrow into Orion's head. Seeing what she had done she set his image, that of a warrior, among the stars, located on the celestial equator where it was pursued by the constellation of the scorpion. Four bright stars form a quadrangle that mark his feet and shoulders.

The giant Orion is shown with his bow in hand, the hunter walking through a wooded countryside headed to the distant sea. Vulcan's apprentice, Cedalion, sits on his shoulders showing him the way. Vulcan is poised along the side of the road and points out the path. A cloud misting about Orion's face suggests that his eyes are veiled. Artemis can be seen floating above him.

Example: Nicolas Poussin, The Metropolitan Museum of Art, New York. (Blunt, fig. 244)

LANDSCAPE WITH ORPHEUS AND EURYDICE. The story of Orpheus and Eurydice is told by Ovid in the *Metamorphoses,* Book 10. Orpheus was a Thracian poet who became famous for the beautiful and hypnotic music he played on the lyre. In fact, so talented was he that he charmed not only the beasts and creatures of the wild, who would come after him at the sound of his lyre, but also the rocks and trees. He married Eurydice, a wood nymph. Hymeneus, the god of weddings, wrapped in a yellow, "crocus-colored" cloak, was called by Orpheus to the shore of the Ciconians to celebrate Orpheus's wedding with Eurydice. However, Hymeneus came reluctantly and did not bring good luck. "His expression was gloomy, and he did not sing his accustomed refrain." There were bad omens and the festivals were without joy. Hymeneus's wedding torch sputtered "and no amount of tossing could make it burn." The smoke brought tears to the eyes of the participants. From the torch came a great cloud of smoke, which hung over the castle of the Ciconians where the wedding had been celebrated. "The outcome was even worse than the omens foretold: for while the new bride was wandering in the meadows, with her band of naiads [nymphs of streams, fountains, lakes], a serpent bit her ankle, and she sank lifeless to the ground."

Before the Baroque, Eurydice is usually shown lifeless on the ground, while Orpheus weeps over her, with demons in the background dragging her soul into the entrance of Hades. Or she may flee the suitor Aristaeus. During the Baroque, however, Orpheus is shown playing his lyre on a rock on the shore of a lake.

Two young women, Ovidian naiads, are seated on the ground at his feet, listening to his song. A man behind them may be Hymeneus, the god of weddings. They are all unaware that Eurydice had started to her feet in terror. The snake wraps around her ankle, or occasionally her arm, or it may be shown slipping silently away having already bitten her (10:1–10). An enormous cloud of smoke hangs over the castle of the Ciconians in the background. Hymeneus stands looking at Orpheus, and behind him Eurydice trips and at the same time looks back at the black snake that has bitten her and now slithers away. Around the lake, which separates the main group from the town of the Ciconians, are many small figures who, naked, enjoy the pleasures of a summer day, sailing, fishing, swimming or lying about together in groups. In their great joy of life, they are a dramatic contrast to the tragic event—the death of Eurydice.

Example: Nicolas Poussin, The Louvre, Paris. (Friedlaender, colorplate 41)

LANDSCAPE WITH POLYPHEMUS. The story of POLYPHEMUS is found in Ovid's *Metamorphoses,* Book 13. One of the race of giant one-eyed Cyclopes, he lived in an enormous cave. Although he is known for his imprisonment of Ulysses (Odysseus) in his cave and the latter's excape after making him drunk and blinding him with a stake, Polyphemus is just as well known for his unrequited love for Galatea. In Ovid's story, Scylla, the sea deity, receives a visit from the beautiful sea goddess Galatea. While Galatea combs her long hair, she tells the deity her sorrowful tale of the lovesick Cyclops, Polyphemus, who played on his flute and sang praises to her beauty. She said, "I was lying in my Acis' arms, hidden by a rock, and my ears caught such words as these—for I marked what I heard—'O Galatea, whiter than the petals of the snowy columbine, a sweeter flower than any in the meadows, more tall and stately than the alder, more radiant than crystal, you are more playful than the tender kid, smoother than shells continually polished by the sea, more delightful than sun in winter or shade in summer, more choice than apples, lovelier to see than tall plane trees, more sparkling than ice, sweeter than ripe grapes, softer than swansdown or creamy cheese and, did you not flee from me, fairer than a well-watered garden.' " He tells her of his many possessions and then says, " 'Quite recently I saw my reflection in the clear water, and I liked what I saw. See how big I am. You speak of some Jupiter or other, who rules in heaven, but Jupiter is no bigger than I. Luxuriant locks hang over my rugged features, and shade my shoulders like a grove.' "

The Cyclops is shown sitting on one of the two far, cragged cliffs that jut into the Sea of Sicily. He has set aside his long staff (as described in Ovid) and plays his pipe of one hundred reeds. The music rings through the cliff-enclosed valley and is heard by all those who live there. In the foreground, not seen by the giant who has his back turned, but listening anxiously to his song, is a female figure, who seems to wring out or comb her recently washed hair. She forms the center of a triangle balanced by two other partly draped figures. This is Galatea hiding behind rugged rocks as she listens to Polyphemus's music. As

a sea creature, Galatea is not adorned with a wreath of reeds, for this crown is reserved for deities of rivers, where reeds are found. Her hair, supposed to be white, is seldom shown so light and is usually darker than that of her companions. Also, her skin is usually sunburned and not the "snowy-petal white" described by Ovid. She is shown listening to the sound of the pipes and the words of the Cyclops and she obviously does not want to be seen, for she is hiding behind an almost-naked figure. This figure could be her young lover, Acis. His body is as yet undeveloped, as emphasized by Galatea herself: " '*Pulcher et octonus iteruym natalibus actis*' [He was beautiful, sixteen years old, and his beard had just started to grow]." On his head is a wreath of reeds, and he holds a light gray urn, the attribute of a river god (although he becomes a river only after his metamorphosis, when his blood turns into the River Acis after he is killed by a stone thrown by Polyphemus.) A figure may warn Galatea of the sly approach of two satyrs, who forever lecherously lust after nymphs. Large urns, lying about before the group, indicate the element of water, and pertain to the habitat of the creatures who live there. Other figures are of little significance, those shown bathing, plowing and digging and drinking from a jug. A bearded river god in the left foreground with two spying satyrs, drawn, as usual, by the nymphs' nudity, indicate that the ambient here is the fictional world of a primitive culture. *See also* ACIS AND GALATEA.

Example: Nicholas Poussin, The Hermitage, St. Petersburg. (Friedlaender, color-plate 42)

LANDSCAPE WITH PYRAMUS AND THISBE. The story of Pyramus and Thisbe is told in Ovid's *Metamorphoses* 4:55–66. "Pyramus and Thisbe lived next door to each other. . . . Pyramus was the most handsome of young men, and Thisbe the fairest beauty of the East. Living so near, they came to know one another, and . . . in time love grew up between them, and they would have been married, but [since] their parents forbade it . . . they agreed to meet at Ninus' tomb. Stealthily Thisbe turned the door on its hinges and slipped out into the darkness, unseen by any. Her face hidden by her veil, she came to the tomb, and sat down under the appointed tree. Love made her bold. But suddenly a lioness, fresh from the kill, her slavering jaws dripping with the blood of her victims, came to slake her thirst at the neighbouring spring. While the animal was still some distance off, Thisbe saw her in the moonlight. Frightened, she fled into the darkness of a cave, and as she ran her veil slipped from her shoulders, and was left behind. When the savage lioness had drunk her fill, and was returning to the woods, she found the garment, though not the girl, and tore its fine fabric to shreds, ripping it with bloodstained jaws. Pyramus came out of the city a little later. He saw the prints of the wild beast, clearly outlined in the deep dust, and the color drained from his face. Worse still, he found the veil, all stained with blood. . . . He picked up Thisbe's veil, and carried it into the shade of the tree where they should have met. Weeping and kissing the garment he knew so well, he said: 'Drink deep, now, of my blood too.' And as he spoke

he took the sword which hung at his waist and thrust it into his side. . . . Now though Thisbe had not yet recovered from her fear, she came back. . . . She looked about. . . . As she stood in doubt, she saw the quivering limbs writhing on the bloodstained ground, and started back. . . . After a moment's pause, she recognized her love. Wailing aloud, she beat her innocent arms, tore her hair, and embracing his beloved form, bathed his wound with her tears, mingling the salt drops with his blood, and passionately kissing his cold cheeks. . . . 'Only death could have separated you from me, but not even death will part us'. . . . As she spoke, she placed the sword blade beneath her breast, and fell forward on the steel, which was still warm from Pyramus' death.''

Baroque painters usually chose the moment of Thisbe's discovery of Pyramus's body. He lies on the ground, his sword at his side. Thisbe runs to him or stands over him, her arms flaying in horror. Or, she may be depicted in the act of killing herself. The lion is sometimes shown in the dark of night landscape, possibly attacking cattle while men chase it away.

Example: Nicolas Poussin, Städel Institute, Frankfurt am Main. (Friedlaender, fig. 76)

LANDSCAPE WITH ST. JOHN ON PATMOS. JOHN THE EVANGELIST is the presumed author of the fourth gospel and, by tradition, of the Apocalypse. His name means the Lord's grace, or he who is in grace. After the Pentecost, the apostles separated and John went to Asia where he founded many churches. The Roman emperor, hearing of his success, summoned him to Rome and had him put into a huge pot of boiling oil, which was set before the gate called the *porta Latina* for all to see. But John came forth untouched. Seeing this, the emperor exiled him to the island of Patmos in the Aegean sea, close to the mainland of Asia Minor, where, living alone, he is believed to have written the book of Revelation, the *Apocalypse.* The Emperor was killed that same year, and the Senate revoked all his decrees. It was in this way that John returned to Ephesus in glory. John was one of the first to be called to follow Christ. He appears with James and Peter in the scene of the Transfiguration.

On Patmos he is usually depicted in a rocky landscape, which may include deserted Greek ruins, in the act of writing his Gospel on a large tablet. In the background, one can distinguish the mainland and a quiet town. John's eagle, the symbol of his inspiration, may be beside him or somewhere in the scene. Some artists depict an inkhorn about the eagle's neck. Also included may be John's vision of the Virgin Mary crowned with stars, holding the baby Jesus. According to John, Revelation 12:1 ''and a great portent appeared in heaven, a woman clothed with the sun, with the moon under her feet, and on her head a crown of twelve stars.''

Example: Nicolas Poussin, The Art Institute, Chicago. (Friedlaender, colorplate 38)

LANDSCAPE WITH STORM AND PHILEMON AND BAUCIS (*Landscape with Philemon and Baucis*). The story of Philemon and Baucis is told in Ovid's *Metamorphoses* (8:627–726). It is a long story of a very old man

and a very old woman who lived in extreme poverty and had nothing. Yet, they took in two travelers who had been turned away by other, grander houses where the people could well afford to feed them. "As the dinner went on, the old man and woman saw that the flagon [of wine], as often as it was emptied, refilled itself of its own accord, and Baucis and Philemon were awed and afraid." The two decided that for the occasion they would kill their only goose, which was used as a guardian for their humble cottage. But "with the help of its swift wing it eluded its owners for a long time, and tired them out, for age made them slow. At last it seemed to take refuge with the gods themselves, who declared that it should not be killed." Jupiter and Mercury then revealed themselves to Philemon and Baucis and took them up the mountain where they saw that the entire country was flooded except for their cottage, which had been changed into a temple with marble columns. Granted a wish by Jupiter, Philemon and Baucis chose to be priests of the temple. When they died they were changed into an oak and a lime tree.

Jupiter and Mercury are usually shown at a table spread with a jug or bowl of wine and food. The goose is nearly always included, and Jupiter stays the hand of Philemon as he tries to catch it. Both gods are wearing the costumes of travelers. Jupiter may have his eagle present. Mercury may have his staff twined with serpents, and he may wear his winged hat. However, since the gods are in disguise, their attributes are usually missing.

Example: Peter Paul Rubens, Kunsthistorisches Museum, Vienna. (Held and Posner, fig. 216)

LANDSCAPE WITH THE FINDING OF MOSES. *See* MOSES FOUND BY THE PHARAOH'S DAUGHTER.

LANDSCAPE WITH THE WOMAN OF MEGARA GATHERING THE ASHES OF PHOCION. *See* BURIAL OF PHOCION.

LAS HILANDERAS. In English, *The Spinners.* Originally recorded as The Fable of Arachne, the story of Arachne (Arcady), a Lydian girl, is told by Ovid in *Metamorphoses* 6:104–46. Arachne was turned into a spider (Greek *arachne*) by Athena after being challenged to a tapestry-weaving contest. "Arachne wove a picture of Europa, deceived by Jupiter . . . Asterie too, held fast by the struggling eagle, and Leda reclining under the swan's wings. . . . Then the girl added further pictures of Jupiter in disguise, showing how he turned himself into a satyr to bestow twins on fair Antiope and assumed the likeness of Amphitryon when he embraced the lady of Tiryns; how he tricked Danaë by changing into a shower of gold, deceived Asopus's daughter as a flame, Mnemoyne as a shepherd, and Demeter's daughter, Prosperpine, as a spotted snake." Arachne showed many others and no one could find flaw in her work. "The Golden-haired goddess [Pallas], wild with indignation at her rival's success, tore to pieces the tapestry which displayed the crimes committed by the gods. Then,

with the shuttle of Cytorian boxwood . . . three times, four times, she struck Idmon's daughter on the forehead. Arachne found her plight beyond endurance: . . . she fastened a noose round her neck, to hang herself. But Pallas pitied her, as she hung there; lifting her up, the goddess said: 'You may go on living, you wicked girl, but you must be suspended in the air like this, all the time. Do not hope for any respite in the future—this same condition is imposed on your race, to your remote descendants.' Then as she departed, she sprinkled Arachne with the juice of Hectaste's herb. Immediately, at the touch of this baneful potion, the girl's hair dropped out, her nostrils and her ears went too, and her head shrank almost to nothing. Her whole body, likewise, became tiny. Her slender fingers were fastened to her sides, to serve as legs, and all the rest of her was belly; from that belly, she yet spins her thread, and as a spider is busy with her web as of old.''

Artists usually show Arachne winding her yarn while Athena, now in her old woman's clothes, spins (the spokes no more than blurs she spins so rapidly). Shown on a tapestry in the back, in a sunlit cove, the goddess, wearing a breast-plate and helmet, declares that the contest is on. Other artists show Arachne at the moment she turns into a spider, her arms tangled within a tremendous web. (Ancients believed the spider web to be woven.)

Example: Diego Velázquez, The Prado, Madrid. (Brown, pp. 153–55)

LAS LANZAS. *See* SURRENDER OF BREDA.

LAS MENINAS (*The Family of Philip IV* and *The Maids of Honor*). This is a 17th-century portrait of the royal family of Spain. The Infanta Doña Margarita is shown with her ladies-in-waiting, the court jester Nicolasito, the female dwarf María Bárbola, and a pet mastiff. All are in a room in the Alcázar palace in Madrid with the artist, Diego Velázquez, first painter to King Philip IV. Exactly what the artist is presenting in this painting is uncertain, but a few explanations have been offered. It is possible that Velázquez was in the act of painting a portrait of the infanta's parents when the young girl and her retinue entered the room and so fascinated him that he turned to painting them instead. Another possibility is that the young princess was not willing to join her parents posing for the court painter and one of her maids of honor, Doña María Augustina Sarmiento, may be trying to persuade her. She offers the girl a tiny red flask that may contain perfumed water or chocolate.

The scene is a typical Baroque illusion (*see* ILLUSIONISM). The king and queen, possibly posing for the painter in the artist's studio, are in the position of the spectator, across the room, outside the painting. They are shown in the painting only by their reflection in a small mirror behind the infanta. The group also appears to be caught in the moment of transitory action: Don José Nieto is just leaving the studio. Muted colors and gloom are arranged in such a way as to create varying distances and the atmosphere of the musty air in this room of the Alcázar. Some scholars believe that the canvas appears to have been taken

from a huge mirror reflecting the whole scene, which would mean that the artist did not paint the princess and her suite, but himself in his own studio in the process of painting them. Three sources of light illuminate the room—two windows not seen on the right and the hallway at the back. A truly 17th-century effect of physical depth and illusion of space has been created.

Velázquez wears the red cross of the illustrious Order of Santiago on his doublet, painted there, according to legend, by the king himself. Scholars believe the artist painted it. Because some of the required certifications of nobility were missing in his background, the artist achieved the order only after a long struggle at the end of his life, and then only after a dispensation was issued from the pope. This large canvas in Velázquez's mind, might have suggested the idea of the king dropping by his studio just as Alexander the Great frequented the studio of Apelles in ancient times. The artist places himself on equal footing, face-to-face with his sovereign, and at the same time elevates the art of painting to the highest status. The room in the painting had once been part of the apartments of Prince Baltasar Carlos, who died in 1646. It was partly modified into a studio after his death.

Las Meninas was painted to hang in the personal office of King Philip in another room of the palace, and, in such a location, it was meant for the king as private viewer. It was not intended to be displayed in a gallery for mass spectators.

Example: Diego Velázquez, The Prado, Madrid. (Brown, pp. 177–84)

LAST COMMUNION OF ST. JEROME. Jerome is from the Latin Hieronymus, meaning holy law. His full name was Jerome Eusebius Hieronymus Sophronius and he was born in 342 at Stridon, on the borders of Dalmatia and Pannonia Dalmatia, a region of southwestern Yugoslavia. He died in 420. St. Jerome is one of the four Latin or Western Fathers of the Church. As a child his father, Eusebius, a nobleman, saw to it that he was well educated. Jerome became master of Greek and Latin, while his native language was Illyrian. As a young man he made a pilgrimage to the Holy Land, and he was, in general, well traveled. In 386 he translated the Old and New Testaments into Latin. This version of the Bible is known as the Vulgate and was made the official Latin text by the Council of Trent in the 16th century. His devotion to classical literature caused him to think he was accused by God of preferring Cicero to the Bible. He dreamed he was whipped by angels for this sacrilege. Also, while in the desert, he imagined he heard trumpets sounding the Last Judgment. His letters describe how, while practicing severe asceticism in the desert, he experienced vivid sexual dreams: ''Ofttimes I imagined that I was surrounded by dancing girls, and in my frozen body and moribund flesh the fires of concupiscence were lighted.'' According to Voragine's GOLDEN LEGEND, Jerome remained a virgin throughout his life; however, in a letter to Pammachius, he stated that he held virginity as high as heaven, but he did not possess it. According to the *Golden Legend,* Jerome pulled a thorn from the foot of a lion

who came to him from the desert. He believed the lion had been sent by God not only to have his foot healed, but also to serve the monks. Most of Jerome's work was done in a large rock-hewn room near the tomb of Jesus. It was here that he was buried after he died at the age of ninety-eight.

Jerome is usually depicted as an extremely old man, emaciated and with gray hair and a beard. As he receives his last communion, he may hold his crucifix. An hourglass, a lion and a skull may be nearby. Also included may be a red cardinal's hat and the red garments of a cardinal, although he never held the office of cardinal. As an allusion to his translation of the Bible (the Vulgate) one may see his inscription on a book, or simply a book held by an angel found in Genesis 1:1: *"In principio creavit Deus caelum et terram."*

Example: Domenic Zampieri Domenichino, Vatican Gallery. (Waterhouse, fig. 12)

LAST COMMUNION OF ST. MARY MAGDALENE. Stories of MARY MAGDALENE, the image of the penitent in Christian art, are found in the gospels Luke 7:44–50 and 10:38–42 and John 20:14–18. She was born of parents of noble station and came of royal lineage. Her father's name was Cyrus and her mother's Eucharia. Together with her brother, Lazarus, and her sister, Martha, she owned the fortified town of Magdala near Genezareth (close to Jerusalem) and a large section of Jerusalem itself. Mary was as beautiful as she was wealthy. She came to be called "the sinner" because of the way she had abandoned her body to pleasure. Yet one day, when Jesus was close by, she went to him and washed his feet with her tears and wiped them with the hair of her head and anointed them with precious ointment. Jesus told those who criticized her that this woman's sins were forgiven her because she loved much. From that day on his words were always in her defense. Mary Magdalene was at the foot of the cross during Jesus' CRUCIFIXION. The story of her last communion is told in Voragine's GOLDEN LEGEND. She knew when the moment had come to die, for she told those about her that the moment was at hand and it was time to leave the earth forever. Saint Maximinus writes that the Magdalene's face, long accustomed to clouds of angels, had become dazzling, blinding; that one could more easily face the flames of the sun than the brilliance of her face. The bishop himself called her priest and his clergy, who gave Mary Magdalene the last rites. It was soon after she had taken Communion that she died, falling lifeless before the altar. Her soul went on to heaven and God. It was said that the scents of her sanctity hovered so strongly that for seven days the small chapel floated full with her precious perfumes. Maximinus had her body interred with exquisite magnificence and grandeur and commanded that when he died his body be placed near hers.

In art, the Last Communion is given to Mary Magdalene either by angels in her cave in the mountains, or according to another legend, by St. Maximin, one of her companions on her voyage to Marseilles, after she had been taken by angels to his chapel in Aix. She may kneel before him, held up by angels, as

he gives her the host. Mary Magdalene is recognized by her jar of ointment and her long hair. She is usually shown nude in Baroque painting.

Example: Francesco Vanni, S. Maria di Carignano, Genoa. (Waterhouse, fig. 179)

LAST SUPPER. *See* EUCHARIST.

LAWRENCE, ST. *See* NATIVITY WITH ST. LAWRENCE AND ST. FRANCIS.

LAWRENCE DISTRIBUTING ALMS. The story of Lawrence, one of the most venerated saints of Christendom, is told in Voragine's GOLDEN LEGEND. A native of Spain, he was brought to Rome by Saint Sixtus and later ordained by him as his archdeacon. Saint Sixtus was arrested and brought before the emperor as one who worshipped Christ. Lawrence begged to follow him to his death. "And Sixtus said, 'I abandon thee not, my son, but greater trials await thee for the faith of Christ. For we, as old men, reach the goal by a lighter struggle; but to thee, a youth, there remains the more glorious triumph over the tyrant; and after three days thou shalt come after me, the Levite after the priest.' And to him he confided all the treasure, commanding him to give it to the churches and to the poor. Thus Lawrence sought out the Christians day and night, and ministered to each according to his need. He came to the home of a widow who had concealed many Christians in her house, and she had long been afflicted with Dolours of the head, and laying his hands upon her, he delivered her of her ailment; and he washed the feet of the poor, and gave alms to all."

Lawrence is shown as a young man with short, dark hair, wearing the deacon's dalmatic (a loose outer garment with short, wide sleeves and open sides). He usually holds or stands on a gridiron, upon which he was burned alive. He may hold a martyr's palm or the processional cross, which it was the deacon's duty to carry. The alms he distributes to the poor are in the form of the church's gold censers and other precious vessels. He is surrounded by beggars, children, old women and cripples. He may hold a bag of money.

Example: Bernardo Strozzi, S. Niccolo Venice. (Waterhouse, fig. 108)

LAY FIGURE. A model of the human figure that is jointed so that it can be set in numerous positions and used as an artist's guide to form, proportions, positions of the human body and general mass. Although marionettes and dolls were used in antiquity, the first description of a lay figure is found in Filarete's third book of his *Treatise on Architecture* (1451–1464). Until the Renaissance, lay figures were mostly small in size. Giorgio Vasari mentions a life-size model of wood that was made by Fra Bartolommeo (c. 1474–c. 1517). During the 17th century, lay figures gradually increased in size, and by the 18th century the lay figure was sophisticated, life-size, jointed and covered with fabric.

LAZARUS. *See* RAISING OF LAZARUS.

LEAD SCULPTURE. Lead, a dense metal with low tensile strength, is an unusually flexible, malleable, heavy lustrous metal. Silver-blue when freshly cut, it is so soft that it is easily scratched with a pointed object. This softness that creates the greatest possibilities for mistakes for the sculptor. The difficulties in keeping a leaden statue from being no more than a weighty, leaden mass are too great for the dilettante. It is possible to work lead directly either by being hammered or otherwise beaten into shape, or one may melt and cast it much the same as one would cast bronze. (*See* CIRE-PERDUE.) The finished product may be hammered and shaped even further. Lead is one of the oldest metals used by sculptors. It was known to the ancient Egyptians and the Babylonians. It was used by the Greeks for reliefs and small statuettes. The Romans used lead not only for their pipes and solder, but also to make vases and garden ornaments. Since then lead has been widely used. Probably no sculptor ever used lead as a medium more successfully than the leading Austrian Baroque artist Georg Raphael Donner.

Example: Donner, *Providence,* Austrian Baroque Museum, Vienna. (Bazin, fig. 193)

LE BRUN, CHARLES. A French painter and decorator, Charles Le Brun (1619–1690), was trained in the studio of Simon Vouet. In 1642, while working in Rome under Nicolas Poussin, the painter responsible for establishing Classical painting as particularly expressive of French taste, Le Brun became a convert to Poussin's austere Classical theories of art, strict academic traditions that went back to the early Renaissance. These ideas, that all good art must be the result of good judgment, a judgment based on sure knowledge, became the foundation of his later academic doctrine. In 1646 he returned to Paris and found his true calling, which was the production of immense and dazzling decorative paintings. The Baroque illusionistic ceiling for the gallery of the Hôtel Lambert is his most important work of the mid-17th century; in its time, it was the most ambitious piece of Baroque ILLUSIONISM to be executed in France. Some historians consider it the finest room of the period to survive. The theme is the Labours of Hercules, to whom the room is dedicated.

In 1661, Le Brun was hired by Colbert to become the chief decorator for LOUIS XIV, and as such, he was the chief influence behind the grand and imposing decorative schemes at Versailles. As Colbert's right-hand man, he helped implement the policies that demanded unified standards of taste through the decorative schemes of Versailles and controlled all artistic production. Le Brun was so successful and admired that in 1662 he was named *Premier Peintre du roi* (first painter to the king); the following year, he was named director of the famous GOBELINS tapestry factory. He produced the designs used by the artists and craftsmen who were employed there in the manufacture of decorations and furniture for the royal palaces.

Concurrently, Le Brun was appointed director, under Colbert, of the reorganized Académie. He turned the school into a tightly run organization with a strictly codified system of orthodoxy in all matters of art. He became so im-

portant and revered that his lectures (based on the Classicism of Nicolas Poussin) were accepted as the official standards for artistic correctness and the authority behind the view that every aspect of artistic creation can be reduced to teachable rules and unwritten laws. His small treatise *Méthode pour apprendre à dessiner les passions proposée dans une conférence sur l'expression générale et particulière* (1698) followed the theories of Poussin.

Le Brun's actual talent lay in dramatically excessive and flamboyant decoration. His most outstanding works for Louis XIV were in the Galerie d'Apollon in the Louvre, executed in 1661, and the famous Galerie des Glaces, or Hall of Mirrors, at Versailles in 1679–1684. This enormous hall (240-feet long) overlooks the park from the second floor of the palace and extends along most of the width of the central block. He also built the Great Staircase of 1671–1678, which was destroyed in 1752.

LEITMOTIF. Also Leitmotiv, a term meaning to lead, or guide. It is actually a short musical phrase representing and recurring with a given situation, character or situation in an opera that was first developed by Richard Wagner. Artists, during the 17th century, used the word as a part of their painterly vocabulary to indicate the recurring use of certain characters and situations.

LE MARRIAGE à LA VILLE. The characters in this work are all dignified, well-dressed members of the *noblesse de robe* and their families, including children. Represented are the life and manners, the practical events one associates with the nobility and a bourgeois marriage. A contract is being signed by an aristocratic man seated at the table, the children return from baptism and other members of the family discuss the coming events.

Example: Abraham Bosse, British Museum, London. (Blunt, fig, 225)

LEUCIPPUS. *See* RAPE OF THE DAUGHTERS OF LEUCIPPUS.

LIBERAL ARTS. During antiquity, the arts were most often differentiated as the liberal arts and the vulgar arts. In the Middle Ages the arts were known mostly in Latin terminology as *artes vulgares,* or *sordidae,* and *artes liberales.*

LIBERATION OF ST. PETER. The release of Christ's apostle Peter from prison is told in Acts 12:1–11. It was during the persecution of the apostles by Herod that Peter was put into prison and also James the Greater was executed. "About that time Herod the king laid violent hands upon some who belonged to the church. He killed James the brother of John with the sword; and when he saw that it pleased the Jews, he proceeded to arrest Peter also. This was during the days of Unleavened Bread. And when he had seized him, he put him in prison, and delivered him to four squads of soldiers to guard him, intending after the Passover to bring him out to the people. So Peter was kept in prison; but earnest prayer for him was made to God by the church. The very night when

Herod was about to bring him out, Peter was sleeping between two soldiers, bound with two chains, and sentries before the door were guarding the prison; and behold, an angel of the Lord appeared, and a light shone in the cell; and he struck Peter on the wide and woke him saying, 'get up quickly.' And the chains fell off his hands. And the angel said to him, 'Dress yourself and put on your sandals.' And he did so. And he said to him, 'Wrap your mantle around you and follow me.' And he went out and followed him; he did not know that what was done by the angel was real, but thought he was seeing a vision. When they had passed the first and the second guard, they came to the iron gate leading into the city. It opened to them of its own accord, and they went out, and passed on through one street; and immediately the angel left him. And Peter came to himself and said, 'Now I am sure that the Lord has sent his angel and rescued me from the hand of Herod and from all that the Jewish people were expecting.' ''

Peter is usually shown in chains, awakened by an angel who appears in a brilliant celestial light. The angel may be guiding him from the dark cell. Soldiers sleep somewhere nearby. The release of Peter from prison by an angel was regarded as symbolic of the coming deliverance of the Christian Church from persecution.

Example: Giovanni Battista Caracciolo, Chiesa del Monte della Misericordia, Naples. (Wittkower, fig. 241)

LORETTO. *See* MADONNA DI LORETTO.

LOS BORRACHOS (*The Drinkers, The Drunkards* and *Triumph of Bacchus*). BACCHUS is the name for the Greek god of drunkenness, Dionysus (the Latin *Liber*), and the form found most often in 17th-century art. Bacchus was responsible for causing individuals to liberate their emotions and be completely free of inhibitions. He inspired men and women with joy and urged them on to good times and even past that to inebriated frenzy. In the example below, a young man depicted as Bacchus, wearing nothing but a cloak and a towel around his waist, appears to be enjoying life, drinking and making jokes. He seems to have just emerged from a swim in a stream close by and is the Classical Bacchus one would expect. He sits comfortably with branches of grape leaves in his hair and has a prankish gleam of mischief in his eye as he crowns a kneeling worshipper, who happens to be a simple Spanish peasant. Other sunburned peasants watch in a festive kind of atmosphere of relaxed goodwill. One peasant grins and hands a cup of wine to (or toasts) the spectator, while another jokingly reaches to take it from him. Behind the merry group a beggar tips his hat and extends his hand for alms. The message is to slip into the delightful intoxications of wine and be happy now for who knows what will happen tomorrow. It is possible, too, that the artist may have been illustrating public drinking spectacles at which time peasants would be given wine until they acted stupid and finally

fell down sodden. This exhibition was performed for the amusement of an audience of courtiers.

Example: Diego Velázquez, The Prado, Madrid. (Brown, pp. 69–71)

LOT AND HIS DAUGHTERS (*Lot Made Drunk by His Two Daughters*). The story of Lot and his daughters is told in Genesis 19:30–38. After the DESTRUCTION OF SODOM and Gomorrah (Genesis 19:1–28), Lot took refuge in a cave with his two daughters. Believing that they were the only persons alive on earth, they decided that in order to perpetuate the human race they each had to bear a child. "Now Lot went up out of Zoar, and dwelt in the hills with his two daughters, for he was afraid to dwell in Zoar; so he dwelt in a cave with his two daughters. And the first-born said to the younger, 'Our father is old, and there is not a man on earth to come in to us after the manner of all the earth. Come, let us make our father drink wine, and we will lie with him, that we may preserve offspring through our father.' . . . Thus both the daughters of Lot were with child by their father."

Artists usually show one daughter laying across her aged father's lap, while the other pours wine for him.

Example: Joachim A. Francis Howard Collection, Inga Aistrup Foto, Denmark. (Larousse, fig. 633)

LOUIS XIII. *See* BIRTH OF LOUIS XIII.

LOUIS XIV. Louis XIV (1638–1715) was king of France from 1643 until his death. After his father's death, his mother, Anne of Austria, was regent for Louis, but, in fact, Cardinal Mazarin had the real power. Louis did not take over the government until 1661 when Mazarin died. France by then had been exhausted not only by the Thirty Years War, but also by fiscal abuses, and by the outbreaks known as the Fronde. But the centralizing policies of Mazarin and Richelieu had paved the way for Louis, under whom absolute monarchy, based on the theory of divine right, reached its zenith. While Louis continued the nobility's exemption from taxes, he forced them into financial dependence on the crown and created a court nobility that thrived on petty intrigues and ceremonial etiquette. The provincial nobles lost political power and a centralized bureaucracy was built with the bourgeoisie. Louis created specialized ministries responsible only to him and curtailed local authorities. Under his minister Jean Baptiste Colbert, commerce and industry expanded, colonial trade was increased and a navy was developed. Under the war minister, the Marquis de Louvois, the foundations of French military greatness were built. Louis married the Spanish princess Marie Thérèse in 1660, a marriage which served as a pretext for the War of Devolution and gained him part of Flanders, although the Dutch moved against him with the triple alliance of 1668. The king limited his aggressive policies to diplomacy for the next ten years.

A great supporter of the arts, the king encouraged and patronized the foremost

artists and writers of his time. His building of Versailles was supervised by the architect Jules Mansart. Louis was called ''Le Roi Soleil,'' or the Sun King, because of the brilliance of his court, which faded after his grandson, Louis XV, succeeded him.

Rigaud's famous portrait shows the king wearing his exquisite robes, draped with the expensive attributes of royalty, worn with an arrogant and splendid majesty. He stands with regal aloofness and stares almost condescendingly at the spectator. Sturdy architecture, bannerlike Baroque curtains, white ermine, exquisite and flowing, and fleur-de-lis exalt the king and promote an image of imposing self-confident power and complete ceremonial luxury. Louis had such an admiration for this portrait that he kept it, although he had intended to give it to Philip V of Spain.

Example: Hyacinthe Rigaud, The Louvre, Paris. (Blunt, fig. 334)

LOUIS XIV VISITING THE GOBELINS FACTORY. The official title of the GOBELINS factory was Manufacture royal des meubles de la Couronne. Planned to produce everything necessary for the furnishing of the royal palace, the factory was founded by Jean Gobelin in the mid-15th century as a dye works. The tapestry section was added later by two Flemish weavers, François de la Planche and Marc de Comans, who had been summoned to France in 1601. LOUIS XIV purchased the Gobelins in 1662, and under the direction of Jean Baptiste Colbert, French comptroller general of finances after 1665, all royal craftsmen were united and a royal furniture and tapestry works was created. The chief designer from 1663 until 1690 was CHARLES LE BRUN. Under him worked an army of sculptors, engravers, painters, embroiderers, weavers, dyers, cabinetmakers, goldsmiths, wood-carvers, mosaicists and marble-workers. He controlled some two hundred fifty workmen, and he supplied the designs for every section. After 1697 the works specialized in the manufacture of tapestry. The factory, even until this day, has always been known for its excellence of workmanship, its high level of technical skill, its unusual and lovely dyes and extraordinary materials. Neither individual ideas nor creativity were ever at a premium at the factory, although one must note that the Gobelins was more than a universal factory. It was a school. The constitution, drawn up in 1767, gave great attention to the training of apprentices. According to this document, not until the student had a firm foundation in drawing could the study of any craft begin. Also, all artists were directly employed by the king and enjoyed the same freedom as the artists who had lodgings in the Louvre. The rare and exquisite Gobelins blue dye originated there.

Fourteen great tapestries made at the Gobelins commemorate the achievements of Louis XIV and are known collectively as the *Histoire du Roi*. The particular tapestry showing the king's visit to the factory shows the vast variety of productions by the two hundred fifty workmen. The composition is cleverly crammed with silver basins, inlaid tables, carpets and a hundred other articles of luxury being laid before King Louis XIV, who enters the room with his

elaborately-dressed entourage. On the wall in the background hangs one of Le Brun's CARTOONS (sketches) for the tapestry illustrating the life of Alexander the Great.

Example: Charles Le Brun, Gobelins Museum, Paris. (Blunt, fig. 268)

LUCRETIA. *See* RAPE OF LUCRETIA.

LUNA AND ENDYMION. Also mentioned in the inventory of Cardinal Mazarin's collection as *Endymion with the Chariot of the Sun.* Luna was the Roman goddess of the moon. Her Greek counterpart was Selene. The Romans identified her with Diana, the Greek Artemis. Endymion was a shepherd. Luna (or Selene), the moon, found Endymion, a youth of incredible beauty, one night in a cave at mount Latmus in Caria. She lay beside him and kissed his eyes. Now he sleeps there permanently in a trance of enchantment, in a magical moonlight that makes his beauty irresistible, almost divine, never growing older or less beautiful, as a prisoner of the moon. Luna's story, as Diana with Endymion, is told in Lucian's *Dialogues of the Gods.* Jupiter gave to Endymion, as the beloved of an Olympian, the choice of aging and dying or of living forever in eternal youth, but forever asleep. He chose the latter. Forever asleep in youthful beauty, he was visited nightly by Luna as a goddess.

Luna is sometimes depicted embracing Endymion as he lies on a leafy bed. Sometimes animals sleep beside him, the animals being symbolic of Luna. Luna may also visit Endymion in the form of moonlight, which covers his body. Amoretti (*see* AMORETTO) or cupids, may be present. Some artists depict Endymion still awake, kneeling, welcoming the arrival of Luna, although his face may show helplessness and despair. Luna's face shows superiority tempered with kindness. A tiny winged PUTTO, clinging to her neck, urges her departure. In the sky, Luna's brother, the sun god, is beginning his long journey across the blue and orange and yellow heavens in his dazzling chariot drawn by four large and eager horses. AURORA, with arms outstretched, leads the way. Luna is identified by a golden crescent moon above her brow. One of her long-legged hunting dogs may stand behind her (in reference to her role as the goddess of the hunt, Diana). Night, a woman draped in the darkest blue and nude above the waist, may be present, reaching to pull the heavy dark curtain of sleep about her. At her feet are two children slumbering in shadows, yet highlighted by long copper rays of the sun. Somnus is still sleeping.

Example: Nicolas Poussin, Detroit Institute of Arts. (Friedlaender, colorplate 14)

M

MAAS AT DORDRECHT. Maas is the Dutch and Flemish name for the Meuse, a river in northeastern France, Belgium and the Netherlands. Its 560-mile length flows toward the North Sea. The Meuse, or Maas, is linked with the Belgian port of Antwerp by the Albert Canal and with Rotterdam and other Dutch ports by the intricate system of Dutch waterways. Most of the cities along the course of the river have been strongly fortified since the Middle Ages. Dordrecht is a city in the southwestern Netherlands, also called Dort. It has always been an important river port. Founded in the early 11th century, it was the scene, in 1572, of the meeting of the Estates of Holland that proclaimed William the Silent stadtholder. During the 17th century, the Synod of Dort, held there in 1618–19, condemned the Remonstrants (Dutch Protestants). River activity was lively in the Netherlands during the 17th century. Dordrecht's location at the fork that formed the North Maas and the Lower Maas made it one of the principal cities of the country until traffic on the Maas was diverted to Rotterdam.

The scene is late afternoon, and sun sparkles on glistening water that mirrors masts sails and sterns. Huge sailing vessels, small craft and rafts are shown, some with rigging like black branches against a sky of rushing clouds.

Example: Albert Cuyp, Kenwood House, London. (Rosenberg, Slive, ter Kuile, fig. 222)

MADONNA DEL ROSARIO. *See* MADONNA OF THE ROSARY.

MADONNA DI LORETTO (*Virgin of the Pilgrims* **and** *Our Lady of Loretto*). This topic is common in chapels dedicated to ''Our Lady of Loretto.'' Although the theme belongs primarily to the art of the COUNTER REFORMATION, one encounters it during the Baroque. The legend that is associated with the shrine at Loretto depicts the image of the Virgin and her Child upon the roof of a house that has been taken aloft by angels, who support its four corners. It tells

how the Holy House of the Virgin in Nazareth, the "Santa Casa" (the house to which Gabriel came when he told Mary she would be the mother of God), was carried away by angels in 1294 (some accounts say 1291) when the Saracens were fighting the crusaders. The angels carried the Santa Casa first to the coast of Dalmatia or the Adriatic Sea, then finally set it down at Loretto, a small village near Ancona in the Marche, in central Italy, on a hill overlooking the Adriatic. Around the Virgin's house, which was a small, conservative brick building, there is a church, the Santuario della Santa Casa, started in 1468 by Pope Paul II. During the 17th century, bronze doors and frescoes were added. Also, the Loreto (or Loretto) order of nuns, named for the Italian town, was founded in 1822 in Ireland. The legend originated in Italy during the 15th century, but was used during the 17th century by the Jesuits in order to make the town known to pilgrims. Today Loreto is a famous place of pilgrimage.

The usual image is of the Virgin and her Child seated on the roof of a house that is supported by angels. The traditional iconography of the Virgin is rejected in Caravaggio's Loreto Madonna. He shows her appearing at the door of her humble house, which has a goat skin hanging in the doorway. She stands, holding her child, before two poor pilgrims, who kneel in complete adoration and awe. The pilgrims are shown with muddy feet and torn and dirty clothes. The detail of the dirty feet, denigrated as a lack of DECORUM, grace and religious feeling by Baroque art critics, historically is an essential detail as pilgrims traveled to Loreto barefoot.

Example: Caravaggio, Sant'Agostino, Rome. (Bottari, figs. 47, 48)

MADONNA DU PILIER. *See* VISION OF ST. JAMES THE GREATER.

MADONNA OF THE ROSARY (*Madonna del Rosario, The Virgin of the Rosary*** and *** The Vision of St. Dominic***).** Dominic was the founder and father of the Order of Preachers. Born in Spain of noble parentage and educated in Palencia, he devoted himself to prayer day and night. While stricken with a fever, during prayer the Virgin came to him in a vision and gave him medicine. She gave him a chaplet of beads he called "Our Lady's crown of roses." He is thus given credit for the invention of the rosary. (A Dominican friar living near the end of the 15th century is also given credit for the use of the rosary as an aid to prayer.) The rosary is used by Roman Catholics as a mnemonic, or helpful memory device, for counting the special sequence of prayers that form the basis of the three cycles of prayers, or the "mysteries of the Virgin." Throughout history the rosary has been believed to have special powers. When the forces of Christendom defeated the Turks in the naval BATTLE OF LEPANTO in 1571, the victory was attributed to the power of the rosary.

During the 17th century, the vision of St. Dominic is found in paintings done for his order. Representations of St. Dominic's vision were fostered during the COUNTER REFORMATION. He is shown receiving the beads from the hands of the Virgin or Jesus; or an angel hands the beads to Jesus, while St. Dominic

kneels in prayer below, his hands extended toward the child. Catherine of Siena, a patron saint of his order, may be depicted. She may also extend her hand to receive a rosary from the Virgin or the Child.

Example: Anthony Van Dyck, Oratorio del Rosario, Palermo. (Waterman, fig. 174)

MADONNA ON THE STEPS. The Madonna, the mother of Jesus, is seen seated on high steps holding her child. She is dressed in her customary blue— the color of truth, blue symbolized heaven and heavenly love—and red (the church's color for martyred saints). To her right, Elizabeth leans forward and toward her with her child, JOHN THE BAPTIST, who offers Jesus a piece of fruit. Joseph, to the Virgin's left, is seated in shadows, his staff placed nearby. Two Corinthian columns are placed on either side of the head of Jesus, just behind him, and a building forms a kind of square halo around his head.

Example: Nicolas Poussin, The National Gallery of Art, Washington, D.C. (Friedlaender, colorplate 32)

MADONNA WITH ST. ANNE. Anne (or Anna), mother of the Virgin Mary, was of Bethlehem and had a sister named Ismeria. Her husband was Joachim, of the town of Nazareth in Galilee. According to Voragine's GOLDEN LEGEND, Anna and Joachim had been married for twenty years and had no children. Together they made a vow to God that if he granted offspring they would dedicate their child to his service. An angel appeared to Joachim and told him that his wife, Anna, would have a daughter, that she would be born of a barren mother, and that she would become the mother of Christ, whose name would be Jesus, and through Jesus salvation would come to all nations. Anna, indeed, did have a girl whom she named Mary. According to "The Nativity of the Virgin Mary," in the *Golden Legend,* Anna actually had three husbands, Joachim, Cleophas and Salome. With Joachim she had one daughter, whom she named Mary, the mother of Jesus, whom they later gave in marriage to Joseph. At Joachim's death, however, Anna became the wife of Cleophas, Joseph's brother, and with him had another daughter, whom she also named Mary. When Cleophas died, Anna married yet again, a man named Salome, and had a third daughter, also named Mary.

St. Anne has no distinctive attributes, but some artists depict her with a green cloak over a red robe. Iconographically (*see* ICONOGRAPHY) green, being the color of springtime, symbolizes rebirth and, by extension, immortality. Red is symbolic of Christian love and martyrdom.

Example: Carlo Saraceni, Galleria Nazionale, Rome. (Waterhouse, fig. 28)

MADONNA WITH THE PATRON SAINTS OF BOLOGNA. This painting, a large banner painted on silk, depicts the Virgin Mary and her child in heaven and the seven patron saints of Bologna kneeling and standing in adoration below. Some hold their palms of martyrdom, others the lily as a reference to their chastity. It was painted as an offering of an ultimate thanks for the liberation

of the city of Bologna from the black plague of 1630–1631. Bologna, the capital of Emilia-Romagna and of Bologna province in north-central Italy, is located at the foot of the Apennines and on the Aemilian Way. Originally Bologna was an Etruscan town called Felsina; it became a Roman colony in 189 B.C. During the 6th century A.D. the city came under Byzantine rule and was later taken by the papacy. The famous university there was founded c.1088. Mary is shown seated on clouds holding her child, who blesses the saints. Angels hold a crown above her head and white roses by her side. The saints kneel in rapt adoration, some holding palms of martyrdom.

Example: Guido Reni, Galleria, Bologna. (Waterhouse, fig. 84)

MAENADS (*Bacchae* or *Thyiades*). Shown frequently in art, maenads were women inspired to ecstatic frenzy by Dionysus (BACCHUS). They wore panther or fawn skins and wreaths of oak, ivy or fir and carried bunches of grapes or snakes. They waved torches or wands and reveled in the power of Bacchus in music, dance and song. The maenads roamed the forests and mountains, carefree and oblivious to fear and all conventions. Strong from the power of Bacchus, they were able to kill ferocious animals and uproot trees. They hunted deer and other animals and ate them. In mythology and art, they accompany Bacchus in his triumphal journeys. They are associated with Bacchus and his invention of wine and are shown gathering grapes or making wine. As women, they represent the liberation of women from the conventions of daily life, the stirring of sexual instincts and the union with nature. Most paintings of maenads involve Bacchus.

MAGDALEN UNDER THE CROSS. The story of the CRUCIFIXION is told in all four gospels: Matthew 27:33–56, Mark 15:22–41, Luke 23:33–49 and John 19:17–37. According to the gospels MARY MAGDALENE was present at the crucifixion and watched Jesus die. According to Matthew 27:55–56: ''There were many women there, looking on from afar, who had followed Jesus from Galilee, ministering to him; among whom were Mary Magdalene, and Mary the mother of James and Joseph, and the mother of the sons of Zebedee.'' In art, Mary Magdalene cannot be distinguished from other women in the presence of Christ until the Renaissance. Around that time, artists begin to show her as a separate figure. She may be richly dressed and her hair becomes longer and lighter and more luxurious. She kneels at the foot of the cross and either embraces it or kisses the feet of Jesus. She is the image of the penitent and is therefore usually at his feet. Her attribute is her jar used to hold the oil with which she anointed Jesus's feet. This story is told in Luke 7:38: ''And standing behind him at his feet, weeping she began to wet his feet with her tears, and wiped them with the hair of her head, and kissed his feet, and anointed them with the ointment.'' Her thick hair, sometimes blond, is usually untied. She may have a crucifix and a skull and more rarely a whip and a CROWN OF THORNS. She reads or prays or raises tear-filled eyes toward heaven where some artists depict angels.

Example: Giambattista Langetti, Palazzo Rezzonico, Venice. (Wittkower, fig. 229)

MAGUS, SIMON. *See* FALL OF SIMON MAGUS.

MAHLSTICK. Also called rest-stick, this instrument is a stick with a pad at one end used to steady the artist's wrist. It was first used, according to record, in the 16th century. After the introduction of oil paint in the north during the mid-15th century, painters felt a need to have a steadier hand. The mahlstick appears during the 17th century in Jan Vermeer's ARTIST IN HIS STUDIO.

Example: Jan Vermeer, *Artist in His Studio,* Kunsthistorisches Museum, Vienna. (Held and Posner, colorplate 43)

MAIDS OF HONOR. *See* LAS MENINAS.

MAIOLICA (Majolica). A type of painted, tin-glazed FAIENCE, associated especially with Italy and, to a lesser degree, with Spain and Mexico. The name refers to Majorcan traders who exported the Hispano-Moresque pottery, which is similiar, from Spain. Although Maiolica was popular during the Renaissance, the 17th-century works are particularly important and reveal the influence of Chinese porcelain. Many pieces are painted in blue alone, especially those showing animals and birds in trees, landscapes or ships. The process of producing maiolica consists of firing a piece of shaped earthenware, then painting on a tin enamel, which dries as a white opaque porous surface. A design is painted on this, and a transparent glaze applied; the piece is then fired again.

MAJOLICA. *See* MAIOLICA.

MALLE BABBE. A Baroque portrait of an old creature. No evidence exists as to the meaning of her name, which is written in 18th-century penmanship on the original canvas stretcher. It is probably an uncomplementary nickname. Often referred to as an ''old crone,'' Malle Babbe might be anywhere from forty to sixty years old. She is probably drunk, having emptied the two-quart tankard she holds, and she is depicted in the midst of a fit of laughter. Some historians feel she might be the town idiot. An owl perches on her shoulder, not as a symbol of wisdom, as with Minerva, but one of foolishness.

Example: Frans Hals, Staatliche Museen, Berlin-Dahlem. (Rosenberg, Slive, ter Kuile, fig. 28)

MANUFACTURE ROYALE DES MEUBLES DE LA COURONNE. *See* GOBELINS, MANUFACTURE NATIONALE DES.

MARCUS AURELIUS. Marcus Aurelius was emperor of the Romans between 160 and 180 A.D. Born in 121, he was the son of Annius Verus, a brother of Faustina the Elder, and from a consular family of Spanish origin. His mother was Domitia Lucilla, whose family owned a tile industry just outside Rome, which was inherited by Marcus and passed into the *patrimonium Caesaris.* Mar-

cus Aurelius gained Hadrian's favor early in life, and the emperor nicknamed him Verissimus and made him a Salian priest when he was eight years old. In 136, Hadrian betrothed him to the daughter of the elegant Lucius Aelius (L. Aelius Caesar) and supervised his education, providing him with the best possible teachers. He was adopted by Antoninus Pius and was betrothed to Pius's daughter (who was Marcus's own cousin), Faustina the Younger, whom he married in 145. The birth of a daughter in 146 brought him also the *tribunicia potestas* and a proconsular *imperium*. A frail, yet athletic student, Marcus Aurelius gave up rhetoric in 146–47 for Stoic philosophy, which inspired all his future life. Ironically war dominated his reign, most of which was spent repressing attacks and rebellions of Britons, Germans and Parthians. His victory over the Marcomanni 167–68 was commemorated with the Antoinine column, erected by his son and successor, Commodus. Today it is located in the Piazza Colonna in Rome. Marcus's *Meditations* were compiled during his campaigns, but his philosophy, Stoicism, endangered empire; "self-sufficiency" did not encourage wise administrative experience, and Marcus used faulty judgment in choosing Commodus as a successor.

Overall, Marcus Aurelius was an improver, not an innovator. He seemed to lack imagination and foresight. Lengthy, costly wars and many largesses emptied a treasury, which could not be revived. This was followed by a plague in 166–67 and a loss of population, from which Rome never fully recovered. He appointed commissioners for communities on the verge of bankruptcy, the consequence of which was a loss of municipal initiative. In the end, economic stagnation and bureaucratic centralization paved the way for the Severan monarchy and the crisis of the third century. Marcus Aurelius was one of the few rulers whose writings have outlasted their practical achievements. His letters, written in his youth chiefly in Latin to his tutor, Fronta, are self-conscious and reveal his virtuous character. It is, therefore, on the twelve books of his *Meditations* that his fame rests. Aurelius lowered the taxes on the poor, was lenient with political criminals and did his best to stop the killings in the arenas, although he regarded Christians as enemies of empire and persecuted them. He is usually always shown astride his horse.

Example: Nicolas Poussin, Drawing, Musée Condé, Chantilly, France. (Friedlaender, fig. 4)

MARGARET OF CORTONA. *See* ECSTASY OF ST. MARGARET OF CORTONA.

MARINE PAINTING. The earliest paintings of the sea go back to the fishing scene in the Etruscan *Tomb of the Hunting and Fishing* at Tarquinia in Italy. During the 17th century, Andries van Eertvelt of the Netherlands painted scenes of the sea. These romantic works were in a colorful style that was carried on by Bonaventura Peeters, Abraham Storck and Pieter Mulier in the Netherlands and, in France, by Claude-Joseph Vernet. Jan Porcellis produced a different kind

of naturalistic seascape, with boats riding soft peaceful waves of the Dutch estuaries. His son carried on his tradition, as did Simon de Vlieger, whose work combined the misty calms of Jan Porcellis with the rocky cliffs and hills of Adam Willaert. His later works are of the hard-rolling waves of the Dutch shallow shores. Willem van de Velde the Younger was the greatest of the Dutch marine painters and the one who had the most profound effect on seascapes for the next two hundred years. His renderings of ships are considered accurate. In England the two van de Veldes painted historical marine pieces. Working in Holland at the same time were Ludolf Bakhuizen and Jan van de Cappelle. While Bakhuizen was the master of the dark, storm-crested sea, Cappelle painted calm, quiet waters with mirrored reflections.

Example: Jan van de Cappelle, *The State Barge Saluted by the Home Fleet,* Rijksmuseum, Amsterdam. (Rosenberg, Slive, ter Kuile, fig. 233)

MARRIAGE OF CONSTANTINE AND FAUSTA. Constantine I, or Constantine the Great, was a Roman emperor. He was born in Naissus, present-day Nis, in Serbia, in c. 288, and he died in 337. His full name was Flavius Valerius Constantinus, the son of Constantius I and St. Helena. Constantine was proclaimed emperor after his father died at York in 306. Maxentius, supported by the Romans and by his father, Maximian, vied with Severus and Galerius for the office of emperor. Constantine, accepting the lesser title of caesar from Galerius, merely watched, while Maxentius and Maximian defeated Severus and Galerius. When the dust settled, Constantine made an alliance with Maximian and married Fausta, Maximian's daughter, thus recognizing Maxentius. When Maximian, in dispute with his son, fled to Constantine, Constantine took him in until Maximian, in an attempt to regain the throne, undertook a revolt in 310 against Constantine's rule in Gaul. Maximian was captured at Massilia and died by his own hand. At this time Constantine considered himself emperor. Maxentius appeared as another claimant to the throne and the rivals met in 312 at the Mulvian, or Milvian Bridge, over the Tiber River near Rome. According to Eusebius of Caesarea, before the battle Constantine is said to have seen in the heavens on a flaming cross the words *In hoc signo vinces,* or "Under this sign thou shalt conquer." Maxentius was killed, and in 313, Constantine issued the Edict of Milan stating that Christianity would be tolerated throughout the empire. Some historians see Constantine as a political genius who used Christianity to unify his empire.

Fausta, actually Flavia Maximiana Fausta, died c. 326 (some accounts say 320). She was the mother of Constantine II, Constantius II, and Constans I. She was put to death by Constantine I when she falsely accused Crispus, Constantine's son by his first wife, of attempting to seduce her. Crispus was executed with her. In the example below, Fausta's father holds her hand as she and Constantine stand waiting to be united in marriage.

Example: Peter Paul Rubens, Tapestry commissioned by King Louis XIII of France in 1622, British Museum. (Wedgewood, page 102)

MARRIAGE OF ISAAC AND REBECCA. The story of the marriage of Isaac and Rebecca is told in Genesis 24:67. Isaac was the second of the great Hebrew patriarchs. His father, Abraham, had been commanded by God to sacrifice him as a test of his faith (*see* SACRIFICE OF ISAAC). (According to Moslem tradition, Abraham's sacrifice took place on the site of the Mosque of Omar in Jerusalem, the Dome of the Rock.) In old age, Isaac was deceived into giving his blessing to his son, Jacob (the third of the great Hebrew patriarchs), instead of to Esau (*see* ISAAC BLESSING JACOB). Abraham desired to find a wife for Isaac and sent his servant Eliezer to look for a young woman who would be suitable. Eliezer was sent to Mesopotamia rather than to the people of Canaan where he lived. When he reached Nahor in Chaldea, he prayed for guidance and asked if the woman who gave him and his camels water at the town well would be an eligible woman. Rebecca came to him, and she invited him to drink from her jar and gave his camels water. He met her parents and gave her presents, then took her back to Canaan. Isaac saw the camels approaching. When Rebecca was told who he was, she descended her camel and covered her face. ''Then Isaac brought her into the tent, and took Rebekah, and she became his wife, and he loved her.''

Isaac and Rebecca are shown in an idyllic landscape surrounded by well-wishers who sit about on the grass watching them dance. A great mill is shown in the background with a waterwheel spilling water into a large lake where boats drift in the sun. *See also* REBECCA AND ELIEZER AT THE WELL.

Example: Claude Lorrain, Pamphili Gallery, Rome. (Ruskin, fig. 5–18)

MARRIAGE OF PELEUS AND THETIS (*Banquet of the Gods*). Thetis was a nereid, or sea nymph, and the mother of Achilles. Peleus, a legendary hero of ancient Greece, the son of Aeacus and king of Aegine, was Achilles's father. Peleus takes part in heroic episodes such as the battle between the Lapiths and Centaurs, the Calydonian boar-hunt, and the voyage of the Argonauts. He first sees Thetis with her sisters when he is returning home on the Argo. The story of their marriage is as old as Homer (before 700 B.C.) and is retold by Aeschylus and Pindar. It is also the subject of Catullus's poem *Peleus and Thetis.* All the gods of Olympus attended the wedding feast bringing gifts, with the exception of Eris, or Discord, the goddess of strife. She arrived uninvited and threw down the fateful golden apple inscribed ''for the fairest,'' which led to the train of events that culminated in the Trojan war (see JUDGMENT OF PARIS). The marriage song was sung by the Fates, who spun their thread and foretold the fate of Achilles.

A table is usually shown under a heavy canopy of shade trees. Around it are seated the gods and goddesses. The bride and groom are in the foreground. Eris, or Discord, can be seen in the clouds above, throwing down the golden apple that will be the prize for the fairest of all the goddesses, Hera (Juno), Venus (Aphrodite), and Athene (Minerva). Jupiter (Zeus) may hold the apple in his hand, while Juno, seated or standing beside him, may reach for it. Athene may

also reach for it. She is dressed in armor. Venus has Cupid near her and she proudly points to herself as the winner. Neptune (Poseidon), with his trident, may be close by; also Mercury (Hermes) may be depicted wearing his winged hat and holding his caduceus (a winged staff with two serpents entwined about it). (It was Mercury's duty to lead the three goddesses to Paris, the handsomest of men, after the judging for the decision.) Ganymede and Hebe carry drinking vessels and dishes. If the muses are present, they play musical instruments.

Example: Abraham Bloemaert, Mauritshuis, The Hague. (Rosenberg, Slive, ter Kuile, fig. 8)

MARRIAGE OF ST. CATHERINE (*Holy Family with St. Catherine*). The story of CATHERINE of Alexandria is told in Voragine's GOLDEN LEGEND. Of royal birth, Catherine, after becoming a queen, was converted to Christianity. She was baptized by a desert hermit and underwent a mystic marriage with Christ. An account, different from that found in the *Golden Legend,* tells that Catherine's mentor, the hermit, gave her a vision of the Virgin Mary and her child. According to this version, Catherine's prayers caused the baby Jesus at first to turn his face towards her, and some time later, when her faith had increased, to place a ring on her finger.

Mary holds the infant Jesus in her lap. He may lean forward to place a ring on Catherine's finger as she kneels before him. Her dress is rich and elegant, that of a queen. Some artists show the mother of the Virgin, Anne. Joseph, Mary's husband, may be present. He is usually shown as an older man, holding the rod by which he was chosen to be Mary's husband.

Example: José Ribera, The Metropolitan Museum of Art, New York. (Waterhouse, fig. 154)

MARRIAGE OF THE VIRGIN (*Betrothal of the Virgin* and *Wedding of the Virgin*). The story of the mother of Jesus Christ, also known as the Madonna or the Blessed Virgin Mary, is told in the 13th-century GOLDEN LEGEND. Mary's marriage to Joseph is not mentioned in the gospels, although the theme is depicted frequently in Christian art and is usually included in the cycle of scenes of the life of Mary. The story is also found in the Protevangelium, the New Testament apocrypha. Joseph was chosen from many suitors by the miraculous flowering of his rod. Seven virgins, companions of Mary, witnessed the miracle. When Mary was fourteen years old, the high priest announced that the virgins who had been raised in the Temple, those who had reached the age of their womanhood, should go back to their families to be given in lawful marriage. All the girls returned to their own homes except Mary, who announced that she could not go home for two reasons. First, her parents had dedicated her to the service of God; and second, she had vowed her virginity to the Lord. The elders who were consulted at the next feast of the Jews, decided collectively that in so delicate a matter they should seek the counsel of God. When they did they were told that each man eligible to be Mary's husband should offer a branch

and put it upon the altar. They were told that one of the branches would blossom with flowers and, upon the petals, the Holy Ghost would alight in the form of a dove. The man to whom the blossoms belonged would be the husband of Mary. Joseph went to the Temple, but being older, it seemed to him that a man of advanced years should not take so young a wife. Because of this, at first, when all the others placed branches upon the altar, Joseph left none. But his omission was noticed and he then did so. Immediately it burst into blossom, and a dove came from heaven and perched along its petals. Thus, it was known to all that Mary was to become the wife of Joseph. When the espousal was over, Joseph traveled to Bethlehem to make ready his house and to prepare all that was necessary for the wedding.

Artists show the high priest of the Temple standing with Joseph and Mary on either side of him. Joseph is depicted as an older, mature man, although not with a gray beard. He may hold his rod, which has burst into bloom, or a dove in one hand, while in the other he may place a gold band on Mary's finger. The supposed ring is in the cathedral of Perugia, and the theme of the marriage is popular in the work of that school. Mary's virgin companions stand behind her. Joseph's suitors wait unhappily behind him. Some artists show a crowd of richly dressed men and women who simply behold the holy scene. The marriage usually takes place before the Temple in which Mary was brought up.

Example: Valerio Castello, Galleria Spinola, Genoa. (Waterhouse, fig. 188)

MARS AND VENUS. The story of Mars and Venus is told in Homer's *Odyssey* 8:266–365 and also in Ovid's *Metamorphoses* 4:171–91. Venus was the Roman goddess of love and fertility, identified with the Greek Aphrodite. Mars, one of the twelve Olympians, was the god of war and also an agricultural deity. He represented two primary Roman preoccupations—fighting and farming. Because of his aggressive and brutal nature, he was hated by nearly everyone, including his parents, Juno and Jupiter. Venus, who fell in love with him, was the only exception. She married Vulcan, a lame blacksmith of the gods, but she had fallen in love with Mars and one night lay with him in his palace. The next morning the sun god, Helios, witnessed her infidelity and informed Vulcan. Furious, the lame blacksmith forged a net, unbreakable, light as gauze and imperceptible. This he set secretly over the lovers' bed. When they made love, they were trapped and unable to move and were caught in the act by Vulcan.

According to Ovid, "[Helios] was the first to see the shameful behavior of Venus and Mars: for he sees everything before anyone else. Indignant at their actions, he showed Vulcan, who was Juno's son and Venus's husband, how and where they were misbehaving. Vulcan's senses reeled, and the iron he was forging fell from his hand. At once, he began to fashion slender bronze chains, nets and snares which the eye could not see. The thinnest threads spun on the loom, or cobwebs hanging from the rafters are no finer than was that workmanship. Moreover, he made them so that they would yield to the lightest touch, and to the smallest movement. These he set skillfully around his bed. When his

wife and her lover lay down together upon that couch, they were caught by the chains, ingeniously fastened there by her husband's skill, and were held fast in the very act of embracing. Immediately, the Lemnian Vulcan flung open the ivory doors, and admitted the gods. There lay Mars and Venus, close bound together, a shameful sight. The gods were highly amused; one of them prayed that he too might be so shamed. They laughed aloud, and for long this was the best-known story in the whole of heaven.''

Venus and Mars are shown reclining together, usually in a pastoral setting that is sheltered by a canopy. His head may seem to languish backwards in sleep. *Amoretti* (*see* AMORETTO) have a good time with the weapons and armor that Mars has put down and encircle him with pieces of it. One holds his shield and another, his helmet. Venus, hopelessly in love, bends toward him.

Example: Nicolas Poussin, Museum of Fine Arts, Boston. (Friedlaender, fig. 95)

MARTIN, ST. *See* MASS OF ST. MARTIN OF TOURS.

MARTYRDOM AND ASCENSION OF ST. JAMES. Saint James the Great, one of Christ's apostles, is said to have been closely related to Christ. The gospels mention Christ as calling aside John, Peter and James, thus suggesting a more intimate relationship with these three followers. They were witness to the Transfiguration and they were with Jesus during the Agony at Gethsemane (AGONY IN THE GARDEN). James was the brother of Saint JOHN THE EVANGELIST, the son of Zebedee; he was called ''the Great'' to distinguish him from the other apostle of the same name, who was surnamed ''the Less'' because he was younger. James the great was by birth a Galilean and by trade a fisherman with his father and brother, probably living at Bethsaida where Saint Peter lived at the same time. One of the Epistles in the New Testament is ascribed to James. The only mention of him after the ASCENSION of Christ is his death. The legend of Saint James is widely read, and as the patron saint of Spain, James became one of the most renowned saints in Christendom, his common name becoming Santiago. It is said that on one of his most famous pilgrimages, he arrived at Compostella in Spain, where he was the first to establish the Christian religion. He returned to Judea, was tried in the year 44 and beheaded by King Herod Agrippa I. After his martyrdom, his body was returned to Spain (some sources say he was buried in Jerusalem) where his body was lost during the Saracen invasion. His body wasn't recovered until the year 800, after which it was taken first to Iria Flavia (now El Padron, in Galicia) and then to Compostella. Numerous miracles took place at the Shrine of Saint James, and the Shrine of Santiago in Spain became one of the greatest of all Christian shrines. His relics still remain in the cathedral in Santiago and were referred to as authentic in a bull issued by Pope Leo XIII in 1884.

James is shown after his martyrdom, his executioner holding his severed head. Above this drama, his body is being taken to heaven by angels, one of which holds the palm of martyrdom. James may hold a martyr's sword. His special

attribute, the scallop shell, may be fastened to his cloak or hat or on a wallet that he carried on his shoulder. (The origin of the scallop shell as the badge of the pilgrim en route to Compostella is not known.)

Example: Domenico Piola, Oratorio di S. Giacomo della Marina, Genoa. (Waterhouse, fig. 193)

MARTYRDOM OF ST. ANDREW. *See* ANDREW ADORING HIS CROSS.

MARTYRDOM OF ST. BARTHOLOMEW. The story of Saint Bartholomew, one of the twelve apostles, is told in Voragine's GOLDEN LEGEND. Bartholomew traveled to India as a pilgrim on a missionary journey and lived there in a temple where he was known to pray a hundred times by day and a hundred times by night on his knees. He drove devils into oblivion and with his miracles gained a large following. In so doing, he outraged King Astrages, who sent a thousand armed men to take him captive. When brought before the king, Bartholomew was accused of subverting the king's brother. He explained that he had not subverted him: rather he had converted him to Christianity. The king declared he would force Bartholomew to abandon his Christian god and worship the god he believed in. Bartholomew told him he had put bonds upon the god his brother had worshipped, and it was thus that the King's soldiers brought him bound before the people and before their eyes forced him to destroy the idol. The king was so furious he ordered the apostle beaten with clubs and skinned alive. The Christians buried his body when the terrible death was over. Although he is mentioned in the New Testament in name only, Saint Dorotheus says, ''Bartholomew preached the faith in the Indies, and likewise gave to the people there the gospel according to Saint Matthew, written in their own tongue. He died at Albana, a city of Greater Armenia, being crucified with his head down.'' Saint Theodore, however, in his history of the *Basilian Monks* says that he was flayed. Other sources say only that he was beheaded. The *Golden Legend* says these contradictions are known and can be reconciled. One only has to say that he was first crucified, then, in order to increase his sufferings, flayed while still alive, and, in the end he was beheaded. Bartholomew is mentioned in the New Testament by name only. Nothing is written of his acts.

In art he is usually depicted with dark hair. He is about middle-aged and has a beard. He holds the knife with which he was skinned alive. Some artists show the flayed skin draped over his arm, or it is held in his hand. Although he is sometimes shown baptizing, exorcising demons or being taken before the authorities and preaching, the most usual scene is the flaying, or skinning. Executioners hold knives, Bartholomew is hoisted up, his arms spread as if crucified. A curious crowd gathers.

Example: José de Ribera. The Prado, Madrid. (Ruskin, fig. 2–3)

MARTYRDOM OF ST. ERASMUS. Erasmus, or Elmo (Italian) or Ermo (Spanish) was a bishop and martyr who died c. 303. He was formerly venerated

as the patron saint of Mediterranean sailors and as one of the Fourteen Holy Helpers. He was the bishop of Formiae, in the Campagna, and, according to St. Gregory the Great, his relics were preserved in the cathedral of Formiae in the sixth century. When Formiae was sacked and demolished by the Saracens in 842, St. Erasmus's body was taken to Gaëta, where he still remains a principal patron. Nothing is known of Erasmus's history, his so-called "acts" being late compilations based only on legends.

Artists have traditionally shown Erasmus with a large wound in his body through which his intestines have been or are being removed like a piece of rope and wound round a windlass, which is set up beside or in front of him. Thus, it is understandable that St. Erasmus is invoked against colic and cramps, especially for children. The blue lights many times seen at mastheads before and after storms were seen by Neapolitan sailors as signs of their patron's protection and were named by them "St. Elmo's Fire." Erasmus's attribute is a capstan (a spool-shaped apparatus on ships used for hauling in cables); and this, according to many, was the origin of the story of his martyrdom by disembowelment. He is shown as a devotional figure dressed as a bishop, with a capstan or sometimes a sailing ship. He may also be depicted with carpenters' nails pushed under his fingernails to allude to further tortures he endured.

Example: Nicolas Poussin, Vatican, Rome. (Blunt, fig. 228)

MARTYRDOM OF ST. MATTHEW. The story of the martyrdom of St. Matthew, one of the twelve apostles of Christ, is told in the GOLDEN LEGEND. After Hirtacus succeeded King Egippus, who had become a Christian after seeing Matthew's miracles, he lusted after a certain woman Ephigenia, who had earlier been dedicated to God by Matthew. Hirtacus promised the apostle the half of his kingdom if he would prevail upon Ephigenia to become his wife. Matthew told him that he should come to the church on the following Sunday and there, in the presence of Ephigenia, he would hear how good was godly matrimony. Here Matthew said: " 'Since marriage is a good thing, ye who are present well know that if a servant dared to molest the king's spouse, he would deserve not only the king's displeasure, but death besides; and this not because he wished to take a wife, but because he violated the king's marriage by carrying off his wife. And thou, O king, who knowest that Ephigenia is espoused to the eternal King, how canst thou purloin the spouse of One mightier than thou, and take her to wife?' When he heard these words the king was consumed with rage, and went out of the church, while the apostle, intrepid and unmoved, exhorted all to patience and constancy, and blessed Ephigenia and the other virgins, who had prostrated themselves in fear at his feet. After the mass the king sent a swordsman, who came behind Matthew as he stood at the altar with his hands raised to heaven in prayer, drove his sword into his back, and so consummated the apostle's martyrdom." Some accounts differ from the above and tell that Matthew was martyred by beheading.

The fallen apostle is shown bleeding, on his back, yet still alive, propped on

one arm, after being struck down before his altar, which looms behind him. An angel descends from heaven and touches him with the palm of martyrdom. Those present in the background shrink back in horror. *See also* CALLING OF ST. MATTHEW.

Example: Caravaggio, Contarelli Chapel, San Luigi dei Francesi, Rome. (Bottari, figs 35–41)

MARTYRDOM OF ST. PETER. The martyrdom, or passion, of Saint Peter occurred in Rome during the reign of Nero (54–68). No written account of it has survived. According to an old, but unverifiable, tradition, Peter was confined in the Mamertine prison, where the Church of San Pietro in Carcere is located today. Tertullian, who died in 225, says that Peter was crucified. The noted Christian theologian Eusebius of Nicomedia says, on the authority of Origen (Origines Adamantius), a Christian philosopher and scholar who died 253, that the apostle was nailed to a cross and then, by his own request, it was turned upside down. Many scholars believe the crucifixion occurred in Nero's gardens. Some sources cite the location as the Janiculum hill in Rome or in a circus arena between two *metae* (a pair of columns set in the ground at the end of each course). According to *Butler's Lives of the Saints,* the generally accepted tradition that Peter's pontificate lasted twenty-five years is probably no more than a deduction based upon inconsistent chronological dating.

Artists usually show Peter nailed to a cross being lifted by soldiers. Sometimes onlookers are included. Domenichino paints the apostle's martyrdom in a different setting, showing Peter being run through with a sword.

Example: Domenico Zampieri Domenichino, Pinacoteca Nazionale, Bologna. (Ruskin, fig. 1–27)

MARTYRDOM OF ST. PETRONILLA. The story of Saint Petronilla is told in Voragine's GOLDEN LEGEND. ''Petronilla was the daughter of the apostle Saint Peter, who, judging her too comely of aspect, obtained from God that she should be stricken with a fever. But one day when his disciples were with him, Titus said to him: 'Master, thou who healest all the sick, why dost thou not make Petronilla to arise from her bed?' And Peter answered: 'Because I deem that it is better so.' This does not mean that Peter was without the power to cure her, for immediately he said to her: 'Arise, Petronilla, and make haste to wait upon us!' The maiden was cured instantly, and came to serve them. But when she had finished her father said to her: 'Petronilla, get thee back to thy bed.' Back she went and again the fever seized her. And later, when she was beginning to be perfect in the love of God her father restored her to perfect health of body.'' When a nobleman named Flaccus asked for her hand in marriage, she began to fast and to pray. She received the holy Communion, lay down on her bed and after three days died. After this she was raised to her feet by Peter. The apostles saw this miracle.

A beautiful young girl, Petronilla is shown being lowered into her grave. *Example:* Guercino, Galleria Capitolina, Rome. (Waterhouse, fig. 97)

MARTYRDOM OF ST. SEBASTIAN. The story of Saint Sebastian is found in Voragine's GOLDEN LEGEND. Actually little is known about this Christian saint and martyr and his legend is without historical foundation. Some scholars believe it has a certain truth as it lacks some of the miraculous elements that one finds in so many of the lives of the early saints. Sebastian was supposedly an officer in the elite Praetorian guard during the time of Diocletian in the third century. The *Golden Legend* tells us he was in the Roman military only to be able to help and bring comfort to persecuted Christians, as he feared they might succumb to their tortures. Even though a military officer, Sebastian was secretly a Christian. This fact was revealed when two of his companions, twin brothers Marcellinus and Mark, were ordered to be beheaded for their Christian belief and Sebastian walked forward to give them support in their final hours of agony. While Sebastian spoke to them, a brilliant light from heaven flooded about him, and they saw him suddenly wrapped about in a gloriole of blinding white. Seven angels hovered before him. Sebastian was denounced to the Emperor Diocletian, who called him an ingrate. He reminded Sebastian that he had given him first rank in his palace and that, thankless wretch that he was, he had gone against him. Furious, Diocletian ordered Sebastian tied to a stake in the middle of the Campus Martius. He then commanded his soldiers to shoot him full of arrows. The soldiers did so until he was covered with barbs; yet not one arrow hit a vital spot, because the emperor had ordered that his suffering be prolonged. The Roman soldiers left him there to suffer.

Rescued by St. Irene, the mother of another martyr, Sebastian returned to Diocletian's palace, and admonished the emperor and his son Tiburtius, berating them severely for their injustice to all Christians. They were stupefied and wondered why he was not dead. Sebastian told them he had been returned to life that he might visit them, and once again he admonished them for their ill treatment of Christians. The emperors, exasperated, had him beaten to death on the spot. Fearful the Christians would find his body and preserve and venerate it as the relic of a martyr, they ordered that it be thrown into the Cloaca Maxima, the main sewer of Rome. Saint Sebastian appeared to Saint Lucina, told her where his body was, and asked her to bury it in the catacombs at the feet of the bodies of Paul and Peter. The saint died about the year 287.

Sebastian is usually alone or surrounded by archers. Rome may be seen in the background. He may be bound to a pillar or a tree and his armor may be at his feet. He is never shown "covered with barbs like a hedgehog," as some accounts state; rather as few as one or several arrows may pierce his body, and never through any of his vital organs. Some artists show the widow Irene releasing him from the tree or the pillar. She may have the help of a servant, who tenderly pulls an arrow from the saint's leg. *Putti* (*see* PUTTO) descend from heaven and flutter above. Since the ancients believed that disease was caused

by the arrows of Apollo, a cult of St. Sebastian as protector against disease began in the fourth century. *See also* ST. SEBASTIAN ATTENDED BY ST. IRENE.

Example: Bernardo Strozzi, S. Benedetto, Venice. (Waterhouse, fig. 107)

MARTYRDOM OF ST. STEPHEN. Stephen is the first Christian martyr, or "protomartyr," who met his death by stoning. His story is told in Voragine's GOLDEN LEGEND. The sermon with which he aroused the wrath of the Sanhedrin and was consequently put to death is found in Acts 7:2–56. Here he said of them, "You stiff-necked people, uncircumcised in heart and ears, you always resist the Holy Spirit. As your fathers did, so do you." He accused them of having murdered the Messiah, whose coming their prophets had foretold. "And they killed those who announced before hand the coming of the Righteous One, whom you have now betrayed and murdered." After the people had heard Stephen's speech, they were enraged "and they ground their teeth against him." They were so angry that "they cast him out of the city and stoned him and the witnesses [who were to throw the first stones] laid down their garments at the feet of a young man named Saul [later to become St. Paul]. And as they were stoning Stephen, he prayed and said, "Lord Jesus, receive my spirit." And he prayed forgiveness for his executioners. According to the *Golden Legend,* Stephen's martyrdom took place the same year as the ASCENSION of the Lord, the third of August.

Artists depict Stephen as he looks to heaven to a vision of Christ and God the Father. *See also* STONING OF ST. STEPHEN.

Example: Lodovico Cigoli, Palazzo Pitti, Florence. (Waterhouse, fig. 130)

MARTYRS ST. CECILIA, ST. VALERIAN AND ST. TIBURTIO WITH AN ANGEL (*Martyrs Valerian, Tiburtius, and Cecilia*). Third-century martyrs Cecilia (Cecily), her betrothed, Valerius, and his brother, Tiburtius, are the subjects of this popular legend. Cecilia was born into a noble Roman family and brought up as a Christian. She was engaged to the nobleman Valerian; but after they were married, she said she had taken a vow of chastity, which she asked him to respect. According to Voragine's GOLDEN LEGEND, she told Valerian, "I have for my lover an angel of God, who guards my body with exceeding zeal. If he sees thee but lightly touch me for sordid love, he will smite thee, and thou wilt lose the fair flower of thy youth, but if he knows that thou lovest me with a pure love, he will love thee as he loves me, and will show thee his glory!" He agreed but said he wanted to see the angel who watched over her. Cecilia sent Valerian to St. Urban, who was working with the Christians in the catacombs and there Valerian was converted to Christianity. When he returned he found an angel with Cecilia bearing two crowns of flowers "of which he gave one to Cecilia and the other to Valerian saying: 'Guard these crowns with spotless hearts and pure bodies, because I have brought them from God's par-

adise to you, nor will they ever fade, and none can see them, save those who love chastity.' ''

Through the angel, Valerian's brother, Tiburtius, was converted to Christianity, and the two brothers began to preach the gospel of Christ. The governor of Rome ordered them to stop, and when they refused he had them executed. At first Cecilia was spared because the governor wanted her wealth. But when she refused his order to sacrifice to the gods, he attempted to kill her by suffocation. When the attempt failed, he ordered his executioner to behead her, but his sword only wounded her neck three times. Cecilia remained alive for three days and during this time gave her wealth to the poor. According to the *Golden Legend,* ''she suffered about the year of the Lord 223, in the time of the Emperor Alexander''; although some sources say that she was put to death in the time of Marcus Aurelius, who ruled about the year 220.

Cecilia, Valerian and Tiburtius look up toward the angel, who holds a crown of white and red roses (some sources say roses and lilies) and the palm of martyrdom above them. An organ, Cecilia's symbol, can be seen in the background. Beside her is another crown of roses and lilies. *See also* CECILIA, SAINT; CECILIA BEFORE THE JUDGE; and CECILIA DISTRIBUTING CLOTHES TO THE POOR.

Example: Orazio Gentileschi, Brera, Milan. (Ruskin fig. 1–13)

MARY MAGDALENE. Mary Magdalene is mentioned in the gospels of Luke 7:36–50; 8:2; 10:38–42 and John 12:4–6; 20:14–18. Her story is also told in Voragine's GOLDEN LEGEND. She has been the object of penitence in Christian art from the Middle Ages and especially from the 15th century, during the Catholic COUNTER REFORMATION, at which time the Church stressed penance. She is identified as the sister of Martha and Lazarus of Bethany, as one from whom Christ exorcised seven devils and as being present at the CRUCIFIXION. The Magdalen, as she is sometimes called, came of royal lineage. She was born of parents of noble station. Her father's name was Syrus and her mother's, Eucharia. With her sister and brother, she owned the fortified town of Magdala in Bethany and a large section of Jerusalem. The property was so divided that Mary owned Magdala: thus, her surname. While her brother served in the army and her sister, Martha, was entrusted with the stewardship of all their properties, Mary gave herself up in complete abandon to the pleasures of the senses. After the death of Jesus, however, all three sold their properties and gave the returns to the apostles of Jesus. Mary was rich and beautiful and, because she had given her body so frequently to pleasure, she was called ''the sinner.''

One day when she heard that Jesus was at the house of Simon the Leper, she went there and washed his feet and wiped them with her hair. After this, recognizing her honest repentance, Jesus defended her in every way possible. He brought her brother, Lazarus, back to life after he had been dead four days. He cured her sister, Martha, of a disease with which she had suffered for seven

years. Mary was present at the death of Jesus. She stood at the foot of the cross and helped anoint his body with spices after his death. Jesus appeared to her first when he had risen and made her apostle to the apostles. After this, in grief and sorrow, Mary Magdalene passed thirty years alone in penance and fasting in a solitary mountain retreat in a cave near Sainte-Baume, which is a place of pilgrimage today.

Baroque artists show Mary Magdalene without clothes or covered by her long hair and she is borne on banks of clouds by angels, one of which carries her jar of ointment (by which she is identified). Mary is usually shown with a crucifix and a skull and usually her jar is nearby. Some artists include a whip and a crown of thorns. During the 17th century artists showed her raising her tear-filled eyes towards heaven and angels. *See also* MAGDALEN UNDER THE CROSS.

Example: Giulio Cesare Procaccini. Brera, Milan. (Wittkower, fig. 45).

MARY MAGDALENE BEING TRANSPORTED TO HEAVEN. During the last thirty years of her life, MARY MAGDALENE retired to a mountain cave. Surrounding the cave she found neither water nor food. Every day, according to the GOLDEN LEGEND, an angel carried her to heaven at the seven canonical hours so that she could hear the glorious choruses of heaven. After this, when she returned to her cave, she had no need for food. Near her cave a priest lived in solitude. One day he saw the angels lift Mary into the air and bring her back after an hour. He wanted to make sure his vision was real, but when he went to the spot, his limbs became paralyzed. He was able to use them only to withdraw. Thus he knew that here was a sacred mystery. When her time had come to die, Mary told the priest that she was ready to leave the earth forever. She asked him to visit the bishop Maximinus, and tell him to go to his oratory where he would find her, having been led there by angels. The priest could not see her; he heard only her voice. He went to Maximinus and told him what he had seen and heard. On the appointed day, the bishop went to his oratory and saw Mary Magdalene surrounded by the angels. He summoned the priest, who gave the body and blood of the Lord to her; as soon as Mary had taken the Communion, her body fell lifeless at the altar and her soul went to heaven.

Mary Magdalene is shown naked, only partially covered by her long hair. She is tenderly transported to heaven by three angels. The priest and a hermit, who stand in the hills of evening, look up at her from below.

Example: Giovanni Lanfranco, Gallery, Naples. (Waterhouse, fig. 33).

MARY MAGDALENE MEDITATING. *See* MARY MAGDALENE and MARY MAGDALENE BEING TRANSPORTED TO HEAVEN.

MASSACRE OF THE GUISTINIANI AT CHIOS. Chios, or the Greek Khíos, is a Greek island in the Aegean Sea off the western coast of Asia Minor that claims to be the birthplace of Homer. Mountainous, it is famous for its

beautiful landscape and temperate climate. Mt. Elias, c. 4,160 feet, is the highest point. Figs, olives and mastic (resin or sap obtained from trees) are produced, and the mountains have marble quarries, sulfur springs and lignite deposits. Goats and sheep are also raised. The Ionians (early Greeks) colonized Chios, and it was later held (between 494 and 479 B.C.) by the Persians, at which time it gained its independence and joined the Delian League. The island remained on good terms with Rome and kept its independence until the reign of Vespasian in the first century A.D. It became part of the Byzantine Empire, then passed in 1204 to the Latin emperors of Constantinople and, in 1261, to Genoa. The Ottoman Turks conquered the island, took it from the Giustiniani family and kept it until 1912. Their rule was oppressive even though they practiced religious tolerance.

As a Baroque subject, the battle for the island shows the Turks using the sword without mercy on the men, women and children.

Example: Francesco Solimena, Capodimonte Museum, Naples. (Bazin, fig. 139)

MASSACRE OF THE INNOCENTS. The story of the killing of all male children in Bethlehem and the surrounding area under the order of Herod after the birth of Jesus is found in Matthew 2:16. ''Then Herod, when he saw that he had been tricked by the wise men, was in a furious rage, and he went and killed all the male children in Bethlehem and in all that region who were two years old or under, according to the time which he had ascertained from the wise men.'' Herod the Great, learning from the Wise Men of the birth of a child who would become ''King of the Jews,'' feared that his throne would be taken and thereby ordered his soldiers to massacre every child in the area surrounding Bethlehem and within the city itself. The Innocents, or children, were the very first martyrs, and their veneration can be traced as far back as the early Christian era.

The scene is usually a courtyard or area near Herod's palace. Soldiers with swords are taking infants from the arms of their screaming, terror-stricken mothers. The ground may be littered with dead male children. Herod may be shown watching from his throne or from a balcony. Usually a mother is shown somewhere in the background running away with her child in her arms. This is Elizabeth, the mother of JOHN THE BAPTIST, who fled into the hills with her child. (The story of this event is told in the apocryphal Book of James.) Likewise in the background, a woman may be depicted weeping over her child's dead body. (This event is taken from the book of Jeremiah 31:15. ''Thus says the Lord: 'A voice is heard in Ramah, lamentation and bitter weeping.' Rachel is weeping for her children; she refuses to be comforted for her children, because they are not.'')

Example: Nicolas Poussin, Musée Condé, Chantilly. (Friedlaender, fig. 92)

MASS OF ST. MARTIN OF TOURS. Saint Martin, the Bishop of Tours (315–397), was a native of Sabaria in Pannonia (now Hungary) but was raised in

Pavia in Italy. He became bishop of Tours in 370. He founded five monasteries in France and destroyed pagan shrines even though his parents were pagans, his father an officer in the Roman army, who had risen from the ranks. Martin thus, at the age of fifteen, was forced into the army against his will. He served for several years under the emperors Constantine and Julian. While he was stationed at Amiens, in France, an incident occurred that made him famous. According to the GOLDEN LEGEND, one winter day Martin passed through the gate of Amiens, and before him stood a beggar—poor, freezing and nearly naked. The pitiful man had received no food that day and was shriveled with cold. Overcome by sympathy, Martin took his great sword and divided his cloak in two parts; he gave one half to the beggar and wrapped himself in the other. The next night, in a dream, he saw Christ wearing the part of his cloak that he had given the beggar; and he heard Jesus tell the angels who hovered over him that Martin, while yet a catechumen, a mere person receiving instructions in Christianity, clothed him with part of his own garment. Martin, instead of being overcome with pride, acknowledged the goodness of God and had himself baptized. He did, though, continue as a soldier for two years, at the insistence of his tribune, who told him that when his term was up, he could renounce the world.

Once Martin celebrated mass in a cheap tunic, for he had given his chasuble to a naked beggar who followed him on his way to church. Martin asked his archdeacon to find clothes for the poor man; but the archdeacon did not follow Martin's instruction, and Martin gave his own tunic to the beggar. The archdeacon had to go into the marketplace where he bought a cheap, short tunic, called a *pænula,* for only five pieces of silver. In a fury he took it to Martin and threw it at his feet. The saint put it on without comment, and even though the sleeves reached only to his elbows, and the hem went only to his knees, he proceeded to the church to celebrate the mass. During the mass, while Martin was making a sacrifice, a blinding ball of fire dazzled like a globe above his head. Everyone in the church saw it, and it is thus that he was said to be equal to the apostles.

Martin is shown either as a Roman soldier wearing a cloak or as a bishop. A lame beggar may be close by. He is also recognized when he stands before an altar celebrating the mass and a ball of fire hovers above his head while others look on in amazement.

Example: Eustache le Sueur. The Louvre, Paris. (Held and Posner, fig. 163)

MATILDA, COUNTESS. *See* COUNTESS MATILDA RECEIVING POPE GREGORY VII AT CANOSSA.

MATTHEW. *See* CALLING OF ST. MATTHEW and MARTYRDOM OF ST. MATTHEW.

MATTHEW AND THE ANGEL (*St. Matthew Inspired by an Angel*). Matthew, also called Levi, was one of the twelve apostles and the author of the first

gospel. His story can be found Voragine's GOLDEN LEGEND. Before being called by Christ, he worked at Capernaum, a seaport, in the customhouse as a tax collector. He collected tolls from seamen on their ships and their goods. Matthew's traditional symbol in early Christian art is a winged person like an angel. It is known commonly as one of the "apocalyptic beasts," one of the symbols of the FOUR EVANGELISTS: Mark shown with a lion, Luke with an ox and John with an eagle. The book of Revelation (Apocalypse) 4:6–8 describes these creatures surrounding the throne of God: "And round the throne, on each side of the throne, are four living creatures, full of eyes in front and behind: the first living creature like a lion, the second living creature like an ox, the third living creature with the face of a man, and the fourth living creature like a flying eagle."

Artists show Matthew writing the gospel with the angel by his side, dictating the work. The angel may hold his pen and inkhorn and his book. According to the *Golden Legend,* the gospel he wrote was discovered with the bones of Saint Barnabas in the year 500. He may also hold a purse as a reminder of his previous occupation and/or a halberd (a kind of ax), a reference to his martyrdom by beheading (*see* MARTYRDOM OF ST. MATTHEW). His figure, along with that of the angel, may fill the picture frame; or Matthew may be shown, as in Poussin's 1640 version, with the angel at his side in a spacious landscape among the ruins of antiquity. (A black and white illustration of this topic by Caravaggio was destroyed by fire in Berlin in 1945.)

Example: Caravaggio, Contarelli Chapel, San Luigi dei Francesi, Rome. (Bottari, colorplates 42, 43)

MEAL OF ST. CHARLES BORROMEO. *See* CHARLES BORROMEO.

MEDICI. *See* APOTHEOSIS OF THE MEDICI DYNASTY.

MEDUSA. In Greek mythology, Medusa was one of the three hideous gorgon sisters, whose appearance was so repulsive that whoever looked at her turned to stone—a power that remained even after her death. She had fangs for teeth and writhing snakes for hair. Her tongue hung out and her eyes stared without blinking. The story of the beheading of Medusa by Perseus is told in Ovid's *Metamorphoses* 4:769–803. After killing Medusa, Perseus told this story: " 'Medusa was once renowned for her loveliness and roused jealous hopes in the hearts of many suitors. Of all the beauties she possessed, none was more striking than her lovely hair . . . the lord of the sea robbed her of her virginity in the temple of Minerva. Jove's daughter turned her back, hiding her modest face behind her aegis: and to punish the Gorgon for her deed, she changed her hair into revolting snakes. To this day, in order to terrify her enemies and numb them with fear, the goddess wears as a breastplate the snakes that were her own creation.' "

In Baroque painting and sculpture, Medusa appears as a portrait study. She is usually dreadful and frightening and has writhing, slimy snakes for hair.
Example: Caravaggio, Uffizi Gallery, Florence. (Bottari, fig. 27).

MELANCHOLY. Melancholy is the 17th-century equivalent of Albrect Dürer's famous 16th-century engraving that glorified the human mind in confrontation with its own inability to attain a knowledge of reality. The Baroque example is a more humble and more Christian figure, meditating on death and on salvation of the soul. Melancholy was the daughter of Saturn, which explains her saturnine, gloomy disposition. She was identified with the introspective, intellectual qualities that typified the "contemplative man." It was thus that theologians, philosophers and artists were regarded as coming under the influence of Saturn.

Some artists depict Melancholy with wings, and she may have a dog at her side. She may be shown sitting or kneeling at a table with her head in her hands, reflecting her despair of acquiring the ultimate wisdom or knowledge or grieving over her loss of creative inspiration. A skull in Baroque painting suggests the conceit of her efforts. A purse, if included, may be present because greed was associated with the melancholic. Melancholy may be surrounded by books and other tools, such as a compass, a set-square and a ruler—all attributes of geometry, the one of the seven LIBERAL ARTS over which Saturn presided. Melancholy may also be shown with a plane (carpenter's tool for leveling and smoothing), saw and other such implements, because carpenters were also among the children of Saturn.
Example: Domenico Fetti, The Louvre, Paris. (Bazin, fig. 43)

MELEAGER AND ATALANTA. In Greek mythology, Meleager was the son of a king of Calydon, a city of Aetolia, a region of ancient Greece north of the Gulf of Corinth and the Gulf of Calydon and east of the Achelous River. Atalanta was a virgin huntress whom he loved. His father had angered the goddess Diana, who in retaliation sent a monstrous wild boar to destroy the countryside. The story of Meleager and his band of companions, who hunted the ferocious killer beast is told by Ovid in the *Metamorphoses* 8:260–546. "The boar was as big as the bulls found in grassy Epirus . . . there was a fiery gleam in its bloodshot eyes, it held its neck high and stiff, its hide bristled with hairs that stuck straight out like spears. It bellowed harshly, the hot foam flecking its broad shoulders and its teeth were like elephants' tusks: fire issued from its jaws, the leaves were set alight by its breath. This monster trampled down the tender shoots of the growing crop, or again, when the harvest had fulfilled the farmers' hopes, it turned their joy to tears by ravaging the fields and breaking down the corn in the ear . . . the boar launched furious attacks on the flocks also: neither shepherds nor dogs could save them, nor could the fierce bulls defend the herds. People fled in all directions, thinking themselves safe only when protected by the walls of the city: till Meleager and a handful of picked men banded themselves together in a desire to win fame and glory."

Atalanta wounded the boar first, and when the beast was finally dead, Meleager gave her the skin and the head. This caused an argument among Meleager's companions and he killed his two uncles. At Meleager's birth the Fates had said that he would not die until a burning log on the hearth was consumed. His mother had taken it out of the fire and kept it; but now, upon hearing of her brothers' deaths, she put it on the fire again, and Meleager shriveled and wrinkled until he was dead.

In the example below, Meleager, surrounded by his giant hunting dogs, sits under a tree beside Atalanta, presenting her with the monstrous head of the Calydonian boar. His uncles, who want the pelt and head for their own, rage like beasts in the background.

Example: Jacob Jordaens, The Prado, Madrid. (Ruskin, fig. 3–13)

MEMENTO MORI. *Memento* means "to remember" and is used with *mori* as a warning to always be prepared for death: to always remember that everyone, everything that lives must die. Also, the term is used to indicate anything that serves to remind one of death. Sometimes a death's head or some other symbolic object is used. The Spanish painter Juan Valdés Leal shows an allegory of "last moments," *Las Postrimerias de la Vida (In Ictu Oculi)*, in which death, a skeleton, stands on a globe holding a coffin and a scythe, extinguishing life's flame with bony fingers. In their versions of ET IN ARCADIA EGO, Nicolas Poussin and Guercino imply that death is always present even in happy Arcadia.

Example: Jean Morin, Engraving after Philippe de Champaigne. (Blunt, fig. 214)

MERCURY AND PARIS. *See* MERCURY GIVING THE GOLDEN APPLE OF THE GARDEN OF THE HESPERIDES TO PARIS.

MERCURY GIVING THE GOLDEN APPLE OF THE GARDEN OF THE HESPERIDES TO PARIS. Mercury (his Latin name), the Greek Hermes, is one of the twelve gods of Olympus, the god of commerce and messages. When shown in fully human form, he is dressed for traveling (in his role as a messenger of the gods or as their guide), with a broad-brimmed hat, winged sandals and a caduceus, or herald's staff, or a magic wand with wings and two snakes entwining it. With this wand, he is able to induce sleep. This son of Jupiter was given the duty of taking the three goddesses, Minerva, Venus and Juno, to the shepherd Paris to be judged (*see* JUDGMENT OF PARIS) for their beauty. Paris, a Trojan prince and a shepherd, was the son of Priam, the king of Troy. Before he was born, his mother had dreamed that her child would cause Troy to be burned to the ground; and for this reason, Paris was given to a shepherd, who was told to leave him on Mt. Ida to die. He was found and raised by another shepherd. As a youth, he married Oenone. In revenge, because she, of all the gods, had not been invited to the wedding, Eris, the personification of strife (competition, rivalry, discord), tossed to the guests a golden apple inscribed "to the fairest." Zeus, having decided on the Trojan War to relieve

Earth of the burden of so many human beings, had presented Eris at the MAR-RIAGE OF PELEUS AND THETIS. There she begins the quarrel between the goddesses as to which is the most beautiful. Zeus refused to judge them and had Mercury take them to Paris. This leads to the Judgment of Paris and then to the war.

Mercury is shown giving Paris the apple of discord. Juno may be present with her peacock.

Example: Annibale Carracci, Galleria Farnese, Rome. (Bazin, fig. 17)

MERCY. *See* SEVEN WORKS OF MERCY.

METAL POINT. A drawing instrument used since classical times, this small metal rod, pointed at one end, may be of gold, silver, copper or lead. Possibly the earliest metal point was lead. During the 16th century, the lead point grad-ually gave way to the graphite pencil. The copper, gold or silver points need a coarse, abrasive drawing surface. On a smooth surface these metals leave no mark. Artists use a surface coated with Chinese white or Chinese white mixed with another watercolor pigment to give a colored GROUND. The most widely used metal point is silver. The fine gray line that silver produces is quite aes-thetically pleasing in the hands of a skilled artist. Also, tones cannot be varied, so that the sensitive quality of the line is best suited to drawings on a small scale. Another feature is that the line cannot be erased. If one attempts to remove it, the ground is disturbed and uneven. Although metal point was revived in the 18th century by miniature painters in France, 17th-century artists did not use it on a grand scale, possibly because the easier to use graphite pencil was gradually becoming available.

MEZZOTINT. A method of engraving in tone, mezzotint was popular during the 17th century for the reproduction of paintings. To produce a mezzotint, a copper plate is roughened by a tool with a serrated edge known as a rocker. This tool is worked back and forth across the surface of the copper in every possible direction. In the process of this scratching, a burr is raised. The burr is scraped away where light tones are needed, and the highlights in the metal are polished as smooth as possible. The plate is covered with ink and wiped with rags. Where the copper plate is coarse, the ink is retained and will print the darkest black. Where it has been smoothed by the scraper, however, less ink will be kept on the plate and a lighter tone will print. In this manner a mezzotint is evolved from dark to light; it is characterized by hazy, gauzy gradations of tone set off by darker areas that can be extremely pleasing. If more definition is needed, engraved or etched lines are used. When this is done, the procedure is called a mixed mezzotint.

The mezzotint process was invented during the 17th century by a German military officer of Dutch origin, Ludwig von Siegen of Utrecht (1609–1676?). His first dated mezzotint was created in 1642. Prince Rupert (1619–1682), for-

merly thought to be the creator of the first mezzotints when he introduced to England mezzotint engraving, was another pioneer. The earliest mezzotints were portraits, and the plates were not prepared as described above. Rather, they were worked from light to dark, using roulettes to roughen selected areas of the copper. Artists combined this procedure with stipples (dots) and lines engraved with the BURIN.

MIDAS AND BACCHUS. The story of King Midas and BACCHUS is told by Ovid in the *Metamorphoses,* Book 11. It is less frequently illustrated than the tale of Midas as the judge of the musical competition between Pan and Apollo. Midas, after being initiated into the Bacchic rites, celebrated with continuous festivities for ten days and nights when, by mistake, Silenus, a fat old drunkard, was brought to him as a prisoner. "He [Bacchus] was attended by his usual throng, satyrs and bacchants, but Silenus was not there. For Phrygian peasants had captured him as he tottered along on feet made unsteady by age and wine. They had bound him with chains of flowers, and taken him to their king Midas, who had once been instructed in the Bacchic mysteries by Orpheus from Thrace." Grateful for this favor done to his foster father, Bacchus granted Midas his free choice of a gift. "The god was glad to have his tutor back, and in return gave Midas the right to choose himself a gift—a privilege which Midas welcomed, but one which did him little good, for he was fated to make poor use of the opportunity he was given. He said to the god: 'Grant that whatever my person touches be turned to yellow gold.' Bacchus, though sorry that Midas had not asked for something better, granted his request." The consequences were so terrible—*see* MIDAS BATHING IN THE RIVER PACTORUS—that the king had to return to Bacchus to ask him to be liberated from his burden.

Midas, in his royal diadem, is shown on his knees as he begs Bacchus to liberate him. Bacchus, in the guise of some Hellenistic figure of Bacchus, seems to adopt a philosophical attitude, trying to explain to Midas that gold and riches have insubstantial, illusory value. To accent this conception, Bacchus's attendants, Silenus and the nymphs, are happily sleeping after drinking copious amounts of wine. Silenus is drunk, napping at a table, nearly in shadow, and a lovely nymph is below him, nude and stretched out in sleep. Beside her a PUTTO, fat and drunk, lies on his stomach, a jar and cup of spilling wine before him. The serenity of the scene is enhanced by children amusing themselves with a goat. A shepherd plays his flute in the shadow of the forest in the background, and this scene forms a blatant contrast with the worldly greed of Midas. In the background Midas is shown again, kneeling on the bank of the river Pactolus, washing off the gold, as Bacchus had instructed.

Example: Nicolas Poussin, Pinakothek, Munich. (Friedlaender, colorplate 10).

MIDAS BATHING IN THE RIVER PACTOLUS. The story of Midas is told by Ovid in *Metamorphoses* 11: 100–145. "The god . . . gave Midas the right to choose himself a gift—a privilege which Midas welcomed, but one which did

him little good, for he was fated to make poor use of the opportunity he was given. He said to the god: 'Grant that whatever my person touches be turned to yellow gold.' Bacchus . . . granted his request. . . . The Phrygian king went off cheerfully, delighted with the misfortune which had befallen him. He tested the good faith of Bacchus' promise by touching this and that, and could scarcely believe his own senses. . . . So he exulted in his good fortune, while servants set before him tables piled high with meats, and with bread in abundance. But then, when he touched a piece of bread, it grew stiff and hard; if he hungrily tried to bite into the meat, a sheet of gold encased the food. . . . Midas prayed for a way of escape from his wealth.'' Bacchus told him to '' 'go to the river . . . plunge your head and body in the water and, at the same time, wash away your crime.' The king went to the spring [the River Pactolus in Lydia] as he was bidden: his power to change things into gold passed from his person into the stream.'' Midas is believed to be the source of the gold-bearing properties of the river thought to have been the source of the wealth of the kings of Lydia, of whom Croesus was the last.

In art, Midas, without his crown, is shown kneeling penitently before Bacchus or he may be washing in the River Pactolus, which is personified by the reclining river god who watches. Two chubby *putti* (*see* PUTTO) splash water into an urn. Midas may also be shown reclining, wearing a crown and a mantle, pensively watching a youth who kneels at his feet searching for gold in the water where Midas washed.

Example: Nicolas Poussin, The Metropolitan Museum of Art, New York. (Friedaender, colorplate 11)

MILL, THE. *See* MARRIAGE OF ISAAC AND REBECCA.

MILO OF CROTON (*Milon of Croton*). Known for his extraordinary strength, Milo was a Greek athlete, who lived at Croton, a Greek settlement in southern Italy, in the later 6th century B.C. He was six times victor in wrestling at the Olympian games and six times victor at the Pythian games (held at Delphi every four years by the ancient Greeks in honor of Apollo). He is said to have carried a heifer to the stadium on his shoulders, killed it with one blow, and eaten the entire animal in one day. According to the Roman historian Valerius Maximus, who lived at the time of Tiberius and was the author of *De Factis Dictisque Memorabilibus Libri IX,* (9:12), on spying a gigantic tree partly cracked open with a wedge, Milo tried to wrench it apart, but only succeeded in causing the wedge to fall out. He was suddenly trapped in the cleft by his hands and, unable to escape even with his great strength, was eaten alive by wolves.

Italian Baroque artists depict Milo as an extremely muscular figure, partly nude, his hands caught in the split tree. He is usually attacked by a lion, or he stands alone terrified, helpless and prey to wild beasts.

Example: Pierre Puget, Brush and ink wash. Museum, Rennes. (Held and Posner, figs. 174, 175)

MIRACLE OF ST. GREGORY. *See* GREGORY AND THE MIRACLE OF THE CORPORAL.

MIRACLES OF ST. FRANCIS XAVIER. A Jesuit missionary, Francis Xavier was born in 1506 and died in 1552. He was born in Spanish Navarre, at the castle of Xavier, near Pamplona. At the college of St. Barbara, where in 1528 he gained the degree of licentiate, he met Ignatius Loyola; and though he did not at once become a follower, he soon became one of the band of seven, the first Jesuits who founded the SOCIETY OF JESUS, vowing themselves to the service of God. In 1540, St. Ignatius appointed St. Francis to join Father Simon Rodriguez in the first Christian missionary work of the society, and he went to the East Indies where he became known as the "apostle of the Indies." Traveling through the East Indies, Japan, Ceylon and southern India, he instructed Christians in the principles of religion and taught them the practice of virtue. He offered mass to lepers, preached in public, visited private houses and finally became so popular that people sang the songs he had taught them everywhere. Xavier always ate the poorest food, usually water and rice; he slept in a hut on the bare ground. As he traveled, village after village received him with open arms. He was said to have held off raiders with only a crucifix as they robbed and massacred and carried into slavery the Christians of Comorin. While entering China, he fell sick and was taken by a severe fever. As a cure, he was bled, but with distressing results. He prayed ceaselessly between spasms and delirium. He died in a reed hut at the age of forty-six, having spent eleven years in the East. Xavier's body had been packed with lime in the coffin; and ten weeks later, when the grave and coffin were opened and the lime was removed from the face, Francis appeared so peaceful that it was as if he had never died. His body was taken to Goa, where it continued to remain in a state as if the saint slept. This was verified by physicians. The body still lies enshrined in the Church of the Good Jesus. Xavier was canonized in 1622, at the same time as Teresa of Avila, Ignatius Loyola, Isidore the Husbandman and Philip Neri.

Francis Xavier is the most widely represented Jesuit saint in art of the COUNTER REFORMATION. Cycles of narratives depicting him curing the sick, baptizing and preaching are found in Jesuit churches. He is also shown performing miracles of healing. Usually he is wearing a white surplice (a loose, wide-sleeved cloak) over a black habit. His hair is dark and he has a trimmed, black beard. He may hold a lily (a symbol of purity) or a crucifix. He is generally shown surrounded by awed primitive tribesmen beside or above a person he has just restored to health or to life. Above him, in the heavens, may be an angel and a vision of Jesus displaying his five wounds, the visible symbols of the PASSION OF CHRIST. The architecture of a heathen temple beside which Xavier is preaching resembles a work from antiquity. A Pan-like bust may be in a niche, further emphasizing the pagan surroundings. A priest and acolytes may be shown falling back in confusion from a pagan altar, as light streams down upon it from a heavenly vision of the Virgin Mary with angels.

Example: Peter Paul Rubens, Kunsthistorisches Museum, Vienna. (Held and Posner, fig. 209)

MIRACULOUS DRAUGHT OF FISHES. The story of the Miraculous Draught of Fishes is told in Luke 5:1–11. ''While the people pressed upon him [Jesus] to hear the word of God, he was standing by the lake of Gennes'aret. And he saw two boats by the lake; but the fishermen had gone out of them and were washing their nets. Getting into one of the boats, which was Simon's, he asked him to put out a little from the land. And he sat down and taught the people from the boat. And when he had ceased speaking, he said to Simon, 'Put out into the deep and let down your nets for a catch.' And Simon answered 'Master, we toiled all night and took nothing! But at your word I will let down the nets.' And when they had done this, they enclosed a great shoal of fish; and as their nets were breaking, they beckoned to their partners in the other boat to come and help them. And they came and filled both the boats, so that they began to sink. But when Simon Peter saw it, he fell down at Jesus' knees saying, 'Depart from me, for I am a sinful man, O Lord.' For he was astonished, and all that were with him, at the catch of fish which they had taken; and so also were James and John, sons of Zeb'edee, who were partners with Simon. And Jesus said to Simon, 'Do not be afraid; henceforth you will be catching men.' And when they had brought their boats to land, they left everything and followed him.'' The sea mentioned is the Sea of Galilee (or Lake of Gennesaret).

The episode is also told in the Gospel of John 21:1–8. John places it after the CRUCIFIXION, so that it becomes one of the appearances of Jesus after his Resurrection from the tomb. This version is rare. Jesus stands on the shore and not in the boat, and Peter plunges into the sea in his hurry to approach him. Some may confuse the scene with the episode of ''Christ Walking upon the Waves.''

In the example below, Jesus is shown standing in the boat, the sails billowing behind him, his hands lifted straight to heaven in the attitude of the early Christian orant (attitude of prayer). He is surrounded by men hauling in nets and women busy cleaning the fish. The sea of Galilee is visible in the background.

Example: Jean Jouvenet, The Louvre, Paris. (Blunt, fig. 323)

MISERIES OF WAR. *See* GRANDES MISÉRIES DE LA GUERRE.

MODELLO. Also *modelleto.* Italian words used to describe a small drawing or painting of a composition—although not strictly speaking a preliminary sketch—which was shown to the patron or body commissioning a larger work in the hope that a commission would be forthcoming. The idea was to impress the patron favorably with a clear illustration of the artist's ideas. The *modello* was more accurate and polished than an ordinary compositional sketch. Many such small versions, often quite highly finished, still exist. Most *modelli* are in oil paint or a combination of chalk, ink and paint. Peter Paul Rubens's small

sketches of the *Marie de Médicis* cycle of elaborately large paintings in the Louvre reveal how thoroughly a painter could use *modelli* to present his ideas as regards color schemes and composition.

Example: Mattia Preti, *Modello for the Plague Fresco,* Galleria Nazionale, Naples. (Waterhouse, fig. 165.)

MONOGRAM. *See* SACRED MONOGRAM.

MOSES AND AARON CHANGING THE WATERS OF EGYPT INTO BLOOD. Moses was the great leader of the Jewish people, the giver of the Law and the founder of their religion. He was the high priest of the Israelites in the wilderness and the prototype for the ancient Jewish priesthood. Aaron, his older brother, accompanies him in several incidents. The Israelites were an oppressed race while in Egypt. Their story is told in the Second Book of Moses commonly called Exodus. The story of Moses and Aaron changing the waters of the Nile into blood is told in Exodus 7:14–19: "Then the Lord said to Moses, 'Pharaoh's heart is hardened, he refuses to let the people go. Go to Pharaoh in the morning, as he is going out to the water; wait for him by the river's brink, and take in your hand the rod which was turned into a serpent. And you shall say to him, "The Lord, the God of the Hebrews, sent me to you, saying 'Let my people go that they may serve me in the wilderness; and behold, you have not yet obeyed.' " ' Thus says the Lord, 'By this you shall know that I am the Lord: behold, I will strike the water that is in the Nile with the rod that is in my hands, and it shall be turned to blood, and the fish in the Nile shall die, and the Nile shall become foul, and the Egyptians will loathe to drink water from the Nile.' " Moses and Aaron did as they had been commanded and "within sight of Pharaoh and in the sight of his servants, he lifted up the rod and struck the water that was in the Nile, and all the water that was in the Nile turned to blood."

Moses is usually shown as an old man with a white beard and long flowing hair. Aaron, an old man also, may wear either a large turban or, as a prefiguration of the priesthood, a papal tiara. He may hold a censer and a flowering rod. Aaron's rod settled the issue of leadership among the twelve tribes when each presented a rod that was put in the tabernacle. Aaron's staff, representing the tribe of Levi, had flowered and produced ripe almonds, (as told in Numbers 16:1–35). Moses and Aaron stand near the banks of the Nile, the ruins of ancient buildings behind them. Pharaoh and his servants stare and point toward the rod.

Example: Bartholomeus Breenbergh, J. Paul Getty Museum, Malibu, California. (Held and Posner, fig. 229)

MOSES FOUND BY THE PHARAOH'S DAUGHTER (*Finding of Moses* and *Landscape with the Finding of Moses*). Moses, the leader of the Jewish people, the founder of their institutional religion and their lawgiver, was born in Egypt. The story of the finding of Moses as an infant is told in the second book of Moses, commonly called Exodus 2:1–10. Pharaoh, fearful of the grow-

ing numbers of Israelites in Egypt, ordered all their male infants killed. He said, "Every son that is born to the Hebrews you shall cast into the Nile, but you shall let every daughter live." Moses's mother hid him for three months, and when she could no longer conceal him, she put him in a basket and placed it in tall reeds beside the river. "Now the daughter of Pharaoh came down to bathe at the river, and her maidens walked beside the river; she saw the basket among the reeds and sent her maid to fetch it. When she opened it she saw the child; and lo, the babe was crying. She took pity on him and said, 'This is one of the Hebrews' children.' " Moses' sister, who had watched at a distance, offered to find a Hebrew woman for a nurse. Pharaoh's daughter agreed and in this manner Moses was taken to his own mother. The episode was interpreted by the early Christian Church as a prefiguration of the FLIGHT INTO EGYPT, the Holy Family's escape from Herod's MASSACRE OF THE INNOCENTS. The story is similar to the account of the birth of the Babylonian king, Sargon I, which tells how his mother put him in the river in a basket.

The baby Moses may be shown still floating in his basket, or he may be shown after his rescue, surrounded by a group of women caring for him. In the example below, the baby Moses is shown in a small basket surrounded by women who attend him.

Example: Nicolas Poussin, Drawing, The Louvre, Paris. (Friedlaender, figs. 44 and 65)

MOSES STRIKING THE ROCK *(Moses Drawing Water from the Rock).* The story of Moses striking the rock is told in Exodus 17:1–7 and Numbers 20: 1–13. Exodus says, "All the congregation of the people of Israel moved on from the wilderness of Sin by stages, according to the commandment of the Lord, and camped at Rephidim; but there was no water for the people to drink. Therefore the people found fault with Moses, and said, 'Give us water to drink.' And Moses said to them, 'Why do you find fault with me? Why do you put the Lord to the proof?' But the people thirsted there for water, and the people murmured against Moses, and said, 'Why did you bring us up out of Egypt, to kill us and our children and our cattle with thirst?' So Moses cried to the Lord, 'What shall I do with this people? They are almost ready to stone me.' And the Lord said to Moses, 'Pass on before the people, taking with you some of the elders of Israel; and take in your hand the rod with which you struck the Nile, and go. Behold, I will stand before you there at the rock at Horeb; and you shall strike the rock, and water shall come out of it, that the people may drink.' And Moses did so, in the sight of the elders of Israel."

The elders are depicted gathered about Moses, who stands at the rock. Some are shown throwing up their hands in thanksgiving, while the Israelites either drink from their vessels or bow down before him. "Water from the Rock" was seen as a symbol of the spiritual sustenance given to the faithful by the church.

Example: Nicolas Poussin, The Hermitage, St. Petersburg. (Friedlaender, fig. 46)

MUSES POLYHYMNIA, MELPOMENE, AND ERATO. The muses were the Greek deities of creative inspiration in music, poetry, literature and dance; later also in philosophy, astronomy, and all intellectual interests. Companions of Apollo, they were the daughters of the Titaness Mnemosyne (Memory) and Zeus (Jupiter). They sang and danced at the festivities of heroes and Olympians, sometimes led by Apollo, and had the power to give inspiration. Their abode was the Castalian spring on Mount PARNASSUS (which is the reason springs and fountains are usually shown with them). They have few myths of their own. Thamyris, the Thracian poet, lost his sight and song when he competed against the muses. They were judges in the contest of Marsyas and Apollo (*Metamorphoses* 6:382–400) in which Marsyas was flayed alive. Once the sirens tried to compete with them; but, defeated, they lost their wings and jumped into the sea. There were nine muses, each of which had her particular influence over the arts and learning. Besides being lovable and beautiful, the muses were among the most influential creations. They were personifications of the highest artistic aspirations and intellectual pursuits. They inspired philosophers, scientists and poets and brought to humanity the purifying power of song, divine wisdom and the inspiration of poetry. Their attributes, especially their musical instruments, changed from period to period, making identification difficult.

In Baroque art, some muses may be without attributes or with one or several of the following: Polyhymnia (or Polymnia), the muse of heroic hymns, is sometimes shown with a portative organ and, more rarely, a lute or other instrument. Melpomene, the muse of tragedy, is sometimes shown with tragic masks, a horn, a dagger or sword, a sceptre lying at her feet and a crown held in her hand. Erato, the muse of love and lyric poetry, is shown with a lyre or a tambourine, more rarely with a viol or a triangle. A PUTTO may be at her feet and sometimes a swan.

Example: Eustache Le Sueur, The Louvre, Paris. (Held and Posner, colorplate 20)

MYTHOLOGICAL PAINTING. Carel van Mander, a Dutch painter and critic, in 1604 published his handbook for artists, *The Painter's Bible,* one section of which is a full summary of Ovid's *Metamorphoses.* Thus, his book became a valuable treasury of classical mythology. All the ancient gods were depicted frequently in the paintings of the 17th century, as were subjects and situations taken from the Old and New Testaments, and from legend. Ovid always held a special place. Another constant source of inspiration was the ancient art, especially sarcophagi (coffins), showing stories in relief of the gods and goddesses. Sculptures, paintings and drawings of the divinities rule in most religions, including those of ancient Mesopotamia and Egypt; but the pictures of legendary and mythological incidents, such as the Hercules cycle or the amorous activities of Jupiter (Zeus), appear to be an accomplishment of Greek art that triumphed in the realistic descriptions of physical action and psychological reaction. Even the rise of Christianity did not entirely obliterate the customs of mythological

painting. (For instance, the deeds of Hercules were illustrated in the 12th century.)

During the Baroque, it was Peter Paul Rubens, the Flemish painter, who restored to the subject its ancient simplicity and feeling. Educated in ancient art and literature, he became the most productive master of mythological painting the world had seen. Nicolas Poussin, the French Baroque painter, and Rembrandt van Rijn, the Dutch Baroque painter, also illustrated stories from mythology.

N

NARCISSUS. Narcissus was a young man of incredible beauty, the son of Cephisus (the Boeotian River) and Liriope, a nymph. According to Ovid's *Metamorphoses* 3:344–51 "She [Liriope] was the nymph whom Cephisus once embraced with his curving stream, imprisoned in his waves, and forcefully ravished. When her time was come, that nymph most fair brought forth a child with whom one could have fallen in love even in his cradle, and she called him Narcissus. When the prophetic seer Tiresias was asked whether this boy would live to a ripe old age, he replied: 'Yes, if he does not come to know himself.' '' Everyone who saw the child, both male and female, fell in love with him because of his unusual and astonishing beauty. Through pride, however, he spurned them all, even Echo, the hapless nymph whom Hera (Juno) had punished by causing her to repeat only the last words that were spoken to her.

As told by Ovid, 3:361–66, "Juno had brought this about because often, when she could have caught the nymphs lying with her Jupiter on the mountainside, Echo, knowing well what she did, used to detain the goddess with an endless flow of talk, until the nymphs could flee. When Juno realized what was happening, she said: 'I shall curtail the powers of that tongue which has tricked me: you will have only the briefest possible use of your voice.' '' And it was thus that Echo could say only the last word she heard. Still, she loved Narcissus who, unfortunately, was soon to die. He came to a pond on Mount Helicon one day and became enraptured when he glanced down and saw his reflection. He sat down and gazed at himself hour after hour. He could not leave the place. He pined away until, upon the grass beside the waters, he died. A pyre, torches and a bier were made ready by Echo and her sisters, but the body of Narcissus was nowhere to be seen when they went for it. In its place, they found a flower, yellow-centered, and with white petals. Echo repeated his dying word, "Alas." Ovid gives an explanation (some scholars wonder whether this is his own) say-

ing Narcissus was punished for his cruelty to Echo. Echo wasted away in sorrow until only her voice remained.

Narcissus is often shown alone, moody and unhappy, leaning over the edge of a fountain or pool, his beauty cast back by the water in a pitiful grimace. Narcissus flowers may blossom at his feet. Some artists show him dead beside the water, while Echo, ghostlike and pale in deep shadows, grieves over him. *see* NARCISSUS AND ECHO.

Example: Caravaggio, Galleria Nazionale di Palazzo Barberini, Rome. (Bottari, color-plate 20)

NARCISSUS AND ECHO. The story of NARCISSUS is told by Ovid in Metamorphoses 3:339–510. The topic, a favorite of Baroque artists, is the tale of a beautiful young man who, after relaxing from a day of hunting, sees his reflection mirrored in the still water of a pond. Unable to distinguish between his own face and his reflection, he falls in love with himself and eventually dies of his desire. Ovid connected this story with the legend of the nymph Echo "with the sonorous voice" who loved Narcissus. She was so-named because she had been condemned by the goddess Juno to repeat only the last words spoken to her. Narcissus, as a punishment for not returning Echo's love, was forced to fall in love with his own reflection. When he died, after living his last days pining away gazing at his reflection in a pool, Echo wasted and withered until only her bones and her voice remained. Even her bones later turned to stone. The story can also be found in François Harbert's poem "*Histoire du beau Narcisse,*" written in 1530.

Narcissus is shown dead or dying from complete exhaustion brought on by his desire for himself. Narcissus flowers spring up about his head. Shown somewhere, usually in the background, is the beautiful but withering Echo, languishing and fading to bones. A winged cupid may be shown holding a flaming torch as if attending a funeral. The ancients believed that a person's soul was in his or her reflection and that to dream of it was an omen of death. The narcissus flower has subsequently become the symbol of a youthful death. *See also* REALM OF FLORA.

Example: Nicolas Poussin, The Louvre, Paris. (Friedlaender, colorplate 9)

NATIVITY. The birth of Jesus is told by Luke 2:1–20 and Matthew 2:1–12. Matthew says, "[W]hen Jesus was born in Bethlehem of Judea in the days of Herod the king, behold, wise men from the East came to Jerusalem, saying, 'Where is he who has been born king of the Jews? For we have seen his star in the East, and have come to worship him.' When Herod the king heard this, he was troubled, and all Jerusalem with him; and assembling all the chief priests and scribes of the people, he inquired of them where the Christ was to be born. They told him, 'In Bethlehem of Judea; for so it is written by the prophet.' . . . And going into the house they saw the child with Mary his mother, and they fell down and worshipped him." According to Luke, "[T]he time came for her

[Mary] to be delivered. And she gave birth to her first-born son and wrapped him in swaddling cloths, and laid him in a manger, because there was no place for them in the inn . . . he was called Jesus, the name given by the angel before he was conceived in the womb.''

By the end of the Middle Ages, the wise men had been changed through legend and stories from priests to kings accompanied by an entourage. After artists began to include an ox and an ass, they were rarely absent. The earliest reference to the ox and ass at the nativity is in the gospel of Pseudo-Matthew (possibly 8th century); according to Isaiah 1:3, ''The ox knows its owner and the ass its master's stall; but Israel, my own people, has no knowledge, no discernment.'' This was seen as a prophecy of the Jews' refusal to accept Christ as the Messiah. Matthew says the men entered a house. Luke says Mary laid the infant in a manger. A cave is mentioned first in the early apocryphal Book of James: ''And he found a cave there and brought her into it.'' Even another account was given in the 14th century by Pseudo-Bonaventura (Giovanni de Caulibus) in his meditations: ''The Virgin arose in the night and leaned against a pillar. Joseph brought into the stable a bundle of hay which he threw down and the Son of God, issuing from his mother's belly without causing her pain, was projected instantly on to the hay at the Virgin's feet.''

The inclusion in art of two midwives present at the birth, a tradition in the Eastern Church, was condemned by the Council of Trent in the mid-16th century. The idea of a midwife did not disappear altogether, however. Mary may be shown holding her child wrapped in swaddling clothes while a woman sits beside her.

Example: Georges de La Tour, Museum, Rennes, France. (Blunt, fig. 221)

NATIVITY WITH ST. LAWRENCE AND ST. FRANCIS. The NATIVITY of Jesus is told by Matthew (2:1–12) and Luke (2:1–7). ''In those days a decree went out from Caesar Augustus that all the world should be enrolled. This was the first enrollment, at a time when Quirin'ius was governor of Syria. And all went to be enrolled, each in his own city. And Joseph also went up from Galilee, from the city of Nazareth, to Judea, to the city of David, which is called Bethlehem, because he was of the house and lineage of David, to be enrolled with Mary, his betrothed, who was with child. And while they were there, the time came for her to be delivered. And she gave birth to her first-born son and wrapped him in swaddling cloths, and laid him in a manger, because there was no place for them in the inn.'' Matthew tells of the wise men who followed the star and brought their gifts; Luke tells of the shepherds who came to see the child, led by an angel. Luke writes that Mary laid the infant ''in a manger because there was no room for them to lodge in the house.''

Jesus is usually shown in a stable, although mention of a cave where Jesus was born is found in the early apocryphal Book of James: ''And he found a cave there and brought her into it.'' The apocryphal Gospel of Pseudo-Matthew is the first source to mention the ox (a symbol of the believer) and the ass (a

symbol of the nonbeliever), both of which are included in most Nativity scenes. Legend tells of the ox who stopped eating when the Jesus was born while the ass continued uninterrupted. "An angel made her dismount and enter a dark cave which began to shine. . . . On the third day Mary left the cave and went into a stable and put the child in the manger, and the ox and the ass adored him."

In art of the 17th century, saints from previous centuries are sometimes included in religious scenes. St. Lawrence, who died in Rome in 258, and St. Francis, who died c. 1226, could not have been present at the Nativity. Lawrence is usually shown holding or standing on a gridiron, a rectangular metal lattice with four or more short legs, the instrument of his martyrdom. He may have a dish of coins or a censer (for incense) or a purse or the processional cross, which it was the deacon's duty to carry. St. Francis is easily recognized by the stigmata (the five wounds corresponding to those of Christ) on his hands, feet and side—the latter showing, in some cases, through a slit in the right side of his tunic. He may hold a crucifix or a lily (for purity). The Virgin, a young girl, is shown gazing at her newborn baby with St. Lawrence and St. Francis on either side of her. St. Joseph, husband of the Virgin, is seated, and an angel hovers above the group, spreading light among the tenebrous shadows and carrying the sign *Gloria in Eccelsis [sic] Deo* (*Eccelsis* is properly spelled *Excelsis*), "Glory be to God on High," the title and first words of the greater doxology (a hymn praising God). Jesus rests on a bed of straw, while the ox lowers his great head toward him. A shepherd, leaning on his staff, gazes upon the child in gentle reverence.

Example: Caravaggio, Oratorio di san Lorenzo, Palermo. (Bottari, colorplate 74)

NAUSICAÄ AND ODYSSEUS. The story of Nausicaä and Odysseus is told in the *Odyssey* Book 6. Nausicaä was the daughter of the Phaeacian king Alcinoüs and his queen Arete. The night of Odysseus's landing in Scheria, Nausicaä was prompted by Athena, in a dream, to bring her family linen to the river mouth to be washed. When she went the next morning, she took her handmaidens and the picnic her mother had packed in a hamper. "While the bright burning sun dried out their linen, Princess and maids delighted in that feast; Then, putting off their veils, they ran and passed a ball to a rhythmic beat, Nausicaä flashing first with her white arms. It happened when the king's daughter threw her ball off line and missed, and put it in the whirling stream—at which they all gave such a shout, Odysseus awoke and sat up. . . . He pushed aside the bushes, breaking off with his great hand a single branch of olive, whose leaves might shield him in his nakedness; So came out rustling, like a mountain lion, rain-drenched, wind-buffeted, but in his might at ease, with burning eyes . . . Odysseus had this look, in his rough skin advancing on the girls with pretty braids; And he was driven on by hunger, too. Streaked with brine, and swollen, he terrified them, so that they fled, this way and that. Only Alcinous's daughter stood her ground, being given a bold heart by Athene, and steady knees."

Odysseus then made known his wants to her and she fed and clothed him and showed him the way to her father's palace in the city, modestly directing him to walk the last part of the distance alone, so that the gossips would not see them together and accuse her of husband-hunting.

This episode was discussed in the lost *Nausicaä* of Sophocles and a few other post-Homeric works: Hellanicus, in *Eustathius* on Homer, says Nausicaä married Telemachus and had a son by him named Perseptolis, the next best thing to marrying Odysseus, as Alcinous had wished on their first meeting. Samuel Butler argued that Nausicaä was the real authoress of the *Odyssey*, an idea which has been given some support from Robert Graves.

In the example below, Odysseus is shown emerging from the bushes, surprising Nausicaä and her servants. Her maids react with looks of horror and hands flung high in fright. A dog barks at Odysseus, who is upon his knees, nude except for a few leaves. Nausicaä, in her cart, is silhouetted against the low horizon and light sky, beautiful and courageous.

Example: Pieter Lastman, Staatliche Gemäldegalerie, Augsburg. (Rosenberg, Slive, ter Kuile, fig. 9)

NERI, PHILIP. *See* VISION OF ST. FILIPPO NERI.

NIGHT PAINTERS. Seventeenth-century artists who used heavy darks relieved only by the dim and sometimes dazzling flickers of candle flames or the golds of fires were referred to as ''night painters.'' Light falls on characters within these paintings as if they are illuminated by a spotlight. The light may be spectacular and then interrupted, which in turn casts a surprising and dramatic shadow on an individual's face or the thin edge of a collar or some other part of the painting's subject. The source of light may be single and may come from within the painting. The source may be partially or wholly concealed by some object in front of it, such as a hand. If the object is a hand, and the light a candle, the hand may seem translucent, glowing iridescent like a live coal. The overall effect is similar to that of opening a bright lantern and seeing a golden flame and all that it touches for a brief second in a pitch-black room.

NIGHT WATCH. It is possible that this large painting is responsible for the financial problems Rembrandt encountered after its completion in 1642. Although today the painting is known as the *Night Watch,* it is in reality a scene that occurred in sunlight. This fact became clear when the painting was stripped of its dirt and dark varnish not long after it was removed from a shelter where it had been stored during World War II. At that time journalists called it ''The Day Watch,'' but there is no justification for that title either, as the civic guards shown did not go out on night or day watches. The title *Night Watch* is based on an incorrect interpretation by early 19th-century critics. The actual title is *The Company of Captain Frans Banning Cocq and Lieutenant Willem van Ruytenburch.*

The subjects shown are a group of musketeers led by Frans Banning Cocq. These men were a part of the Civic Guard of Amsterdam. They were actually amateur soldiers, but since they were not pleased with the anonymity of ordinary military service, their closeness in the group portrait takes on the character of an important club. Therefore, although the musketeers commissioned a painting meant to show their full military spirit and costume, they expected to see themselves in the final work as more individual and important. Rembrandt placed some of the men in gloom and shadows. One guard has an arm in front of his face covering all but his eyes. Because Rembrandt's group portrait was for him more a study in light and dark (so typical of the Baroque), he offended many of his sitters. In the long run dissatisfaction led to fewer commissions. He was paid 1600 guilders for the painting, and at that time the canvas was larger. It has been cut on all four sides. Old copies reveal that the left side showed two additional men and a child.

Example: Rembrandt Van Rijn, Rijksmuseum, Amsterdam. (Rosenberg, Slive, ter Kuile, fig. 67)

NURTURE OF BACCHUS. The story of the nurture and education of BACCHUS is told in Ovid's *Metamorphoses* 3:314–15. After his birth (*see* BIRTH OF BACCHUS), Bacchus was "given to the nymphs of Nysa who hid him in their caves, and fed him milk." Those who helped bring him up were: Silenus, the maenads (nymphs who attended Bacchus), and the satyrs (woodland deities who attended Bacchus). He is usually depicted as a chubby little boy with curly hair being fed wine from a bowl or a cornucopia held by a satyr. Another satyr may support him as he eagerly drinks the wine from the bowl. Behind them, a bacchante (a worshiper of Bacchus) leans on a thyrsus (a staff tipped with a pine cone entwined with ivy or vine leaves) watching the proceedings. Nearby, a goat is led by a fat PUTTO. The inebriating effects of too much wine are shown by the drunk, sleeping bacchante with a baby at her breast.

Example: Nicolas Poussin, The Louvre, Paris. (Friedlaender, colorplate 18)

NURTURE OF JUPITER. Jupiter is the Greek Zeus, the supreme ruler of all mortals and the gods and the chief of the twelve Olympians. His mother had run to Crete where she had her baby in a cave. To save the baby Jupiter from Saturn (Cronus), his voracious father, the god who ate his children after it was prophesied that one of them would usurp him, Jupiter's mother gave him to two nymphs, Melissa and Amalthea, who fed him on goat's milk and honey. In place of her baby, she gave Saturn a stone the size of a child and wrapped it in swaddling clothes. Saturn swallowed it unsuspectingly. Jupiter was brought up in the hills of Mt. Ida, the highest mountain on the island of Crete, located below the Greek mainland. In some accounts the goat is called Amalthea.

A bearded shepherd is shown milking a spotted goat, while the nymph Amalthea feeds the infant milk from a pitcher. The nymph Melissa reaches to her right side for a honeycomb in beehives that swarm with bees.

Example: Nicolas Poussin, Dulwich Gallery, London. (Blunt, fig. 234)

NYMPH CARRIED BY A SATYR. In ancient Greece lovely young female spirits who were believed to inhabit certain classes of natural objects were known as nymphs. The nymphs of the Aegean, for example, were the nereids, who were daughters of Nereus, the old man of the sea. Other famous nymphs were Galatea and Thetis. Naiads were the fresh water nymphs. The lovely pristine virgin-like companions of Diana are sometimes called nymphs. They hunt with Diana and are also armed with bows and arrows and quivers; and they bathe with her in secret forest pools. Satyrs were one of several spirits to inhabit the forests and mountains; they were identified with the god Faunus of Roman mythology. They attended BACCHUS, and it was from him that they derived their hairy legs, hooves, tails, bearded faces and horns. They usually wear a crown of ivy, sacred to Bacchus. Satyrs were renowned for being lecherous and lazy and spent their time chasing nymphs and getting drunk.

A nymph being carried by a satyr is a bucolic, erotic mythological subject that depicts satyrs and nymphs in an ideal landscape. Such pagan genre scenes—a nymph riding the back of a goat, or groups of merrymakers drinking and lounging about, for instance—originated in ancient representations on gems and cameos. In the event illustrated, a ménage on the move, a group led by a pretty, chubby PUTTO carrying musical pipes (a symbol of lust) and followed by a male carrying the picnic, a load of provisions—of which grapes (the symbol for wine) appear to be plentiful—searches for a secluded picnic place. The nymph, naked and beautiful, rides the shoulders of a satyr. The theme of nymphs and satyrs together in seductive scenes was popular during the Baroque period, the erotic idea being perhaps an allegory of Chastity overcome by Lust.

Example: Nicolas Poussin, Gallery, Cassel, Germany. (Friedlaender, colorplate 6)

O

OATH OF CLAUDIUS CIVILIS. Civilis was a Batavian hero. The Batavi, a Germanic people, lived between the Old Rhine and the Waal, where their name is preserved in the Dutch district of Betuwe. An offshoot of the Chatti, they helped Drusus in the conquest of western Germany in 12 B.C. and were of great military value to the Romans. Even after the Roman withdrawal to the Rhine in A.D. 9, they remained incorporated in the empire and paid no taxes; they helped Germanicus in his attacks on their fellow Germans in A.D. 16. By the middle of the first century A.D., their warriors formed auxiliary regiments, which served under their own chiefs in the Roman army. Batavi are also found until A.D. 68 as personal bodyguards of the emperors. Under the leadership of Claudius Civilis, they headed the great revolt of 69–70. How it ended is not known because that part of the story, as told in Tacitus's *Histories* (the original source for the life of Claudius Civilis), is lost.

Example: Rembrandt van Rijn, National Museum, Stockholm. (Held and Posner, colorplate 38)

OLYMPIAN GODS. *See* GODS OF OLYMPUS.

ORDINATION. In religion, the term "ordination" is used to designate the clergy of the Protestant church, especially those who repudiate the claims of Apostolic Succession. (In Christian theology, this is the doctrine proclaiming that the selected successors of the apostles enjoyed, through God's grace, the same power, responsibility and authority as was conferred upon the apostles by Christ.) The ceremony by which one receives the office of a minister is called ordination. Unlike holy orders in the Roman Catholic Church, Protestant ordination is not a sacrament. The Reformation doctrine of the "priesthood of all believers" underlies the preference of some Protestant bodies to diminish the distinction between laity and ministry. Some Protestant groups, such as the

Plymouth Brethren, dispense with the ordination of ministers altogether. Quakers, The Society of Friends, ordain but make only slight practical distinction between laity and ministers. Presbyterianism and Lutheranism give the office immense dignity. Methodism, in the United States, has an Episcopal type of church organization but one not at all similar to the episcopacy of the Church of England. Most Protestant groups believe that God will accept the soul without the need of priestly mediation. Hence, the role of the ministry is interpreted strictly as one of assistance to the religious life through preaching, counseling and the administration of sacraments.

Artists show the apostles arranged in a long row with Christ, his left hand raised, and Saint Peter on the left. Others show Christ, his left hand raised, in the middle of the composition, with Saint Peter kneeling at his feet.

Example: Nicolas Poussin, Collection Earl of Ellesmere, on loan to National Galleries of Scotland, Edinburgh. (Friedlaender, fig. 52)

ORPHEUS AND EURYDICE. *See* LANDSCAPE WITH ORPHEUS AND EURYDICE.

P

PACHECO, FRANCISCO. An influential 17th-century Spanish writer and portrait and religious painter, Francisco Pachecho was born in 1564 and died in 1654. He is best known as the author of *Arte de la Pintura,* which was completed in 1637/38 but not published until 1649. A new and more extensive edition was published in 1956. The text includes dates on Pachecho's contemporaries. He was the master of Diego Velázquez and Alonso Cano. Scholars agree that he probably did not travel to Italy, as did other masters, having worked mostly in Seville, Spain. He did, however, have a collection of engravings, including some after Albrecht Dürer, Michelangelo, Paolo Veronese and Lucas van Leyden. Velázquez became his pupil in 1611; also in 1611, Pacheco made a trip to Madrid and Toledo where he visited the Greek painter El Greco. In 1618 he received the appointment ''Censor of Paintings to the Inquisition,'' and in 1619 he was made painter to the King. Pacheco is said to have completed one hundred and fifty portraits by 1647. The museums in Seville and Madrid hold most of his works, and there is one in Williamstown, Massachusetts.

PALA D'ALTARE. *See* ALTARPIECE.

PAN AND SYRINX. The story of Pan and Syrinx is told in Ovid's Metamorphoses 1:688–712 and is similar to that of APOLLO AND DAPHNE. Both Daphne and Syrinx are known for scorning the amorous advances of a pursuer. Mercury tells the story: '' 'In the chill mountains of Arcadia there lived a nymph, the most famous of all the wood nymphs of Nonacris. The other nymphs called her Syrinx. Many a time she had eluded the pursuit of satyrs and of other spirits who haunt the shady woodlands or the fertile fields. She was a follower of the Ortygian goddess, imitating her in her pastimes, and in her virtue too. When she had her garments caught up out of the way, for hunting, as Diana wears hers, she could easily have been mistaken for Leto's daughter, save that

her bow was of horn, Diana's of gold; even in spite of this, she used to be taken for a goddess. As she was returning from Mount Lycaeus Pan caught sight of her, Pan who wears on his head a wreath of sharp-leafed pine, and he spoke these words'.... Mercury still had to tell what Pan said to the nymph and how she, scorning his prayers, ran off through the pathless forest till she came to the still waters of sandy Ladon. When the river halted her flight, she prayed her sisters of the stream to transform her; and when Pan thought that he had at last caught hold of Syrinx, he found that instead of the nymph's body he held a handful of marsh reeds. As he stood sighing, the wind blew through the reeds and produced a thin plaintive sound. The god was enchanted by this new device and by the sweetness of the music. 'You and I shall always talk together so!' he cried. Then he took reeds of unequal length, and fastened them together with wax. These preserved the girl's name [as a syrinx, a panpipe].''

In the example below, Syrinx is white and smooth-skinned, while Pan is dark and leathery. The nymph, terrified, flees into the arms of Ladon. Her body sprouts reeds. A PUTTO hovers above ready to inflict the arrow that will cause her to fall in love with Pan. He also holds the nuptial torch. Other river nymphs are shown in the background and putti, on reeds, play in the foreground and serve as a form of REPOUSSOIR.

Example: Nicolas Poussin, Gallery, Dresden. (Friedlaender, colorplate 23)

PANTOGRAPH. The pantograph is an instrument, used since the 17th century, for copying a work of art on a smaller or a larger scale. The artist uses an uncomplicated system of levers that has a point on one arm to follow the pattern of the work. It has another arm with a drawing instrument attached to repeat the pattern on to another surface and is thus able to trace the outline of the original work.

PARABLE OF THE WORKERS IN THE VINEYARD (*Parable of the Laborers in the Vineyard***).** The story of the laborers in the vineyard is told in Matthew 20:1–16. ''For the kingdom of heaven is like a householder who went out early in the morning to hire labourers for his vineyard. After agreeing with the labourers for a denarius [the penny of the New Testament] a day, he sent them into his vineyard. And going out about the third hour he saw others standing idle in the market place; and to them he said, 'You go into the vineyard too, and whatever is right I will give you.' So they went. Going out again about the sixth hour and the ninth hour, he did the same. And about the eleventh hour he went out and found others standing; and he said to them, 'Why do you stand here idle all day?' They said to him, 'Because no one has hired us.' He said to them, 'You go into the vineyard too.' And when evening came, the owner of the vineyard said to his steward, 'Call the labourers and pay them their wages, beginning with the last, up to the first.' And when those hired about the eleventh hour came, each of them received a denarius. Now when the first came, they thought they would receive more; but each of them also received a denarius.

And on receiving it they grumbled at the householder saying, 'These last worked only one hour, and you have made them equal to us who have borne the burden of the day and the scorching heat.' But he replied to one of them, 'Friend, I am doing you no wrong; did you not agree with me for a denarius? Take what belongs to you, and go; I choose to give to this last as I give to you. Am I not allowed to do what I choose with what belongs to me? Or do you begrudge my generosity?' '' So the last will be first, and the first last.

The householder is shown seated on a throne-like chair offering a plate of coins to a worker, who is identified by his shovel. Several laborers stand behind him and wait for their money, one of whom is obviously angry. A laborer who had worked all day stands beside the householder with dark resentment on his face.

Example: Francesco Maffei, Museo di Castelvecchio, Verona. (Wittkower, fig. 230)

PARADISE. Ovid, in his Metamorphoses 1:89–150, describes how the creation of the world was followed by four ages: Golden, Silver, Bronze and Iron. The Golden Age was an earthly paradise, an Arcadia or a Garden of Eden. ''In the beginning was the Golden Age, when men of their own accord, without threat of punishment, without laws, maintained good faith and did what was right. There were no penalties to be afraid of, no bronze tablets were erected, carrying threats of legal action, no crowd of wrong-doers, anxious for mercy, trembled before the face of their judge: indeed, there were no judges, men lived securely without them . . . cities were not yet surrounded by moats.'' Ovid describes the Age of Silver: ''When Saturn was consigned to the darkness of Tartarus, and the world passed under the rule of Jove, the age of silver replaced that of gold, inferior to it, but superior to the age of tawny bronze. Jupiter shortened the springtime which had prevailed of old, and instituted a cycle of four seasons in the year, winter, summer, changeable autumn, and a brief spring. Then, for the first time, the air became parched and arid, and glowed with white heat, then hanging icicles formed under the chilling blasts of the wind. It was in those days that men first sought covered dwelling places: they made their homes in caves and thick shrubberies, or bound branches together with bark. Then corn, the gift of Ceres, first began to be sown in long furrows, and straining bullocks groaned beneath the yoke.''

The third age was bronze ''when men were of a fiercer character, more ready to turn to cruel warfare, but still free from any taint of wickedness.'' Last of the four ages was iron: ''Immediately, in this period which took its name from a baser ore, all manner of crime broke out; modesty, truth, and loyalty fled. Treachery and trickery took their place, deceit and violence and criminal greed. . . . The land, which had previously been common to all, like the sunlight and the breezes, was now divided up far and wide by boundaries, set by cautious surveyors. . . . War made its appearance. . . . Men lived on what they could plunder: friend was not safe from friend, nor father-in-law from son-in-law, and even between brothers affection was rare. Husbands waited eagerly for the death

of their wives, and wives for the death of their husbands. Ruthless stepmothers mixed brews of deadly aconite, and sons pried into their fathers' horoscopes, impatient for them to die. All proper affection lay vanquished and, last of the immortals, the maiden Justice left the blood-soaked earth.'' Each age that followed the Paradise of the Golden Age seemed to sink deeper into suffering and distress for those alive on the earth.

Artists depict the Golden Age, illustrating a beautiful wooded area replete with birds and animals, sunlight and flowers and all of nature that is gentle and good.

Example: Jan Brueghel, Dahlem Museum, Berlin. (Held and Posner, fig. 215)

PARIS. *See* JUDGMENT OF PARIS.

PARNASSUS. In Greece, Parnassus is a mountain range, an outlying spur of the Pindus range, running southeast with a maximum height of 8,200 feet. These mountains separate the Amphissa valley from that of Cephissus and extend into the Corinthian gulf at Cape Opus. Being composed of limestone, the area is mostly barren; but the foothills are cut with streams. In ancient times, Parnassus was a sacred mountain, especially to the early Greeks known as the Dorians. The mountain was sacred to the muses and Apollo and was the habitual dwelling of music and poetry.

Artists usually show the mountain as a hill, or they show no mountain at all and include a laurel grove. Usually Apollo is there playing some musical instrument or simply reclining. He is surrounded by the muses in the form of poets, crowned with laurel leaves and carrying their books. The stream of Castalia runs at their feet. Some artists depict Pegasus, the winged horse and the symbol of Fame, especially of poetic genius, although this is rare. *Putti* (*see* PUTTO) fly about and offer water from the stream.

Example: Nicolas Poussin, The Prado, Madrid. (Friedlaender, fig. 24)

PASSAGE OF THE RED SEA. The story of the crossing of the Red Sea is found in Exodus 14:19–31: ''And the Lord drove the sea back by a strong east wind all night, and made the sea dry land, and the waters were divided. And the people of Israel went into the midst of the sea on dry ground, the waters being a wall to them on their right hand and on their left. The Egyptians pursued, and went in after them into the midst of the sea, all Pharaoh's horses, his chariots, and his horsemen. . . . Then the Lord said to Moses, 'Stretch out your hand over the sea, that the water may come back upon the Egyptians, upon their chariots, and upon their horsemen.' So Moses stretched forth his hand over the sea, and the sea returned to its wonted flow. . . . The waters returned and covered the chariots and the horsemen and all the host of Pharaoh that had followed them into the sea; not so much as one of them remained. But the people of Israel walked on dry ground through the sea, the waters being a wall to them on their right hand and on their left.''

According to Walter Friedlaender's *Nicolas Poussin,* "Passage of the Red Sea" as a title is inaccurate. The painting depicts the excitement and gratuity of the Israelites after their miraculous journey, not during the tribulations of the trip itself. Countless multitudes are shown as the Israelites make a song of thanksgiving, and the women, along with Moses's sister, Miriam, dance with great joy. Some of the Israelites still carry their belongings in bundles on their heads as do peasants. Some kneel in prayer. Moses stands to the side, his arm raised. The early Christian Church interpreted the event as a symbol of Christian baptism.

Example: Nicolas Poussin, National Gallery of Victoria, Melbourne. (Friedlaender, fig. 43)

PASSION OF CHRIST. The last events of Christ's earthly life, from his entry into Jerusalem to his burial, are collectively called The Passion. The scenes most frequently illustrated are the following: The Entry into Jerusalem (Mark 11:9), Christ Washes the Feet of the Disciples (John 13:4), The Last Supper, or EUCHARIST (Matthew 26:26), The AGONY IN THE GARDEN (Matthew 26:40), The Betrayal (Mark 14:44, John 18:10), Christ before Caiaphas (*see* CHRIST BEFORE THE HIGH PRIEST) (Mark 14:53), The DENIAL OF ST. PETER (Mark 14:53), Christ before Pilate (Matthew 27:24), The FLAGELLATION (Matthew 27:26), The Mocking of Christ (Mark 15:15), ECCE HOMO (John 19:4,5), The Road to Calvary (John 19:17) and The Stations of the Cross (Christ's journey to Calvary), which comprise: (1) Jesus is condemned to death; (2) Jesus receives his cross; (3) Jesus falls the first time under his cross; (4) Jesus meets his afflicted mother; (5) Simon of Cyrene helps Jesus carry his cross; (6) Veronica wipes the face of Jesus (and produces the sudarium, or VEIL OF SAINT VERONICA); (7) Jesus falls the second time; (8) Jesus speaks to the women of Jerusalem; (9) Jesus falls the third time; (10) Jesus is stripped of his garment; (11) Jesus is nailed to the cross; (12) Jesus dies on the cross; (13) Jesus is taken down from the cross (the DEPOSITION); (14) Jesus is laid in the sepulcher. All four versions of the gospel describe the CRUCIFIXION. John mentions it in 19:23. The descent from the cross is described in John 19:40. The ENTOMBMENT OF CHRIST is described in John 10:42.

PEACE OF NIJMEGEN (*Louis XIV Resting after the Peace of Nijmegen***).** A city in the Gelderland province of the Netherlands, Nijmegen is located on the Waal River near the German border. Founded in Roman times, it is one of the oldest cities in the Netherlands. During the 8th and early 9th centuries the city flourished under Charlemagne. In 1184 it was chartered and became a free imperial city and later joined the Hanseatic League. In 1579 the city subscribed to the Union of Utrecht, which had been formed as a defensive precaution against Philip II of Spain. The treaty that ended the Dutch wars of LOUIS XIV of France was signed in Nijmegen. The first of the great wars of Louis XIV was fought 1672–1678 to end Dutch competition with French trade and to ex-

tend the king's empire. Peace was negotiated at Nijmegen in 1678. Maastricht was given to the Dutch, and a trade treaty modified the French restrictive tariffs in favor of the Dutch.

The treaty is displayed in one of the typical "empty allegorical" compositions of the period, with broken columns and *putti* (*see* PUTTO) and angels blowing long horns, the accoutrements of war pushed aside.

Example: Antoine Coypel, Musée Fabre, Montpellier. (Blunt, fig. 325)

PEGASUS. *See* FOUR MUSES WITH PEGASUS.

PENANCE. Penance is one of the seven sacraments recognized by the Roman Catholic and Eastern Churches. It consists of repentance or contrition for sin, confession to a priest, submission to penalties imposed on the confessor and absolution by a priest. Penance is also any voluntary punishment or suffering to show repentance for a sin. Jesus is usually shown with his hand in the air granting absolution. Some artists do not depict the sacrament in a strictly liturgical sphere, choosing instead a historical form that is at the same time idealized and precise.

Example: Nicolas Poussin, Collection Earl of Ellesmere, on loan to National Galleries of Scotland, Edinburgh. (Friedlaender, fig. 51)

PERIPETEIA. The peripeteia is the Aristotelian high point of a drama—that moment in a story toward which all the action has led and from which all sensation springs, the moment that now captures the viewer's full attention. It can be a point of nearly unendurable tension immediately following the climax, and it has an extraordinary theatrical effect that is parallel in its tenseness to such moments in the tragedies of Corneille. This purposely dramatic suspense, this concept of an "instant," dominates many Baroque paintings. It is a breathless moment in time just before or just as a miracle takes place—as in the Baroque versions of the CONVERSION OF ST. PAUL. Artists show those fleeting seconds when Saul, the Roman soldier, has been flung to the ground, converted, and becomes Paul, the Christian.

PERSEUS AND MEDUSA. In Greek mythology, Perseus was the son of DANAË, who had been shut up in a bronze tower by her father to keep her suitors away because it had been said that the king would be killed by his daughter's son. Jupiter (Zeus), however, descended to her tower and lay with her as a shower of golden rain. MEDUSA was one of three monstrous sisters, the snake-haired gorgons, who lived in the far west. She had the power to turn anyone who looked at her into stone. One of Perseus's most heroic accomplishment was beheading this monster. The story of Perseus and Medusa is told in Ovid's *Metamorphoses* 4:772–86. Perseus was asked to tell how he cut off the head which has snakes instead of hair. "There is a place beneath the chill slopes of Atlas, that is securely shut away behind a mass of solid rock. At the entrance

to this spot dwelt two sisters, the daughters of Phorcys, who shared the use of a single eye. Perseus had managed by his skill and cunning to get hold of that eye, by interposing his hand when it was being transferred from one sister to the other. Then, by remote and pathless ways, through rocky country thickly overgrown with rough woods, he reached the Gorgon's home. Everywhere, all through the fields and along the roadways he saw statues of men and beasts, whom the sight of the Gorgon had changed from their true selves into stone. But he himself looked at dread Medusa's form as it was reflected in the bronze of the shield which he carried on his left arm. While she and her snakes were wrapped in deep slumber, he severed her head from her shoulders.'' Perseus put the head in his magic wallet and put on his helmet of invisibility. He did so just in time, for the other two gorgons awoke, and, seeing their dead sister, they chased Perseus intending to kill him. But he was able to fly without being seen and eluded them.

Perseus may be depicted grabbing Medusa's snake-hair, about to behead her with his sword. He is shown with his head turned towards Minerva, who holds his shield for a reflection. Medusa's hideous sisters may be shown sleeping in the background. Pegasus, the winged horse, born of Medusa's blood, may also be in the background, along with his brother, Chrysaor, who was born at the same time.

Example: Claude Lorrain, The Earl of Leicester, Holkham, Norfolk. (Blunt, fig. 253)

PETER, ST. *See* CRUCIFIXION OF ST. PETER, DENIAL OF ST. PETER, LIBERATION OF ST. PETER, and MARTYRDOM OF ST. PETER.

PETRONILLA, ST. *See* BURIAL OF ST. PETRONILLA and MARTYRDOM OF ST. PETRONILLA.

PHILIP IV. *See* PORTRAIT OF PHILIP IV.

PHOCION. *See* BURIAL OF PHOCION and FUNERAL OF PHOCION.

PIETÀ. The term *Pietà*, which is Italian for "pity," also means "Lamentation," and is used to describe the scene after the CRUCIFIXION of Jesus, immediately following the DEPOSITION, or the Descent from the Cross. In a Lamentation scene Christ's body is stretched flat on the ground, having just been removed from the cross and is on an altar-like block of stone or on the ground itself. He is surrounded by mourners. In art, the *Pietà* depicts the suffering Virgin alone with the body of her son on her lap, although there is no evidence in the gospels that Mary ever held her dead son on her lap. The theme occurred first in the 12th century in Byzantine art and passed into the west in the 13th century and was used frequently during the Baroque period and after

(even by the 19th-century Romantic painter Eugène Delacroix). A great emphasis is placed upon the suffering of the Virgin Mary.

Example: Gregorio Fernández, Valladolid Museum, Spain. (Bazin, fig. 38)

PIETRE DURE. An Italian term for "hard stone," which is used in reference to a certain type of mosaic work in which colored stones are used to imitate as closely as possible the effect of painting. The stones used may include porphyry (a dark red or purplish Egyptian rock), agate (a semiprecious stone with striped or clouded coloring) and lapis lazuli (a blue, opaque, semiprecious stone). In 1588, the Grand Duke Ferdinand established a factory in Florence, which continued to produce these types of mosaics well into the 19th century. The workshop's artists produced mainly panels for cabinets and table tops decorated with flowers and birds or landscapes. One of the artisans, Baccio Cappelli, who worked between 1621 and 1670, had a landscape used as an inset in a cabinet designed by the English architect and archeologist Robert Adam (1728–1792).

PLAGUE OF ASHDOD. The first book of Samuel 5:1–9 tells how the Philistines confiscated the Israelites' sacred ark of the covenant and placed it in the temple of the Philistine god, Dagon. "When the Philistines captured the ark of God, they carried it from Ebene'zer to Ashdod; then the Philistines took the ark of God and brought it into the house of Dagon and set it up beside Dagon. And when the people of Ashdod rose early the next day, behold, Dagon had fallen face downward before the ark of the Lord, and the head of Dagon and both his hands were lying cut off upon the threshold; only the trunk of Dagon was left to him. This is why the priests of Dagon and all who enter the house of Dagon do not tread on the threshold of Dagon in Ashdod to this day. The hand of the Lord was heavy upon the people of Ashdod and he terrified and afflicted them with tumors."

The Plague of Ashdod shows the ark of the covenant and the fallen idol of Dagon, its head and arms separated from the body. A multitude of terrified, stricken, dying Philistines rush about in frenzied chaos, some dressed as patricians, others as commoners. One man holds his nose against the evil. Many are already dead.

Example: Nicolas Poussin, The Louvre, Paris. (Friedlaender, colorplate 7)

PLASTER CASTS. Plaster casts are sometimes made as duplicates of existing sculptures, or they are made from natural objects or clay models and then used as guides for sculptors. Plaster casts are made because clay figures disintegrate or crumble unless kept moist or fired. A plaster cast may later be used as a model for casting in metal (such as bronze), or it may be used by a sculptor carving in marble or some other stone. By POINTING, the artist can reproduce the model in stone. The first plaster cast was probably made by Lysistratus, a contemporary of Alexander the Great (356–323 B.C.). The Romans made many plaster casts from Greek statues, but after the fall of Rome, the use of casts

went out of favor until the Renaissance. Andrea del Verrochio (c. 1435–1488) is said to have been the first to use the plaster cast after the Romans. Also, the use of death masks began in the fifteenth century. During the 17th century in the Paris Académie des Arts, the drawing of plaster casts was a necessary part of the curriculum. When Gian Lorenzo Bernini visited the Académie in 1665, he praised the students' drawings of casts. The Paris program was used and elaborated upon in nearly all the academies of art in Europe. The Berlin Academy in 1696 is illustrated in a series of drawings, which include a scene that is entitled "drawing from plaster."

PLUTO AND PROSERPINA. Pluto was the Greek god who ruled the underworld, or Hades. The word Pluto is derived from the Greek word meaning "giver of riches" and was used of him euphemistically. Therefore his near-namesake Plutus, the god of riches, was also sometimes depicted with a crown. Proserpine (Latin Proserpina, Greek Persephone), the daughter of the corn goddess Ceres (Demeter) and Zeus, was the goddess of springtime. After being abducted by Pluto, she became queen of the underworld, Pluto's wife. Pluto had been struck by one of Cupid's arrows. Cupid had chosen from his one thousand arrows the sharpest and the surest, the "most obedient to the bow . . . and he struck Pluto to the heart." Crazed by love, Pluto took Proserpine by force to his lower kingdom. This story is told in Ovid's *Metamorphoses* 5:385–424. "Perserpine was playing, picking violets or shining lilies. With childlike eagerness, she gathered the flowers into baskets and into the folds of her gown, trying to pick more than any of her companions. Almost at one and the same time, Pluto saw her, and loved her, and bore her off—so swift is love. With wailing cries the terrified goddess called to her mother, and to her comrades, but more often to her mother. She rent and tore the upper edge of her garment, till the flowers she had gathered fell from its loosened folds: and she was so young and innocent that even this loss caused her fresh distress. Her captor urged on his chariot, called each of his horses by name, encouraging them to greater efforts, and shook his reins, dyed a dark and sombre hue, above their necks and manes. On they raced, across deep lakes and over the sulfurous pools of the Palici, that boil up, bubbling, through the earth; past the place where the Bacchiadae, a people who came originally from Corinth on its isthmus, had built their city walls between two harbours, a larger and a smaller one. Half-way between Cyane and Pisaean Arethusa there is a narrow stretch of sea, shut in by jutting headlands. Cyane herself lived there: she was the most famous of the Sicilian nymphs, and from her the pool itself took its name. She rose from the midst of her waters as far as her waist, and recognized the goddess. 'You will go no further, Pluto!' she cried. 'You cannot be the son-in-law of Ceres, if she does not wish it. You should have asked for the girl, instead of snatching her away. . . . As she spoke, she stretched out her arms on either side, to block their path. Pluto, Saturn's son, contained his wrath no longer, but urged on his grim steeds, and with his strong arm hurled his royal sceptre into the depths of the pool.

Where it struck the bottom, the ground opened up to afford a road into Tartarus, and the yawning crater received his chariot as it hurtled down.''

In art, Pluto grasps Proserpine by the waist. He is large, bearded, black-haired and usually wears a crown. Proserpine flings her arms high in anguish and usually reveals bared breasts above her torn dress. *Amoretti* (*see* AMORETTO), symbols of love, may fly overhead, leading the way. Proserpine's friends flee in terror or stand and watch her go. If the cavern is shown, its walls reflect the red flames of hell (even though, for the Greeks, Hades had no fires). Cerberus, in Greek mythology the many-headed dog, sometimes shown with a serpent's tail, guards the entrance of Hades. *See also* RAPE OF PROSERPINE.

Example: Luca Giordano, Collection Mahon, London. (Held and Posner, fig. 125)

POINTILLÉ TECHNIQUE. *Pointillé* is French for stipple drawing or engraving, or it is used to denote a dotted line. During the Baroque, the *pointillé* is different from that *pointillisme,* or pointillism, seen later during the 19th century when artists, such as Georges Seurat (1859–1891) used dots of pure pigment that were additively mixed by the eye to create a figure or a form. The *pointillé* technique, used by 17th-century artists, such as Jan Vermeer, is a process of spreading thick bright points as highlights over a dark area. The effect is an illusion of dancing, sparkling light that does not change the basic value of the form. The *pointillé* technique allows the artist to lighten passages, increase the illusion of flickering sunlight and shimmering shadows and produce a thick and grainy IMPASTO effect without subduing or overwhelming the underlying darks and shades and pales of the design. *See* CAMERA OBSCURA.

Example: Jan Vermeer, *Woman at a Window,* Rijksmuseum, Amsterdam. (Ruskin, fig. 3–22).

POINTING. Pointing is a method used by sculptors for transferring mechanically to stone the proportions of a three-dimensional model that is usually made of plaster. The basic principle of pointing is that if three points are placed in space, it is possible to locate any other point in relation to them. In order to carry out the process, the sculptor must first choose three points on a model (from which one can measure all other points easily). One point might be on the top or head of a figure, while two points could be at the base or feet of a figure. The distances between these points on the model are measured with three pairs of calipers. The measurements are transferred to stone and three marks are made on the stone where the points come. The points must be fixed so that the entire figure will be contained in the available stone. A point at the navel is chosen, and the distances between this fourth point and the first three are taken with the calipers. The calipers are then used on the block so that one end of each pair touches one of the three points. When a point is sought inside the stone, the stone is drilled or chiseled away until the points meet. At that mark another point is made. Each successive point is found by reference to the three previously established. Pointing is continued until the figure is completed. When

the sculptor desires a larger figure than the one he is copying, he must change the measurements accordingly throughout all points. Various methods have been created over the centuries for making enlargements and copies, and some mentioned by Leone Battista Alberti (1404–1472), Benvenuto Cellini (1500–1571) and Georgio Vasari (1511–1574), are still in use.

POLYPHEMUS. The adventures of Aeneas and the Trojans in their voyages in the *Aeneid* were patterned by Virgil on the account of the voyage of Odysseus in the *Odyssey* of Homer. As told in *Aeneid* 3: 817–32, one of the supernatural beings, a Cyclops or one-eyed giant, Polyphemus, leads a group of his comrades in an attack on Aeneas and his band when the Trojan ships anchor near Mount Etna. Polyphemus is the son of Poseidon. He captures Ulysses (the Greek Odysseus) and twelve of his men and, after their imprisonment in his cave, eats two of them every evening, four in all. ''The giant rears his head against the stars. . . . The innards and the dark blood of poor fellows are what he feeds on: I [Ulysses] myself looked on when he scooped up two crewmen in his hand midcave, and as he lay back smashed them down against the rockface, making the whole floor swim with spattered blood: I saw him crunch those dead men running blood and excrement, the warm flesh still a-quiver in his teeth.'' The others escape by getting him ''gorged with feasting and dead-drunk with wine'' and blinding him with a pointed stake in his one eye. 3: 842–44. ''Then with a pointed beam bored his great eye, his single eye, under his shaggy brow, big as a Greek shield or the lamp o' Phoebus.'' They slip out under the bellies of his sheep and goats when the giant lets the animals out the next morning. Polyphemus hurls rocks at the departing Greeks and cries to Poseidon for help; thus it is that Poseidon delays Ulysses's return home.

Homer described the giant's home as being on the mainland opposite an uninhabited island populated with goats. This area has been identified with one of the Aegadian islands off the west coast of Sicily (Greek *aigos* means ''goat''). Ancient tradition, however, placed Polyphemus in eastern Sicily, where there are the seven *Scogli de' Ciclopi*, the rocks which the giant, after being blinded, hurled at Ulysses's boat as he escaped. They are located near the River Acis where Polyphemus, in local legend, was rejected by the nymph Galatea.

The giant may be shown spread-eagled on his back, drunk and snoring, while Ulysses and his warriors sneak toward him carrying a sharpened stake, or he may be shown hurling rocks. Some artists show him as a monstrous giant hurling a monstrous boulder at the fleeing Acis. *See also* ACIS AND GALATEA and LANDSCAPE WITH POLYPHEMUS.

Example: Annibale Carracci, Farnese Gallery, Rome. (Wittkower, figs. 18 and 19)

POPE CLEMENT IX. Born in Pistoia, Italy, January 28, 1600, Giulio Rospigliosi (Clement IX) died in Rome, December 9, 1669. He was pope from 1667 to 1669. From 1644 until 1652 he served as papal ambassador to Spain. He did

not get along with LOUIS XIV of France because the French king meant to free his country of any religious divergence he perceived as a threat to the unity of his kingdom. An intellectual, Clement wrote several libretti (books containing the text of an opera) and gained fame through his dramas and religious themes. Besides this he wrote poetry. He is credited with inventing comic opera as an individual form. His *Chi soffre speri* ("He who suffers"), the first comic opera, premiered in Rome on February 27, 1639. Maratta's contemporary portrait shows Clement IX wearing the robes of his office and as a scholar with book in hand, eyes alert, and body straight yet relaxed.

Example: Carlo Maratta, Vatican Gallery, Rome. (Waterhouse, fig. 68)

POPE NICHOLAS V BEFORE THE BODY OF ST. FRANCIS. Nicholas V (1397–1455) was pope from 1447 until his death. He was an Italian named Tommaso Parentucelli born probably in Sarzana Liguria, a region in northwest Italy that borders France on the west. He succeeded Eugene IV from whom he inherited the antipapal enactments of the Council of Basel (1431–1449). This council is the first part of the 17th ecumenical council in the Roman Catholic Church that fell into heresy in 1437; after that it became a contest between council and pope for supremacy and is regarded as an anticouncil. Nicholas gained the Concordat of Vienna by a conciliatory policy in 1448 with the Holy Roman emperor Frederick III. This repaired a lot of the damage done to papal authority, and the following year the council and the antipope, Felix V, submitted to Nicholas. A jubilee in 1450 marked the end of the schism. Known for piety and learning, Nicholas founded the Vatican Library and established the papacy as a patron of the humanities.

In the portrait below, the pope is shown on his knees before St. Francis, who stands with hands folded looking toward heaven. The saint's stigmata (wounds resembling the crucifixion wounds of Christ) are clearly visible in his hands, and a nail can be seen in his foot.

Example: Laurent de La Hyre, The Louvre, Paris. (Blunt, fig. 205)

PORTRAIT GLORIEUX. A portrait of a general, financier, king, minister or anyone whose features were painted or sculpted and glorified for the sake of history. The sitter was always shown in dramatic action with movement of the clothes, the head, or the wig, and every detail was designed to enhance the noble and inspired quality of his spirit. Gian Lorenzo Bernini was the creator of the *portrait glorieux,* and his bust of LOUIS XIV, commissioned by Louis in 1665, had a decisive influence over this type of portrait work in France. (Hibbard, fig. 87)

PORTRAIT OF PHILIP IV (*Fraga Philip*). Philip IV (1605–1665) was king of Spain, Sicily and Naples from 1621 until his death. As Philip III, he was king of Portugal from 1621 until 1640. Although known for his intelligence, Philip lacked enthusiasm and those qualities necessary for rule; thus affairs of

state until 1643 were handled by the Conde de Olivares. It was during this time that Spain continued to decline economically and politically. Spain was involved in the Thirty Years War (1618–1648); and tension increased when, in 1621, war was resumed in the Netherlands, and battles began in 1622 with France over the Valtellina question. Even after the Treaty of Westphalia, which ended the Thirty Years War in 1648, the war with France continued and was complicated by Spanish intervention in the French Fronde. The affair ended in 1659 with the humiliation of Spain. During this time, Portugal revolted and chose John IV as king. Catalonia rebelled and was occupied by the French. Spain had to recognize the independence of the United Provinces of the Netherlands at Westphalia and also lost part of the Spanish Netherlands and Roussilon to France at the Peace of the Pyrenees. Marie Thérèse, Philip's daughter, married LOUIS XIV of France.

Because of Diego Velázquez, his court painter, Philip IV was probably one of the most frequently painted monarchs in history. Some critics believe, however, that Velázquez's portraits of Philip IV are not faithful to appearance. It is known that at the beginning of his career the painter evolved a refined formula for the royal physiognomy. The portrait known as the *Fraga Philip* is so called because it was painted in the city of Fraga in Aragon where Velázquez had accompanied the king in 1644 on a military campaign. Philip is shown in red and silver campaign dress. The artist does not beautify the long Hapsburg face; rather he ennobles it and manages to paint an image of a commanding, superior king.

Example: Diego Velázquez, The Frick Collection, New York. (Brown, pp. 13–15)

PORTRAIT OF THE ROYAL FAMILY. *See* LAS MENINAS; also called *The Maids of Honor.*

PORUS. *See* DEFEAT OF PORUS BY ALEXANDER.

POTTERY. The making of pottery is the molding and baking of clay objects. It is among the oldest and most widely utilized crafts. Neolithic potters made not only functional wares, but pots with painted or simple incised decoration. During the Baroque, potters at Delft, Holland, were influenced by Chinese blue-and-white porcelain. They produced a thinner, more whitely glazed pot painted in blue only; and this Delft style, in which artists mixed the newly imported Chinese shapes and ornaments with their own, became popular and influential throughout Europe until the end of the 17th century. In Germany and France, a strong preference for polychrome painted subjects that were typically Baroque dominated. This style was described by GIOVANNI PIETRO BELLORI, the 17th-century Italian antiquarian, biographer and collector, in his description of a fresco by the Italian painter Giovanni Lanfranco, one of the founders of the Baroque style of painting, in the Roman church of S. Andrea della Valle: "This painting has been rightly likened to a full choir, when all the voices together

make up the harmony; for then no particular voice is distinguished, but what is pleasing is the blending, and the overall measure and substance of the singing.'' *See* FAIENCE.

POUSSINISTES. Those painters who, after the manner of the French 17th-century painter Nicolas Poussin, adhered to the doctrine that form, rather than color, was the primary ingredient for a composition. Painters who held the opposite philosophy were known as RUBÉNISTES (after Peter Paul Rubens) and adhered to the doctrine that color, rather than form, was the most important element in a painting.

PRESENTATION. *See* PRESENTATION IN THE TEMPLE.

PRESENTATION IN THE TEMPLE. The Presentation of the infant Jesus by Mary and Joseph to the Temple in Jerusalem to be ''consecrated to the Lord'' is told in Luke 2: 22–25. Mosaic law required that the firstborn of all living things be sacrificed to God, but children could be redeemed by their parents, who had to pay five shekels (Numbers 18: 15–17). This ceremony commemorated the slaying of the firstborn in Egypt when the Jews were spared (Exodus 13: 11–15). The early Church adopted it as a Christian feast. The earliest feasts of the Purification involved a long procession of candles; thus its name, Candlemas. According to Luke, ''When the time came for their purification according to the law of Moses, they brought him [Jesus] up to Jerusalem to present him to the Lord (as it is written in the law of the Lord, 'Every male that opens the womb shall be called holy to the Lord') and to offer a sacrifice according to what is said in the law of the Lord, 'a pair of turtledoves or two young pigeons.' . . . Inspired by the Spirit he [Simeon] came to the temple; and when the parents brought in the child Jesus, to do for him according to the custom of the law, he took him up in his arms and blessed God and said, 'Lord, now lettest thou thy servant depart in peace, according to thy word; for mine eyes have seen thy salvation.' ''

Saint Simeon is sometimes identified with the high priest of the Temple. In art he wears priest's vestments and sometimes has a saint's halo. (The apocryphal Book of James, or Protevangelium, says Simeon had succeeded to the office on the death of the high priest Zacharias.) Mary may hold the infant out toward him, or he may be in the process of handing the child back to her. The doves, in allusion to the theme of the Purification, are held by a female attendant or by Joseph. According to the GOLDEN LEGEND, doves were offered by the poor and young lambs were offered by the rich. Some artists show Joseph counting out the five shekels or simply reaching for his purse. Mary's mother, Anna (mentioned in Luke 2: 36 as being ''of a great age''), as the prophetess may also be included with her right hand raised and her finger pointing, the gesture of prophecy. The acolytes or sometimes the main figures usually carry candles in reference to Candlemas.

Example: Rembrandt van Rijn, Mauritshuis, The Hague. (Rosenberg, Slive, ter Kuile, fig. 51)

PRESENTATION OF THE VIRGIN. The GOLDEN LEGEND tells the story of the childhood of the Virgin Mary and her Presentation at age three in the Temple. Her mother, Anna, and her father, Joachim, brought her to the Temple with offerings, as was the custom. At the Temple, after the fifteen psalms of degrees, there were fifteen steps to ascend, because the Temple was set on a high podium. When the child Mary was placed on the lowest step, she ascended without any help, and when the offering had been made, Anna and Joachim left their daughter in the Temple with the other virgins. Mary lived in the Temple with the other virgins from that day until she was fourteen years old, and she made a vow to preserve her chastity, unless God otherwise disposed.

Artists usually show Mary as a child climbing the steps of the Temple (not always fifteen steps, sometimes only three or four). The high priest Zacharias may be shown waiting for her at the top. Usually she appears to be older than three or is simply depicted as a small adult. Her parents stand at the bottom of the stairs, and a number of people follow or (though not mentioned in the text) help her up the stairs. Other artists depict Mary kneeling before the priest with angels overhead who may swing censers. The theme depicts more than the carrying out of the requirements of Jewish Law; it was also meant to be a symbol of Mary's consecration as the "chosen vessel" of Christ's Incarnation (appearance in human form). The fifteen "psalms of degrees" are numbers 120 to 134. "I lift up my eyes to the hills. From whence does my help come? My help comes from the Lord." This is an example of the "Songs of Ascents," or "Gradual Psalms," that is, those that were sung or recited during the journey to Jerusalem on the occasion of the great pilgrim feasts. Also, the psalms were chanted on the fifteen steps that, according to Josephus, separated the men's court from the women's at the Temple.

Example: Eustache Le Sueur, The Hermitage, St. Petersburg. (Blunt, fig. 257)

PROCESSION OF ST. CARLO BORROMEO. This painting represents Saint CHARLES BORROMEO carrying the reliquary of the Holy Nail among the plague-stricken. Carrying torches, they bow down before him. A woman offers her sick child.

Example: Pietro da Cortona, S. Carlo ai Catinari, Rome. (Held and Posner, fig. 110)

PRODIGAL SON. *See* RETURN OF THE PRODIGAL SON.

PROPHETS. The four major prophets that appear frequently in art are Ezekiel, Isaiah, Jeremiah and, later, Daniel. They are representatives of the old law and the deliverers of God's message and a prefiguration of the FOUR EVANGEL-ISTS. They usually hold a scroll with a verse from their prophetic writings or their name or a phylactery (a small leather case inscribed with scripture pas-

sages). Isolated depictions of the prophets appeared early in Christian art, and book illustrations sometimes showed scenes from the lives of the prophets. From the 15th century, the prophets were sometimes shown with the sibyls (women consulted as oracles or prophetesses by the ancient Greeks and Romans).

Isaiah is particularly important in art because of two famous prophecies: *"Ecce virgo concipiet et pariet filium,"* "A young woman is with child and she will bear a son" (which sometimes appears as an inscription on his scroll when Isaiah is shown in an ANNUNCIATION), and "A shoot shall grow from the stock of Jesse." Isaiah usually holds a scroll or a book.

Jeremiah taught that the Hebrews would find spiritual salvation only through suffering and oppression, and it was this view that led to his death in Egypt by stoning. He is traditionally the author of the book of Lamentations from which come two inscriptions, *"O vos omnes qui transitis per viam,"* "Is it of no concern to you who pass by?" and *"Spiritus oris nostri, Christus Dominus, captus est in peccatis nostris?"* "The Lord's anointed, the breath of life to us, was caught in their machinations." Lamentations is a commiseration over the devastation in 586 B.C. of Jerusalem at the hands of the Chaldeans. Rembrandt shows Jeremiah in deep sorrow while the city burns in the background (Rijksmuseum, Amsterdam). Jeremiah, too, usually holds a book or a scroll.

Daniel's story is told in the Book of Daniel, which is partly apocalyptic prophecy and partly legendary history. It tells how Daniel reached a position of influence in the Babylonian court because of his skill in interpreting dreams. Daniel is a personification of Justice. The scene of Daniel in the lions' den, Daniel chapter 6 and Apocryphal Additions to Daniel vv. 23–42, popular in early Christian art, is rare in the Renaissance, but recurs during the Baroque. After Daniel was put in with the lions, the prophet Habakkuk was told by an angel, traditionally Michael, of the danger Daniel faced. The angel told Habakkuk to take food and, lifting him by the hair, took him to the lions' den. Because of this Daniel believed that God had not forsaken him. When the king returned after seven days, and found Daniel unharmed, he was convinced of the power of the Jewish god. The courtiers who had plotted against Daniel were themselves put in with the lions and eaten immediately. Daniel is usually shown seated or standing in a sunken pit or courtyard and is surrounded by lions. Habakkuk may be accompanied by an angel while he brings food and water.

Ezekiel was one of the Hebrews exiled to Babylon in 579 B.C. Here, beside the River Kebar, he had apocalyptic visions. His call to prophesy reached him through a vision of God on a throne among four creatures that had the faces of a lion, man, eagle and ox. All four had wings—the "apocalyptic beasts" that recur in the book of Revelation and that the medieval Church turned into the symbols of the FOUR EVANGELISTS. His inscriptions are (44:2) *"Porta haec clausa erit; non aperietur,"* "This gate shall be kept shut; it must not be opened," and (36:26) *"Et dabo vobis cor novum,"* "I will give you a new heart and put a new spirit within you." Ezekiel is shown as old. He has a long

white beard and sometimes carries a double wheel symbolizing the Old and New Testaments.

PROSERPINE. *See* PLUTO AND PROSERPINA.

PSYCHE. *See* CUPID AND PSYCHE.

PUNISHMENT OF MIDAS. In Greek legend, Midas was a king of Phrygia. His story is told in Ovid's *Metamorphoses* 11:154–81. "Pan was boasting to the gentle nymphs, singing them his songs, and playing some trivial tune on the reeds, joined by wax, that formed his pipes. As he did so, he had the audacity to speak slightingly of Apollo's music, compared to his own, and entered into unequal competition with the god, in a contest to be decided by Tmolus. The elderly judge . . . looked at the god of the flocks and said: 'The judge is ready.' Pan struck up an air on his rustic pipes and, with his wild strains, charmed Midas, who happened to be near at hand when he was playing. After hearing Pan, Tmolus swung round his head to face Phoebus, and as his gaze moved round, his forests followed. Apollo had wreathed his golden hair with laurel from Parnassus. . . . His very stance was that of a musician. Then he plucked the strings with skillful fingers till Tmolus, enchanted by the sweetness of the melody, bade Pan admit his pipes inferior to the lyre. Everyone else agreed with the verdict of the venerable mountain, but not Midas. He objected to the decision, declaring it to be unjust. The Delian god would not allow ears so foolish to retain their human shape; he lengthened them, filled them with bristling gray hairs, and made them movable, at the point where they joined the king's head, so that they could twitch. The rest of Midas' shape remained human, for he was condemned to lose only this one part: but he was made to assume the ears of a lumbering ass."

Midas is shown pointing to the indignant Apollo and appears to be calling him an ass, as great ears sprout from his head on each side of his crown. Behind Midas the mountains and trees seem to echo the amusing and absurd transformation. *See also* MIDAS AND BACCHUS.

Example: Domenico Zampieri Domenichino. National Gallery, London. (Held and Posner, colorplate 8)

PURIFICATION. *See* PRESENTATION IN THE TEMPLE.

PUTTO. Plural is *putti*. A young, usually naked, child used in Italian painting and sculpture.

PYRAMUS. *See* LANDSCAPE WITH PYRAMUS AND THISBE.

Q

QUADRATURA. A kind of illusionism created by a *quadraturista,* also known as *quadrature,* in which sculptural and architectural impressions are painted on ceilings to create the illusion of a room's pilasters or columns, figures and arches being extended to unrealistic heights.

Example: Fra Andrea Pozzo, *The Glorification of St. Ignatius,* Ceiling fresco in the nave of Sant' Ignazio, Rome. (Bazin, fig. 25)

QUADRO RIPORTATO. Italian for ''carried picture.'' A term used to indicate easel paintings seen in normal scientific linear one-point perspective, which have been simulated as a wall painting into a ceiling design. Painted scenes are arranged as actual paintings with painted frames that appear to be framed pictures on the surface of a curved, usually shallow vault.

Example: Annibale Carracci, Ceiling fresco detail in the Palazzo Farnese, Rome. (Held and Posner, colorplate 5)

R

RAISING OF LAZARUS. The story of the raising of Lazarus, the brother of MARY MAGDALENE and Martha, is told in John 11:1–44. When Lazarus lay dying at Bethany, word was sent to Jesus so that he might help. According to John, ''when Jesus came, he found that Lazarus had already been in the tomb four days. Bethany was near Jerusalem, about two miles off, and many of the Jews had come to Martha and Mary to console them concerning their brother. When Martha heard that Jesus was coming, she went and met him, while Mary sat in the house. Martha said to Jesus, 'Lord, if you had been here, my brother would not have died. And even now I know that whatever you ask from God, God will give you.' Jesus said to her, 'Your brother will rise again.' Martha said to him, 'I know that he will rise again in the resurrection on the last day.' Jesus said to her, 'I am the resurrection and the life; he who believes in me, though he die, yet shall he live, and whoever lives and believes in me shall never die. Do you believe this?' She said to him, 'Yes Lord; I believe that you are the Christ, the Son of God, he who is coming into the world' . . . and he [Jesus] said, 'Where have you laid him?' They said to him, 'Lord, come and see.' Jesus wept. So the Jews said, 'See how he loved him!' But some of them said, 'Could not he who opened the eyes of the blind man have kept this man from dying?' Then Jesus, deeply moved again, came to the tomb; it was a cave, and a stone lay upon it. Jesus said, 'Take away the stone.' Martha, the sister of the dead man, said to him, 'Lord, by this time there will be an odor, for he has been dead four days.' Jesus said to her, 'Did I not tell you that if you would believe you would see the glory of God?' So they took away the stone. And Jesus lifted up his eyes and said, 'Father, I thank thee that thou hast heard me. I knew that thou hearest me always, but I have said this on account of the people standing by, that they may believe that thou didst send me.' When he said this, he cried with a loud voice, 'Lazarus, come out.' The dead man came

out, his hands and feet bound with bandages, and his face wrapped with a cloth. Jesus said to them, 'Unbind him, and let him go.' "

Mary and Martha are shown weeping over their brother after he has been brought from the tomb. Bodies were entombed upright in ancient Jewish funeral rites, as confirmed by John's text. Jesus points to the stiff dead man, still in the standing position, and brings him back to life. The topic is a kind of resurrection and is featured in religious art from the earliest times.

Example: Caravaggio, Museo Nazionale, Messina. (Bottari, figs. 70–72)

RAPE OF EUROPA. In Greek mythology, Europa was the beautiful daughter of Agenor, the king of Tyre. Her story is told by Ovid in his *Metamorphoses* 2:836–75. She was raped by Jupiter (Zeus) who had "adopted the guise of a bull; and, mingling with the other bullocks, joined in their lowing and ambled in the tender grass, a fair sight to see. His hide was white as untrodden snow, snow not yet melted by the rainy South wind. The muscles stood out on his neck, and deep folds of skin hung along his lanks. . . . Agenor's daughter [Europa] was filled with admiration for one so handsome and so friendly. But, gentle though he seemed, she was afraid at first to touch him; then she went closer, and held out flowers to his shining lips. The lover was delighted and, until he could achieve his hoped-for pleasure, kissed her hands. He could scarcely wait for the rest, only with great difficulty did he restrain himself. . . . Gradually the princess lost her fear, and with her innocent hands she stroked his breast when he offered it for her caress, and hung fresh garlands on his horns: till finally she even ventured to mount the bull, little knowing on whose back she was resting. Then the god drew away from the shore by easy stages, first planting the hooves that were part of his disguise in the surf at the water's edge, and then proceeding farther out to sea, till he bore his booty away over the wide stretches of mid ocean. The girl was sorely frightened, and looked back at the sands behind her, from which she had been carried away. Her right hand grasped the bull's horn, the other rested on his back, and her fluttering garments floated in the breeze." Jupiter took her to Crete where he ravished her.

Europa may be depicted sitting upon the bull's back, her attendants surrounding her, placing the flower garland around his horns. Some artists show the bull plunging through the water, Europa desperately holding his horn while her friends stand stunned and astonished on the distant shore.

Example: Nicolas Poussin, Drawing, National Museum, Stockholm. (Friedlaender, fig. 85)

RAPE OF GANYMEDE. The story of Ganymede, a shepherd, the son of Tros, a legendary king of Troy, is told by Ovid in his *Metamorphoses* 10:152–61. It seems Ganymede's beauty was so astonishing that Jupiter (Zeus) fell in love with him. "The king of the gods was once fired with love for Phrygian Ganymede, and when that happened Jupiter found another shape preferable to his own. Wishing to turn himself into a bird, he none the less scorned to change

into any save that which can carry his thunderbolts. Then without delay, beating the air on borrowed pinions, he snatched away the shepherd of Ilium, who even now mixes the wine cups, and supplies Jove with nectar, to the annoyance of Juno.'' The god transformed himself into an eagle and took Ganymede to Olympus where he made him his cup-bearer. The story was a favorite in ancient Greece because it seemed to illustrate religious validation for homosexual love.

Ganymede is usually shown as a young boy caught in the eagle's talons. He is pulled into the heavens by the bird's powerful talons and wings. The young man may hold a small wine bottle in anticipation of his heavenly role. Rembrandt's version shows a young child caught in the eagle's talons and is in such utter horror that he urinates from the heavens.

Example: Rembrandt van Rijn, Staatliche Kunstsammlungen, Alte Meister, Dresden. (Copplestone, fig. 41)

RAPE OF LUCRETIA. In the legendary history of Rome, Lucretia, the wife of Tarquinius Collatinus, a nobleman, was raped by Sextus, the son of Tarquinius Superbus or Tarquin the Proud. According to Livy, 1:57–59, it was at a supper in which Sextus Tarquinius was a guest that he saw Lucretia's beauty and decided that he must have her. ''A few days later Sextus, without Collatinus's knowledge, returned with one companion to Collatia, where he was hospitably welcomed in Lucretia's house, and, after supper, escorted, like the honoured visitor he was thought to be, to the guest-chamber. Here he waited till the house was asleep, and then, when all was quiet, he drew his sword and made his way to Lucretia's room determined to rape her. She was asleep. Laying his left hand on her breast, 'Lucretia,' he whispered, 'not a sound! I am Sextus Tarquinius. I am armed—if you utter a word, I will kill you.' Lucretia opened her eyes in terror; death was imminent, no help at hand. Sextus urged his love, begged her to submit, pleaded, threatened, used every weapon that might conquer a woman's heart. But all in vain; not even the fear of death could bend her will. 'If death will not move you,' Sextus cried, 'dishonour shall. I will kill you first, then cut the throat of a slave and lay his naked body by your side. Will they not believe that you have been caught in adultery with a servant— and paid the price?' Even the most resolute chastity could not have stood against this dreadful threat. Lucretia yielded. Sextus enjoyed her, and rode away, proud of his success.'' Lucretia summoned her father and her husband by letter and when they returned she told them everything and, after making them swear revenge, plunged a knife into her breast. The incident resulted in a popular rebellion led by Junius Brutus, the nephew of Tarquin, against the Tarquins. Tarquin and his family were expelled from Rome as a result. Most scholars agree that the story of Lucretia arose from popular poetry, independent of Greek influence; her father Lucretius was invented by Roman analysts who expanded the legend.

Artists show Lucretia's bed chamber, sometimes in a state of disarray as if after a struggle. Beautiful and innocent, she is naked on her bed, and Sextus

may stand in front of her with a dagger or sword. A servant may stand in shadows holding a candle. Lucretia may be shown holding her sword, contemplating her suicide, or she may be shown after she has killed herself.

Example: Rembrandt van Rijn, Minneapolis Institute of Arts. (Held and Posner, fig. 273)

RAPE OF PROSERPINE. The story of Proserpine (Latin Proserpina, Greek Persephone), the daughter of the corn goddess Ceres, is told by Ovid in his *Metamorphoses* 5:385–424. "Cupid opened his quiver and, at his mother's wish, selected one of his thousand arrows, the sharpest and surest, and most obedient to the bow. Then, bending his pliant bow against his knee, he struck Pluto to the heart with the barbed shaft. . . . Pluto saw her [Persipine], and loved her, and bore her off." The myth tells how Pluto carried Proserpine down to his kingdom below and also of Ceres's long wanderings in search of her daughter, carrying a flaming torch. It tells of Proserpine's return to earth each spring for one third of the year.

Pluto is usually shown standing in his chariot with his left arm holding Proserpine tightly by the waist. His right hand guides his black horses. He is bearded, has black hair and may wear a crown. Proserpine throws her arms in despair. Symbols of love, *amoretti* (*see* AMORETTO) flutter about and may even ride the horses or prepare to shoot more arrows. Proserpine's friends stand transfixed in terror as they see her leave. *See also* PLUTO AND PROSERPINA.

Example: Charles de la Fosse, École des Beaux-Arts, Paris. (Blunt, fig. 318)

RAPE OF THE DAUGHTERS OF LEUCIPPUS. The daughters of Leucippus were raped by a set of twins, Castor and Pollux (Greek Polydeuces), often called the Dioscuri or Sons of Zeus (Jupiter). Castor and Pollux are twin brothers of Helen and sons of Leda, wife of Tyndareus, king of Sparta. They are also referred to as Castores. Some legends say they hatched from an egg after Zeus lay with Leda in the shape of a swan. Other legends say they are the sons of Tyndareus, or that Polydeuces comes from the egg and Castor is fathered by Tyndareus. Their final exploit on earth was the carrying off of the two daughters of Leucippus, the Leucippides, Phoebe and Hilaeira. Leucippus was a king of Messenia whose daughters were stolen by the twins. They were chased by the nephews of Leucippus, Idas and Lynceus, and Castor and both pursuers were killed in a battle to rescue them because the two women were betrothed to another set of twins, cousins of Castor and Pollux. Some legends say the two maidens were carried away and had sons by Castor and Pollux.

Artists usually show two armed warriors on magnificent gleaming horses in the act of seizing two beautiful, naked maidens, who offer small resistance.

Example: Peter Paul Rubens, Alte Pinakothek, Munich. (Wedgewood, pp. 158, 160–61)

RAPE OF THE SABINES (*Rape of the Sabine Women*). The Sabines were ancient people of central Italy, living mainly in the Sabine Hills, northeast of

Rome. From the first days of its founding, there was a Sabine influence in Rome. Many Roman religious practices are believed to have Sabine origins, for example. Rome was involved in several wars with the inland Sabines. Horatius is said to have defeated them in the 5th century B.C., and Marcus Curius Denatus finally conquered them in 290 B.C. The Sabines, however, did not became Roman citizens until 268. The story of the rape of the Sabine women to supply wives for the womanless followers of Romulus (the founder of Rome) is a legend explaining this fact. The population of the newly founded city of Rome consisted only of soldiers, outlaws and vagabonds from other towns. There were no women. If a new community were to be created, women of childbearing age were a necessity. The isolated villages about Rome refused to give their young women to the Romans in marriage. The story of the rape of the Sabine women is told in Livy's *Early History of Rome* 1:9. Romulus decided to resort to a subterfuge. He planned to invite the men, women and children of the neighboring settlements, including the Sabines, to a *consualia,* a solemn festival consisting of sacrifices, sports and amusements in honor of a newly discovered sanctuary of Neptune, patron of the horse. ''On the appointed day crowds flocked to Rome, partly, no doubt, out of sheer curiosity to see the new town. The majority were from the neighboring settlements of Caenia, Crustumium, and Antemnae, but all the Sabines were there too, with their wives and children. Many houses offered hospitable entertainment to the visitors; they were invited to inspect the fortifications, layout, and numerous buildings of the town.'' They were all amazed at the rapid growth and changes they encountered. When the festivities began, not one of them could look at anything else.

The Romans seized the opportunity, and, at a predetermined signal, Romulus's men attacked the crowd and carried away the young women. The young girls taken belonged to whoever captured them first, but a few especially beautiful ones had been noted earlier and designated for important senators. These women were taken to their homes by special soldiers. One young woman of much greater beauty than the rest was captured by a group of men belonging to the household of the Roman Thalassius. In answer to the many questions about where she would be taken, the men, in order to keep anyone else from seizing her, told them Thalassius's. The men and their families were allowed to leave unharmed.

Later the women became reconciled to their fate and acted as peacemakers between the Sabine armies and the warring Romans. According to Plutarch, ''they had taken no married women, save one.'' He also says ''they did not commit this rape wantonly, but with a design purely of forming alliance with their neighbours by the greatest and surest bonds.'' The story served thereafter to exemplify the much-admired power, resolution and patriotism in the days of early Rome that permitted any act, even an uncivilized or inhumane one, which would assure the future of Rome. Plutarch says the origin of the custom of carrying a bride across the threshold of her husband's house can be traced to the Sabines.

Romulus is shown standing on the steps of the temple of Neptune, elevated above the scene, raising his mantle with a sharp movement, giving the signal for attack. He may wear a ceremonial garment and seem to be ready to perform a solemn religious act. A throng of soldiers, some on foot, some on horseback, take the protesting women. The setting is a public square or the forum of a large city. Women are struggling against the men who carry them away. Babies cry. Old women wail, terrified.

Example: Nicolas Poussin, The Metropolitan Museum of Art, New York. (Friedlaender, colorplate 24)

REALM OF FLORA (Realm or *Garden of Flowers*, or *Giardino dei fioti*). In the fifth book of Ovid's *Fasti,* FLORA gives an account of her garden "fanned by the breeze and watered by a spring of running water." This enchanting garden was a gift from her husband, Zephyrus, who "filled it with noble flowers" (most of which were metamorphosed personages) and told her, " 'Goddess, be Queen of Flowers.' " The garden is enclosed on two sides of a long, arched and open trellis. A HERM of Priapus, the god of the garden shown on the left, is taken from an engraving of the Fontainebleau School (16th-century school in France started by Francis I, 1494–1547). Water to refresh the flowers flows from a high rock. Flora, in a green chiton (Greek tunic worn by men and women), dances in the center of her garden distributing flowers and surrounded by *putti* (*see* PUTTO).

Ajax, the dying figure on the left, out of his mind and naked except for his helmet, throws himself on his sword. This tale is taken from Ovid's *Metamorphoses* 13:386–99. "Grief and rage conquered the unconquered Ajax. He snatched out his sword, and cried: 'This, at any rate, is mine! Or does Ulysses demand to have it too? This is what I need, to use it on myself. The blade so often steeped in Trojan blood will now stream with its master's own, that none may conquer Ajax save himself!' So he spoke and, where there was a vulnerable spot, buried the deadly sword in his breast, till then unwounded. His hands had not the strength to pull away the weapon he had implanted: blood itself forced out the sword. Then the earth, crimsoned with his gore, produced from the green turf that purple flower which had previously sprung up from Hyacinthus's blood. In the heart of its petals letters are traced, which apply to the boy and the hero alike, for they record the sound of the hero's name, and of the boy's cry of distress."

Directly to the right of Ajax, Narcissus is mesmerized by his own image mirrored in the water of an urn held for him by a naiad (nymph of springs and fountains), although not necessarily Echo. His death had been predicted at birth, as told in Ovid's *Metamorphoses* 3:344. "When the prophetic seer was asked whether this boy would live to a ripe old age, he replied: 'Yes, if he does not come to know himself.' "

In back of Narcissus, Clytie raises her face to the sky to watch her lover, Apollo, who soars through the sky in his golden chariot, oblivious of her pining.

Apollo had changed her into the heliotrope, as described in *Metamorphoses* 4: 265–72: "She never stirred from the ground: all she did was to gaze on the face of the sungod, as he journeyed on, and turn her own face to follow him. Her limbs, they say, became rooted to the earth, and a wan pallor spread over part of her complexion, as she changed into a bloodless plant: but in part her rosy flush remained, and a flower like a violet grew over her face. Though held fast by its roots, this flower still turns to the sun, and although Clytie's form is altered, her love remains."

On the right side is Hyacinthus, raising his hand to the dreadful wound in his head, a wound he received while sporting with Apollo as described in *Metamorphoses* 10:173–84: "One day, when the sun was halfway between the night that was over and the night that was to come, equally far from both, the god and the boy stripped off their garments, rubbed their bodies, till they gleamed, with rich olive oil, and began to compete with one another in throwing the broad discus. Phoebus threw first: he poised the discuss, then flung it through the air. Its weight scattered the clouds in its path and then, after a long time, it fell back again to its natural element, the earth. It was a throw which showed skill and strength combined. Immediately the young Spartan, in his eagerness for the game, ran forward without stopping to think, in a hurry to pick up the discus, but it bounced back off the hard ground, and rose into the air, striking him full in the face."

Next to Hyacinthus is the hunter Adonis, with his spear and hunting dogs. He points to his thigh, which was gored by a boar as described in the *Metamorphoses* 10:714–22: "By chance, his [Adonis's] hounds came upon a well-marked trail and, following the scent, roused a wild boar from its lair. As it was about to emerge from the woods, the young grandson of Cinyras pierced its side with a slanting blow. Immediately the fierce boar dislodged the bloodstained spear, with the help of its crooked snout, and then pursued the panic-stricken huntsman, as he was making for safety. It sank its teeth deep in his groin, bringing him down, mortally wounded, on the yellow sand."

In the right corner are Crocus and the shepherdess Smilax, who were metamorphosed into the crocus and the yew tree because of the impatience of their love, as told in the *Metamorphoses* 4:283: "There is the tale of Crocus and Smilax, both of whom were changed into tiny flowers."

Example: Nicolas Poussin, Gallery, Dresden. (Friedlaender, colorplate 17)

REBECCA AND ELIEZER AT THE WELL (*Rebecca at the Well*). The story of Rebecca and Eliezer is told in Genesis 24. The patriarch Abraham, desiring to find a wife for his son Isaac, sent his trusted and most faithful servant, Eliezer, to look for a suitable woman among his own kindred in Mesopotamia, rather than among the people of Canaan where he lived. When Eliezer finally reached the city of Nahor in Chaldea, he prayed to God for help and asked that the maiden who gave him and his camels water at the well would be revealed to him by God to be the woman who would be right as a wife for Isaac: " 'Let

her be the one whom thou hast appointed for thy servant Isaac.' '' Before he had finished speaking, a woman named Rebecca came to the well with her water jar. ''The maiden was very fair to look upon, a virgin, whom no man had known. She went down to the spring, and filled her jar. . . . Then the servant ran to meet her and said, 'Pray give me a little water to drink from your jar.' '' And when she had done this Rebecca said, '' 'I will draw for your camels also, until they have done drinking.' ''

Eliezer is shown at the moment at which he reveals himself to the maiden that she has fulfilled his sign and will become the wife of the son of the Israelites' patriarch. She lifts her skirt slightly in modesty and, with her right hand, points to herself. Other women fill their jars and watch as Eliezer speaks to Rebecca. *See also* MARRIAGE OF ISAAC AND REBECCA.

Example: Nicolas Poussin, The Louvre, Paris. (Friedlaender, colorplate 31)

RECONCILIATION OF DAVID AND ABSALOM. The story of David and Absalom is told in II Samuel chapters 13–19. Absalom, one of David's sons, had a sister named Tamar. Another of David's sons, Amnon, her half-brother, raped her. David would not punish his son, and for two years Absalom secretly seethed with the determination to avenge his sister. One day he invited Amnon to a sheep-shearing and had him killed as he ate in his tent. Absalom went to live with another tribe while David grieved the death of a son. But David also loved Absalom and yearned for him, and so in time they were reconciled. Absalom, though, was determined to seize power from his father and assembled an army among the tribes for an uprising. David's men defeated him and he was killed. ''And Absalom chanced to meet the servants of David. Absalom was riding upon his mule and the mule went under the thick branches of a great oak, and his head caught fast in the oak, and he was left hanging between heaven and earth, while the mule that was under him went on. . . . And he [Joab] took three darts in his hand, and thrust them into the heart of Absalom, while he was still alive in the oak. And ten young men, Joab's armor-bearers, surrounded Absalom and struck him, and killed him.''

David, who dearly loved his son Absalom, is shown during the moment when rebellious young Absalom is forgiven by his father. David has his arms about the weeping young man, and Absalom cries on the breast of the king, who maintains his dignified attitude and embraces his beloved son with a tender fatherliness. The two stand steeped in a second of silent, intense emotion.

Example: Rembrandt van Rijn, The Hermitage, St. Petersburg. (Rosenberg, Slive, ter Kuile, fig. 72)

REGULUS. *See* DEATH OF REGULUS.

RELIEF. The word ''relief'' is used to indicate a type of sculpture in which the objects stand out from a flat or curved surface. The word is taken from the Italian *rilievo,* which in turn is from *rilievare,* meaning ''to raise.'' The term

"high relief," or *alto rilievo,* is used when the scale of projection is half or more than half of the figure, although the term is often applied to architectural sculpture carved fully in the round, yet attached to the architectural background. The term *mezzo rilievo* is used to indicate carving that is about half the scale of the figure. *Basso rilievo,* or more commonly, "bas relief," is used when the objects project less than half of the figure. The term *rilievo stiacciato* is used to indicate an extremely low relief (in some cases barely discernible). This was used for the first time in the 15th century by Donato Donatello on the plinth, or base, of his statue of St George.

REPOUSSOIR. The use of a large and obviously defined figure or tree or object in the foreground of a painting in order to balance, give depth to, push back, lead the spectator's eye into the main action. This strengthens the central episode or scene and amplifies, even dramatizes, the action of the principal scene's figures.

REPRODUCTION. It is interesting to note that neither the Greeks, the Romans nor the artists of the Middle Ages knew how to reproduce an image precisely, if one excludes PLASTER CASTS, medals and seal impressions. But during the 17th century, reproduction of works had become widespread, and the transmission of artistic ideas was accelerated to a point theretofore unheard of. The Baroque style, by means of several types of reproductions, was sent into all parts of Europe where it propagated rapidly and thoroughly in a way that had been impossible in centuries previous. Of course, what the public saw was far from the original. They saw the work of three successive hands: the engraving, stylized in the artist's own manner, made from a work which was itself a translation from the original canvas or print. Such a print could give the viewer only an idea of the grouping of figures and the composition and the ICONOGRAPHY (illustrating by using pictures or images). But the surface, the quality and texture of the original could not be shown. The artist's characteristics of surface texture, such as IMPASTO, were lost. ETCHING became popular during the 17th century, and some of the works by Rembrandt, such as his *The Three Crosses* (a CRUCIFIXION scene), have not been surpassed.

Example: Rembrandt, *The Three Crosses,* The Metropolitan Museum of Art, New York. (Hartt, fig. 994)

REREDOS. *See* ALTARPIECE.

RESCUE OF THE INFANT PYRRHUS. In a story in Plutarch's *Lives,* a group of men and women have the king's infant son Pyrrhus, who is being pursued by enemies of the royal family and is in mortal danger. "The Molossians, afterwards falling into factions and expelling Aeacides, brought in the sons of Neoptolemus, and such friends of Aeacides as they could take were all cut off; Pyrrhus, yet an infant, and searched for by the enemy, had been stolen

away and carried off by Androclides and Aroplus; who, however, being obliged to take with them a few servants, and women to nurse the child, were much impeded and retarded in their flight, and when they were now overtaken, they delivered the infant to Androcleon, Hippias, and Neander. . . . At last, having hardly forced them back, they joined those who had the care of Pyrrhus; but the sun being already set, at the point of attaining their object they suddenly found themselves cut off from it. For on reaching the river that runs by the city they found it looking formidable and rough, and endeavoring to pass over, they discovered it was not fordable . . . perceiving some of the country people on the other side, they desired them to assist their passage, and showed them Pyrrhus, calling out aloud . . . they however, could not hear for the noise and roaring of the water . . . one recollecting himself, stripped off a piece of bark from an oak, and wrote on it with the tongue of a buckle, stating the necessities and the fortunes of the child, and then rolling it about a stone . . . threw it over to the other side, or, as some say, fastened it to the end of a javelin, and darted it over. When the men on the other shore read what was on the bark, and saw how time pressed, without delay they cut down some trees, and lashing them together, came over to them. And it so fell out that he who first got ashore, and took Pyrrhus in his arms, was named Achilles.'' Once they were out of danger the townspeople spoke to the King of the Illyrians, Glaucias, whom they found at home with his wife, and they put the child down before them.

Two men are shown asking the people in the town of Megara for help by throwing a lance and a stone across the river to the townspeople, who stand on the other side. Women guard the small infant and hold him aloft, while soldiers frantically and bravely fight off the approaching enemy.

Example: Nicolas Poussin, The Louvre, Paris. (Friedlaender, fig. 41)

RESIN (resin varnish). Resin from plants and trees is used by artists as a constituent of varnish. Resins used by painters during the Baroque (especially Rubens and Rembrandt) are not easy to identify, but it is known that they include both hard fossil resins, such as amber and copal, and soft resins from living trees, such as dammar, sandarac, mastic Canada balsam and Venice turpentine. Some scholars believe that Rembrandt used a medium made of a resin varnish and sun-thickened or boiled oil, both treated to the consistency of honey. The luminous, neon-like qualities he produced that can be so dazzling cannot be created with raw turpentine and raw linseed oil—materials used by the majority of painters. Oil colors, especially blues, will yellow with time. Some Baroque masters put their pictures in hot sunlight in order to produce a different effect.

REST ON THE FLIGHT INTO EGYPT (*Repose on the Flight into Egypt*).
Matthew 2:14–15 tells that Joseph took his family, Mary and her son Jesus, into Egypt. ''And he rose and took the child and his mother by night, and departed to Egypt, and remained there until the death of Herod. This was to fulfill what the Lord had spoken by the prophet, 'Out of Egypt have I called by son.' '' The

gospels tell nothing about the journey into Egypt, although the subject, as a devotional topic rather than a narrative subject, was a popular theme in the art of the 16th-century COUNTER REFORMATION.

Usually, Jesus and Mary are seated in a landscape under a tree, often a palm tree. If the artist included broken images scattered on the ground, they allude to a story from the apocryphal gospel of Pseudo-Matthew: when the Holy Family reached Sotinen, a small town in Egypt, the Virgin and her child entered a temple and immediately the statues of the Egyptian's gods fell from their pedestals and broke to pieces on the ground. Also from Pseudo-Matthew is the story of the palm tree under which the family rested, which lowered its branches at the orders of the baby Jesus so that Joseph and Mary could gather its fruit. Joseph may be picking palm dates and handing them to the child. Angels hold down a branch. Another scene may show Mary washing clothes by the river just as a countrywoman would do.

During any of the ''rest'' scenes, Joseph is beside Mary and Jesus and their donkey may be close by or in the background. Their belongings are scattered about the ground or tied up in a bundle. An angel may hover overhead or bring them food. If an old woman is depicted, she is Salome, the midwife present at the birth of Jesus. In Caravaggio's example, an angel stands playing a violin and Joseph is seated holding the music. The angel is especially beautiful, with head turned and seen in soft profile. The angel is so exceptional in its pulchritude that GIOVANNI PIETRO BELLORI, the 17th-century Italian antiquarian and biographer whose work is considered by some to be the basic source for the history of the Baroque period, mentioned its purity and beauty. In a century when angels were painted by every painter alive, when artists vied with each other over their angels, it was Caravaggio who painted the most perfect of all. *See also* FLIGHT INTO EGYPT.

Example: Caravaggio, Galleria Doria, Rome. (Bottari, figs. 15,16)

RESURRECTION OF LAZARUS. *See* RAISING OF LAZARUS.

RETABLE. A carved or painted ALTARPIECE made up of one or more permanent panels, although the structure is not hinged like a triptych (a three-paneled altarpiece). It may also be a ledge or a shelf or a frame enclosing ornamented panels located above the back of an altar.

RETROUSSAGE. A term used in engraving, it is the technique of putting a muslin fabric of good quality over a warm engraved plate that has already been inked and then removing it, thereby absorbing much of the ink and redistributing it over the edges of the lines. The procedure produces a more muted and somber effect in printing.

RETURN OF THE PRODIGAL SON. The story of the Prodigal Son is told in Luke 15:11–32. It is the story of a man who had two sons. The youngest

told his father to give him his share of the family property. The father divided all he had between them. The younger son then left and traveled to a far country, and there he squandered his inheritance. When he had spent all he had, a famine arose, and he began to starve. So he took a job feeding swine. But soon he asked himself, "How many of my father's hired servants have bread enough and to spare?" It was thus that he left and went home. His father saw him coming and ran and embraced him. And the son told him he had sinned. He said he was no longer worthy to be called a son. But the father told his servants, to bring "the best robe, and put it on him; and put a ring on his hand, and shoes on his feet; and bring the fatted calf and kill it, and let us eat and make merry; for this my son was dead, and is alive again; he was lost, and is found." His elder son came near and heard music and dancing. A servant told him his brother had come home and the fatted calf had been killed. But he was angry and would not go in. His father asked him to join them but he answered his father, "Lo, these many years I have served you, and I never disobeyed your command; yet you never gave me a kid. When this son returned, who has wasted your living with harlots, you killed the fatted calf." And the father told him, "Son, you are always with me, and all that is mine is yours. It was fitting to make merry and be glad, for this your brother was dead, and is alive; he was lost, and is found."

An old theme, the Prodigal Son is found first in the stained glass of 13th-century cathedrals in France. During the Baroque, different sections of the story are illustrated, but the return shows the wayward son dressed in rags as he kneels repentant before his father, who embraces him or makes a gesture of blessing or pardon. Servants may stand in the background holding the robe his father requested. The elder brother stands to the side, receiving him with restraint. Some artists show the slaughter of the fatted calf in the background—as if it were a sacrifice in appeasement for the son's sins.

Example: Rembrandt van Rijn, The Hermitage, St. Petersburg. (Held and Posner, figs. 265, 266)

RICHELIEU. Armand Jean du Plessis, duc de Richelieu, also Cardinal Richelieu, lived between 1585 and 1642. He was the chief minister of King Louis XIII, a French prelate and statesman, and cardinal of the Roman Catholic Church. Consecrated bishop of Luçon in 1607, by 1614 he was a delegate of the clergy to the States-General. Through the favor of the king's mother, Marie de' Medici, in 1616 he became a secretary of state. He went into exile with her after the king freed himself from her influence. Richelieu was restored to favor after the reconciliation of Louis XIII and Marie. He was made cardinal in 1622 and became the chief minister in 1624, but by 1630 Marie had plotted a conspiracy against Richelieu. Unable to win the king's support, however, she was sent into exile. After this Richelieu had full control of the government. Although Richelieu died before the signing of the Treaty of Westphalia (1648), the peace ending the Thirty Years' War, the terms agreed upon followed his ideas. Among

his literary works are his memoirs, written in 1650, and the *Testament politique,* completed in 1688.

As a patron of the arts, Richelieu founded the French Academy, commissioned the frescoes in the dome of the Sorbonne, and had one gallery painted at the Palais Royal. Richelieu is shown as a tall, slender, elegant man wearing the elaborate red robes of a cardinal.

Example: Philippe de Champaigne, National Gallery, London. (Blunt, fig. 209)

RINALDO AND ARMIDA. Torquato Tasso's late 16th-century Italian epic poem *Gerusalemme Liberata,* or ''Jerusalem Delivered,'' is the story of Rinaldo and Armida. The tale involved a pair of lovers set against the background of the First Crusade, which ended in 1099 after the capture of Jerusalem and the establishment of Christianity. Armida was known to be forbiddingly beautiful, a virgin and a witch. With her terrible beauty she had been sent by Satan (enlisted by the Saracens) to bring about the Crusaders' downfall by sorcery. Her anger, however, was provoked when Rinaldo rescued his companions whom she, like Circe, had changed into monsters.

The story of Armida's hate turned to love, of her flirtations with Rinaldo in her magic kingdom and Rinaldo's final desertion of her, forms a series of themes widely adopted by painters during the Baroque. Armida's meeting of Rinaldo is the first of the sequence. It seems Rinaldo found a marble pillar beside the River Orontes in Syria. On it he discovered a legend inviting him to see the wonders of an island paradise that lay in the middle of the Orontes (14:57–58). At this time a magic spell was cast upon him and he fell asleep on the river bank. Armida appeared ready to take her revenge. Instead, seeing his beautiful face, she fell in love with him (14:66). In order to abduct him, she tied him with a magic chain of roses, lilies and woodbines; and with her companions, put him in her magic chariot (14:68). Later, two patriotic knights, Carlo and Ubaldo, looking for Rinaldo, came to the Fortunate Island in mid-ocean, where Armida had Rinaldo in her palace. Nymphs bathing in a pool tried unsuccessfully to seduce them. They fought the guardian dragon to liberate Rinaldo from the enticements of the sorceress. They found the lovers (16:17–23) beside a lake under the shade of a tree. Gazing at his own reflection in her eyes, Rinaldo held a mirror to Armida's face, and they thus saw their own love in the image, his face all aflame, her face smiling. Yet, when Rinaldo's men called him to duty, he abandoned Armida and left her on the shore as she begged him to stay. But when she saw that he would not return, her pleading changed to curses (much as Dido's at the departure of Aeneas).

Rinaldo is shown in his armor, asleep on the river bank. Armida leans over him, ready to take her revenge, a knife in her right hand. Instead, as a PUTTO stays her hand, seeing his beautiful face, she falls in love.

Example: Nicolas Poussin, The Louvre, Paris. (Friedlaender, fig. 39)

ROMAN SCHOOL. After the fall of Rome and the long years of pillaging and disfigurement formally known as the Dark Ages, Roman art began again during

the 16th century under the pontificate of Julius II (1503–1513). The Sack of
Rome in 1527 had scattered the artists who had helped the new ideas spread.
During the 17th century, however, two important schools of painting originated.
One followed the powerful TENEBRISM and expressionistic naturalism of Ca-
ravaggio, who had decorated chapels in several Roman churches; the second,
originating in Bologna, followed the classical, academic tenets of the Carracci
brothers. The most important achievement of this school was the Salon in the
Palazzo Farnese in Rome. It was during this time that Rome was the center of
the type of painting known as BAMBOCCIATE.

Spectacular feats of urban building were undertaken in Rome during the Ba-
roque. During the pontificates of Urban VIII (1623–1644), Innocent X (1644–
1655), and Alexander VII (1655–1667), monuments such as the enormous pi-
azza in front of St. Peter's by Gian Lorenzo Bernini and the astonishing works
of Francesco Borromini came under construction. Illusionistic ceiling painting
in TROMPE L'OEIL (*see also* ILLUSIONISM) flourished in the hands of such
artists as Fra Andrea Pozzo and his ceiling in S. Ignazio, Rome. (Bazin, fig. 25)

RUBÉNISTES. Those painters who, after the manner of Peter Paul Rubens,
held that color, rather than form, was the most important element in a painting.
Painters who held a philosophy that adhered to the doctrine that form, rather
than color, was the most important ingredient in a painting, were known as
POUSSINISTES.

RUTH AND BOAZ. The story of Ruth and Boaz is found in the Book of Ruth.
Ruth, a Moabite woman, was the great-grandmother of King David (of the
lineage of Christ). She was married to a Hebrew immigrant in Moab, and after
his death, left her native land and went to Bethlehem with her mother-in-law,
Naomi. Here she was allowed to glean corn in the fields belonging to Boaz, a
wealthy farmer and kinsman of Naomi. He instructed his men to " 'let her glean
even among the sheaves, and do not reproach her. And also pull out some from
the bundles for her, and leave it for her to glean, and do not rebuke her' " (Ruth
2:15–16). Ruth, on Naomi's advice, and true to her good nature, kept a modest
countenance among the young men working at the harvest. Again, on Naomi's
advice, she "lay at his [Boaz's] feet until the morning, but arose before one
could recognize another; and he said, 'Let it not be known that the woman came
to the threshing floor' " (3:14). By this act Boaz saw her goodness.

"So Boaz took Ruth and she became his wife" (4:13). For Christians, Ruth
and Boaz symbolize the union between Christ and his Church. The cornfield at
which many men and women work symbolizes the consecrated bread as the
body of Christ given at the EUCHARIST.

Boaz, the landowner from Bethlehem, is depicted standing in the foreground
near a tree, a kind and kingly figure in rich clothing, for he was a wealthy man.
He wears a great turban on his head. Ruth, the young Moabite widow, kneels
before him, asking for his protection and also asking for permission to glean

the ears left behind by the harvesters. Boaz orders his foreman, a humble young man with a spear, to stand guard so that Ruth, a stranger and a foreigner, can work unmolested. Other harvesters are shown behind them working. Five horses are being driven by a man with a whip. Poussin's painting *Ruth and Boaz* is also known as *Summer.*

Example: Nicolas Poussin, The Louvre, Paris. (Friedlaender, colorplate 46)

S

SABINE WOMEN. *See* RAPE OF THE SABINES.

SACRAMENT OF CONFIRMATION. Sacrament, from the Latin "something holy," is generally accepted as an outward sign of something sacred instituted by Christ. A sacrament is a visible sign of invisible grace (grace being such things as brotherly love, mercy, forgiveness, kindness, good will). Christianity is divided as to the operation and number of sacraments. Roman Catholics and certain Anglicans count the sacraments as seven: BAPTISM, penance, anointing of the sick, EUCHARIST, marriage, holy orders and confirmation. These, according to the Church, produce grace in the soul of the recipient by the very execution of the sacramental act (*ex opere operato*). The beneficiary need only have the right purpose. Most Protestant denominations acknowledge two sacraments, communion, or the Last Supper, and baptism. For the most part, Protestants hold that it is the faith of the believer, itself a gift from God, rather than the power of the sacramental act that produces Christian love and benevolence and compassion.

The sacrament of confirmation is the rite in which the initiation into the church that takes place is confirmed by baptism. Confirmation consists of anointing with chrism, a mixture of balm and oil and the laying on of hands. Scriptural passages cited as authority for the sacrament of confirmation include Acts 8:14–17: "Now when the apostles at Jerusalem heard that Samaria had received the word of God, they sent to them Peter and John, who came down and prayed for them that they might receive the Holy Spirit: for it had not yet fallen on any of them, but they had only been baptized in the name of the Lord Jesus. Then they laid their hands on them and they received the Holy Spirit."

A priest is usually shown either anointing a person (which can be a child

assisted by his mother) or performing the laying on of hands, while an altar boy stands to the side holding the oil.

Example: G. M. Crespi, Gallery, Dresden. (Waterhouse, fig. 90)

SACRED MONOGRAM. A monogram is a character designed with two or more letters. The superimposition of the letters, according to the multitude of possible arrangements, produces in some instances a symbolic design. Some symbols are combined with other symbols to represent the Persons of the Godhead, or God. The most common monograms are those representing Christ. XP are the two Greek letters Chi and Rho that are used most frequently in a monogram. They are the first two letters of the Greek word for Christ, ΧΡΙΣΤΟΣ, or for the Greek letters iota and chi, the first two letters of the Greek word for "fish," which also became a symbol of the faith. The combination of these two Greek letters, the P superimposed over the X, forms the configuration of a cross, and the cross itself was introduced into the monogram as it was closely associated with the Sign of the Cross. This is the sign, that according to biographers, was adopted by the Emperor Constantine on the Labarum, the military standard of the Roman army. For about a hundred years it was seen on coins, seals and tombs. The sign appeared in a dream or a vision to Constantine on the eve of his battle against Maxentius in 312 at Saxa Rubra. From then on the monogram came to be traditionally known as the Chi-Rho.

IC XC NIKA was the ancient monogram meant to symbolize Christ as the Conqueror. I and C are the first and last letters of the Greek word for Jesus, IHCUC. X and C are the first and last letters Christ's name in Greek, XPICTOC. NIKA is the Greek word for conqueror. X and P were adopted by early Christians as a symbol of Christianity, and this monogram was popular from the 4th century on. It was frequently enclosed in a wreath or a circle, the triumphal wreath possibly symbolizing the Resurrection of Christ. Sometimes the monogram is set in the nimbus of Christ, and it may also be found in a medallion supported by angels. Some artists combined the first and last letters of the Greek alphabet, ALPHA and OMEGA, signifying the beginning and the end, with an allusion to Revelation.

Another form of the monogram is the letters IOTA, ETA, SIGMA, IHS or IHC, being the first two and the last letters of the Greek name Jesus. IHS superseded the Chi-Rho monogram by the 12th century, although the latter was not abandoned. The meaning *Jesus Hominum Salvator* (Jesus Savior of Men) was revealed to St. Bernadino of Siena in a vision. After the foundation of the SOCIETY OF JESUS in 1540, the Jesuits attached to it such meanings as *In hoc salus* (In his safety), *Iesu Humilis Societas* (Humble Society of Jesus) or *In hoc signa* (In this sign thou shalt conquer). IHS was associated with the *Triumph of the Name of Jesus* (*see* ADORATION OF THE NAME OF JESUS), which has an important place in the illusionistic ceiling painting (*see* ILLUSIONISM) of many Baroque churches, for example Il Gesú in Rome. El Greco's *Dream of Philip III* (in the Escorial) painted in 1580, represents the adoration of the

name of Jesus and is an allegory of the Holy League against the Turks. The monogram, shining in the sky, is adored by Philip himself and by all mankind.

Example: Giovanni Baciccio, *Triumph of the Name of Jesus,* Ceiling fresco, Il Gesù, Rome. (Held and Posner, fig. 122)

SACRIFICE OF ISAAC. The story of the sacrifice of Isaac is told in Genesis 22: 1–19. "God tested Abraham and said to him, 'Abraham.' And he said 'Here I am.' He said, 'Take your son, your only son Isaac, whom you love, and go to the land of Moriah, and offer him there as a burnt offering upon one of the mountains of which I shall tell you.' So Abraham rose early in the morning, saddled his ass, and took two of his young men with him, and his son Isaac; and he cut the wood for the burnt offering, and arose and went to the place of which God had told him. . . . And Abraham took the wood of the burnt offering and laid it on Isaac his son; and he took in his hand the fire and the knife. So went both of them together. . . . When they came to the place of which God had told him, Abraham built an altar there, and laid the wood in order, and bound Isaac his son, and laid him on the altar, upon the wood. Then Abraham put forth his hand, and took the knife to slay his son. But the angel of the Lord called to him from heaven, and said, 'Abraham, do not lay your hand on the lad or do anything to him; for now I know that you fear God, seeing you have not withheld your son, your only son from me.' " At this time Abraham saw a lamb caught in the brambles and he sacrificed it instead.

Abraham's intended sacrifice of his son was seen by Christians as a type of CRUCIFIXION, the same as God's sacrifice of his son, Jesus. Isaac carrying the wood prefigured Jesus carrying the Cross. The lamb became Christ crucified. The thorns in the brambles were the CROWN OF THORNS.

The sacrifice took place, according to Moslem tradition, on the site of the Mosque of Omar (the Dome of the Rock) in Jerusalem. Isaac became the second of the great Hebrew patriarchs. In old age he was deceived into giving his blessing to his son Jacob instead of to Esau (*see* ISAAC BLESSING JACOB).

Artists show Abraham with his knife held high. Sometimes his other hand covers the young boy's eyes. Isaac either kneels or lies, usually naked, on a type of low altar on which there is a pile of wood. An angel is in the act of taking Abraham's hand and at the same time pointing towards the lamb in the bush. Abraham's attribute in painting or sculpture is the knife with which he meant to sacrifice his son Isaac.

Example: Rembrandt van Rijn, Etching, British Museum, London. (Held and Posner, fig. 264)

SACRIFICE OF MANOAH. The story of the sacrifice of Manoah is told in Judges 13. The birth of Samson was preceded by an annunciation made by an angel. The archangel Gabriel appeared to Samson's mother, foretold the event and predicted that her son would deliver Israel from the enemy Philistines: "And there was a man of Zorah of the tribe of the Danites whose name was Manoah;

and his wife was barren and had no children. And the angel of the Lord appeared to the woman and said to her, 'Behold, you are barren and have no children; but you shall conceive and bear a son. . . . No razor shall come upon his head, for the boy shall be a Nazarite to God from birth; and he shall begin to deliver Israel from the hand of the philistines'. . . . And Manoah said to the angel of the Lord, 'what is your name, so that, when your words come true, we may honour you?' And the angel of the Lord said to him, 'Why do you ask my name, seeing it is wonderful?' So Manoah took the kid with the cereal offering, and offered it upon the rock to the Lord, to him who works wonders. And when the flame went up toward heaven from the altar, the angel of the Lord ascended in the flame of the altar while Manoah and his wife looked on. . . . And the woman bore a son, and called his name Samson; and the boy grew, and the Lord blessed him.''

Manoah is shown kneeling in prayer beside his fire on an altar. His wife kneels in absorbed reverence beside him, her hands in the attitude of prayer. Both, in a moment of silence and profound devotion, have closed their eyes, deeply affected by the sanctity of the incident and dazzled by the angel from heaven. At the very moment the sacrifice flames up, the angel vanishes in the flames toward heaven.

Example: Rembrandt van Rijn, Gemäldegalerie, Dresden. (Rosenberg, Slive, ter Kuile, fig. 68)

SACRIFICE OF POLYXENA. Polyxena was the daughter of Priam, the King of Troy. Achilles, the Greek hero, though on the opposing side in the Trojan war, fell in love with her the first time he saw her. Polyxena brought about his death by a plot. After the sack of Troy by the Greeks, the ghost of Achilles appeared to the other Greek chieftains and demanded that Polyxena be sacrificed at his tomb. This story is told by Ovid in the *Metamorphoses* 13:440–55. ''Agamemnon had moored his fleet on the Thracian shore, until the sea should become calm, and the winds more friendly. Here the earth suddenly split wide open, and the ghost of Achilles emerged, as huge as when he was alive, and on his face a threatening expression, like the one he wore when, fiercely and without justification, he attacked Agamemnon with his sword. 'So!' he cried, 'You Greeks are departing, forgetting me! The gratitude my valour inspired was buried with me! This must not be: that my tomb may have its share of honour, let Polyxena be sacrificed, to appease Achilles' shade.' No sooner had he spoken than his former comrades obeyed the pitiless ghost. The girl Polyxena, almost the sole remaining comfort of Hecuba, was snatched from her mother's arms. Brave in spite of her misery, showing more than a woman's courage, she was led to the tomb, and offered as a sacrifice at that grim pyre. As she stood before the cruel altar, and realized that the barbarous rites were being prepared for her, she did not forget herself. Seeing Neoptolemus standing sword in hand, his eyes fixed on her face, she said: 'Be quick, and shed my noble blood. I do not hinder you. Bury your sword in my throat or in my breast!' She uncovered her breast

and her throat together.'' Even the priest was weeping, as the executioner ''with unwilling hands drove home the knife, piercing the breast she offered him. Her knees gave way, and she fell to the ground: but her face retained its look of fearless courage to the end. Even when she was falling, she took care to cover the parts of the body that should be covered, and to preserve what was proper for a modest girl.''

Polyxena is shown kneeling beside the tomb. Neoptolemus, the son of Achilles, who is the executioner, stands beside her with his sword raised. An equestrian statue of Achilles may be on the tomb. His ghost floats in the air above them. Agamemnon, the Greek leader who denounced the sacrifice, is shown pleading in vain for the girl's life.

Example: Pietro da Cortona (Pietro Berettini), Capitaline Gallery, Rome. (Waterhouse, fig. 38)

SAINT AGNES IN PRISON. Agnes (her name coming from the Greek meaning chaste), was a virgin martyr, one of the earliest to be venerated by the Church. She lived in Rome during the time of the persecutions in the latter part of the reign of the Roman emperor Diocletian, who ruled from 284 to 305. Her story is told in Voragine's GOLDEN LEGEND. It seems that the son of a prefect saw her one day as she returned from school and fell in love with her. So strong were his feelings that he promised her great riches if she would become his wife. But Agnes told him to go away because she had already been promised to another lover. The young man left her, yet sickened with love to the point that he was in danger of death. Seeing this, his father the prefect, called upon Agnes and asked her about her lover. Someone told him that it was Christ she had referred to; thus, he began to question her at first gently, and then, when she did not answer, he threatened her with punishment. But Agnes told him that she would not give up her secret. The prefect had her stripped and led naked to a house of ill-repute, but God caused her hair to grow in such abundance that it covered her completely. Upon entering the house of shame, she discovered an angel awaiting her holding a robe of brilliant white.

Thus, the house became her house of prayer, and the angel caused a supernatural light to fall about her. The prefect's son came to the house with several friends and invited his companions first to have their pleasure with her. But when they entered the room where Agnes lived, they were so terrified they ran to the prefect's son, at which time he called them cowards and rushed like a madman into her room. But he was stopped, because he had not honored God. Agnes was then taken to be burned as a witch, but the flames did not touch her. In the end she was beheaded. The theme of a female martyr thrown into a brothel, could have originated from the Roman law that forbade the execution of virgins. Before being put to death, they had to be violated.

Agnes is usually shown with her attribute, a white lamb, held in her hand or curled up at her feet. She may be kneeling on the extinguished pile of wood while her executioners lie prostrate. One stands holding a sword. The heavens

reveal Christ and an angel, who holds a crown and the martyr's palm. Agnes holds a martyr's palm or sometimes a crown of olives or an olive branch, a dagger or a sword, the instrument of her martyrdom, or a flaming pyre. Since, according to tradition, she died at age thirteen, she is shown as a young girl. Her hair is flowing and long. CATHERINE of Alexandria and Agatha appear with Agnes in devotional pictures. Her foster sister, Emerantiana, who was stoned to death while standing before Agnes's tomb, "inveigh[ing] against the pagans who had slain her," (p. 112), is sometimes shown with Agnes.

Example: José or Jusepe Ribera, Gemäldegalerie, Dresden. (Bazin, fig. 41)

SALOME. According to Jewish historian Josephus, Salome was the daughter of Herodias and the stepdaughter of Herod Antipas, the tetrarch (ruler appointed by Rome) of Peraea and Galilee, a region in Palestine. She is said to have been the immediate agent in the BEHEADING OF SAINT JOHN THE BAPTIST. Josephus says that Salome was married twice, first to her uncle Philip the tetrarch and then to Aristobulus, the king of Lesser Armenia, a country in biblical times in western Asia. Josephus says (with no proof) that her father was Philip, the brother of Herod Antipas and first husband of Herodias. According to the gospels of Matthew 14:1–12 and Mark 6:14–29, in which her name is not given, she brought about the death of JOHN THE BAPTIST. Herod Antipas had John put in jail for condemning his marriage with his deceased brother's wife because the marriage violated Mosaic law. He was, however, afraid to execute him. According to Matthew's story, Salome danced at a birthday party given by Herod for his courtiers and officers and the leading men of Galilee. After the dance he was so pleased that he promised to give her whatever she asked: "Whatever you ask me, I will give you, even half of my kingdom." At her mother's suggestion, the girl requested the head of John the Baptist on a platter: "I want you to give me at once the head of John the Baptist on a platter." Herod was forced by his oath to give it to her.

Another Salome is mentioned in the Bible as one of the holy women present at the CRUCIFIXION of Jesus and later at the empty tomb of Jesus (Mark 15: 41 and 16:1). This Salome was probably the wife of Zebede and the mother of the apostles John and James. The Salome painted by Guido Reni is the daughter of Herodias.

Example: Guido Reni, Chicago Art Institute. (Waterhouse, fig. 85)

SALOMÓNICA. This is the Spanish and Portuguese word for a column, usually of the Corinthian Order, with a shaft that is spirally twisted. The name derives from a Roman example preserved in St. Peter's in Rome. This column, according to legend, came from Solomon's temple. Rules for the proportions for twisted columns were set forth by the Italian Renaissance architect Giacomo da Vignola (1507–1573) in his *Five Orders.* Gian Lorenzo Bernini used them for his BALDACCHINO (1624–1633) located over the altar in St. Peter's. He gilded, painted and decorated the four spirally twisted bronze columns with

laurel vines, bees, *putti* (*see* PUTTO), birds and other motifs. Salomónicas were used for ALTARPIECES and façades of buildings by architects such as José de Churriguera (*see* Churrigueresque) during the first phase of Iberian Baroque (c.1680–c.1720).

SAMSON. One of the Old Testament judges of Israel, Samson emerges as more of a daredevil adventurer of immense physical strength and a womanizer than a judge. And though his term in office lasted twenty years, none of his judicial acts are recorded. Most scholars agree that some strong historical figure existed whose legendary feats of strength were kept alive through the ages in the local traditions of storytelling. His stories are told in the Old Testament Judges. Samson's long hair was a symbol of his vows to God, and because of this covenant Samson was strong. He killed a lion with his bare hands, as told in Judges 14: 5–9: "And behold, a young lion roared against him; and the Spirit of the Lord came mightily upon him, and he tore the lion asunder as one tears a kid; and he had nothing in his hand." He killed a thousand Philistines (the enemies of his people) with the jawbone of an ass, as told in Judges 15:14–16: "And he found a fresh jawbone of an ass, and put out his hand and seized it, and with it he slew a thousand men."

But forever a womanizer, he succumbed easily to female flattery and, finally, to the fatal temptations of Delilah, a Philistine woman, whom he took as his lover. She discovered the secret behind his prodigious strength, Judges 16:4–20. "And he told her all his mind, and said to her, 'A razor has never come upon my head; for I have been a Nazarite to God from my mother's womb. If I be shaved, then my strength will leave me, and I shall become weak, and be like any other man.' " By cutting his hair, Delilah forced Samson to break his vow to God and thus destroyed his might.

His death "eyeless in Gaza," is told in Judges 16:21–31: "And the Philistines seized him and gouged out his eyes, and brought him down to Gaza, and bound him with bronze fetters; and he ground at the mill in the prison. But the hair of his head began to grow again after it had been shaved." He was taken to a house full of Philistines where a boy took him to the pillars supporting the roof so that he could rest. But Samson grabbed the pillars, shook them and the house collapsed and killed him and large numbers of Philistines. The Samson cycle was possibly taken from popular oral folk tales and may be a myth connected with the cult of sun worship. John Milton's *Samson Agonistes* is an English poem in which Samson, after he was blinded, is the tragic hero. He is the prototype of Fortitude (one of the four cardinal virtues, signifying strength, courage and endurance), whose attribute is a broken pillar.

Samson, huge and muscular, long-haired and handsome, is often shown dying amid the crumbling pillars of the temple he caused to collapse. He may also be shown triumphant on a battlefield littered with dead Philistines and their swords and helmets. *See also* BLINDING OF SAMSON.

Example: Guido Reni, Galleria, Bologna. (Waterhouse, fig. 83)

SAMSON POSING A RIDDLE AT THE WEDDING FEAST. The Israelite Samson married a Philistine, a woman from the enemy camp. During his wedding feast he set his guests a riddle: "Out of the eater came forth meat and out of the strong came forth sweetness" (Judges 14:14). The riddle referred to the lion Samson had killed with his bare hands and in whose body he later found a honeycomb. He had told only his wife the riddle's answer, but she betrayed him. She told the story to her countrymen. Angered, Samson killed thirty Philistines.

Samson, sitting to the right of the table with hair flowing about his shoulders, is shown telling the riddle and using rhetorical gestures to add force to his words. His wife sits in the middle of the composition, aglow and haughty in a magnificent gown, a look of sly and fox-like cunning upon her face.

Example: Rembrandt van Rijn, Staatliche Kunstsammlungen, Alte Meister, Dresden. (Gerson, fig. 85)

SATYRS. In ancient Greece satyrs and sileni were spirits of hills and mountains and wild life in woods. The Romans identified satyrs with the god Faunus. They are known for being bestial in their behavior and desires and having parts of either a goat or a horse. Sileni are sometimes confused with satyrs. They usually have horse ears and are old, while satyrs are usually young and more often have the hairy legs, hooves, tails, bearded faces and horns of a goat. Satyrs and sileni were attendants of the Greek Dionysus and the Roman BACCHUS. During and after the Renaissance, they came to personify excessive sexual appetite, lust and evil. (The cloven hoof and horns of Satan are taken from the satyr.) They love BACCHANALS and are most often depicted dancing with abandon and making music in orgiastic rites. The satyr's attributes are the snake and the wine pitcher. The snake as a symbol is taken from the tale of the Roman god Faunus, who, desiring to have his own daughter, made her drunk with wine, but was only able to ravish her by turning himself into a snake. Satyrs play pipes and are sometimes depicted holding a thyrsus (a rod tipped with a pine cone and often entwined with vine leaves or ivy), a fertility symbol taken from Bacchus. Surrounding them during the Bacchanalia may be baskets of fruit and a cornucopia—symbols of fertility. They may also be shown in the company of nymphs who help them gather fruit from trees.

SAUL AND DAVID. Saul, a Benjamite, was the first king of the ancient Hebrews who reigned in the 11th century. David was the shepherd boy who became king of Israel (c.1012–c.972 B.C.), the successor of Saul. Saul's territory included the hill country of Judah and the region to the north. He was in constant conflict with his close neighbors, the Philistines. Saul's story, told in the Bible, is really the story of David who was at first the protégé and then the rival and then the successor. Jonathan, Saul's son, was David's friend—a fact that lends a sympathetic note to the story of Saul's attempt to pull David down. David, on the other hand, would not harm Saul, who nonetheless met a disheartened

end after he visited the witch of Endor and listened as she prophesied his defeat and death. Rather than be captured after being wounded in battle with the Philistines on Mt. Gilboa, Saul committed suicide. Though he was unsuccessful in defeating the Philistines, the way was cleared for national unity under David. According to 1 Samuel 16:16–23, Saul's servants told him an evil spirit from God tormented him day and night, that he needed a man who was skillful in playing the lyre so that when the evil spirit from God entered his mind, he could listen to the music. "So Saul said to his servants, 'Provide for me a man who can play well and bring him to me,' One of the young men answered, 'Behold, I have seen a son of Jesse the Bethlehemite, who is skillful in playing, . . . and the Lord is with him.' Therefore Saul sent messengers to Jesse and said, 'Send me David your son, who is with the sheep.' . . . And David came to Saul, . . . And Saul loved him greatly, and he became his armors-bearer. And Saul sent to Jesse, saying, 'Let David remain in my service, . . . And whenever the evil spirit from God was upon Saul, David took the lyre and played it . . . so Saul was refreshed, . . . and the evil spirit departed from him."

David is shown as a young boy sitting before the king, his fingers upon the strings of an instrument, usually a harp but sometimes an instrument of the viol family. Saul, depressed and haunted by gloom and dark melancholy, wipes running tears from his eyes.

Example: Rembrandt van Rijn, Mauritshuis, The Hague. (Rosenberg, Slive, ter Kuile, fig. 99)

SCAGLIOLA. Imitation marble, scagliola is a compound of plaster of Paris, colored matter, glue and marble pieces. Scagliola was known to the Greeks and Romans, but the secret of its composition was lost and not rediscovered until the 17th century in the north of Italy. There it was used for intricate colored inlay work. Later it was important for surfacing columns when architects worked in the Roman manner.

SCHOLASTICA. *See* DEATH OF ST. SCHOLASTICA.

SCHOOLMASTER OF THE FALERII. Falerii was a 4th-century B.C. Etruscan town defeated by Marcus Furius Camillus, the second founder of Rome after the Gallic invasion. During the invasion of Falerii, a Falerian schoolmaster became a traitor to his students and to his city. The story is told in Livy's *History of Rome* 5:27. It seems that schoolmasters in Falerii at this time had charge of their pupils both during the day and after school. One man had a number of boys under his care. This man was the best available scholar, as he had been appointed to teach the children of the leading families. During peacetime, the schoolmaster indulged in the practice of leading his boys beyond the town walls for exercise and play. In spite of the fact that his country was at war, he continued to take his boys outside the walls, always distracting them with talk on various subjects. The day came when he took the boys for a longer walk than

usual, walking them right through the enemy lines to the Roman camp, all the way to Camillus's headquarters. As if this treachery weren't horrible enough, what he told the Roman officer was worse. He said that the parents of his pupils controlled their affairs and that he, the schoolmaster, was delivering their children into Roman hands so that Falerii now belonged to them. The Roman officer Camillus rejected him with such extreme contempt and disgust that he had his officers strip him and tie his hands behind his back. The students were given rods and ordered to whip their teacher all the way back to their city. The inhabitants of the city, amazed by this example of Roman honesty, yielded their city.

Marcus Camillus is shown seated, making his judgment, pointing to the schoolmaster. Roman soldiers carrying fasces (bundle of rods bound about an ax with a projecting blade) and standards flank him and look on. The schoolmaster, naked, his hands tied behind his back, is being flogged by his students.

Example: Nicolas Poussin, The Louvre, Paris. (Friedlaender, fig. 27)

SCIPIO AND THE PIRATES. Scipio was the family name, or cognomen, of Roman generals. It was Scipio Africanus Major, Publius Cornelius, the son of Publius and husband of Aemilia, who lived between 236 and 184/3 B.C., who became famous for his military victories in Spain and North Africa against the Carthaginians. These battles brought the Second Punic War to an end. This Scipio was noted for drilling his army in new tactics and possibly adopted the Spanish sword and improved the *pilum* (javelin used by Roman foot soldiers). As consul in 205, he carried through his determination to invade Africa, despite senatorial opposition. He was an amazing man of action and at times is known to have felt himself divinely inspired and the favorite of Jupiter Capitolinus. This part of his incredible character gave rise to the "Sciopionic legend," born during his lifetime but later made larger and more elaborate. He was even paralleled with Alexander the Great. Petty jealousies and hatreds against his generous foreign policy and his love of Greek culture created envy and hate and eventually led to his downfall. In Rome political attacks, led by Cato, were launched on the Scipios, culminating in the "Trials of the Scipios," on which the evidence is conflicting. Scipio (Africanus Major), embittered and ill, soon afterwards withdrew to Liternum, where he died in 184 or 183 B.C.

Scipio and the Pirates is an episode from the life of the great hero of Stoicism. It illustrates the courage of the man who allowed a band of pirates to enter his villa at Linturnum, knowing they wanted only to pay homage to him (which he felt he deserved). Scipio stands between two men and receives the attention of the pirates who reach forward to pay homage and to touch him. The CONTINENCE OF SCIPIO was also a popular subject during the Baroque.

Example: Nicolas Poussin, Drawing, École des Beaux-Arts, Orléans. (Friedlaender, fig. 64)

SCOURGING OF ST. ANDREW. Andrew, a Galilean fisherman and the brother of Peter, was one of Christ's twelve apostles and is the patron saint of

fishermen. According to John 1:40, Andrew was the first to follow Jesus. "One of the two who heard John speak, and following him, was Andrew, Simon Peter's brother." According to Voragine's GOLDEN LEGEND, Andrew made missionary journeys to Scythian Russia, Greece and Asia Minor, where he preached and performed many miracles of healing. As an old man, Andrew was put to death by Aegeas, the Roman governor of Patras in the Peloponnese. Among those whom Andrew baptized was the wife of Aegeus. He also persuaded her to deny her husband his marital rights forever. The proconsul, furious because his wife had adopted Christianity, and, because of Andrew, denied him as a husband, ordered twenty-one men to seize him, scourge him and crucify him.

Andrew is portrayed as frail and old with white hair and a beard. He is shown on a table being tied by Roman soldiers while an executioner flogs him with reeds. A crowd watches in horror and sympathy. *See also* ANDREW ADORING HIS CROSS and ANDREW BOUND TO THE CROSS.

Example: Domenico Zampieri, Domenichino, Fresco, S. Gregorio Magno, Rome. (Friedlaender, fig. 17)

SCUMBLE. A thick upper layer of paint used to change the color of the surface of a painting. It is different from a GLAZE, which is transparent, because the pigment is opaque. The thick, pasty paint, which makes up the scumble, must be applied irregularly: that is, it must be scruffed or dragged across the surface in such a way so as to allow areas of the under painting to show through. Another method of application is used when the scumble is thin enough to allow some light to penetrate through to the under canvas. Baroque artists who perfected scumbling techniques were able to produce effects such as "optical grays" which cannot be produced by applying paint directly to the surface.

SEBASTIAN. *See* ST. SEBASTIAN ATTENDED BY ST. IRENE and MARTYRDOM OF ST. SEBASTIAN.

SÉGUIER. *See* CHANCELLOR SÉGUIER.

SEICENTO. Term used to designate the 17th century, or Baroque period, in the art of Italy. Literally *seicento* means "the 1600s."

SERAPION, ST. Peter Serapion of Thmuis was an English monk who suffered martyrdom in 1240. He had traveled to North Africa to pledge himself to the Mohammedan enemy in return for the release of Christian prisoners they kept. It was while he waited for the monastic order that would have ransomed his freedom that he preached, with great exuberance, the word of Christ to the Moors. For this he was executed in a horrible way. His enemies cut open his stomach so that his entrails fell out, and he thus suffered a long and agonizing death.

Serapion is shown at that moment of death when he lost the strength needed to sustain his body and hangs from ropes by lifeless hands. His young face, finally at peace, rests on his right shoulder. His praying lips are silenced. All details of his appalling death have been subordinated, and his martyrdom becomes a symbolic representation.

Example: Francisco de Zurbarán, Wadsworth Atheneum, Hartford. (Brown, color-plate 5)

SEVEN WORKS OF MERCY. The works of mercy commended by the sages, the Law and the Prophets, are at the heart of the Old Testament. According to Isaiah 58:7, they are: "Sharing your bread with the hungry, sheltering the oppressed and the homeless, clothing the naked when you see them, and not turning your back on your own." In the New Testament one finds a deeper development of the concept of mercy. The people are now not only those who are merciful, but also those in misery and in need of mercy. In the Incarnation is a work of mercy for human suffering, both Jewish and pagan. The Christian spirit brought to life a new way of looking upon misfortune and a new scope to free generosity. The works of mercy as described in Matthew 25:35–37 are: "for I was hungry and you gave me food, I was a stranger and you welcomed me, I was naked and you clothed me, I was sick and you visited me." The long established list is as follows: to feed the hungry, to give drink to the thirsty, to clothe the naked, to shelter the homeless, to visit the sick, to ransom the captive, to bury the dead. The last, not mentioned in Matthew, was added out of the respect owed to the body as a "temple of the Holy Spirit," as mentioned in 1 Corinthians 3:16.

In the example below, the seven acts of piety have all been included in a single composition.

Example: Caravaggio, Pio Monte della Misericordia, Naples. (Bottari, figs. 60, 61)

SHEBA, QUEEN OF. *See* EMBARKATION OF THE QUEEN OF SHEBA.

SIBYLL. *See* CUMAEAN SIBYL.

SILENUS. *See* DRUNKEN SILENUS.

SINGERIES. In 1695, JEAN BÉRAIN first came upon the idea of replacing classical statues and fauns (Roman rural deities usually depicted with the body of a man who has the horns, pointed ears, tail and hind legs of a goat) with figures of monkeys and Renaissance GROTESQUES (fanciful fantasy decorations with mixed human and animal forms and floral ornament found in Roman buildings). Bérain was a French designer and decorator and one of the most imaginative of all Baroque designers. His grotesques and ARABESQUES (flowing lines interwoven with fanciful figures, fruit and flowers) inaugurated a new movement, which led artists toward the Rococo of the 18th century. Singeries

is the concept of using figures of monkeys to ape human sports and occupations. The concept goes back to medieval manuscript decorations.

SIZE. A word used in painting for highly purified glue or gelatine. Size, however, is sometimes used to indicate any glue. The preparation of size from parchment waste by soaking it in water and heating it is mentioned by Cennino Cennini, the 14th-century artist and writer, author of the craftsman's handbook *Il Libro dell' arte,* the earliest Italian treatise on painting. Baroque artists used size for filling the porous surface of a canvas or a wooden panel and to provide an appropriate GROUND for the painting. Size color is a method of painting in which 17th-century artists mixed powdered pigment with hot glue-size.

SLAUGHTER OF THE INNOCENTS. *See* MASSACRE OF THE INNOCENTS.

SOCIETY OF JESUS. A religious order of the Roman Catholic Church whose members are called Jesuits. Its founder, St. Ignatius of Loyola, named it *Compañía de Jesús,* Spanish for (military) company of Jesus. The Latin is *Societas Jesu.* An extremely disciplined organization, its members form the largest single religious order. It is devoted to the pope and ruled by its general, who lives in Rome. Jesuits wear no special habit. They are not allowed to accept an ecclesiastical office or honor. They are noted for their discipline and spartan training which may last for more than fifteen years, two of which are spent in spiritual training. After this the simple vows of chastity, poverty and obedience are taken. Thirteen years (sometimes longer) are then spent as a scholar in teaching and study. Near the end of this time the individual is ordained and becomes a co-adjutor (bishop). Then a fourth vow of special obedience to the pope is taken and the individual becomes professed. The society has distinguished itself in the pursuit of scholarly activities in the humanities and sciences and is known for its schools and missions.

SODOM AND GOMORRAH. *See* DESTRUCTION OF SODOM.

SOTTO IN SÙ. *See* DI SOTTO IN SÙ.

SPINNERS. *See* LAS HILANDERAS.

SPRING. This topic, the first in a series followed by *Summer, Autumn* and *Winter,* by Nicolas Poussin, depicts man's status before the Law: Adam and Eve are shown beneath the tree of knowledge in their earthly Paradise. Eve sits and Adam kneels before her. Paradise here prefigures the coming Church; Adam indicates the coming Christ. The story of the creation of Adam and Eve is told in Genesis 1:24–31. The Garden of Eden is depicted in Genesis 2:8–20. The

Virgin Mary is the "new Eve" found in Genesis 3:1–7 and the story of the Expulsion is found in Genesis 3:8–24.

Example: Nicolas Poussin, The Louvre, Paris. (Friedlaender, fig. 128)

STONING OF ST. STEPHEN. Stephen (Esteban in Spanish, Étienne in French) was the first Christian martyr or "protomartyr," who was put to death by stoning at Jerusalem around A.D. 36. He was condemned after being accused of blasphemy and being brought before the Sanhedrin at Jerusalem. When he spoke to defend his beliefs, he further angered his accusers, who were Hellenistic Jews. As recorded in Acts 7:2–56, he said, "You stiff-necked people, uncircumcised in heart and ears, you always resist the Holy Spirit. As your fathers did, so do you. Which of the prophets did not your fathers persecute? And they killed those who announced beforehand the coming of the Righteous One, whom you have now betrayed and murdered, you who received the law as delivered by angels and did not keep it . . . and they ground their teeth against him. . . . They cast him out of the city and stoned him." One of the first seven deacons, Stephen was chosen by the apostles. His beliefs showed the enormous differences that were evolving between Judaism and the Jewish-Christian community in Jerusalem. The feast of his martyrdom is December 26.

Stephen is usually shown as a gentle, beardless youth. He may wear a deacon's dalmatic (a loose outer garment with wide, short sleeves and open sides). He may hold a stone in his hand, or stones (sometimes stained with blood) may be placed on his shoulders or even his head or may lie in a fold of his robe, or at his feet or on a book that he holds. He may hold a martyr's palm and sometimes a censer. During the stoning he is surrounded by angry men throwing stones down upon his head. Those who watched laid their coats at the feet of Saul (who later became Paul), who also stood in the audience. Artists show the elders watching the event, some pressing their hands to their ears as Stephen points and looks at a vision of Christ in heaven. Saul may be shown to one side in gloom and shadows, isolated or in the background. He may have a pile of coats at his feet. *See also* MARTYRDOM OF ST. STEPHEN.

Example: Annibale Carracci, The Louvre, Paris. (Rosenberg, Slive, ter Kuile, fig. 46)

STORM ON THE SEA OF GALILEE. Matthew 8:23–27, Mark 4:35–41 and Luke 8:22–25 tell the story of the storm on the sea of Galilee. According to Mark, "On that day, when evening had come, he [Jesus] said to them, 'Let us go across to the other side.' And leaving the crowd, they took him with them just as he was, in the boat. And other boats were with him. And a great storm of wind arose, and the waves beat into the boat, so that the boat was already filling. But he was in the stern, asleep on the cushion; and they woke him and said to him, 'Teacher, do you not care if we perish?' and he awoke and rebuked the wind, and said to the sea, 'Peace! Be still!' and the wind ceased, and there was a great calm. He said to them, 'Why are you afraid? Have you no faith?'

And they were filled with awe and said to one another, 'Who then is this, that even wind and sea obey him?' "

Artists show a ship tossed about in dark stormy seas. Men tug the tiller and pull helplessly on the sails. Christ is shown sometimes sleeping, sometimes sitting peacefully in the middle. The Christian symbolism involved is the Church as a strong ship on a stormy sea.

Example: Rembrandt van Rijn, Isabella Stewart Gardner Museum, Boston. (Gerson fig. 60)

STORY OF AENEAS. In classical legend, Aeneas was a Trojan prince, the son of Venus (Aphrodite) and a Trojan shepherd, Anchises, of Mt. Ida, a mountain on the island of Crete south of Greece. In the *Iliad,* his part is small. However, later legend described his escape by sea after the Greek sack of Troy: As Troy burned, Aeneas carried his aged father on his back and was followed by his son Ascanius. His wife, who left with him, was lost in the dark. Aeneas stayed at Carthage after the Trojans were washed ashore during a storm at sea and was directed by Venus, disguised as a huntress, to the legendary queen and founder of Carthage, Dido. Venus caused Dido to fall in love with Aeneas and created an unquenchable passion in Aeneas for Dido. The lovers passed a winter together and Aeneas stayed until he was visited by Mercury with orders from Jupiter to leave. After tears and scenes of endless pleading, he went to Latium in Italy where he settled. (Dido had her sister Anna build a huge funeral pyre in the courtyard of the palace. She killed herself on it with Aeneas's sword.)

Another storm drove Aeneas back to Sicily, where he celebrated the anniversary of the death of his father with funeral games that included a foot race, boating, a race between ships, a mock battle on horseback and shooting games. Aeneas and his men then sailed to the coast of Campania on the Italian mainland, by Cumae, where he visited the Sibyl in her temple. He prayed to see his father's face once more. Guided by the Sibyl and protected by a twig of mistletoe (the ancient symbol for life), he descended into the underworld. In Charon's boat with the Sibyl, Aeneas crossed the River Styx and landed on the other side at the gates of Hades, which were guarded by the monstrous multiheaded dog, Cerberus. Among others there Aeneas saw Dido, and, in the Elysian fields, he saw the shade of his father, who showed him the souls of his lineage—those yet unborn, a line of kings, emperors and consuls reaching down to Virgil's own day. After reaching the Tiber River, the Trojans battled hostile tribes. Then Aeneas sailed up the Tiber to Pallanteum where he made an alliance with King Evander. Included above are only the more important scenes usually depicted by artists and sometimes shown in great allegorical and legendary cycles.

Example: Pietro da Cortona, Ceiling fresco in the salon, Pamphili Palace (Piazza Navona), Rome. (Ruskin, fig 1–45)

STRIKING THE ROCK. *See* MOSES STRIKING THE ROCK.

ST. SEBASTIAN ATTENDED BY ST. IRENE (*St. Sebastian Tended by Irene and Her Maid*). Sebastian, whose story is told in the GOLDEN LEGEND, was a Christian saint and martyr who died c. 287. Although the legend of his life is without historical foundation, most historians believe it bears the stamp of truth. He was a native of Narbonne and a citizen of Milan. He was made First Cohort of the Praetorian guard in the 3d century by Diocletion, who felt great affection for him, so much so that he attached him to his personal following. It is said that Sebastian was secretly a Christian and wore the knightly mail only to be able to help the persecuted Christians, to keep them from succumbing to their inevitable tortures. While comforting twin brothers condemned to be tortured to death for their belief, Sebastian walked forward to give them support when they weakened, and was thus revealed. "And while Sebastian was speaking, a great light, coming from Heaven surrounded him, and they [the twin brothers] saw him suddenly wrapped about in a mantle of gleaming white, with seven angels standing before him." He was shortly after denounced to the Emperor Diocletian who said: "Ingrate, I have given thee the first rank in my palace and thou hast striven against me and my gods!" And Diocletian ordered him to be tied to a stake in the middle of the Campus Martius (the Palatine hill in Rome, supposed place of his martyrdom) and commanded his soldiers to kill him with arrows. Sebastian was left for dead but none of his vital organs received an arrow. He was nursed back to health by a widow named Irene.

In art, Sebastian is always recognized by arrows. His body is pierced by one or many. He may still be fixed to a tree or standing against a column, or he may be on the ground, the arrows still in his body. Irene leans over him. She may be accompanied by another woman. *See also* MARTYRDOM OF ST. SEBASTIAN.

Example: Georges de La Tour, Church of Broglie, France. (Bazin, Fig. 110)

SUMMER. *See* RUTH AND BOAZ.

SUPPER AT EMMAUS. The story of the sequel to the Journey to Emmaus, is found in Luke 24:28–32. After the CRUCIFIXION and the death of Jesus, Cleopas and one unnamed disciple were on their way to Emmaus, a small village near Jerusalem, when they were met by Jesus, although neither one recognized him. "So they drew near to the village to which they were going. He appeared to be going further, but they constrained him saying, 'Stay with us, for it is toward evening and the day is now far spent.' So he went in to stay with them. When he was at table with them, he took the bread and blessed, and broke it, and gave it to them. And their eyes were opened and they recognized him; and he vanished from their sight." The theme is first found in the 13th century in French Romanesque churches. After this it can be found occasionally taking the place of depictions of the Last Supper, or EUCHARIST, which usually decorated the walls of refectories in monasteries.

During the 17th century, Rembrandt painted several versions which, with a

silent spiritual sensuousness, express the character of Jesus without the drama or the energetic stage-like effects one finds in Italy. An enchanted atmosphere and an immense calm prevail, and the mood is deeply sacred. The figures are enveloped by a mysterious illumination as they sit at their table in an apse-like architectural setting. Basically, the theme shows three figures seated at a table: Christ is in the center and is in the act of breaking bread. The two disciples are shown in various attitudes of bewildered recognition of this man who had been recently crucified.

In Caravaggio's version, one sees the recognizable emblem of the pilgrim, the cockle shell, on the shirt of one of the disciples. The cockleshell is the attribute of James the Greater, but in scenes of the Supper at Emmaus, the shell alludes to all pilgrims who traveled and worshipped religious relics. Caravaggio also chose the "great gesture" to draw the beholder into the orbit of the painting and to increase the dramatic and emotional impact of the event. Christ's right arm is extremely foreshortened. The same treatment is given the arm of the older disciple, and both seem to break out of the picture plane and reach into the space of the spectator. The precarious placement of the basket of fruit on the table in the foreground serves the same purpose. These methods increase the participation of the worshipper, a common goal for Baroque artists. During the 17th century in the Netherlands, a relationship developed between depictions of the Supper at Emmaus and the Greek myth, Philemon and Baucis. Here one finds a similar story of hospitality given to the gods who astonish their two hosts when they reveal their identity in the middle of a meal. This classical theme is often seen in Netherlandish art of the Baroque, and some historians believe that Rembrandt based his treatment of the theme upon it.

Example: Caravaggio, National Gallery, London. (Bottari, fig. 29)

SURRENDER OF BREDA. Also called by its Spanish name, *Las Lanzas.* Breda is situated at the confluence of the Aa and Mark rivers in the North Brabant province in the Southern Netherlands. A transportation and industrial center, its manufactures have included textiles and machinery. The city, founded in the 11th century as a principal stronghold of the Spanish Netherlands, had been captured by the Dutch in their struggle to free themselves from the government of Spain. Breda was besieged successfully by the Spaniards in 1624–1625, led by the Spanish general Ambrogio Spinola.

In the example below, the surrender of Breda's heroic garrison is shown with Spinola, as a mannered gentleman, accepting the keys of the city from the vanquished Justin of Nassau. The defeated Dutch on the left are an oppressed crew, while the proud and victorious Spanish army on the right is shown as powerful and formidable within its forest of vertical lances.

Example: Diego Velázquez, The Prado, Madrid. (Held and Posner, fig. 189)

SUSANNA AT THE BATH (*Susanna and the Elders*). Susanna was a romantic heroine who, with her exceptional beauty and innocence, was able to

triumph over evil. Her story can be found in the Old Testament Apocrypha. She was the extraordinary wife of a wealthy Jew who lived in Babylon. Her pristine goodness was as renowned as her beauty. It was, though, because of her beauty, that two elders of the community desired her and together plotted to seduce her. After they discovered that it was her habit to take her bath everyday outside in her garden, they hid behind plants and flowers. Waiting until she was completely naked and alone, her maids having been sent away, they revealed themselves and demanded that she lay with them. They told her that unless she did what they asked, they would reveal publicly that they had found her in the act of adultery. Such a crime would have caused her to face the penalty of death. But in spite of this threat, Susanna screamed for help. Even though the elders disappeared, they later carried out their threat, and Susanna was brought before a judge on false charges. She was found guilty and sentenced to death. Later, as she was led to her execution, a young man named Daniel interceded and complained that she had not been given a fair trial. Daniel then separated the elders and cross-examined each one alone. Since their stories had not been planned in detail, they gave conflicting evidence and Daniel was able to prove that they both lied and that Susanna was innocent. In the end it was the elders who were condemned to death and Susanna was set free.

In early Christian art, Susanna was a symbol of the saved soul. Her chastity was taken as a prefiguration of the Virgin Mary and the story of her acquittal was shown in art and told in stories during the Middle Ages to represent Justice. Some artists, however, have chosen to use Susanna as an opportunity to paint a sensuous nude in the setting of a bath. In Hebrew, Susanna's name means lily, a symbol for purity. She is most often shown as a beautiful nude woman, although rarely she is dressed while a maid washes her feet. She may show shyness or that moment of alarm when she discovers that the elders have been watching her. Some artists show the elders peeking out from behind bushes, and sometimes the stoning of the elders is shown in the background.

Example: Rembrandt van Rijn, Mauritshuis, The Hague. (Copplestone, colorplate 28)

SWEARING OF THE OATH OF RATIFICATION OF THE TREATY OF MÜNSTER. This picture was painted in Westphalia during the time when the negotiations for the peace treaty between Spain and Holland were being discussed. The Treaty of Westphalia ended the Thirty Years' War and gave the Netherlands complete independence. The painting is small, measuring about 18 by 23 inches. This size is extraordinary since the canvas, a depiction of the actual ceremony, contains over fifty portraits of plenipotentiaries and their retinues, as well as the artist's self-portrait. It was rare in 17th-century Dutch painting to depict a contemporary historical event. Although this work documented one of the most important episodes in the history of the Dutch people, apparently the artist, ter Borch, was unable to sell it, for the picture was still in his possession when he died. It is recorded that he asked 6,000 guilders for the work, which was about 4,500 guilders more than Rembrandt received for

his NIGHT WATCH; and possibly because he was offered less, he decided to keep it.

Example: Gerard ter Borch, National Gallery, London. (Rosenberg, Slive, ter Kuile, fig. 172)

SYNDICS OF THE CLOTHWORKERS' GUILD (*Syndics of the Cloth Drapers' Guild*). The wealth and prosperity of Amsterdam was based on the commercial success and solidity of the trading houses and guilds, and one of the most successful and important guilds was the Cloth Guild. The syndics, or business, agents were elected annually, and the individuals in this group portrait were those officials representing the year 1662 (it has not been established whether they are outgoing or incoming). The syndics are shown interviewing one of their members, and are all portrayed revealing a strong sense of responsibility toward him. Each individual is a separate and powerful portrait forming a part of a strong unit. The composition, unified by the warm scarlets of the table rug, is clear and simple; yet so clever is the design that the placement of it in relation to the proper significance of the men is such that each figure is emphasized in its own subtle way. Most historians agree that the painting is a dramatic interpretation of the technical mastery of the complexities of light and at the same time a serious interpretation of the human spirit.

Example: Rembrandt van Rijn, Rijksmuseum, Amsterdam. (Rosenberg, Slive, ter Kuile, fig. 89)

T

TEMPERANCE. With Fortitude, Prudence, and Justice, one of the four Cardinal Virtues formulated by Plato in the *Republic* 4:427 as being those virtues required of all citizens of an ideal city-state. In 1593, Cesare Ripa wrote his *Iconologia,* a treatise not in Latin but in Italian, that fixed the character of a great many religious and secular allegories in the 17th century. *Iconologia* describes in detail, and in some cases with illustrations, the important attributes belonging to each of the personifications. He wrote not only of the virtues and vices, but also of the four elements, the Liberal Arts and the parts of the world.

Temperance signified abstinence from alcoholic beverages and was depicted as a woman pouring liquid from one vase into another in the act of diluting wine with water. A torch, which may be held by a PUTTO, suggests sexual moderation or abstinence. A vessel of water may be close by, used to put out the burning flames of lust. Temperance, usually a beautiful young girl, may have a clock, symbolic of a well-disciplined, orderly life and indicating the triumph of work over pleasure. She may carry a sheathed sword, the hilt bound with leather cords, or a *putto* may carry it for her. She may carry a bridle in her hand, and some earlier artists have shown the bit in her mouth—an indication of extreme self-control—or a *putto* may carry the bridle for her, her discipline so firm she no longer has need for it. During the Baroque, palace ceilings were sometimes painted to extol the good qualities of cardinals and princes, and classical gods and goddesses were used as personifications of the virtues.

Example: Giovanni Baciccia, S. Agnese a Piazza Navona, Rome. (Waterhouse, fig. 62)

TEMPTATION OF ADAM AND EVE. The story of the temptation of Adam and Eve is told in Genesis 3:1–7 and forms a part of the story of the Garden of Eden in Hebrew mythology. ''Now the serpent was more subtle than any

other wild creature that the Lord God had made. He said to the woman, 'Did God say, "You shall not eat of any tree of the garden"?' And the woman said to the serpent, 'We may eat of the fruit of the trees of the garden; but God said, "You shall not eat of the fruit of the tree which is in the midst of the garden, neither shall you touch it, lest you die." ' But the serpent said to the woman, 'You will not die. For God knows that when you eat of it your eyes will be opened, and you will be like God, knowing good and evil.' So when the woman saw that the tree was good for food, and that it was a delight to the eyes, and that the tree was to be desired to make one wise, she took of its fruit and ate; and she also gave some to her husband, and he ate. Then the eyes of both were opened, and they knew that they were naked; and they sewed fig leaves together and made themselves aprons.'' The Temptation was seen by some to be a fore-shadowing of the ANNUNCIATION in which the Virgin Mary represented the ''new Eve'' and redeemed the sin of the old.

In art, the tree is usually a fig or an apple. A snake—the symbol of evil and biblical synonym for Satan—coiled about the trunk, has the head of a beautiful young girl. The snake may also have the torso of a girl. (This idea could be taken from the pre-Christian image of the serpent guarding the tree in the legend of Jason and the golden fleece and the golden apples of the Hesperides.) Adam and Eve stand before the tree or beside it. Eve holds the fruit, or she may pluck it from a lower limb. She may have already taken a bite and be in the act of offering it to Adam.

Example: Cavaliere Cesare D'Arpino, Fresco, Villa Aldobrandini, Frascati. (Held and Posner, fig. 76)

TEMPTATION OF ST. ANTONY. St. Antony, the abbot, was born in Upper Egypt, in 251, in a village south of Memphis. Because he was kept at home and never educated, he could read no language but his own. He found himself wealthy when his parents died, but he gave the money away and went into the Egyptian desert where he lived for many years. He became a model of humility and charity. He ate little except bread once every three or four days—and never before sunset—and drank only water. He slept on a bare floor or a coarse rush mat. Like other hermits who lived an ascetic life in the desert and ate little, Antony was subject to vivid hallucinations. Satan assaulted him and terrified him with gruesome noises and on one occasion beat him so brutally that he lay almost dead and would have died if not found by a friend. About the year 305, Antony left the desert and founded his first monastery in Faiyum, Egypt. He is usually regarded as the founder of monasticism. When the persecution was re-newed under Maximinus, Antony went to Alexandria to give courage to the martyrs.

Antony's ''temptations'' take two forms in art: erotic visions and the assault of grotesque and hideous demons. The women, his temptations, are usually young, beautiful and nude; and he either attempts to ward them off with prayer or shakes a crucifix in their direction. The hideous demons attack him and even

carry him aloft. Some artists show monsters and wild creatures, which tear his flesh and pull his hair. He is shown as an old man, bearded, wearing a monk's cloak and cowl. (He was, supposedly, one hundred and five years old when he died.) He has a tau-shaped handle on a stick he carries. (The tau, a T-shaped cross, known as the Egyptian cross, was a symbol of immortality in ancient Egypt.) Anthony may be accompanied by a pig, an animal bred by the Antonine monks during the Middle Ages—its lard said to have been used as a remedy for the disease that became known as St Antony's fire. (Erysipelas, an acute infection of the skin caused by the hemolytic streptococcus, was eventually named after the saint because he cured so many who had been stricken by it.) Antony may hold a bell, or the bell may hang around the pig's neck. (During the 17th century, pigs owned by the Hospital Brothers of St. Antony were given special grazing rights and were distinguished by the bell around their necks.) The bell, too, was commonly used to drive off evil spirits and alludes to Antony's temptations.

Example: Salvator Rosa, Palazzo Pitti, Florence. (Wittkower, fig. 212)

TEMPTATION OF ST. JEROME. Jerome is one of the four Latin (Western) Fathers of the Church. The son of a nobleman named Eusebius, his full name was Eusebius Hieronymus Sophronius. He was born in 342 in Stridon, a town on the borders of Dalmatia and Pannonia. He died in 420. According to the GOLDEN LEGEND, Jerome became a penitent in the desert. Some of his fellow monks made a mockery of him by placing a woman's garment beside his bed so that when he arose for Matins he put on the garment thinking it was his own. Thus, he went into the church and to the other monks it seemed as if he had had a woman in his chamber. His horror was immense. After receiving further instruction in the Holy Scriptures, under the guidance of Gregory of Nazianzen, the bishop of Constantinople, Jerome went into the desert. In a letter to Eustochium he wrote: " 'For as long as I dwelt in the desert, in that vast solitude, burnt with the heat of the sun, which provides a fearsome abode for the monks, I thought that I was in the midst of the delights of Rome. My twisted members shuddered in their sackcloth, my squalid skin was as black as an Ethiop's. Daily I wept, daily I groaned; and when sleep finally beat me down, my bare bones were bruised on the hard ground. Of food and drink I say naught, since even sick men drink cold water, and to them also it is somewhat of a luxury to eat cooked food. Yet, while I lived thus, the companion of scorpions and wild beasts, oft times I imagined that I was surrounded by dancing girls, and in my frozen body and moribund flesh the fires of concupiscence were lighted. For this I wept unceasingly, and subjugated the rebellious flesh with week-long fasts. Often I joined the days with the nights, nor stayed from beating my breast until the Lord restored my peace of spirit. . . .' His legend says that he remained a virgin through his life, although he himself writes as follows to Pammachius: 'I hold virginity as high as heaven, albeit I do not possess it.' "

Jerome is usually shown as an old man, emaciated, gray-haired and bearded.

As the penitent, he is shown partly naked, starved and unkempt, kneeling before a crucifix in the desert. He may hold the sharp stone with which he beat his breast. Nearby may be an hourglass and a skull. Beautiful women may stand before him playing musical instruments as he throws his thin hands and withered arms up against them.

Example: Francisco de Zurbarán. Hieronymite Monastery, Guadalupe. (Held and Posner, fig. 182)

TENEBRISM. From the Italian, *tenebroso,* or the "dark manner."

TENEBRISMO. A term found in Spanish painting so called because of a dramatic use of CHIAROSCURO (light and dark) to achieve the extreme lights and darks reminiscent of the style practiced by Caravaggio. One of the first Spanish artists to adopt this Baroque style was Fernández de Navarette, known as El Muto. Italian followers of Caravaggio's new style were known as *tenebrisi.*

TESTAMENT OF EUDAMIDAS. Lucian, in his second century A.D. work, *Toxaris,* a dialogue on friendship, cites the example of a citizen of Corinth called Eudamidas, who was wretchedly poor but who had friends of such quality that he was, he believed, a rich man. While dying, Eudamidas dictated his will which read: "I leave my mother to Aretaeus, to support and cherish her in her old age, and to Charixenus my daughter, to bestow in marriage with the largest dowry that he can give out of his own means." When Eudamidas died and the will was finally read, there were many who found it absurd. But the two men mentioned saw their inheritance as the fruit of their friendship and provided for Eudamidas' daughter and mother as well as they could. With this tale, Lucian speaks of the complete confidence of Eudamidas in his friends as one of the highest examples of the devotions and loyalties of friendship. The story of Eudamidas represents the ideal of friendship and the sternest Stoic moralities. It is interesting to note that Napoleon Bonaparte took a copy of this subject with him on his Egyptian campaign.

Eudamidas is shown lying on his deathbed. A physician is present and may feel his pulse or his chest. A scribe is shown usually writing as the dead man dictates the testament to him. The gloom and surroundings speak of wretched poverty. The walls are bare with possibly only the insignia of the *civis* (citizen), the round shield, a spear and crossed swords.

Example: Nicolas Poussin, State Museum of Art, Copenhagen. (Friedlaender, colorplate 35)

THERESA OF AVILA, ST. *See* ECSTASY OF ST. THERESA.

THISBE. *See* LANDSCAPE WITH PYRAMUS AND THISBE.

THOMAS, ST. *See* DOUBTING THOMAS.

THREE MARYS (*Three Marys at the Tomb* or *Three Marys at the Sepulcher* or *Holy Women at the Sepulcher*). All four gospels mention the holy women who found the tomb empty after Christ's resurrection: Matthew 28:1–8, Mark 16:1–8, Luke 24:1–11 and John 20:1–9. According to Mark: "When the Sabbath was past, Mary Magdalene and Mary the mother of James and Salome brought spices so that they might go and anoint him. And very early on the first day of the week they went to the tomb when the sun had risen. And they were saying to one another, 'Who will roll away the stone for us from the door of the tomb?' And looking up they saw that the stone was rolled back; for it was very large. And entering the tomb, they saw a young man sitting on the right side, dressed in a white robe; and they were amazed. And he said to them, 'Do not be amazed; you seek Jesus of Nazareth, who was crucified. He has risen, he is not here; see the place where they laid him. But go, tell his disciples and Peter that he is going before you to Galilee; there you will see him, as he told you.' "

The gospels do not agree as to who were the women who visited the tomb. Artists show three women and call them the Three Maries or *myrrhophores* or women bearing spices to the tomb of Christ. Accounts vary as to the angel or angels or the young man who announced to them that Christ had risen. The tomb, with the lid removed, is usually an empty sarcophagus (coffin) and may be beside a dark cave.

Example: Annibale Carracci, The Hermitage, St. Petersburg. (Held and Posner, fig. 97)

THREE MUSES. Muses, companions of Apollo, were the goddesses of creative inspiration in song, poetry and other arts. They were the daughters of the Titaness Mnemosyne (Memory) and Jupiter (Zeus). Originally the muses were nymphs who presided over springs that had the power to provide inspiration, especially Hippocrene and Aganippe on Mount Helicon and the Castalian spring on Mount PARNASSUS. Thus, flowing streams and fountains are sometimes shown in pictures of the muses. Nine muses were part of Apollo's retinue: Clio of history, Melpomene of tragedy, Calliope of epic poetry, Thalia of comedy, Terpsichore of dance, Erato of love verse, Polyhymnia of sacred songs, Urania of astronomy and Euterpe of lyric poems. Their attributes have changed over time, and thus identification is sometimes impossible. From the Baroque period the attributes given in Ripa's *Iconologia* are generally accepted.

Euterpe, the muse of music and lyric poetry, is recognized by her flute and, from the 17th century, a garland of wild flowers around her head. Melpomene, the muse of tragedy, is shown with her tragic masks, and, from the 17th century, she may hold a dagger or sword or hold a crown in her hand. Calliope, muse of epic poetry, can be recognized by her trumpet, and from the 17th century,

she may hold a laurel crown and a book. They sit in a secluded mountain valley beside a running stream under the shade of several trees. Euterpe plays her flute while Melpomene and Calliope listen.

Example: Eustache Le Sueur, The Louvre, Paris. (Blunt, fig. 258)

TIMOCLEA AND ALEXANDER. The story of Timoclea and Alexander is told by Plutarch in his *Lives of the Ancient Kings, Statesmen and Philosophers* 33:12. A matron of Thebes, the Greek city sacked by Alexander, Timoclea was raped by one of his captains, but avenged herself successfully. This occurred after some Thracian soldiers broke into the home of Timoclea, a woman known as a person of excellent character and high repute. The soldier's captain, after abusing her, to satisfy not only his greed but also his lust, asked her if she knew where any money was concealed. She told him she did and asked him to come into her garden. Here she showed him a well. She told him she had thrown everything she had of value into the well when she saw that the city was being taken. When the Thracian soldier leaned over the edge of the well to see her valuables, Timoclea sneaked up behind him and shoved him into the well. Then she threw huge stones down upon him until he was dead. After this, his soldiers bound her and took her to Alexander. He saw right away that she was a woman of dignity and education and was astonished that she showed no fear. He asked her who she was, and she told him she was the sister of Theagenes, who had fought in the battle of Chæronea with his father, Philip, and that her brother had died there for the liberty of Greece. Alexander, impressed at what she had done and what she said, told her he would give her and her children their freedom to go wherever they desired.

Timoclea is depicted, with her children, being brought before Alexander. Recognizing a woman of spirit, he lets her go free.

Example: Domenico Zampieri Domenichino, The Louvre, Paris. (Friedlaender, fig. 19)

TITUS. Titus was Rembrandt's son and the only child of his wife, Saskia, to reach maturity. He was one of the artist's favorite subjects, perhaps second only to his housekeeper, Hendrickje Stoffels, the daughter of a soldier and his "second wife." (The relationship, however, was never legalized because of conditions set forth in Saskia's will.) Titus was portrayed most frequently during the 1650s. In 1665, the date of this portrait, he is a deeply thoughtful fourteen-year-old boy. His death in 1668 was a tremendous blow to the aging artist.

Example: Rembrandt van Rijn, Boymans-Van Beuningen Museum, Rotterdam. (Rosenberg, Slive, ter Kuile, fig. 82)

TITUS (Roman Emperor). *See* TRIUMPH OF TITUS.

TOBIAS AND THE ANGEL. The story of Tobias, the son of Tobit, and his adventures with his companion and guardian, the archangel Raphael, are found in the Book of Tobit. The complete Aramaic original of Tobit has not survived,

and it was not included in the Jewish canon at the end of the first century A.D. Tobit was written in Egypt and exhibits a strictly Jewish doctrine. Some scholars believe it may have a historical basis; however, events and dates, persons and places have been woven into the narrative in such a way as to have little resemblance to the actual historical record. It seems that the writers may have used historical material to impart a religious message. The story begins in 8th century B.C. Nineveh during the time of Jewish exile in Assyria. Here, Tobit lived with his wife, Anna, and their son. One day as he lay in an open field, bird droppings fell into his eyes, and the resulting infection blinded him. Tobit, feeling that death was near, instructed his son, Tobias, to made the journey to Medina to collect money owed him. When Tobias searched for a companion with whom to travel, he met the archangel Raphael, who went with him. Tobias thought Raphael only an ordinary mortal. They both received Tobit's blessing and left on their journey. Tobias's dog followed.

At the River Tigris, Tobias stopped to wash, and a monstrous fish there would have eaten him except that Raphael told him to catch it, gut it and set aside the gall and liver. This he did. According to Raphael, these entrails were used for warding off evil spirits and the gall would cure Tobit's leucoma (from the Greek meaning white, or colorless; hence, a thick white opacity in the cornea of the eye). Tobias collected the debt money at their destination, and then Tobias and the angel went to stay with a kinsman whose daughter, Sarah, was of the appropriate age to be a bride for Tobias. Sarah, though, was bewitched by a demon that had already caused the death of seven previous husbands before the marriages had been consummated. Tobias married Sarah, and the demon was exorcised with the burnt fish's offal. The couple returned to Nineveh, where Tobias successfully used the fish's gall to restore his father's sight. At this time Raphael revealed his identity, and Tobit and Tobias fell down before him. This is a story of a family dwelling among a pagan people yet trusting fully in God in spite of enormous difficulties.

Tobias is shown as a young boy being directed and helped by the archangel Raphael across the slow-flowing river. Both are dressed as travelers, and Tobias carries a walking stick. Following is the dog, an animal regarded as unclean by the Jews and an unusual feature. One must note that the dog is seldom represented elsewhere in the Bible as man's friend. The fish mentioned is thought to have been a crocodile, whose heart and liver were taken in ancient magic and used as a charm against demons. Tobias carries the fish in his right hand. The later healing of Tobit's blind eyes is depicted by some artists as a kind of anointing. Some 17th-century northern painters show a surgical operation. This is probably taken from the use of the word in the Dutch Bible for the "whiteness" in Tobit's eyes. Tobit's blindness is a subject in votive paintings paid for by victims of leucoma in the hopes that their sight will be restored. *See also* TOBIT AND ANNA.

Example: Hendrick Goudt, Engraving, Rijksmuseum, Amsterdam. (Rosenberg, Slive, ter Kuile, fig. 194)

TOBIT AND ANNA. Tobit is a biblical book that follows Nehemian in the Western canon. It is not included in the Hebrew Bible but is included in the Apocrypha in the Authorized Version. It tells of Tobit (Tobias in the Vulgate), a pious Jew in exile, and of his wife, Anna, and his son, Tobias. Despite his many good works, Tobit is accidentally blinded by bird droppings as he sleeps in a field. His agony is so great he asks God to take his life. Concurrently, in Ecbatana, a woman Sarah, who is plagued by a demon, Asmodeus, who has killed her seven husbands on their wedding day, also asks God to take her life. God hears both invocations and sends the archangel Raphael to help. The young Tobias is sent by his father on business to a distant city. He, along with his dog, is guided by the archangel Raphael (in the form of a young man) to the house of Sarah. There Tobias meets and marries Sarah and, following the arch-angel's instructions, exorcises her evil demon. They return to his home, where the young man is able to cure his father's blindness. The book concludes with a prophecy by the father that Jerusalem will be restored. The story inculcates ideals of prayer, marriage between Jews and good works. The ancient texts are of great diversity; hence, the different English versions differ materially in detail. The original language of the book is not known. The book was written after the Exile at some time during the Persian period, though the story is probably older than that.

Anna, the mother of young Tobias, is shown as an old woman presenting a young animal to Tobit, who, dressed in rags and still blind, prays.

Example: Rembrandt van Rijn, Baroness G.W.H.M. Bentinck-Thyssen-Bornemisza, London, on loan to the Rijksmuseum, Amsterdam. (Rosenberg, Slive, ter Kuile, fig. 48)

TOILET OF VENUS. Venus, the Roman goddess identified with the Greek Aphrodite, was, in the beginning, an unknown Italian deity whose name meant "charm" or "beauty." She is connected with the classical Latin adjective *ven-ustus.* Her Greek name, Aphrodite, may be taken from *aphros,* which means foam. Venus was concerned with agricultural, not animal, fertility. (No evidence exists that she had anything to do with animal fertility.) Venus was born at sea, created from the foam originated by the genitals of the castrated Uranus when they were thrown to the waters. She floated ashore on a scallop shell steered by sea breezes. She landed at Paphos in Cyprus, one of the principal seats of her worship in antiquity. According to Hesiod in his *Theogony* (188–200), as the deity of love, particularly sexual love, Venus was first identified with Aphrodite through the cult of Aphrodite on Mount Eryx in Sicily, which had been tradi-tionally founded by Aeneas after the death of his father, Anchises. She was the mother of Cupid and her attendants were the Three Graces. From 217 B.C., Venus Erycina had a temple in Rome, and Venus took on all the functions and associates of Aphrodite. She was important in the official state cult because the Julian family (of which Nero was the last member to be emperor) claimed descent from Aeneas, who was the son of Aphrodite. In this she is Venus Ge-netrix, the limitless mother and creator of all living things, whom Lucretius

addresses in the opening words of his *De rerum natura,* and whose festival is renowned in the late Latin poem *Pervigilium Veneris.*

In the Middle Ages Venus was known both as Anadyomene (rising from the sea, where she is shown standing and wringing water from her hair) and as Genetrix (mother of the *gens Iulia*). More often she is identified with the medieval sin of *luxuria,* or carnality. She is usually shown gazing into her mirror as a symbol of idle coquetry to be overcome by Chastity. In the allegorical Battles of the Soul, for which the *Psychomachia* of Prudentius was the model, she is always shown with the vices; and this interpretation continues into the Baroque. Her many attributes include swans or pairs of doves, which may draw her chariot; dolphins and the scallop shell (both allude to her birth from the sea); a flaming torch and a magic girdle (both of which kindle love) and a flaming heart. Sacred to her are the myrtle (evergreen like love) and the red rose stained by her blood.

The nude Venus may be shown in a number of different poses, reclining, sitting or standing. Some standing poses such as the *Venus Pudica,* or Venus of Modesty, originated in the religious art of antiquity. In this pose, Venus stands with one hand covering the pubic area while the other covers the breasts. In the *Toilet of Venus,* she is shown young and beautiful gazing into a mirror held by her son, Cupid. The Three Graces may attend her. Her doves are usually at her feet.

Example: Johann Liss, Collection Schoenborn, Pommersfelden, Germany. (Held and Posner, colorplate 10)

TOMBS. The tomb occupies an important place during the Baroque, at which time innovations became noticeable and important. After the COUNTER REFORMATION, especially in Catholic countries, a recognized stress was placed upon dying as a release from the pains of this world and the spectacular features of death were emphasized. In the early 17th century, Papal tombs as usual displayed the seated pope offering the blessing above two life-sized allegorical figures.

Gian Lorenzo Bernini changed this tradition. His *Alexander VII,* carved in 1671, dramatizes Death rising up from a dark prison and striking the pope down while in prayer. At this time, richly colored and veined marbles became common. Bernini's *Fonseca* of 1668–1675 shows a half-length portrait of the man yearning with rapture for death. Death carrying away a medallion portrait of the deceased emerged first in Italy; but the "Death in action" subject was more highly developed in Flanders. The zenith of the Italian Baroque is considered by some to be the funerary chapel of the Cornaro family in Sta. Maria della Vittoria in Rome, where Bernini placed statues of the family in two loggias observing the ECSTASY OF ST. THERESA; even more unusual, no sarcophagus accompanies the dramatic display. If the Italians were dramatic to the extreme, the French were varied. Some depict the deceased alive, others, in the act of dying. Cardinal Mazarin (in the Louvre) kneels above attendant Virtues;

in Les Invalides in Paris, Marshal Turenne succumbs to Death in the arms of victory; At the Sorbonne, Cardinal RICHELIEU dies on his bier accompanied by grieving Allegories. Some sculptors showed angels pointing to heaven or flying down with crowns of glory, implying a theme of certain resurrection. Biblical figures are not shown. In the north, in Flanders, the deceased often kneels and looks at the Virgin with her Child. The lamenting *putti* (*see* PUTTO) theme, popular throughout Europe in the 17th century, appears in incalculable smaller tombs, often with a bust, and continues into the Rococo of the 18th century.

TONDO. Italian for round, a *tondo* (plural *tondi*) is a relief carving or any kind of picture in a circular shape. Although the *tondo* became popular in Italy in the mid-15th century, earlier examples are known. The circular shape was used during the Barogue and is still a favorite.

TOPOGRAPHICAL ART. A term used for graphic and pictorial art that is produced to show towns, buildings, places in general and natural prospects. Topographical art is distinguished from landscape (into which it sometimes merges) by the fact that it is closer to a craft whose object is to provide information. Landscape, on the other hand, is produced primarily for aesthetic enjoyment. During the latter half of the 17th century, a growing interest in the picturesque and in idealized nature emerged; topographers used a more refined and atmospheric style of painting. The reproduction of natural views was promoted. In France, the work of Israël Silvestre (1621–1691), who became drawing-master to the dauphin (eldest son of the king of France), is among the most insightful at this time. His ETCHINGS of ceremonies, fêtes and architectural works are revered for the historical information they provide. In England, Jan Vorstermans (1643?–1699?) may also be noted for his fine views of Windsor in mid-century.

TREE OF JESSE. In the Bible, Jesse is the descendant of Rahab, the grandson of RUTH AND BOAZ and the father of David. Because Jesse was ancestor of the house of David, a custom of medieval artists was to show the genealogy of Jesus as beginning from him and also beginning with his mother, the Virgin Mary. The prophecy is from Isaiah 11:1–3 that a Messiah would spring from the family of Jesse, the father of David: "There shall come forth a shoot from the stump of Jesse, and a branch shall grow out of his roots. And the Spirit of the Lord shall rest upon him, the spirit of wisdom and understanding, the spirit of counsel and might, the spirit of knowledge and the fear of the lord. And his delight shall be in the fear of the Lord. He shall not judge by what his eyes see, or decide by what his ears hear." Jesse as the ancestor of the house of David also appears in the gospel genealogy in Ruth 4:17–22, 1 Samuel 16:1–22, 17:12–58, 1 Chronicles 2:12–13, Isaiah 11:1–10, Matthew 1:5–6 and Luke 3:32.

The subject was interpreted visually in the Middle Ages as a genealogical

tree, often executed in the stained glass of cathedrals (the "Jesse window" at Chartres in France and at Wells in England, for example). The typical window showed the figure of a reclining Jesse with a tree rising from his loins. On each branch appear the ancestors of Christ. The whole terminates in the Virgin Mary and the Savior, Jesus. Artists of the 17th century presented the subject differently. David is shown with his harp; the Virgin, with the infant Jesus in her arms, wears a crown and sits on the uppermost branch of the tree; on either side are usually the prophets Jeremiah and Isaiah. Jeremiah 23:5 also tells of the coming of a Messiah: "Behold, the days are coming, says the Lord, when I will raise up for David a righteous Branch and he shall reign as king and deal wisely, and shall execute justice and righteousness in the land." The tree of Jesse may also be shown as an attribute of the Virgin Mary, in which case it takes the form of a branch wound with blooming flowers. This is the genealogical tree of Christ, stemming from Jesse.

Example: Jean Tassel, Museum, Troyes. (Blunt, fig. 208)

TRINITY IN GLORY. Latin from the meaning three-foldness, the Trinity is the fundamental doctrine of Christianity by which God is of one nature yet existing in three persons, all coequal, coeternal and indivisible, of the same substance: God the Father, God the Son (who became incarnate as Jesus) begotten of the Father, and God the Holy Ghost, proceeding from the Father and the Son. The Trinity takes its authority from Matthew 28:19, who says, "Go therefore and make disciples of all nations, baptizing them in the name of the Father and of the Son and of the Holy Spirit." Also, the doctrine was discussed by Augustine in the *De Trinitate.* The Trinity is a mystery: that is, its nature cannot be fully understood or known by human intelligence. It is therefore called a truth of revelation.

The theme does not exist in primitive and early medieval religious art, a fact the Church explains by its resistance to represent in a realistic manner the first person of the Trinity, who, never being seen, was unrevealable. Symbols, therefore, were used. Originally God the Father was shown as an all-seeing eye or a powerful hand emerging from clouds. The Holy Ghost was seen as a white dove. God the Father came to be seen as a powerful old man who sometimes had a triangular halo, the three sides of which referred to the Trinity. Christ may sit on the right side of God, with God slightly above, elevated and enthroned on clouds. Beside Christ a dazzling multitude of angels may hold the Symbols of the Passion (*see* PASSION OF CHRIST). High above in heaven, the Holy Spirit hovers.

Example: Pietro da Cortona, S. Maria in Vallicella, Rome. (Wittkower, fig. 157)

TRIUMPH OF BACCHUS. *See* LOS BORRACHOS.

TRIUMPH OF BACCHUS AND ARIADNE. Ariadne was the daughter of King Minos of Crete. She fell in love with Theseus when he came to the island

of Crete. She helped him plot and kill the Minotaur imprisoned in the labyrinth beneath her father's palace that had been designed by Daedalus. After Theseus had killed the Minotaur, Ariadne helped him escape from the labyrinth with the aid of a magic ball of string she had gotten from Daedalus. In return he abandoned her. According to Ovid's *Metamorphoses*: 8:174–179: "Immediately he [Theseus] set sail for Dia, carrying with him the daughter of Minos; but on the shore of that island he cruelly abandoned his companion. Ariadne, left all alone, was sadly lamenting her fate, when Bacchus put his arms around her, and brought her his aid. He took the crown from her forehead and set it as a constellation in the sky, to bring her eternal glory."

Artists depict their triumph as a procession that is packed with merrymaking figures. It is usually led by the Greek rural god Silenus, one of the retinue of BACCHUS, who may ride his donkey and be so drunk that he is held on both sides by SATYRS or revelers. Some artists depict him drunk and still drinking on a cart drawn by a donkey. Satyrs and Maenads blow syrinxes and pipes and crash cymbals. *Putti* (*see* PUTTO) fly back and forth overhead with wine cups and jugs. Bacchus, riding in his car and holding a thyrsus, follows. Ariadne may be with him or riding in her own chariot.

Example: Annibale Carracci, Fresco, Gallery, Palazzo Farnese, Rome. (Wittkower, fig. 20)

TRIUMPH OF DAVID. The story of the triumph of David is told in I Samuel 18:6–7: "As they were coming home, when David returned from slaying the Philistine, the women came out of all the cities of Israel, singing and dancing, to meet King Saul, with timbrels, with songs of joy, and with instruments of music. And the women sang to one another as they made Merry, 'Saul has slain his thousands, and David his ten thousands.' " David returned triumphantly from battle carrying Goliath's severed head, after killing the Philistine with a stone flung from his sling. According to I Samuel 50, "there was no sword in the hand of David." David took the head to Jerusalem. The Israelite women came from their homes dancing, playing musical instruments and singing.

David is shown carrying Goliath's huge head high on the point of a spear or a sword or in his hand. The wound that killed the Philistine is in the center of his forehead. David usually walks and is accompanied by women who dance happily and look at him in amazement. Several men may play musical instruments and others look on from a different vantage point—the stairs of a temple, for example.

Example: Nicolas Poussin, Dulwich College Picture Gallery, England. (Friedlaender, fig. 18)

TRIUMPH OF FLORA. FLORA is the ancient and amiable Italian goddess of spring and flowers and blossoming plants. The Floralia, her festival, was celebrated with utter sexual abandon, unrestraint and wantonness. Flora's festival is not in the calendar of Numa, and therefore was movable. However, in

238 B.C., by the advice of the Sibylline books, a temple was dedicated to her on April 28 and games were then celebrated annually. "Games" included dissolute farces (*mimi*) of a shameless and vulgar character.

The lewd festival, or "triumph," is depicted as a crowded procession led by a debauched and dancing Venus. In honor of the celebration, Venus has lent to Flora her *Amoretti* (*see* AMORETTO). Nude and lustful, they gaily pull her golden chariot and gather flowers to make her crown. Behind Venus is Adonis, her lover, who carries the red anemones that she later caused to spring from his love. Adonis, sometimes with his spear and his hunting dogs, offers his flowers to Hyacinthus, who, mortally wounded in the head in his game with Apollo, bends down so that a PUTTO may place a wreath on his head. Flora accepts the tribute of Ajax, the warrior metamorphosed into the larkspur. Also included is NARCISSUS, who also offers his flower. Clytie (who became a sunflower or a marigold), in love with the sun (Apollo) beyond all measure, is depicted in the right foreground, bending down to pluck heliotrope. As described in Ovid's *Metamorphoses* IV:283, the two reclining figures at the left may be Smilax and Crocus, both of whom were changed into tiny flowers.

Example: Nicolas Poussin, the Louvre, Paris. (Bazin, fig. 111)

TRIUMPH OF NEPTUNE AND AMPHITRITE. Neptune is the Roman god of earthquakes and water, who ruled the sea and all its inhabitants. He was worshipped on all occasions connected with the sea and navigation. His Greek name is Poseidon, interpreted as "Husband of earth," or "Lord of earth." Being a great god, sailors invoked him before long voyages to ensure a safe trip; when angered, however, Neptune could cause stormy seas and shipwrecks. He is usually depicted as an old man with long hair and a beard and can be serene and noble. Some Baroque artists showed him as haggard and wrinkled, with long hair streaming in the wind. He carries a trident—a three-pronged fork—and sometimes a fish or a dolphin; thus, without attributes, he is hard to distinguish from Zeus. His wife is the Nereid, or sea nymph, Amphitrite, the official queen of the sea. Their son, Triton, a merman, may be shown blowing a conch horn.

Neptune's triumph was his capture of Amphitrite after she fled his wooing. She ran to the limits of the sea and was caught at Atlantis. He sent dolphins after her, and she was brought back to become his bride. She is shown riding beside his chariot on a large cockle-shell car drawn by dolphins and surrounded by a retinue of nereids and tritons. *Putti* (*see* PUTTO) fly overhead strewing flowers and shooting arrows; one holds a torch to light the way (a motif related to nuptials). A fluffy cloud above may come from the smoke of the *putti*'s torch. Neptune stands on his chariot drawn by four wild and eager horses. The scene of Neptune's triumph may be filled with cavorting nereids and other tritons—the name for mermen in general who may have normal legs instead of fish tails. A *putto* on the back of a dolphin leads the way.

Example: Nicolas Poussin, Philadelphia Museum of Art. (Friedlaender, colorplate 20)

TRIUMPH OF PAN. This scene of triumph, shows a HERM of Pan placed behind a stage filled with figures who engage in orgiastic merry-making—drinking, making music, riding goats, eating. Pan is garlanded by a lovely bacchante (worshipper of BACCHUS), who kneels on a goat and reaches into a small basket held by a PUTTO. Pan and the bacchante are flanked by two maenads, one carrying a dead, upside-down fawn on her shoulder, the other playing a large tambourine. A corybant (a reveler) blows a long, thin trumpet and a maenad, riding a brown and white goat (the attribute of lust personified) with a heavy collar, turns to pluck flowers from a tray carried on the head of a kneeling SATYR. At the same time, she is embraced from behind by a garlanded satyr who smiles into her face. Before the Herm of Pan, a nymph is playing with and pulling the hair of a satyr who has fallen at her feet, and on the right, two youths struggle to lift a drunken satyr. Before the scene is all manner of bacchanalian (*see* BACCHANAL) paraphernalia: vases, masks, pipes, bowls, tambourines, baskets and cloths—all reminiscent of the poetry of Catullus, as well as ancient sculptures. The stage is set against a screen of tall dark tree trunks through which a mountain scene spreads in venetian golds and reds and bronzes.

Example: Nicolas Poussin, Morrison Collection, Sudeley Castle, Gloucestershire. (Friedlaender, colorplate 19)

TRIUMPH OF SAMSON. *See* SAMSON.

TRIUMPH OF SILENUS. In scenes of the triumph of Silenus, the rural god, one of the retinues of BACCHUS, is shown as a fat, happy old drunkard. He is completely naked, usually holding a pitcher of wine and riding his donkey or on foot, usually borne along by a crowd of SATYRS, who hold branches and grapes and sticks. Silenus may be depicted with one leg over a large striped cat. Within the crowd of merrymakers are maenads with cymbals. Ivy, sacred to Bacchus, trails behind them or is tangled in their hair. The foreground is strewn with cloths, musical instruments, a shepherd's staff and an urn for wine. For these motifs artists drew upon ancient literature, such as the poetry of Catullus, as well as the BAS RELIEFS on ancient sculptures.

Example: Painting after Nicolas Poussin, National Gallery, London. (Friedlaender, fig. 101)

TRIUMPH OF ST. IGNATIUS. *See* GLORY OF ST. IGNATIUS; *see also* ENTRANCE OF ST. IGNATIUS INTO PARADISE.

TRIUMPH OF THE BARBERINI. The Barberini was an important Roman family. The "triumph" celebrates the family's virtues and glories and also reveals the secularizing trends of the seventeenth century. The iconographic program was created by the poet Francesco Bracciolini. Mythological scenes depict, through allegory, the virtuous accomplishments of the then reigning Barberini pope Urban VIII, a Florentine named Maffeo Barberini, who succeeded Gregory

XV. Throughout Urban's pontificate the Thirty Years War raged throughout Germany. For different political reasons, the pope gave scant help to the Catholics. His policy in Italy was ineffectual, and he was disgraced by defeat at the hands of the Farnese of Parma. Urban was extremely active in church affairs: he conventionalized liturgical practice, published the revised breviary, supported the reformation of the church and established new orders. He built and refurbished extensively in Rome. He authorized the condemnation of Galileo (who was tried in 1633 for saying the earth was a moving body revolving with the other planets about the sun), but later freed him. He condemned the posthumous work of the Dutch Roman Catholic theologian Cornelis Jansen (1565–1638), *Augustinus,* from which arose the movement called Jansenism. Urban's strict legislation against easy acceptance of miracles is still in effect.

During the 17th century, the ceiling of a palace was frequently painted to pay tribute to the qualities of a cardinal or a pope by use of the conventional personifications of the virtues and the classical gods. In illustrating the classical pantheon and the females that stood for the virtues and vices, Baroque artists had available for their guidance a number of dictionaries of mythography published towards the end of the Middle Ages and afterwards. Francesco Bracciolini, court poet from Pistoia, was responsible for the program of the Barbarini ceiling. He devised an intricate story in terms of mythology, allegory and emblematic conceits. In this illustrated *Triumph of the Barberini,* Divine Providence, or Wisdom, floats just below center in a luminous aureole. Elevated on bulging clouds above, Time and Space (Chronos and the Fates) hold a book and the eternal flame of Wisdom, who requests Immortality to add the star-filled crown to the Barbarini bees (themselves the emblems of Divine Providence). The bees fly in the formation of the Barberini coat of arms. They are surrounded by a laurel wreath held by the three theological virtues (so as to form a cartouche): Faith (holding her cross and sometimes a candle as the light of faith), Hope (her attribute a crow because it calls "Cras, cras," Latin for "tomorrow, tomorrow"), and Charity, her common attribute at this time being the pelican feeding its young with her own blood. The laurel is another Barberini emblem. In antiquity the laurel was the tree from which the victor's crown was fashioned. Immortality, her symbol also the laurel, flies to set a crown of twelve stars upon the family coat of arms, while above, two more crowns are offered: a large, jeweled papal tiara held by a PUTTO, glowing in incandescence, and the poet's laurel (Urban VIII was known as a gifted poet). The figures flow in undulating waves between the five sections. The vault is merged with otherworldly light and glowing atmosphere that, together with the continuity of movement, fuses the spectator's space with the imaginary space of allegory and mythology. The entire illustration is an illusion to the immortality, fame and poetical gifts of Urban VIII. The visually persuasive conceit tells us that Urban, the poet-pope, chosen by Divine Providence and himself the voice of Divine Providence, is worthy of immortality. The four scenes along the cove, accessory to the central one, are like a running commentary on the temporal work of the pope. They

illustrate, in the traditional allegorical mythological style, his courageous fight against heresy (Pallus destroying Insolence and Pride in the shape of the Giants), his piety that overcomes lust and intemperance (Silenus and SATYRS), his justice (Hercules driving out the harpies), and his prudence, which guarantees the blessings of peace (Temple of Janus). The entire work is in the tradition of QUADRATURA.

Example: Pietro da Cortona, Ceiling fresco, Gran Salone, Palazzo Barberini, Rome. (Waterhouse, figs. 40–42)

TRIUMPH OF THE NAME OF JESUS. *See* ADORATION OF THE NAME OF JESUS.

TRIUMPH OF THE NAME OF MARY. Mary is the name of the virgin mother of Jesus, called Our Lady or the French *Notre Dame,* to which many of the cathedrals in France are dedicated. Her name in Hebrew is Miriam. Several events of her life are mentioned in the New Testament: Matthew 1:18–25, Luke 1:26–56, John 2, Mark 3:31–35 and 6:3, Luke 11:27–2, Matthew 12:46–50, John 19:25–27 and Acts 1:14. Events of her life mentioned in scripture include the ANNUNCIATION to her of Jesus's birth, the visit she made to Elizabeth, the mother of JOHN THE BAPTIST, the NATIVITY, or birth of Christ, her purification at the Temple and her place at the Cross during the CRUCIFIXION. Also according to the new Testament, she was first betrothed, then married to Joseph and was the cousin of Elizabeth. According to Voragine's GOLDEN LEGEND, Mary was the daughter of St. Anne and St. Joachim. She was announced miraculously to them and was said to have been conceived and born without original sin. She was presented at the Temple as a virgin and later betrothed to Joseph. After the Crucifixion of her son, she was cared for by JOHN THE EVANGELIST and after her death, she was "assumed" into heaven (known as the ASSUMPTION OF THE VIRGIN). From early Christian times, Mary's intercession was thought to be especially effective on behalf of Christians and the Church; she has been called upon throughout the history of Christianity to meet the needs of all individuals. A blinding burst of light surrounding a large M, topped with a crown and a Latin cross, hovers beneath the arms of God in heaven. Angels and saints watch in adoration.

Example: Filippo Gherardi, Ceiling of the nave of S. Pantaleo, Rome. (Waterhouse, fig. 64)

TRIUMPH OF TITUS. Titus Flavius Sabinus Vespasianus, born September 39, 71 A.D., was Roman emperor from 79 until his death in 81. The son of the emperor Vespasian, he played an unusually active role in his father's military campaigns. He became coruler with the emperor in 71. By 70 he had served in Germany and in Britain and in August, 70, he captured Jerusalem. For this his troops saluted him "imperator," a title of honor, and he was crowned at Memphis on his way home. His independent triumph was turned into a joint triumph

with his father and because of this he was made a partner in Vespasian's rule. Ruthless in suppressing disaffection, however, he became unpopular. He succeeded Vespasian, who died June 23, 79, without challenge. Titus completed the Coliseum in Rome and had the luxurious baths built that carry his name. During his reign two great disasters occurred: the eruption of Vesuvius in 79 A.D., which buried Herculaneum and Pompeii, and the great fire and plague in Rome. During both disasters, Titus had repairs made and was generous with aid to the wounded and the homeless. Some work was done with his own personal largesse. It was during this time also that there were no executions. It has been suspected that he died of poisoning, but most scholars believe he died of natural causes September 13, 81.

The *Arch of Titus,* which today stands outside the ancient entrance to the Palatine, was built by Domitian to commemorate Titus's brilliant conquest of Jerusalem. On the inner walls of the arch is located the bas relief *The Triumph of Titus.* Depicted are marching soldiers carrying the spoils from the Temple of Jerusalem and Titus in his chariot drawn by four prancing horses. The event was described by Josephus, a contemporaneous statesman, Jewish soldier and statesman. He said that most of the treasures were piled up in a nondescript heap; but more astonishing than all the rest were those taken from the Temple of Jerusalem—a table of gold weighing several hundredweight and a lamp of gold. A tall column was attached to the base and from this shaft several branches sprang like the prongs of a trident. Each prong was forged into a lamp. There were seven in all, indicating the honor paid to that number by the Jews. After all this splendor came the last of the spoils, the Jewish Law. Next came a group bearing all sorts of ivory and gold images of victory. Finally, Vespasian drove by and Titus was behind him. Domitian, on a splendid horse, rode alongside.

Example: Nicolas Poussin, Drawing, National Museum, Stockholm. (Friedlaender, fig. 5)

TROMPE L'OEIL. *Trompe l'oeil* means "eye fooling" in French. It is a kind of illusionistic painting (*see* ILLUSIONISM) that attempts to represent an object in such a realistic way that it seems to exist in three dimensions at the surface of the painting. The true measure of success is in its ability to deceive the eye. The authentic *trompe l'oeil* painting is, of necessity, a painting of shallow depth in terms of perspective, as it is restricted in subject matter to surfaces that lie in or near the picture plane. One usually sees such objects as a postage stamp, a deck of cards, a letter or some such object pinned to a board, or a BAS RELIEF sculpture. It is an easy matter for the eye to detect the absence of parallax in representations of objects of greater dept. The deceptions work if the *trompe l'oeil* is placed where it can be seen from only one point of view and at a designated distance. Stories exist of miraculously real *trompe l'oeil* works that astonished and tricked even the most practiced eyes. During the Baroque entire walls and ceilings were painted with exaggerated and dramatic illusions.

Caravaggio's bowls of fruit or flowers sometimes included insects and drops of water that could fool the most practiced eye.

Example: Caravaggio, *Boy Bitten by a Lizard,* Longhi Collection, Florence, Italy. (Bottari, figs. 6, 7)

TWO PANTALOONS. During the 17th century a type of comedy known as *commedia dell'arte* flourished in Italy. This popular form of enjoyment involved improvised dialogue and masked characters. It had tremendous influence on European drama that can be seen especially in French pantomime and in the English harlequinade. In 1661 a company called the *Comédie-italienne* was established in Paris. So thoroughly convincing were the characters that many of the actors used the character's name in everyday life. The zanni, or servant types, were the plot weavers whose job it was to arouse laughter. Pantalone, or Pantaloon, was a caricature of the Venetian merchant—miserly, cruel, retired and wealthy. He usually had an adventurous daughter or a young, spirited wife. In the example below, he is shown with his chin thrust forward upon which grows a pointed beard. In the background are the ladies and gentlemen of Florence out for a walk dressed in their richest finery. Their movements are so exaggerated that they seem to be taking part in a ballet.

Example: Jacques Callot, Etching, British Museum, London. (Blunt, fig. 148)

U–V

URSULA, ST. *See* EMBARKATION OF ST. URSULA.

VANITAS. *Vanitas* (Latin meaning "emptiness") belongs to the Spanish tradition of allegorical scenes of Vanity that reach back to Netherlandish late medieval art. Vanity is used not in the sense of pride or self-admiration, but to indicate the futility, the uselessness of earthly possessions. Piled haphazardly on a table are the symbols of materialism, of worldly culture, of power, wisdom and wealth: pearls, jewels, books, money, crown, sceptre; but a frightening skull, tipped on its side, is there also to remind us that we all must die. If a sword is included, it is a reminder that a weapon is no protection against death. Flowers, especially with water drops on the petals and leaves, are symbols of the brevity of life and, hence, an indication of decay. A cup or vase on its side is symbolic of the literal meaning of *vanitas,* emptiness. A PUTTO may sit alone blowing bubbles, a symbol of the passage of time, the shortness of life, pointing out the futility of earthly ambitions and accomplishments. A terrestrial globe indicates the world we inhabit, upon which we waste our short time scrambling for objects that death takes away in seconds. A candle, which will burn to nothing and then extinguish itself, alludes to the fleeting passage of time. A curtain is pulled aside to reveal a Last Judgment, to which we must all succumb. In secular allegory Vanitas is one of the minor vices.

Example: Juan de Valdés Leal. Wadsworth Atheneum, Hartford. (Held and Posner, fig. 194)

VEIL OF SAINT VERONICA. Although depicted during the Baroque, the veil of Veronica (or the *sudarium,* or vernicle) enjoyed its greatest popularity during the Late Middle Ages. Veronica was one of the persons present as Jesus carried his cross up the hill of Calvary. She offered him a cloth with which to wipe the blood and sweat from his face. When he returned the cloth to her,

Veronica saw that his image had been miraculously imprinted upon it. The supposed cloth became a venerated relic—a *vera icon*—or true image (from which Veronica's name was derived). According to the GOLDEN LEGEND, Veronica wanted a portrait of Jesus because he was always traveling and preaching and therefore she could not always be with him. She was on her way to a painter's studio one day to have his face painted on a cloth and Jesus passed her. When she told him that she was going to the painters to have his portrait drawn, he took the cloth from her, pressed it against his face and left his image upon it. Veronica's veil is today preserved as a holy relic in St. Peter's in Rome.

In early depictions, Veronica is shown holding her cloth in the presence of other individuals along with Jesus, who carries his cross. It was the late medieval artists who, in their works, removed Veronica from the narrative sequence and showed her alone, holding the cloth with the image of Jesus before her. Artists used this idea during the 15th and following centuries when gradually the image became more simplified. She was finally omitted altogether and only the veil was shown, held by angels. El Greco omitted the angels and painted the veil by itself attached to a dark background by two large nails. This image was preferred during the 17th century because it was reasoned that the veil would have been hung on nails in a reliquary. Christ's face seems to dissolve mysteriously into the cloth. It has the blurred quality of a face whose transfer has been miraculously effected with an ink of sweat and blood.

Example: Francisco de Zurbarán, National Museum, Stockholm. (Brown, colorplate 27)

VENUS AND ANCHISES. In mythology, Anchises was the son of Capys and grandson of Assaracus, who belonged to the younger branch of the Trojan royal house. He was a Trojan shepherd of Mt. Ida (on the island of Crete) or possibly a prince, who was loved by Venus (Aphrodite), who bore his son, Aeneas. In Virgil's *Aeneid* 2:671–729 ("The Fall of Troy"), Anchises is carried from burning Troy on his son's back after which he shared his son's wanderings (*see* STORY OF AENEAS). Many accounts of his death exist: Virgil says he died in Sicily at Drepanum and later describes him in the Elysian fields. Anchises was buried at Eryx and appears among the blessed spirits in the underworld to foretell the future greatness of Rome. Venus fell in love with the shepherd-prince Anchises and disguised herself as a mortal to visit him. She came to him anointed with perfume and adorned with jewels as he pastured herds on the slopes of Mt. Ida and lay with him on his couch. The offspring of this union was Aeneas, born on the peaks of Ida, the legendary ancestor of the Romans. Forbidden to reveal the name of his son's mother, he is said to have boasted of it among his friends, and because of this he was lamed by lightning or blinded.

In art, Venus is shown undressed and seated on a silken canopied bed. Anchises is at her side and may be in the act of taking off one last item of clothing, her sandal. Cupid (sometimes shown more mischievous than usual) is close by. These words, from the opening of the *Aeneid* may be included, "*Genus unde Latinum,*" or "Whence came the Latin race." *See also* TOILET OF VENUS.

Example: Annibale Carracci, Gallery, Palazzo Farnese, Rome. (Held and Posner, colorplate 5)

VERONICA. *See* VEIL OF SAINT VERONICA.

VERTUMNUS AND POMONA. The story of Vertumnus and Pomona is told in Ovid's *Metamorphoses* 14:623–97 and 765–71. An Italian god and goddess, both are protectors of ripening fruit, orchards and gardens. Vertumnus was possibly Etruscan in origin, a god of changing seasons (Latin *vertere* means "change"), and especially of the ripening fruits of autumn. He had the power to change his shape and became associated with money-changing. Pomona was the Italian goddess of *poma,* or tree fruits, such as apples, who was given a priest of minor rank by the Romans and had a sacred precinct outside Rome but no known festival. Vertumnus tried to gain Pomona's love (as had many before him) and was unsuccessful. He disguised himself as a herdsman, a vineyard worker, a soldier, a fisher so as to be able to approach his love in order to enjoy the sight of her beauty. "Then one day, he even turned his hair gray at the temples, put an embroidered cap on his head, and pretended to be an old woman. Leaning on a stick, he entered the well-kept gardens and admired Pomona's fruit. 'It makes you all the more desirable,' he said, and with these words of praise kissed her several times, in a way in which a real old woman never would have done. . . . [Vertumnus] pleaded with Pomona, but it was all to no purpose. Then he returned to his own shape, revealing himself as a young man. Stripping off the trappings of age, he appeared to the girl in all his glory, as when the sun's brilliant orb conquers the clouds that veil his face, and shines forth undimmed. He was preparing to use force, but there was no need for that. The nymph, entranced by the God's beauty, was smitten with a passion equal to his own."

Artists usually show Vertumnus as an old woman sitting beside or bending over the beautiful and naked Pomona. He may touch her and lean forward to kiss her. Pomona is often seated under a tree, luscious fat grapes and other ripe fruits may be on the ground beside her, or they may spill in all their abundance from a cornucopia. She usually holds a curved pruning knife. The tree may have a vine's tendrils growing up one side, one of the ways, according to Ovid, in which the grape was grown.

Example: Hendrick Goltzius, Rijksmuseum, Amsterdam. (Rosenberg, Slive, ter Kuile, fig. 6)

VICTORY OF JOSHUA OVER THE AMALEKITES (*Victory of Moses*). The Amalekites were an aboriginal people of Canaan and the Sinai peninsula. They waged constant warfare against the Hebrews until they were finally dispersed by Saul. Their ancestor, Amalek, for whom they were named, was a duke of Edom and Esau's descendant. Their story is told in Genesis, Exodus, Numbers, Judges, 1 Samuel and Chronicles. Joshua, whose name is a variant of the

name Jesus, was the successor of Moses. Christians consider him one of the many Old Testament prefigurations of Christ. He was the leader in the war of the Israelites, who took Jericho and then conquered Canaan, that territory which was the same as ancient Palestine, lying between the Jordan, the Dead Sea, and the Mediterranean. It was the Promised Land of the Israelites, and after their delivery from Egypt they subjugated it. This story is found in the Book of Joshua (Josue) in the Old Testament. The story of the victory of Joshua over the Amalekites is found in Exodus 17:8–13. While Moses and Joshua were in the desert, the Israelites fought the tribe of the Amalekites. According to the account, ''Am'alek came and fought with Israel at Reph'idim. And Moses said to Joshua, 'Choose for us men, and go out, fight with Am'alek; tomorrow I will stand on the top of the hill with the rod of God in my hand.' So Joshua did as Moses told him, and fought with Am'alek; and Moses, Aaron, and Hur went up to the top of the hill. Whenever Moses held up his hand, Israel prevailed; and whenever he lowered his hand, Am'alek prevailed. But Moses' hands grew weary; so they took a stone and put it under him, and he sat upon it, and Aaron and Hur held up his hands, one on one side, and the other on the other side; so his hands were steady until the going down of the sun. And Joshua mowed down Am'alek and his people with the edge of the sword.''

Joshua, young and vigorous, is shown in savage battle with men on horseback and on foot, while Moses stands on the hill overlooking the chaotic, bloody battlefield with both arms raised, as told in the Bible. Aaron and Hur stand beside him and support his arms. Moses is old with a white beard.

Example: Nicolas Poussin, The Hermitage, St. Petersburg. (Blunt, fig. 227)

VICTORY OF MOSES. *See* VICTORY OF JOSHUA OVER THE AMALEKITES.

VIRGIN OF THE PILGRIMS. *See* MADONNA DI LORETTO.

VIRGIN OF THE ROSARY. *See* MADONNA OF THE ROSARY.

VISION OF ST. DOMINIC. *See* MADONNA OF THE ROSARY.

VISION OF ST. FILIPPO NERI. Filippo Romolo de' Neri, also Saint Philip Neri (1515–1595) was an Italian reformer. The son of a Florentine lawyer, he was religious as a child and studied theology in Rome in 1533. By 1537 he had sold his books to give money to the needy. After this he was supported by a wealthy Florentine whose son he tutored. His charity work that followed was among the crowds of Rome, helping the sick and the poor and telling them of their need for religion. He founded the Confraternity of the Most Holy Trinity so that he could take care of pilgrims and convalescents. Although still only a layman, he was a successful preacher. He was not ordained until 1551, at which time he went to the Church of San Girolamo where the priests carried on the

city missionary work. So well-loved was he that his confessional was visited more frequently than that of other priests and his casual meetings brought about a true and simple religious awakening in Rome. Philip Neri is called "the apostle of Rome" because of the lasting effects he had on individuals of every class, rich and poor. Because of his success he built an oratory over the church and held exercises with vernacular prayers and hymns for the people. He also included concerts of sacred music. From those the oratorio derives its name. Besides his place at San Girolamo, he accepted the rectorship of the Florentine Church of San Giovanni and founded an oratory there. In 1575 his community of secular priests was canonically established and this marks the beginning of the Congregation of the Oratory. He left his position as superior of his community in 1593, two years before his death. Besides the revivification of the faith, he is credited with the extension of vernacular services and of the exposition of the Sacrament. He is known especially for his attachment to the cult of the Virgin Mary. He also has the reputation for having experienced the state of ecstasy.

He is usually depicted kneeling in prayer before a vision of Mary with her Child and with angels. He raises his arms to heaven and wears a chasuble (a hooded garment). In front of him on the ground lies a lily, the symbol of purity. Some artists show him experiencing his vision while celebrating the Mass, or fainting into the arms of angels. It is thought that he had a heart condition brought about by his exalting spiritual rapture, which became the source of his inscription: *"Dilatasi cor meum,"* "When thou didst enlarge my heart." Sometimes he is shown with CHARLES BORROMEO, a friend whom he frequently advised. The example below was painted while the Church of S. Maria in Vallicella was under construction, which explains the scaffolding, ladders and workmen surrounding Philip and the Virgin.

Example: Pietro da Cortona, Fresco, ceiling of the nave, S. Maria in Vallicella, Chiesa Nuova, Rome. (Waterhouse, fig. 45)

VISION OF ST. JAMES THE GREATER (*Madonna du Pilier*). St. James, the brother of JOHN THE EVANGELIST, the son of Zebedee, a fisherman of Galilee, was named "the Greater" to distinguish him from the other apostle of the same name, called "James the Less" because he was the younger. Of all the apostles, James the Greater was the closest to Jesus. He was called "the son of thunder" because of the sonority of his preaching. James was present with Peter and John as spectators of the Transfiguration of Christ and they alone were taken into the recesses of Gethsemani (*see* AGONY IN THE GARDEN) on the night of the beginning of the PASSION OF CHRIST, where they slept while Christ prayed. According to the GOLDEN LEGEND, James was put on trial in Jerusalem by Herod Agrippa and beheaded on March 25, 44 A.D. Legends tell of his mission to Spain and eventual burial at Compostella. None are based on historical fact, although the church at Compostella in Spain became one of the great places of Christian pilgrimage. Legends about St. James, dating from the

10th century, could have been promoted to encourage pilgrimage to Compostella. One such legend tells of the Mother of God appearing to him in a vision in Saragossa, Spain. She was seated on top of a column of jasper and commanded him to build a church on the spot. The church built there is called Nuestra Señora del Pilar.

James is usually depicted as older with long, dark hair. He may hold a martyr's sword, or, when grouped with other saints, the pilgrim's staff. The Virgin is shown with the infant Jesus seated on top of a high black column. She points to James.

Example: Nicolas Poussin, The Louvre, Paris. (Friedlaender, fig. 15)

VISION OF ST. ROMUALD. Saint Romuald, c. 952–1027, a citizen of Ravenna, Italy, joined the Order of St. Benedict as an act of atonement for his father, who had murdered a relative. While in the monastery, he had a vision of St. Apollinaris, who instructed him to establish a new order in the service of God. Romuald, a man of great asceticism, shocked at the laxity of many of those who professed to be living the religious life, saw a need for extensive reforms. None of the existing orders was willing to live by the severity of the rule that he wanted to impose. Therefore, in 975, Romuald founded the Order of Camaldoli, whose members vowed perpetual silence and solitude. The best known Camaldoli monastery is near Arezzo in the Apennines. According to legend, when Romuald was searching for a place to build his monastery, he dreamed that he saw a ladder stretching from earth to Heaven, on which men in white raiment were ascending. Taking this as a sign, he decreed that the monks of his new order should wear white robes.

In art, Romuald may be seen seated with his brethren under the shadows of a great tree, telling them about his dream of the ladder to heaven on which the deceased members of the order ascend to paradise. At the same time he points to it, dazzling and white, in the background. Other saints of his order were Benedict and Scholastica. Sometimes Romuald is seen with the Devil (evil) trampled under his feet. He is shown as an old man with a long white beard dressed in the white, loose-flowing wide-sleeved habit of the Camaldoli Order. Most often he appears in paintings commissioned for the Benedictine communities.

Example: Andrea Sacchi, Vatican Pinacoteca, Rome. (Wittkower, fig. 160)

VISITATION. The story of the Virgin Mary's visit to her cousin Elizabeth is told by Luke 1:39–56. "Mary arose and went with haste into the hill country, to a city of Judah, and she entered the house of Zechariah and greeted Elizabeth. And when Elizabeth heard the greeting of Mary, the babe leaped in her womb, and Elizabeth was filled with the Holy Spirit and she exclaimed with a loud cry, 'Blessed are you among women, and blessed is the fruit of your womb. And why is this granted me, that the mother of my Lord should come to me? For behold, when the voice of your greeting came to my ears, the babe in my

womb leaped for joy.' And Mary remained with her about three months, and returned to her home.'' Elizabeth, the mother of JOHN THE BAPTIST, was in her sixth month of pregnancy when Mary had conceived.

Mary is shown after she has crossed the mountains and at the happy moment of her arrival at the house of Zacharias and Elizabeth. A Negro servant lifts her cloak from her shoulders. Zacharias, old and bearded, makes his way slowly down the stairs of his large house, aided by a boy. He is anxious to greet his wife's cousin. A little dog (a symbol of loyalty) sniffs at the hem of Mary's dress. Mary and Elizabeth glance at each other in a knowing way. Elizabeth is shown as an elderly matron compared to the youthful and beautiful virgin.

Example: Rembrandt van Rijn, The Detroit Institute of Arts. (Rosenberg, Slive, ter Kuile fig. 71)

W

WASH. A technical term for a layer of transparent watercolor or diluted ink spread evenly over a broad area so as to leave no brush marks. Washes of bistre or India ink are sometimes used for the modeling or the CHIAROSCURO (shadows) of a drawing. Cennino Cennini, an Italian writer and artist born in 1370, gives various instructions for reinforcing a pen drawing with the brush. During the Renaissance brush work loosened somewhat, and by the 17th century, Claude Lorrain, Adam Elsheimer, Rembrandt and Nicolas Poussin used washes freely, although each in his own individual way.

WAY TO GOLGOTHA (*Road to Calvary, The Ascent,* or *Procession To Calvary*). Golgotha, which means "skull" in Latin and Hebrew, is the place outside the wall of Jerusalem where Jesus was crucified, although the exact location is not known. The CRUCIFIXION is mentioned by all four of the gospels: Matthew 22:33, Mark 15:22, Luke 23:33 and John 19:17–20. According to John, "They took Jesus, and he went out, bearing his own cross, to the place called the place of a skull, which is called in Hebrew Golgotha. There they crucified him, and with him two others, one on either side and Jesus between them. Pilate also wrote a title and put it on the cross; it read, 'Jesus of Nazareth, the King of the Jews' . . . the title was written in Hebrew, in Latin, and in Greek."

Traditionally the location of the site of Golgotha was made by St. Helena when, in 327, she found what was thought to be a relic of the Cross. This site is within the Church of the Holy Sepulcher. The places through the streets of Jerusalem where Christ fell and halted on his way to Golgotha are known as the *Via Dolorosa,* "the Way of the Cross." The road to Golgotha is Christ's final journey from Pilate's house where he had been flogged and then mocked by the Roman soldiers and then crowned with thorns. It culminates on the hill of Golgotha where he was crucified. On the road he fell three times under the

weight of the cross; he met his mother, Simon the Cyrenian and St. Veronica. The Way of the Cross is also known as the Stations of the Cross. Originally seven stations were used to illustrate the different incidents of Christ's journey. Later seven more were added, and fourteen remain to this day.

Jesus is usually shown bent and staggering or falling to the ground under the weight of an enormous cross. Roman soldiers and onlookers straggle along beside and behind him. A person may lead the procession with the sign written by Pilate, holding it high for all to see.

Example: Arent de Gelder, Ältere Pinakothek, Munich. Rosenberg, Slive, ter Kuile, fig. 119)

WEDDING OF THE VIRGIN. *See* MARRIAGE OF THE VIRGIN.

WINTER. *See* THE DELUGE.

WOMAN TAKEN IN ADULTERY. *See* CHRIST AND THE ADULTEROUS WOMAN.

WORKS OF MERCY. *See* SEVEN WORKS OF MERCY.

X

XAVIER, ST. FRANCIS. *See* MIRACLES OF ST. FRANCIS XAVIER.

XENOPHRON'S SACRIFICE TO DIANA. A Greek historian, the son of Gryllus of the Athenian deme Erchia, Xenophron lived from c.428 to c.354 B.C. He and his wife, Philesia Xenophron, had two sons, Gryllus and Diodorus; the former died in the battle of Mantinea in 362 B.C. Born into a wealthy family, Xenophron was, in his youth, a follower of Socrates, who is featured in his *Memoirs* and *Symposium.* He admired the elder Cyrus and served under the Spartan king Agesilaus, to whom he became strongly attached. He later wrote idealized biographies of both. Around 399, the year that Socrates died, Xenophon was formally exiled, and for the greater part of his life he lived in his estates at Olympia near Scillus, lands that had been given him by the Spartan government.

Xenophron wrote on a wide range of subjects; and his treatises on estate management, hunting, finance and horsemanship, originally compiled for his sons, are the oldest extant complete works on these subjects. Also still extant is his *Anabasis,* or *Persian Expedition* (in seven books) on his adventures with the ten thousand mercenary soldiers enlisted by the younger Cyrus and of their return to safety. He wrote *Hellenica,* a history of Greek affairs (also seven books) from 411 to 362 (where Thucydides's work stops). Xenophron's own personal interests were horsemanship and hunting; in both subjects he displays a scientific and exact knowledge. His sacrifice to Diana after his happy return from the East is discussed in his *Anabasis* 5:3. The sacrifice was meant to celebrate the homecoming of the Barberini (*see* TRIUMPH OF THE BARBERINI) after their exile.

In the example below, Xenophron is shown young and strong and with dark hair, as he stands at the altar before a Greek Monopteral (round) pseudo-Doric temple. Men bring a slain animal to him; women carry wine and food.

Example: Pietro da Cortona, Palazzo Barberini (formerly), Rome. (Wittkower, fig. 158)

Appendix A:
List of Popes of the
Baroque Age

The popes of Baroque Rome nurtured art patronage on a grand scale after 1592 when Clement VIII assumed the office. They are listed below with dates of their family names and reigns.

Clement VIII (Aldobrandidi), 1592–1605

Paul V (Borghese), 1605–1621

Gregory XV (Ludovisi), 1621–1623

Urban VIII (Barberini), 1623–1644

Innocent X (Pamphily), 1644–1655

Alexander VII (Chigi), 1655–1667

Clement IX (Rospigliosi), 1667–1669

Clement X (Altieri), 1670–1676

Innocent XI (Odescalchi), 1676–1689

Alexander VIII (Ottoboni), 1689–1691

Innocent XII (Pignatelli), 1691–1700

Clement XI (Albani), 1700–1721

Appendix B:
List of Artists

Albani, Francesco (1578–1660), Italian

Allori, Cristofano (1577–1621), Italian

Assereto, Gioacchino (1600–1649), Italian

Baciccio, Giovanni Battista Gaulli (1639–1709), Italian

Bakhuizen, Ludolf (1631–1708), Dutch

Bamboccio, an Italian name meaning fat and lively baby given Pieter van Laer (q.v.)

Barbiera, Giovanni Francesco (1591–1666), Italian

Baroccio, Fredericio Barocci (1535?–1612), Italian

Barra, Didier. *See* Monsù Desiderio (1593–?), Italian

Battistello. *See* Caracciolo.

Bellange, Jacques (active 1602–1617), French

Bernini, Gian Lorenzo (1598–1680), Italian

Blanchard, Jacques (1600–1638), French

Bloemaert, Abraham (1564–1651), Dutch

Bombelli, Sebastiano (1635–1716), Italian

Borch, Gerard ter (also Ter Borch, Terburg, Terborch) (1617–1681), Dutch

Borgianni, Orazio (1578?–1616), Italian

Borromini, Francesco (1599–1667), Italian

Bosse, Abraham (1602–1676), French

Breenbergh, Bartholomeus (1599/1600–1657), Dutch

Brouwer, Adriaen (1605/6–1638), Flemish

Bruegel, Jan I (called ''Velvet Bruegel'') (1658–1625), Dutch

Cagnacci, Guido (1601–1663), Italian

Cairo, Francesco del Cairo (1607–1665), Italian

Callot, Jacques (1592/3–1635), French

Canaletto (Giovanni Antonio Canale) (1697–1768), Venetian

Cantarini, Simone (1612–1648), Italian

Canuti, Domenico Maria (1626–1684), Italian

Caracciolo, Giovanni Battista (called "Battistello") (c. 1570–1637), Italian

Caravaggio, Michelangelo Merisi da (1571–1610), Italian

Carpioni, Giulio (1613–1679), Italian

Carracci, Agostino (1557–1602), Italian

Carracci, Annibale (1560–1609), Italian

Carracci, Lodovico (1555–1619), Italian

Castello, Valerio (1624–1659), Italian

Castiglione, Giovanni Benedetto (c. 1610–1663/65), Italian

Cavallino, Bernardo (1616–1656), Italian

Cavedoni, Giacomo (1577–1660), Italian

Cerano. *See* Crespi, Giovanni Battista.

Champaigne, Philippe de (1602–1674), Belgian

Cigoli, Lodovico (1559–1613), Italian

Coli, Giovanni (1636–1681), Italian

Cortese, Gugliemo (1628–1679), Italian

Cortona, Pietro Berrettini da (1596–1669), Italian

Coypel, Antoine (1661–1722), French

Cozza, Francesco (1605–1682), Italian

Crespi, Daniele (c. 1598–1630), Italian

Crespi, Giovanni Battista ("Il Cerano") (c. 1575–1632), Italian

Crespi, Giuseppe, Maria (1665–1747), Italian

Cuyp, Albert (1620–1691), Dutch

D'Arpino. Giuseppe Cesari (known as Cavaliere d'Arpino) (1568–1640), Italian

Desiderio, Monsù. Name under which Didier Barra and Francesco de Nome have been grouped.

Dolci, Carlo (1616–1686), Italian

Domenichino, Domenico Zampieri (1581–1641), Italian

Donner, Georg Raphael (1693–1741), Austrian

Duck, Jacob (c. 1600–1667), Dutch

Duquesnoy, Frans or Francis (sometimes called Fiammingo) (1594–1643), Flemish

El Greco, Domenikos Theotocopoulos (1541–1614), Greek

Elsheimer, Adam (1578–1610), German

Everdingen, Caesar Boëtius van (1606–1678), Dutch

Fabritius, Carel (1622–1654), Dutch

Fernández, Gregorio (c. 1576–1636), Spanish

Ferrari, Giovanni Andrea de (1598–1669), Italian

Fetti, Domenico (also Feti) (c. 1588/9–1623), Italian

Flinck, Govert (1615–1660), Dutch

Fosse, Charles de la (1636–1716), French

Francanzano, Francesco (1612–1656?), Italian

Furini, Francesco (1603–1646), Italian

Gaulli. *See* Baciccio.

Gelder, Arent de (1645–1727), Dutch

Gentileschi, Artemisia (c. 1597–1652/3), Italian

Gentileschi, Orazio (1563–1639), Italian

Gherardi, Filippo (1643–1704), Italian

Gimignani, Giacinto (1612–1681), Italian

Giordano, Luca (1632–1705), Neapolitan

Giovanni, Giovanni da San (1592–1636), Italian

Goltzius, Hendrick (1558–1617), Dutch

Goudt, Hendrick (1585–1648), Netherlands

Guercino, or "squint-eyed," name given to Giovanni Francesco Barbiera (q.v.)

Haffner, Enrico (1640–1702), Italian

Hals, Frans (1581/5–1666), Flemish

Helst, Bartholomeus van der (1613–1670), Dutch

Honhorst, Gerrit van (1590–1656), Dutch

Jordaens, Jacob (1593–1678), Dutch

Jouvenet, Jean (1644–1717), French

La Hyre, Laurent de (1606–1656), French

Lanfranco, Giovanni (1582–1647), Italian

Langetti, Giambattista (1625–1676), Italian

Lastman, Pieter (1583–1633), Dutch

La Tour, Georges de (1593–1652), French

Leal, Juan de Valdés (1622–1690), Spanish

Le Brun, Charles (1619–1690), French

Lely, Sir Peter (real name van der Faes) (1618–1680), German (of Dutch parents)

Le Nain, Antoine (1588–1648), French

Le Nain, Louis (c. 1593–1648), French

Le Nain, Mathieu (1607–1677), French

Le Sueur, Eustache (1616/17–1655), French

Liss (Lys), Johann (c. 1597–1629/30), German

Lorrain(e), Claude Gellée (1600–1682), French

Maffei, Francesco (c. 1600–1660), Italian

Manetti, Rutilio (1571–1639), Italian

Manfredi, Bartolommeo (c. 1580–1620/1), Italian

Maratta (Maratti), Carlo (1625–1713), Italian

Mazzoni, Sebastiano (c. 1611–1678), Italian

Mola, Pier Francesco (1612–1666), Italian

Molinari, Antonio (1665–1727), Italian

Morazzone, Pier Francesco Mazzuchelli (called Morazzone) (1521 or 73–1626), Italian

Murillo, Bartolomé Esteban (1617–1682), Spanish

Nomé, Francesco de. *See* Monsù Desiderio (1593–?), Italian

Novelli, Pietro (1603–1647), Italian

Pacheco, Francisco (1564–1654), Spanish

Parrocel, Joseph (1646–1704), French

Pérelle, Gabriel (1602–1677), French

Piola, Domenico (1627–1703), Italian

Piranesi, Giovanni Battista (1720–1778), Italian

Porcellis, Jan (1584–1632), Dutch

Poussin, Gaspard (Gaspard Dughet) (1615–1675), French

Poussin, Nicolas (1594–1665), French

Pozzo, Fra Andrea (1642–1709), Italian

Preti, Mattia (Il Cavaliere Calabrese) (1613–1699), Italian

Procaccini, Guilio Cesare (1574–1625), Italian

Puget, Pierre (1620–1694), French

Queirolo, Francesco (1704–1762), Italian

Rembrandt van Rijn (1606–1669), Dutch

Reni, Guido (1575–1642), Italian

Ribalta, Francisco (1565–1628), Spanish

Ribera, José or Jusepe (Lo Spagnoletto) (1591?–1652), Spanish

Ricci, Sebastiano (1659–1734), Italian

Rigaud, Hyacinthe (1659–1743), French

Romanelli, Giovanni Francesco (1610?–1662), Italian

Rosa, Salvator (1615–1673), Italian

Rubens, Peter Paul (1577–1640), Flemish

Sacchi, Andrea (1599–1661), Italian

Saraceni, Carlo (1579–1620), Italian

Scarsella, Ippolito (known as Lo Scarsellino) (c. 1550–1620), Italian

Schedoni, Bartolomeo (1578–1615), Italian

Scorza, Sinibaldo (1589–1631), Italian

Solimena, Francesco (called L'Abate Ciccio) (1657–1747), Italian

Stanzione, Massimo (1585–1656), Italian

Stomer, Matthias (1600–after 1650), Dutch

Strozzi, Bernardo (nicknames "Il Cappucino" and "Il Prete Genovese") (1581–1644), Italian

Tassel, Jean (1608?–1667), French

Testa, Pietro (1607/11–1650), Italian

Tiarini, Allesandro (1577–1688), Italian

Torrentius, Johannes (1589–1644), Dutch

Trevisani, Francesco (1656–1746), Italian

Uytewael, Joachim A. (1566–1638), Dutch

Valentin Le, (Moïse Valentin, Valentin de Boullogne) (c. 1591 or 1594–1632), French

Van de Capelle, Jan (c. 1624–1679), Dutch

Van de Velde, Willem the Younger (1633–1707), Dutch

Van Dyck, Anthony (1599–1641), Flemish

Van Hoogstraten, Samuel (1627–1679), Dutch

Van Laer, Pieter (called Il Bamboccio) (1592 or 1595–1642), Italian

Vanni, Francesco (1563?–1610), Italian

Van Ruisdael (1628–1682), Dutch

Varallo, Tanzio da (1574/80–1635), Italian

Vasari, Giorgio (1511–1574), Italian

Velázquez, Diego Rodriguez de Silva y (1599–1660), Spanish

Vermeer, Jan (1632–75), Dutch

Vinckboons, David (1576–1632), Dutch

Volterrano, Baldassare Franceschini (called il Volterrano) (1611–1689), Italian

Vouet, Simon (1590–1649), French

Vroom, Hendrick (1566–1640), Dutch

Wtewael, Joachim (1566–1638), Dutch

Zurbarán, Francisco de (1598–1664), Spanish

Bibliography

Alpers, Svetlana. *The Art of Describing: Dutch Art in the Seventeenth Century.* Chicago: University of Chicago Press, 1983.

Bazin, Germain. *Baroque and Rococo Art.* New York: Praeger, 1974.

Blunt, Anthony, ed. *Art and Architecture in France 1500–1700.* Baltimore: Pelican, 1973.

———. *Baroque and Rococo: Architecture and Decoration.* Cambridge: Harper & Row, 1982.

Book of Saints. Compiled by the Benedictine Monks of St. Augustine's Abbey, Ramsgate. 5th ed. New York: Crowell, 1966.

Bottari, Stefano. *Caravaggio.* Trans. Diane Goldrei. New York: Grosset & Dunlap, 1971.

Brown, Dale. ed. *The World of Velázquez 1599–1660.* New York: Time Life Books, 1969.

Brown, Jonathan. *Francisco de Zurbarán.* New York: Abrams, n.d.

———. *Velázquez: Painter and Courtier.* New Haven: Yale University Press, 1986.

Burckhardt, Jacob. *Recollections of Rubens.* London: Phaidon Press, Ltd., 1950.

Butler's Lives of the Saints. Ed. Michael Walsh. New York: Harper & Row, New York, 1985.

Chilvers, Ian, and Osborne, Harold, eds. *The Oxford Dictionary of Art.* New York: Oxford University Press, 1988.

Copplestone, Trewin. *Rembrandt.* London: Paul Hamlyn, Ltd., 1967.

Encyclopedia of World Art. 15 vols. New York: Publisher's Guild, 1959–1968. Supplementary vols. 16, 1983; 17, 1987.

Ferguson, George. *Signs and Symbols in Christian Art.* New York: Oxford University Press: 1954.

Fokker, Timon H. *Roman Baroque Art: The History of a Style.* London: Oxford University Press, 1938.

Freedberg, Sydney J. *Circa 1600: A Revolution of Style in Italian Painting.* Cambridge: Harvard University Press, 1983.

Friedlaender, Walter. *Caravaggio Studies.* Reprint, Ann Arbor, Michigan: Bowker, 1955.

Fromentin, Eugène, *The Old Masters of Belgium and Holland.* Trans. Mary C. Robbins; intro. Meyer Shapiro. New York: Schocken, 1963.

Fuchs, R.H. *Dutch Painting*. New York: Oxford University Press, 1978.

Gerson, Horst, and ter Kuile, E.H. *Art and Architecture in Belgium 1600–1800*. Baltimore: Penguin, 1960.

———. *Rembrandt Paintings*. New York: Reynal, 1968.

Golzio, Vincenzo. *Seicento e Settecento*. 2d ed., 2 vols. Turin: Unione tipografico editrice torinese, 1968.

Gowing, Lawrence. *Vermeer*. New York: Harper & Row, 1968.

Grant, Michael. *Myths of the Greeks and Romans*. New York: New American Library, 1962.

Haak, Bob. *The Golden Age: Dutch Painters of the Seventeenth Century*. London: Thames & Hudson, 1984.

———, *Rembrandt: His Life, His Work, His Time*. New York: Abrams, 1969.

Haggar, Reginald G. *A Dictionary of Art Terms: Architecture, Sculpture, Painting, and the Graphic Arts*. England: Poole, New Orchard Editions, 1984.

Hartt, Frederick. *Art, A History of Painting, Sculpture, Architecture*. vol. 2. New York: Abrams, 1985.

Haverkamp-Begemann, E. *Rembrandt: The Night Watch*. Princeton, N.J.: Princeton University Press, 1982.

Held, Julius, and Posner, Donald. *17th and 18th Century Art*. New York: Abrams, 1974.

Hempel, Eberhard. *Baroque Art and Architecture in Central Europe*. Penguin, Baltimore: 1965.

Hibbard, Howard. *Bernini*. Harmondsworth, England: Penguin, 1976.

———. *Caravaggio*. New York: Thames & Hudson, 1983.

Hind, Arthur M. *A History of Engraving and Etching from the Fifteenth Century to the Year 1914*. 3d rev. ed. New York: Dover, 1963.

Hinks, Roger P. *Michelangelo Merisi da Caravaggio*. London: Faber & Faber, 1953.

Kahr, Madlyn Millner. *Dutch Painting in the Seventeenth Century*. New York: Harper & Row, 1978.

———. *Velázquez: The Art of Painting*. New York: Harper & Row, 1976.

Kitson, Michael. *The Age of Baroque*. London: Hamlyn, 1976.

Lafuente, Enrique. *Velázquez*. London: Phaidon Press, 1943.

Larousse Encyclopedia of Renaissance and Baroque Art. Ed. René Huyghe. New York: Prometheus Press, 1967.

Lees-Milne, James. *Baroque in Italy*. New York: Macmillan, 1960.

Livy. *The Early History of Rome*. London: Penguin, 1971.

———. *Rome and Italy*. London: Penguin, 1982.

Martin, John R. *Baroque*. New York: Harper & Row, 1977.

Münz, Ludwig, and Haak, Bob. *Rembrandt*. New York: Abrams, 1967.

Murry, Peter, and Murry, Linda. *A Dictionary of Art and Artists*. New York: Penguin, 1976; paperback, 1984.

Myers, Bernard Samuel, ed. *Encylopedia of Painting: Painters and Painting of the World from Prehistoric Times to the Present Day*. 4th rev. ed. New York: Crown, 1979.

Nicolson, Benedict. *The International Caravaggesque Movement*, Oxford: Phaidon, 1979.

Ovid. *Metamorphoses*. Trans. Mary M. Innes. New York: Penguin, 1955.

Plutarch. *Fall of the Roman Republic*. Trans. Rex Warner. London: Penguin, 1972.

———. *Lives of the Noble Grecians and Romans*. Trans. John Dryden; rev. by Arthur Hugh Clough. New York: The Modern Library, Random House, Inc., n.d.

———. *Makers of Rome*. Trans. Ian Scott-Kilvert. Baltimore: Penguin, 1965.

Radice, Betty. *Who's Who in the Ancient World.* London: Penguin, 1977.

Rosenberg, Jakob. *Rembrandt.* 2d ed. London: Phaidon, 1964.

Rosenberg, Jakob, Slive, Seymour, and E.H. ter Kuile, E.H. *Dutch Art and Architecture, 1600–1800.* 2d ed. Baltimore: Penguin, 1972.

Ruskin, Ariane. *17th & 18th Century Art.* New York: McGraw Hill, 1964.

Spear, Richard E. *Caravaggio and His Followers.* New York: Harper & Row, 1975.

Stechow, Wolfgang. *Dutch Landscape Painting of the 17th Century.* Oxford: Phaidon, 1981.

Tacitus, Cornelius. *Histoires,* IV. Paris: Belles Lettres, 1992.

Tapié, Victor L. *The Age of Grandeur.* New York: Grove Press, 1957.

Voragine, Jacobus de. *The Golden Legend.* Trans. Granger Ryan and Helmut Ripperger, 1941. Reprint, New York: Arno Press, 1969.

Waterhouse, Ellis Kirkham. *Baroque Painting in Rome.* London: Phaidon, 1976.

———. *Italian Baroque Painting.* 2d ed. London: Phaidon, 1969.

Wedgewood, C.V. *The World of Rubens.* Alexandria, Virginia: Time-Life Books, 1967.

Wemble, Harry B. *Great Paintings from the Prado.* New York: Harry N. Abrams, 1963.

Whinney, Margaret D., and Millar, O. *Rembrandt as an Etcher.* 2 vols. University Park: Pennsylvania State University Press, 1969.

White, Christopher. *Peter Paul Rubens: Man and Artist.* New Haven: Yale University Press, 1987.

Wittkower, Rudolf. *Art and Architecture in Italy 1600–1750.* Middlesex, England: Penguin, 1958.

———. *Gian Lorenzo Bernini: The Sculptor of the Roman Baroque.* 3d rev. ed. Oxford: Phaidon, 1981.

Wölfflin, Heinrich. *Principles of Art History: The Problem of the Development of Style in Later Art.* 7th ed. New York: Dover, 1950.

Wright, Christopher. *The Dutch Painters: One Hundred Seventeenth Century Masters.* Woodbury, N.Y.: Barron, 1978.

———. *The French Painters of the 17th Century.* New York: New York Graphic Society, 1986.

Index

About the Author

IRENE EARLS is a Professor at the University of Florida and teaches advanced placement Art History to academically gifted high school students. She is the author of *Renaissance Art*: *A Topical Dictionary* (Greenwood, 1987) and *Napoleon III L'Architecte et l'Urbaniste de Paris* (1991).

ISBN 0-313-29406-2

EAN

9 780313 294068

HARDCOVER BAR CODE